GOYA

Pierre Gassier

GOYA

A WITNESS OF HIS TIMES

CHARTWELL BOOKS, INC.

Translated from the German by Helga Harrison and edited by Arts & Letters, Inc.

Typography by Arts & Letters, Inc.
Brookline, MA

Published by
CHARTWELL BOOKS, INC.
A Division of **BOOK SALES, INC.**
110 Enterprise Avenue
Secaucus, New Jersey 07094

© 1983 Office du Livre, Fribourg, Switzerland

Reprinted with permission by William S. Konecky Associates, Inc.

ISBN: 0-89009-842-5

Printed and bound in Israel.

Table of Contents

I

The Time of the Masters

I The Time of the Masters

Artistic life in Spain at the ascension of Charles III (1759): — the royal residences — the new palace in Madrid — the Academy — Goya and his first masters at Saragossa — arrival of Mengs and the Tiepolos — disappointments in Madrid — stay in Italy — El Pilar, the Bayeus — through his marriage Goya enters the Bayeu clan — settles in Madrid — discovers Velázquez

With the ascension of Charles III to the throne of Spain, the peninsula's artistic life underwent a series of major upheavals. The new sovereign came from Naples where he had reigned for twenty-five years, earning the reputation of a great monarch — not only a scrupulous administrator of his realm, but at the same time an enlightened patron of the arts. The Neapolitan civilization of the eighteenth century owed much of its lustre to him. Through his encouragement of architects, sculptors, painters and skilled craftsmen, his reign was graced with a succession of outstanding artistic and scientific achievements. In Naples itself there was the San Carlo Opera House, one of the finest theatres in the world; the imposing Royal Palace of Capodimonte; and on an even grander scale, the Poorhouse. Outside the city his name is still linked with two royal residences, one in Portici at the foot of Vesuvius and towards the north, the ambitious "Reggia" in Caserta with which he sought to rival Versailles. In addition, he initiated the excavations at Herculaneum and Pompeii whose discoveries were decisive in the development of the new Neo-Classical style. Throughout the Kingdom of Naples his name was synonymous with grandeur, wisdom and justice. A builder-King

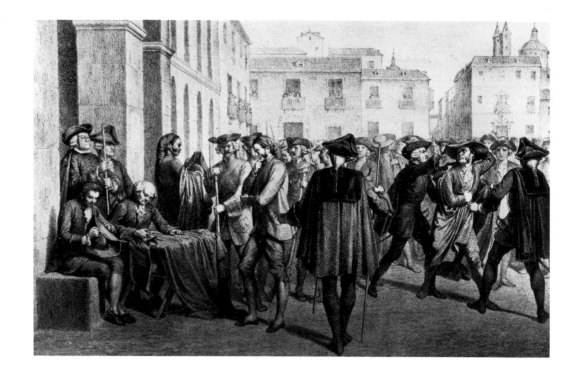

1. *Origen del motin contra Esquilache (The Origins of the Esquilache Mutiny)*. 1766. Lithography from the *Historia de la Villa Corte de Madrid*. Madrid, Bibliotheca Nacional.

Under the Bourbons Spain had experienced only one single revolutionary uprising by 1808, the Esquilache Mutiny of 1766. This lithograph reminds us of the apparently insignificant reason, the prohibition of large coats and broad-brimmed hats thought to be suitable to disguise criminals and to thus make them unrecognizable. In fact, the revolt could be traced to the unpopularity of the Neapolitan minister of Charles III because he was not a Spaniard and, above all, to various political and economic circumstances that were perhaps even cleverly emphasized by the Jesuits.

in the great Bourbon tradition, but at the same time an enlightened monarch — such was the new ruler who at the age of forty-three landed in Spain on the death of his half-brother Ferdinand VI.

Charles III, Bourbon and Neapolitan, arrived in Madrid with a group of Italian ministers and advisers who soon aroused the mistrust and anger of the populace. The most unpopular figure was the Marquis of Squillace, "Esquilache" in Spanish, whose judicious reforms did not prevent the public — deeply wounded in its national pride by regulations banning certain types of dress — from insisting on his dismissal in 1766. This famous "Esquilache mutiny," which Goya was to illustrate, was the most striking political manifestation of a certain state of mind that would come to preside (though more gradually and gently) over the emergence of a new generation of exclusively Spanish artists. In fact, since the accession of the Bourbons to the Spanish throne, the marked decline in the arts that followed the Golden Century had obliged Philippe V, then Ferdinand VI, to summon foreign architects, sculptors and painters to the Court — first from France, then at the instigation of Elizabeth Farnese, from Italy. After Michel-Ange Houasse, Jean-Ranc and Louis-Michel Van Loo, a wave of Italian artists flooded into Madrid. This was a return to the very old tradition of artistic links between the two countries that had started with the reign of Philippe II and the decoration of the Escorial, and persisted all through the seventeenth century.

Yet another of the periodic appeals by the Spanish Court to the life-giving powers of Italian art was made with some urgency after the fire at the Alcázar of Madrid on Christmas night 1734. The old palace of the Hapsburgs had been entirely destroyed with incalculable losses in works of art, archives and furnish-

ings. On the other hand, the disaster providentially opened the way for a revival for which the Bourbons of Spain alone would be responsible. The first architect summoned to Madrid to draw up the plans for the new palace was an Italian, Filippo Juvara, who had been trained in Rome in the great tradition of Bernini and was architect to the Count of Piedmont. He died soon after his arrival in Madrid and was replaced by his pupil Giambattista Sachetti, another Italian, who worked on the reconstruction of the Alcázar until 1760. The Bourbons' predilection for Italian architects was to continue for some time with the employment of Francesco Sabatini whose father-in-law Luigi Vanvitelli, had been Charles III's favorite architect in Naples. As the center of Spanish political and court life from 1740 on, the Royal Palace in Madrid thus became a powerful focus of Italian influence, affecting the artistic activities of the whole kingdom.

However, the Spanish capital still lacked an Academy like those in Paris, Rome and even Seville that could introduce a certain order into the world of the

2. Corrado Giaquinto: *Sketch for the Cupola of the Chapel of the Palacio Real in Madrid.* 1754. Oil on canvas. 90 by 137 cm. Madrid, Museo del Prado.

The three sketches preserved in the Prado are the best testimony to Giaquinto's style that is defined by Italian art. The masterful method of composition, indebted to the rococo—in which towering clouds and groups of figures are effortlessly bound together by means of a clever use of light—had a strong influence on the resurgent Spanish painting school, as is proven by Goya's beginnings in Saragossa, above all at the Nuestra Señora del Pilar.

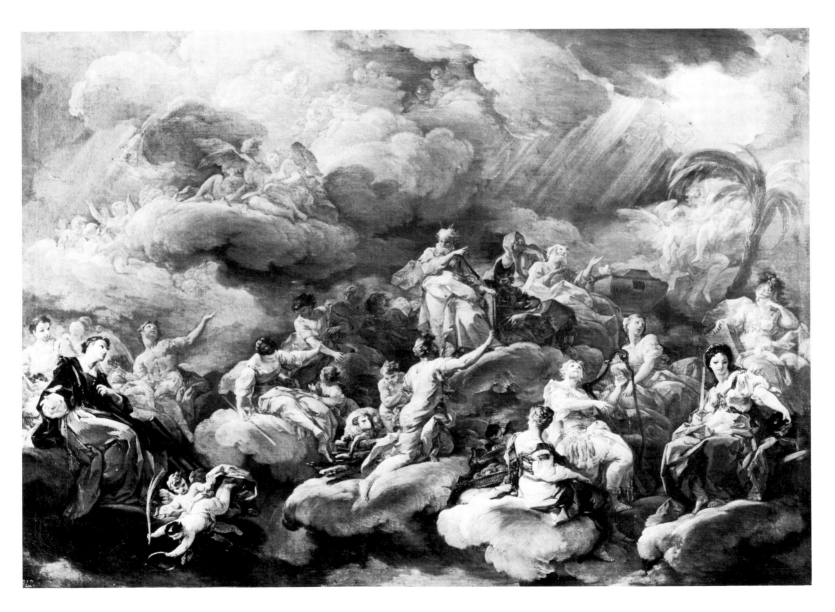

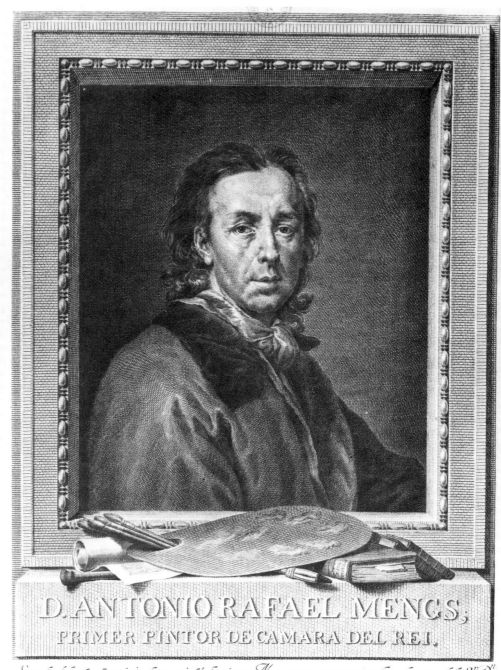

D. ANTONIO RAFAEL MENGS,
PRIMER PINTOR DE CAMARA DEL REI.

Sacado del retrato original que pintó el mismo Mengs, y se conserva en la coleccion del S.ʳ D.ⁿ Bernardo de Yriarte, y grabado por D.ⁿ Manuel Salvador Carmona Yerno de aquel insigne Profesor:

3. Manuel Salvador Carmona: *Antonio Raphael Mengs.* 1780. Etching based on a self-portrait by Mengs. 31 by 23 cm. Madrid, Bibliotheca Nacional.

Mengs was summoned to the court of Charles III and arrived in Spain in 1761. In 1766 he was nominated the *Primer Pintor de Cámara* and until 1777 he was the absolute ruler in all questions pertaining to the arts in Madrid. Between 1769 and 1774 he resided in Italy again and was perhaps of help to Goya who lived in Rome from 1770 to 1771.

arts, channeling royal patronage more judiciously and, in particular, seeing to the training of young artists. Such an institution, namely, the Royal Academy of San Fernando, was founded and opened in 1752, thanks largely to the efforts of Louis-Michel Van Loo. But it rapidly came under the domination of the Neapolitan School in the person of Corrado Giaquinto who was summoned to Madrid by Ferdinand VI in 1753 and took over the responsibility for decorating the royal residences from the recently deceased Giacomo Amigoni. On his arrival

the King appointed him *primer Pintor de Cámara;* at the same time he was made Director-General of the San Fernando Academy and Artistic Director of the Royal Tapestry Factory of Santa Barbara, so designated in 1746. This shows the fundamental role that this painter, long neglected by art historians, would have in the development and orientation of Spanish painting.

Pérez Sánchez had no hesitation in saying that "he is undoubtedly the eighteenth-century Italian painter who most deeply influenced his Spanish contemporaries." Trained by Solimena in Naples, he brought to the Spanish Court the splendid exuberance of the rococo Neapolitan style — color, elegance, and charm that would influence a whole generation of young Spanish painters, including Bayeu and Goya himself.

Before his arrival in Madrid Giaquinto had been closely in touch with the Spanish colony in Rome. Among the works he had executed in various buildings of the city, mention must be made of those at the Fatebene Fratelli Hospital in the Isola Tibernia and the Spanish Church of the Holy Trinity at the entrance to the Via Condotti. These were both of the highest importance for the future development of painting in Spain and particularly in Saragossa. We shall return to the first of them when dealing with Goya's stay in Rome in 1770-71; the other had long before been at the core of what Roberto Longhi called "the culture of the Via Condotti" — a wholly Neapolitan culture inspired by Giaquinto. In the little church which has always been and still is Spanish, there are oil paintings and frescoes (remarkably well restored in the nineteen-fifties) that constitute an obvious link between the two countries. A large canvas by Giaquinto above the High Altar represents the Holy Trinity and dates from about 1742. Its positioning and its exceptionally rich colors set the tone for all the decorative paintwork, in particular the frescoes by the Spaniard Antonio González Velázquez, a pupil of Giaquinto's, which ornament the cupola and the four pendentives of the choir, and the two oval canvases hanging on the side walls. The archives of the church give the dates of these important works: 1748 for the frescoes, 1750 for the canvases. Because of the vigorous brushwork and color of the paintings on the cupola, some people insist that they must have been painted by Goya himself during his stay in Rome. This shows their ignorance of the talent of the man who actually painted them and to whom the Academy of San Fernando had awarded a scholarship in 1746 to study in Rome. On his return to Spain after six years, González Velázquez was the first Spanish fresco painter to take over from the Italians.

In 1753, just when Corrado Giaquinto was making his way to Madrid to take up his duties as *primer Pintor de Cámara,* González Velázquez was in Saragossa painting one of the cupolas of El Pilar Basilica. In June, the master visited his pupil to see how the work was progressing; it is known, moreover, that González Velázquez was using preliminary sketches that had been painted in Rome, perhaps by Giaquinto himself and in any case under his direction. Subsequently, Antonio González Velázquez, in collaboration with his brother Luis, would work on the decoration of a number of religious buildings in Madrid and, in particular, of the Royal Palace between 1763 and 1765. He was the first Spanish

painter to be commissioned to paint a ceiling there — an important milestone in the history of what Yves Bottineau has called "the national recuperation."

It was Saragossa, however, that in 1753 experienced the first impact of the rococo Neapolitan style brought over by González Velázquez. There the young Francisco Bayeu, who had been trained locally in the studio of José Martinez Luzán, was so struck by it that he could not wait to get to Madrid for further training with the man who had revealed its glories to him. Thus started the career of one who was to become Goya's master, then his brother-in-law. However, although he seems to have exceeded all expectations at the outset of his career by brilliantly carrying off the special prize of the Academy of San Fernando at the age of twenty-two, his relationship with his master soon turned sour as a result of serious disagreements at work. His scholarship from the Academy was withdrawn and he had to go back to Saragossa, a bitter, impoverished orphan with four brothers and sisters to look after. This enforced withdrawal to his native province meant a near break with the great rococo movement that had drawn him to Madrid. Until 1762 he fell back on various jobs in the churches of Saragossa, spending much of his time on the artistic education of his younger brother Ramón who was born in the same year as Goya.

Meanwhile, in Madrid the new King Charles III had ascended the throne of Spain. In the area of the fine arts an immense task awaited him. After almost twenty years the rebuilding of the Palace was still not finished and the Royal Family would not be able to move in for another five years, i.e., in 1764, the takeover being more symbolic than real. There were plans for decorative work on a large scale, notably the painting of the ceilings. Outside Madrid, the royal residences had taken on renewed importance with the arrival of the Bourbons. Every season, the Court moved from one palace to another, following a timetable that had been laid down in the minutest detail once and for all. Easter saw them installed at Aranjuez on the road to Andalusia, surrounded by running streams and flower gardens; when summer came with its fierce heat, they left for the cool woodlands of La Granja in the heart of the Sierra; the hunting season in autumn was spent in the old monastery of the Escorial; finally, before Christmas they returned to Madrid. The palace of El Pardo, nearest the capital, received the Court for a few days after Twelfth Night. However, the Bourbons devoted most care to the palaces of Aranjuez and La Granja where extensions, transformations, restorations and redecoration required the services of a host of architects, painters, sculptors and craftsmen of every kind.

On his ascension Charles III found that he had only a handful of painters and decorators at his disposal. They were placed under the general authority of Corrado Giaquinto and included: a Frenchman, Charles Flipart who had come to Spain with Amigoni; a Neapolitan, Matias Gasparini, who specialized in stuccowork and embroidery; and a few Spaniards such as Andres de la Calleja, Antonio González Ruiz, and Antonio González Velázquez. The King's first important decision was to summon to his Court a group of prestigious artists capable of shedding a European lustre on his reign. He already had as First

4. *Self-portrait.* Oil on canvas. 58 by 44 cm. Madrid, private collection.

It is the earliest still preserved self-portrait of Goya. The full oval of the face and the youthful expression justify the opinion that the artist depicted himself here about the time of his marriage to Josefa Bayeu (1773). The picture was probably painted in Saragossa, where it remained until 1947.

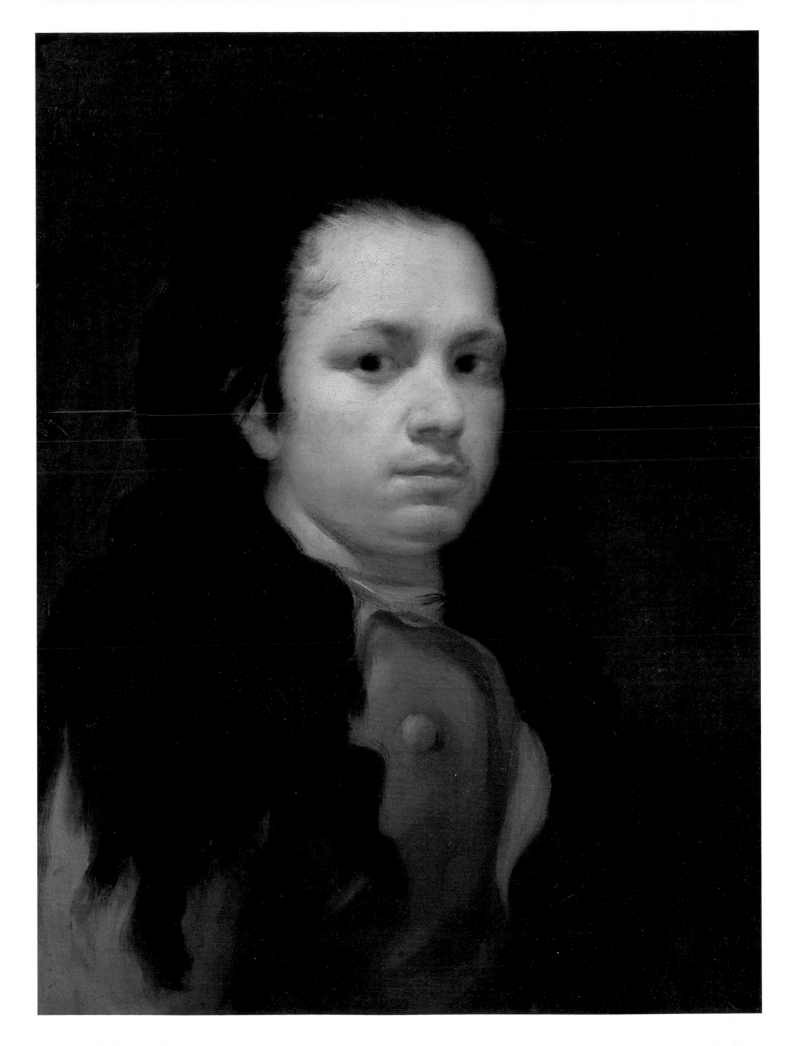

Court Painter, Corrado Giaquinto, of whose exceptional ability he was undoubtedly well aware; since the painter's arrival at the Court he had carried out an immense amount of work, particularly at the Royal Palace. His imposing paintings in the Hall of Pillars and the Royal Chapel, for instance, had made him the indisputable master of the fresco in Madrid. However, Charles III seems to have dreamed of assembling three of the greatest names in Italy — Mengs, Tiepolo and Giaquinto — around his throne. This daring combination of three aces would mean the coexistence in Madrid of the three main currents of painting, from Naples to Venice by way of Rome, where Neo-Classicism was already starting to make its way. His plan only half succeeded, for no sooner had Mengs arrived than Giaquinto, realizing that he had had his day and that it would be impossible to live at peace with someone he knew to be so difficult, preferred to go back to Naples. But he left Madrid on tiptoe, as it were — *sin desperdirse ni obtener licensia* (without saying goodbye or obtaining permission) as the records of the Academy of San Fernando put it; and with him a whole style of painting, a certain lushness of form and color, departed from Spain.

His place was taken by the new arrival Anton Raffael Mengs, twenty-five years his junior (Fig. 3). This was not so much a succession as a complete break with the past. From the rococo style of an era that had already ended, there was an abrupt shift to the scholarly requirements of the Neo-Classical School, the fruit of the opportune meeting in Rome between Mengs and Johann Joachim Winckelmann, the theorist of the new movement.

The first question that arises is why Charles III wanted to entice Mengs to Madrid. It might at first be thought that he wanted to inject new blood into the sclerotic veins of Spanish art and at the same time to show his resolute sponsorship of the latest trends, for which — it may be noted — he himself was to some extent responsible because of the active part he had played in launching the excavations at Herculaneum and Pompeii. But there is another very simple reason which has not always been sufficiently stressed: the fact that Mengs, a native of Bohemia, was a subject of the Elector of Saxony Frederick Augustus III whose daughter Maria Amelia was married to Charles III. In 1751 he was appointed First Painter to the Court in Dresden, but he returned to Italy shortly afterwards, going first to Venice and then to Rome where he was admitted to the Academy of St Luke and given a teaching post at the Capitol Academy by Benedict XIV. His friendship with Winckelmann opened his eyes to the role of classical archeology in the arts, and the writer, who had just published his *Thoughts on the Imitation of Greek Works in Painting and Sculpture,* found in Mengs a painter capable of illustrating his theories which had already created quite a stir. Before leaving Italy, Mengs had painted a fresco at the Villa Albani on the subject of Parnassus; this gained instant fame because of its style which was resolutely opposed to the sometimes facile exuberance of rococo art. Frederick Augustus III had very naturally recommended him to his daughter and son-in-law whom he visited in Naples shortly before their departure for Spain. So it was quite normal that Charles III should have sent for an artist whose talent both his father-in-law and he himself had already recognized.

5. *Francisco Bayeu*. Around 1780. Oil on canvas. 49 by 35 cm. Madrid, private collection.

Francisco Bayeu (1734-1795) came from Aragon, as did Goya, and had also worked with Jose Luzan in Saragossa. He was summoned by Mengs in 1763 to help with the decoration of the new Palacio Real. Soon he was the leader of the young Spanish painting school of the second half of the 18th century. Prior to his departure for Italy, Goya was Bayeu's pupil and he married his sister Josefa Bayeu upon his return; this introduced him into the powerful family league of the Bayeu which included — under the leadership of Francisco — Ramon, Goya's competitor in the manufacturing of tapestries and of the same age as he, and Fray Manuel, a painter as well.

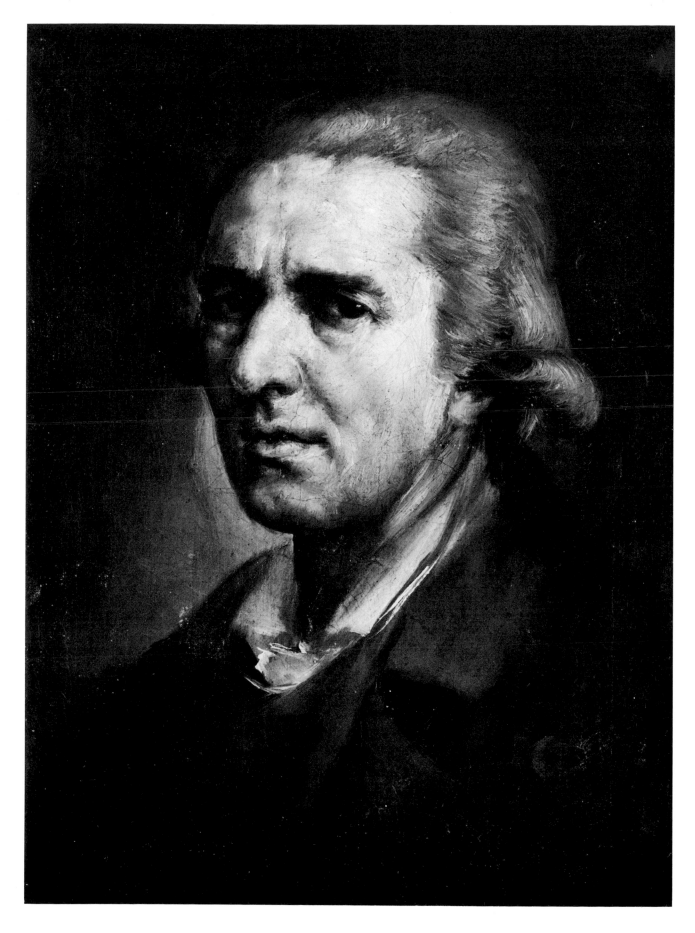

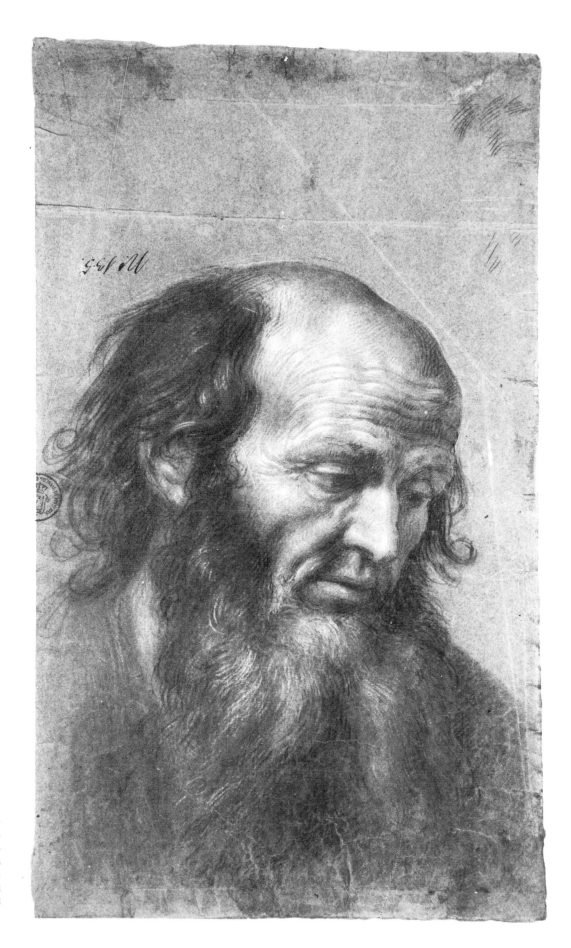

6. Francisco Bayeu: *Head of St. Matthew (?)*. Around 1772. Drawing, black crayon, enhanced with chalk, on greenish paper. 55.8 by 32.6 cm. Madrid, Museo del Prado.

This head of an old man very closely resembles Matthew in one of the pendentives of the cupola of the collegiate church of La Granja. It is an especially representative example of Bayeu's style. The drawings of Goya for his first tapestry cartoons can hardly be distinguished from the works of Bayeu under whose guidance he worked during his first period in Madrid and whom he tried hard to imitate to achieve equal success.

No European painter in the eighteenth century enjoyed such dazzling marks of royal favor as those showered upon Mengs when he embarked at Naples to sail for Spain. In a despairing letter dated July 28, 1761, his friend Winckelmann gives us the main details: "Sire Mengs is leaving me and going to Spain as First Painter to His Catholic Majesty with an annual salary of 8000 crowns, accommodation and carriage with royal livery. For me it is an irreparable loss which I shall always mourn. He is leaving, perhaps next month, on a warship which is coming to Naples." Eight thousand crowns, or almost 125,000 reals, was the most fabulous sum ever offered a painter. Goya himself, at the height of his official glory in 1799, received only 50,000 reals as First Court Painter to Charles IV. On September 7, 1761 Mengs finally disembarked at Alicante and took the road for Madrid. The departure of Corrado Giaquinto in April 1762 would apparently leave Mengs as the sole master painter practicing at the Spanish Court, but his reign was to be short. The very day on which he disembarked at Alicante, Esquilache wrote to the Duke of Montalegre, Spanish Ambassador in Venice, asking him to persuade the last of the great Venetian painters, Giambattista Tiepolo, to go to Madrid.

Nine months later, accompanied by his two sons Grandomenico and Lorenzo, Tiepolo arrived at Aranjuez where Charles III was in residence. A letter from Sabatini to Esquilache, dated June 4, 1762, confirms this: *"questa mattina é arrivato il pittore Tiepoletto da Venezia."* The diminutive form "Tiepoletto" is probably an allusion to the painter's shortness of stature. In his correspondence Mengs had already foreseen the struggles ahead, adding a typically haughty comment: "I now have Sire Corrado and Tiepoletto as rivals, both of them very able fresco painters, but they don't know how to give their work warmth." What extraordinary presumption this is on the part of a man who in his vanity had long been under the delusion that through the magic of his two first names he combined the purity of Raphael with the luminosity of Corregio! It seems incredible that someone whose own work was characterized by coldness of tone and static composition should criticize Giaquinto and, above all, Tiepolo for lack of warmth! Once Giaquinto had left, it was inevitable that the rivalry between the aging Venetian and the young man from Bohemia should develop into hostility and then into implacable hatred. Winckelmann, who knew his friend's character better than anyone, wittily defined it as follows: "He is a man who makes an elephant out of a mosquito, a great hairsplitter, inclined to look from the left side at what you are showing him from the right...His happiness consists in being unhappy."

Mengs' visit to Saragossa was as decisive for Francisco Bayeu's career as Giaquinto's visit in 1762 had been for that of González Velázquez. The new Court Painter no doubt had the faults that went with his suspicious nature but he nevertheless displayed many admirable qualities all through his life. First of all, his intellect and culture were unequaled; this is demonstrated by his *Reflections on Beauty* published in 1766 and, in particular, he had a profound understanding of the art of painting, as can be seen from his letter to Don Antonio Ponz (1776), which displays powers of analysis unusual for a painter. In addition, Mengs was

undoubtedly one of the best talent-spotters Spain has known. At Saragossa he immediately saw that among the artists of the younger generation, Bayeu was most suited to the service of the King — and his principal painter. The enthusiastic support of Mengs, whose word was all-powerful in Madrid, marked the beginning of Bayeu's meteoric career at Court. He settled in the capital in the spring of 1763; two years later he entered the Academy where Mengs sponsored his appointment as Assistant Director of Painting. The next year, 1766, Charles III appointed him Court Painter and under his protection, his younger brother Ramón, born in 1746 like Goya, entered the circle of Mengs' protégés in his turn (though in a relatively modest way in the absence of any outstanding talent).

The parallel development of the careers of Ramón Bayeu and Goya is in itself one of the most interesting aspects of this period of artistic activity at the Court. The younger Bayeu's career was brilliant at the outset, whereas his future brother-in-law was still an outsider; this is evident from the results of the Academy competitions. They worked side-by-side at the Royal Tapestry Factory until 1791, and together produced the largest number of cartoons on subjects that were often very similar. But by the time they were engaged in this official work Goya had already married Josefa Bayeu and belonged to the clan. Once the family advantages were the same, Goya's genius easily and conclusively triumphed over Ramón's honest workmanship.

We know that Francisco Bayeu settled in Madrid in 1763, accompanied by all his family, including young Ramón and his sister Josefa; but what of Goya's early years? He was not born in Saragossa but some ten leagues farther south. The geographical and economic characteristics of this part of Aragon are of little interest as far as the future master of Spanish painting is concerned, since it was quite by chance that his family happened to be staying there at the time of his birth. His father José Goya, a master gilder, and his mother Clara Gracía Lucientes were actually residents of Saragossa where they were married on May 21, 1736 in the Church of San Miguel de los Navarros. Traces have been found in the Basque country of families called Goya that emigrated to Aragon in the seventeenth century; this background was certainly more important for the painter's future than his actual place of birth, however picturesque. It explains that taste for the fantastic that made him unique in his period. Visions, dreams, nightmares, monstrous animals or people, witches and wizards — all these aspects of his work link it with the ancient superstitions of northwest Spain and, more generally, with a broad Germanic tradition that runs from Bosch to Fussli. It also explains his lifelong predilection for Basque families and society — for example, the Goicoechea family, with which his own family became linked through his son's marriage to Gumersinda, and also the Zorillas and Galarzas with whom he would have close ties.

Little is known of his childhood in Saragossa. Did he study with the Fathers of the Escuelas Pías as most of his biographers concede? It is highly probable that he did. It is also generally agreed that the large painting of the *Last Communion of St. José de Calasanz* (Fig. 156), executed in 1819 for the Chapel of the Escuelas Pías de San Antón in Madrid, is a warm tribute to the religious community that

7. *A Hunter.* 1775. Drawing; black crayon, enhanced with white, on blue paper. 32.2 by 20.6 cm. Madrid, Bibliotheca Nacional.

This drawing was ascribed to Francisco Bayeu in 1906 in the catalogue of the National Library of Madrid, the logical consequence of attributing the corresponding cartoons, *The Quail Hunt,* to this master. It demonstrates how close the style of Goya's first tapestry cartoons was to the comparable works of Francisco Bayeu as well as to those of his younger brother Ramon; his contemporaries recognized only one hand in all these works, the hand of Francisco Bayeu.

had known him as a child. A letter of November 28, 1787 to his friend Martín Zapater refers to a certain Father Joaquín who had taught them both in Saragossa. No other document sheds any further light on the subject. The oldest known biography of Goya by his son Francisco Javier mentions only his training as an artist, stating that "he studied drawing from the age of thirteen at the Saragossa Academy under Don José Luzán." Founded in 1754 at the instigation of the Pignatelli family to whose munificence the city was greatly indebted, the Saragossa Academy was the culmination of efforts dating back to 1714 to give the teaching of the fine arts a place worthy of the capital of the ancient Kingdom of Aragon. A simple drawing-school before becoming an academy, it had already counted among its pupils Francisco Bayeu and, at the same time as Goya, Bayeu's younger brother Ramón. José Luzán Martínez, who started out as a drawing teacher at the Academy and later became its Director, had been sent by the Pignatellis to Italy where he studied under a fellow student of Solimena's. The notes in the Prado's first catalogue which was printed in Goya's lifetime reveal that he spent four years in Luzán's studio where he had to copy "the best prints he had," a commonplace task at all art schools and academies. But none of this sheds any light on Goya's early career.

These scanty documents do, however, furnish some interesting chronological details, since they show that the end of Goya's studies in Saragossa coincided with his first journey to Madrid in 1763 when he was among the eight candidates who presented themselves at the Royal Academy of San Fernando on December 4 to take part in a competition for scholarships in painting. The set subject was a pencil drawing of the statue of Silenus at the Academy. The candidates, all of them under the age of 21, had until January 15 to complete their task. That it entailed working in the round suggests that Goya had already become familiar with this kind of academic exercise in Luzán's studio in Saragossa. The verdict was not in his favor; the jury, consisting of teachers of painting and the Director-General of the Academy, Don Antonio González Ruiz, unanimously awarded the scholarship to Gregorio Ferró, a twenty-year-old Galician, who in the course of Goya's career would often outshine him in academic competitions.

After this first failure there is no trace of Goya until 1766. Did he go back to his family in Saragossa? But if so, what did he intend to do there? All that is known is about his four years in Luzán's studio, and apart from the Academy, his native province offered no other opportunities for training. Francisco Bayeu, however, was already in Mengs' service in Madrid where he was now established with his younger brother Ramón who was the same age as Goya and had studied with him in Saragossa. Francisco had opened a private drawing school in the capital and that soon achieved a certain fame. Moreover, the official documents of the Academy of Parma on the occasion of a competition in 1771 in which Goya took part describe him as "pupil of Sire Francisco Bayeu, Painter to His Catholic Majesty." It thus seems highly probable that he returned to Madrid to work with Bayeu while waiting for another competition in which he might have better luck.

This opportunity came in 1766, exactly two years after his first failure. But this time it was a much more serious affair with two test pieces. First, the competitors

8. *Majo beating the rhythm with his hands.* 1777. Drawing, black crayon, enhanced, on blue paper, 28.9 by 22.5 cm. Madrid, Museo del Prado.

Study for the figure on the far right in the cartoon *Dance on the Banks of the Manzanares*. Of all the drawings preserved for us from this time period this is the most personal and the one executed with the most ease. The lines are assured and supple, the accents have been set with a totally new force. The drawing shows how quickly Goya developed in two years.

were given six months in which to execute a large painting, 168 x 126 cm., on the somewhat complicated subject of "Martha, Empress of Constantinople appearing at Burgos before King Alphonso 'the Wise' to claim from him a third of the sum he had agreed upon with the Sultan of Egypt for the ransom of the Emperor Baudoin, her husband, and the Spanish Monarch then ordering that she should be given the whole sum." The second test was described as *"de repente"* (i.e., an improvisation); in two-and-a-half hours on July 22 the competitors had to do a sketch on another somewhat special subject: "In Italy in the presence of the Spanish Army, Juan de Urbino and Diego de Paredes quarrel as to which of them should be given the arms of the Marquis of Pescara." There were seven candidates for this triennial competition, including Gregorio Ferró, the victor in 1763 and, for the first time, Ramón Bayeu, who was sponsored by his brother (now a member of the Academy). An imposing jury consisting of the most eminent Spanish Academicians — Antonio González Ruiz, the Director General, Antonio González Velázquez, Andres de la Calleja, the architect Ventura Rodríguez, Salvador Maella, and Francisco Bayeu himself — awarded the gold medal to Ramón Bayeu (whose brother naturally abstained from voting). The second prize went to a certain Luiz Fernandez, and the third to Gregorio Ferró. Not a single vote, not the slightest mention of Goya. For the twenty-year-old painter, this fresh failure was even more painful than the first. The very quality of the jury, representing the fine flower of the youthful Royal Academy, lent the verdict such weight that it was felt as a veritable condemnation. The basis for the decision can hardly be understood, since the actual works have vanished. Were Goya's efforts really so mediocre as to justify their elimination from the competiton? Were his rivals, and particularly Ramón Bayeu so much better? Or was it simply that his treatment of the prescribed subjects was an affront to the taste of the Academicians, already won over to the cause of Neo-Classicism? Up to 1771 the clues are so few that it is practically impossible to answer these questions. There is, however, a solitary light in the darkness enshrouding Goya's early career that may help us to trace out the path he was taking. Two small pictures that have never definitely been proved to be Goya's nevertheless contain, in embryo, certain stylistic features that no other painter of his period would have been capable of developing later on. These are *The Esquilache Riots* and *Charles III Promulgating the Edict for the Expulsion of the Jesuits*, which have always been catalogued together since 1898 (sale of the Triarte Collection).

Goya was in Madrid on March 23, 1766 when the *"Esquilache Mutiny"* (Fig. 9) — the only real revolutionary movement in the Spanish capital during the eighteenth century — broke out. Charles III's rule was briefly shaken, and the King had to yield to the threatening crowd that besieged his palace demanding the dismissal of the Neapolitan minister and the abrogation of his decrees which were considered to be anti-Spanish. It was obviously an exciting experience for a young man of twenty, particularly one who already had such a perceptive eye, to see these men and women streaming out of the Lavapiés and Cuatro Caminos districts towards the center of the city by torchlight and howling "Muera,

9. Le motin de Esquilache (The Esquilache Riots). Around 1766-1767. Oil on canvas. 46 by 60 cm. Paris, private collection.

The Esquilache riots took place in Madrid on March 23, 1766. The Neapolitan minister of Charles III had made himself very unpopular with various economic reforms, but mainly by prohibiting the Spanish coat—a large cape—and the broad-brimmed hat. Presumably, the riots were also connected with the activities of the Jesuits in Spain; during the following days the King decreed their expulsion. Goya was in Madrid at the time of the riots and was an eye witness of the unrests.

Esquilache, muera," the words that appear on the placard brandished by a stump orator in the picture. The scene is straight from life, all movement and rapid strokes of color, in that sketchlike style from which Goya would later draw his most personal effects. The other scene has traditionally been considered as a rapidly sketched allusion to the expulsion of the Jesuits from Spain; this political move, prepared for by the Count of Aranda, Secretary of State to Charles III, took place one year after the Esquilache riots, and in the opinion of many people of the time — an opinion shared by historians today — the two events were closely linked. These two small canvases attributed to Goya are probably first-hand records, perhaps the earliest works that might suitably bear the famous caption to the *Disasters of War: Yo lo vi* ("I saw it") (Fig. 142).

Goya's first prolonged stay in Madrid was to be even more important in that it brought him a host of new and exciting impressions: first, the life of the capital, gay and colorful with its crowds of *majos* and *majas* in their picturesque costumes, its popular amusements — balls, verbenas, romerias (pilgrimages) — its theatres and magnificent avenues such as the recently finished Prado where the continual coming and going of horsemen and of courtiers in their carriages was the most dazzling of sights in itself. For the young Goya Madrid was also that *Villa y Corte* where the great painters held sway. Through Francisco Bayeu he was able to approach the all-powerful Mengs of whom he had perhaps already caught a glimpse during his visit to Saragossa in 1762. The First Painter was busy with the decoration of the Royal Palace where he had just finished the fresco on the ceiling of the so-called Gasparini Room; this *Apotheosis of Hercules* was an assertion of the new tendencies in painting in opposition to Giaquinto's rococo. There could have been no better lesson for a budding artist than to pass from the *Triumph of Bacchus* in the Hall of Pillars, painted by the Italian artist at the height of his powers, to the severe composition of the painter from Bohemia.

But the crowning joy and bafflement for Goya was his discovery of the work of the last great Italian called to the court of Charles III: Giambattista Tiepolo from Venice. On his arrival at the court on June 4, 1762, as noted above, accompanied by his two sons Giandomenico and Lorenzo, he quickly set to work. In 1761 he completed the last of the three ceilings he had been commissioned to paint for the Royal Palace — the little Hall or Antechamber of the Queen. Two years earlier at the age of sixty-eight he had finished the huge fresco in the Throne Room, the most dazzling masterpiece he ever produced. Sánchez Cantón called it "a delight both for the senses and the mind which overwhelms the spectator," and justly considered it "the testament of the Venetian School." After Venice, Wurzburg, and the Villa Valmarana, Tiepolo — six years before his death in Madrid — had brought to the harsh plateau of Castile this airy evocation of the skies of the lagoon where figures and diaphanous clouds float in insubstantial radiance. For Goya this *Glorification of the Spanish Monarchy* — the third panel of the great triptych of his century's painting that Charles had dreamed of setting up in his new Alcazar — was certainly the greatest lesson in painting that he received during his first stay at the court. More than anything else, it impelled him to leave Madrid where the doors on which he had knocked had all slammed

10. *The Sacrifice to Vesta.* 1771. Oil on canvas. 32 by 24 cm. Signed and dated. Barcelona, private collection.

Presumably, the small painting was created in Rome at the same time as the *Sacrifice to Pan* that can be found in the same collection. The representation fits into the circle of religious and mythological scenes Goya in all probability painted at the side of Thaddäus Kuntz, the Polish painter, with whom he lived in Rome. The pyramid behind the sacrificing priest brings the Cestius pyramid at the Porta San Paolo to mind.

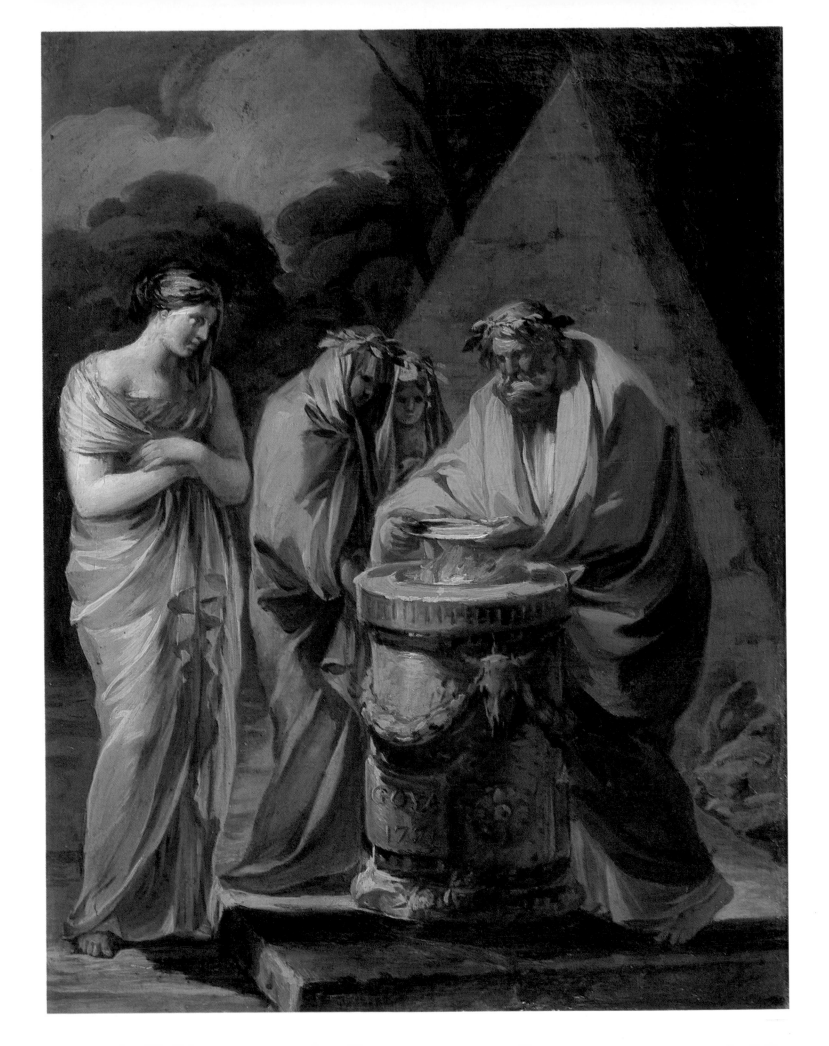

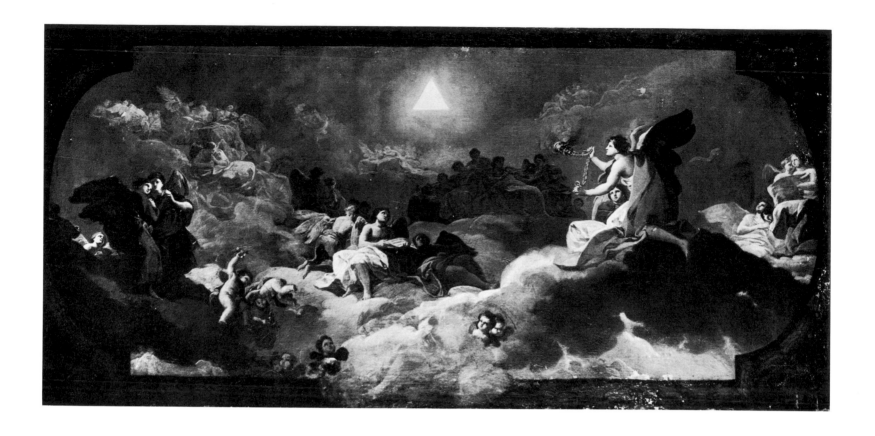

11. *The Adoration of the Name of God.* Oil on canvas. 75 by 152 cm. Barcelona, private collection.

The relatively large painting is the sketch for the ten times as large fresco for the ceiling of the *coreto* in the Nuestra Señora del Pilar in Saragossa for which Goya was commissioned upon his return from Italy. The composition shows clearly how much Goya's first works have to thank to the style of Corrado Giaquinto who was continually before his eyes here in the twenty years older paintings of Antonio Gonzalez Velázquez, the pupil of Giaquinto.

in his face. What the Academy of San Fernando had refused him might be found elsewhere, namely in Italy.

A number of young Spanish artists before him had achieved the dream of studying in Italy, but with the aid of the Academy; for example, Antonio González Velázquez and more recently, Mariano Salvador Maella who returned from Rome in 1765 and was at once admitted to the Academy of San Fernando. Others were helped by influential benefactors wishing to take them into their service when they returned. This was the case with Goya's contemporary Luís Paret y Alcázar, born in Madrid in 1746, who had been sent to Italy by the Infante Don Luis de Bourbon, younger brother of the King. He stayed there for three years and returned to Madrid in 1766 just when Goya was experiencing his second academic failure. This was yet another incitement to follow the same course. Unfortunately he had no patron, no scholarship, no aid of any kind. A well-known document, dated July 24, 1779, gives us valuable information on the financial circumstances of his journey to Italy. In it Goya addresses the King directly to ask for a post as Court Painter and mentions his past services *"habiendo exercido este Arte en Zaragoza su patria y en Roma a donde se conduyo y existió a sus expensas…"* ("having exercised his art in Saragossa, his homeland, and in Rome whither he went and lived at his own expense…"). It is therefore clear that although his circumstances were modest it was his family that made the necessary sacrifices to enable him to try this last chance.

All Goya's biographers have come up against the problem of his journey to Italy and, while being aware of its importance and putting forward some quite

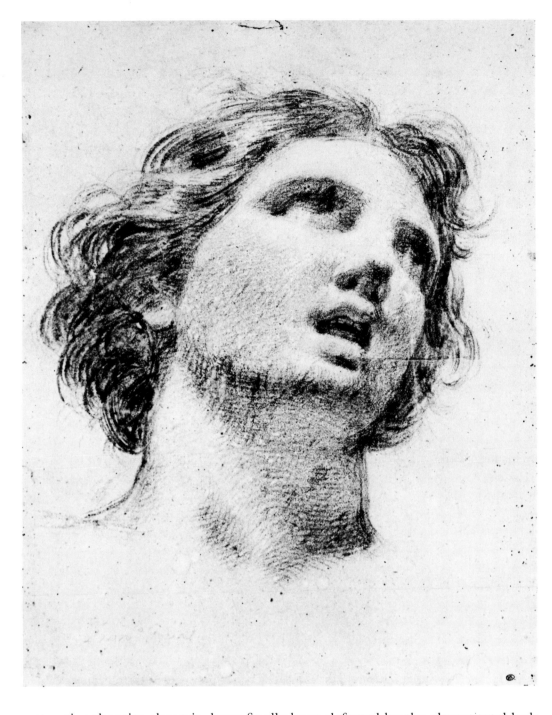

12. *Angel Head*. 1771. Red pencil drawing. 45 by 33 cm. Paris, Musée du Louvre, Cabinet des Dessins.

This angel's head on shaded paper belongs to the preparatory studies for the fresco in the Nuestra Señora del Pilar. The sheet belonged to Paul Lafond who had published it in his book on Goya that appeared in 1902. The other two known studies can be found in Spain in the Prado and in the Carderera collection. The technique coincides in all three pictures; it proves that Goya is using with great success in 1771 what he learned in his youth under his first teacher Jose Luzan.

attractive theories about it, have finally been defeated by the almost total lack of useful documentation. When did he leave? What routes did he take to and from Rome? How long did he stay in Italy? What towns did he visit? Where and with whom did he live? What did he do while he was there? Whom did he meet? It is impossible to reply to any of these questions with certainty. A halo of mystery, conducive to the wildest legends, envelops this period of his life and, despite their legitimate attempts to dissipate it, all too many eminent commentators have let themselves be drawn beyond the limits of simple credibility.

At the present stage of research, leaving aside the plea to the King quoted above, the only details on Goya's sojourn in Italy come from documents relating

to the competition held by the Academy of Parma in 1771. First, there is an autographed letter of April 20, 1771, signed "Franco Goya," in which he informs Count Rezzonico, Permanent Secretary of the Royal Academy of the Fine Arts in Parma, of the dispatch of the picture he was submitting for that year's competition. He chose as its motto a line of Virgil's from the Sixth Book of the *Aeneid:* *"Jam tandem Italiae fugientes prendimus oras."* The letter is written in correct Italian. The subject of this canvas is evident from the text announcing the competiton which took place on May 20, 1770. *"Annibal vincitore che rimira, la prime volta dalle Alpi, l'Italia"* ("From the Alps victorious Hannibal looks at Italy for the first time"). On June 27, 1771 the Academy published the decisions of the jury. The only prize, consisting of a gold medal weighing five ounces, went to Paolo Borroni of Verona, a student at the Parma Academy. The number of votes for the prize-winner is not stated but from the reference to the prize for architecture, it is clear that there were nine. The report then mentions Goya's picture in terms that deserve to be quoted in full since they represent the first published criticism of his work: *"Il cuadro contrasegnato dal verso di Virgilio 'Jam tandem Italiae fugientis prendimus oras' a riportato sei voci. Vi si e osservato con piacere in maneggio facile di pennello, una calda espressione nel volto e nell'attitudine d'Annibale un carattere grandioso, e se piu al verso s'accostassero le sue tinte e la composizione all'argomento, avrebbe messa in dubbio la palma riportata dal primo. L'autore n'è il Sigr. Francesco Goja Romano, é scolare del Francesco Vajeu Pittore di Camera di S. M. Cattolica."* ("The picture bearing Virgil's line *'Jam tandem Italiae fugientes prendimus oras'* obtained six votes. The jury was pleased by the ease of the brushwork, the warmth of expression on Hannibal's face and the majesty of his bearing. If the colors had been more true to life and the composition more faithful to the subject, it would have put the final attribution of the prize in doubt. The painter is Sire Franceso Goja of Rome, pupil of Sire Franceso Bajeu, Court Painter to His Catholic Majesty.")

A letter from du Tillot, Prime Minister of Parma, states that Goya's picture was returned to him in the second quarter of 1771, i.e., between June 27 and 30, and mentions that the first address given by Goya in Valencia had to be changed since "the Spanish painter is now in Saragossa." Finally an account of the competition appeared in the *Mercure de France* in January 1772. These are the only known documents concerning Goya's visit to Italy. They yield at least two essential pieces of information: that the painter took part in the competition in Parma, and that he left Rome almost as soon as the jury's decisions were known. Since the appearance of Carderera's well-known article in the *Gazette des Beaux-Arts* in 1860, it has often been believed that Goya was awarded second prize, though there was no second prize. Did he boast of one himself on his return to Spain? It is not known, but this hypothesis should not be discarded. Other biographers, in order to give a further demonstration of his total inability to submit to the canons of academic painting, have transformed this third competition into a resounding failure for the young artist. It should be noted that the persistent desire to turn Goya into a rebel, an anti-conformist from the beginning to the end of his career, is not only a travesty of the facts but the product of a ridiculous,

13. *The Internment of Jesus.* Around 1771-1775. Oil, originally on plastering. 130 by 95 cm. Madrid, Fundación Lázaro Galdiano.

Originally, the painting decorated the ceiling of the Sobradiel palace in Saragossa; the decoration of the room furthermore included a *Dream of Joseph* on the left wall, a *Visitation* on the right wall and four small representations of biblical figures. Presumably Goya received the commission after his return from Italy, where he had been able to collect sufficient experience in mural painting under Thaddäus Kuntz. The paintings were later removed and transferred to canvas. This scene, the best preserved of the group, is based on a composition by Simon Vouet.

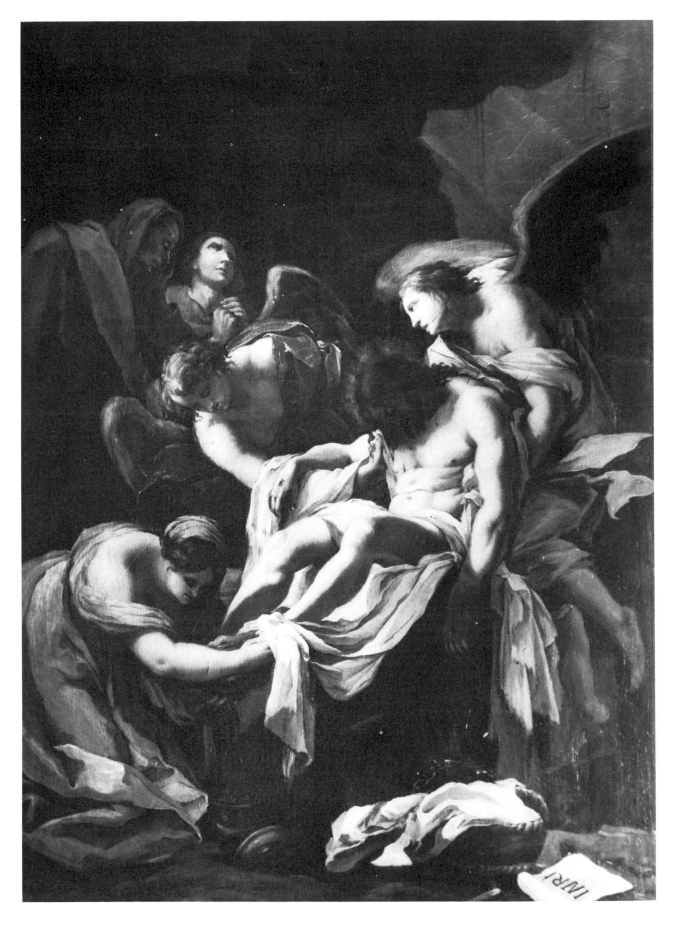

if fashionable notion that every great artist must of necessity be self-taught or an enemy of the bourgeoisie, an "outcast."

In examining the verdict of the Parma Academy, it can be seen that Goya obtained two-fifths of the votes of the fifteen members of the jury, whereas in Madrid in 1763 and 1766 he had not obtained even one vote. But more important, there are the generally favorable comments on his picture. The Academicians of Parma, as connoisseurs, were at least as distinguished as the Spanish and had two adverse criticisms to make: the colors were not true to life and the composition was not sufficiently faithful to the subject. On the other hand, the painter's future is foreshadowed with amazing accuracy in the qualities singled out for praise. First, there is "the ease of the brushwork;" until his death Goya would possess to the highest degree that spontaneity of touch, that *soltura* (freedom) as his compatriots call it, that made him the worthy successor of Velázquez and the first of the great masters of modern painting; next, the "warmth of expression" on the features of the principal figure. Here one thinks of that long series of splendid portraits in which the faces retain a warmth and humanity that are endlessly fascinating: *Moratin* (Fig. 94), *La Solana, Manuel Osorio (Fig. 65), the Countess of Chinchón* (Fig. 84), *Guillemardet* (Fig. 73), *Queen Maria Luisa,* (Fig. 76), *Pedro Romero* (Fig. 46), the *Majas* on the balcony, and a host of others right up to the marvelous *Milkmaid of Bordeaux.* Finally, the "majesty of his bearing:" Although Goya was never a historical painter like his contemporary David, he was not less imbued with the sense of majesty that the Parma Academy recognized in his Hannibal. He expressed it in his own way in certain pictures, notably in the large figures at the Carthusian Monastery of Aula Dei, the full-length portrait of *La Tirana,* the portraits of *Fernán Nuñez* and the *Duke of San Carlos,* and the anonymous tragic hero of the *Shootings of the Third of May.* It can therefore be asserted that although it did not award him the prize the Parma Academy had already recognized his talent and that his performance in the competition could hardly be considered a failure. The fact that it was such a distinguished academy that first rescued his name from obscurity was enough to ensure him a measure of fame on his return to Spain.

But, leaving aside the Parma episode which is relatively well-known despite the most regrettable disappearance of the picture that was the object of the exercise, what remains to be said about Goya's stay in Italy? First of all, its length. The most reasonable estimates situate it roughly from 1769 to 1771. It has even been thought that Goya may have accompanied Mengs when the latter left Madrid at the end of 1769. This is an attractive hypothesis. The Court Painter, who was no doubt known to Goya through his friends the Bayeus, set sail from Barcelona so seriously ill that he had to land at Monaco. Once he was better, he went on to Genoa and Florence. After spending some time in Florence where he painted the royal family at the behest of Charles III, Mengs arrived in Rome in February 1771. It may be observed that this lengthy journey necessitated stops at Parma and Bologna, visits to which would have been of the highest interest to Goya, particularly in the company of Mengs.

Unfortunately, this is only one hypothesis among many. And it is certain that if Goya, then an obscure novice had had the honor of accompanying Mengs, a master of European reputation, to Rome, he would not have failed to mention it in his letter of 1779 to the King. Nor was it probable that, in this case, he would have traveled at his own expense as he said he did. It is more likely that he went to Rome alone well before the return of Mengs. Since his means were certainly limited, it is thought that he was at least supplied with recommendations to Spaniards in Rome who could guide him in his first steps through the Eternal City. A small painting representing the *Agony of St. Anthony, the Abbot* (private collection, Switzerland), which was recently rediscovered and identified as a copy of a large painting by Corrado Giaquinto, offers an interesting clue. The canvas by the great Italian master whose frescoes Goya could already have admired at the Royal Palace in Madrid was one of an important group of paintings executed for the Hospital of St. John the Divine run by the Fatebene Brothers on the Island of Tiberina. It has therefore been concluded that on his arrival in Rome the young Spanish painter was offered hospitality by the monks whose Prior came from Aragon.

14. Domenico Tiepolo: *Man's Head from Raccolta di Teste* (1st series, Number 24). Published prior to 1762, etching. Paris Bibliothèque Nationale.

There is a close technical relationship between this etching by the hand of the son of Giovanni Battista Tiepolo and some of Goya's earlier works, for example, *St. Francis of Paula* (illustration 15). In all probability Goya was acquainted with the Tiepolo between 1765 and 1770 while he was working with Francisco Bayeu in the latter's school of painting.

15. *St. Francis of Paula.* Around 1775-1780. Etching and dry-point. 13 by 9.5 cm.

This sheet belongs to Goya's very first graphic experiments. There has been speculation that this representation could be connected with the birth of Goya's fourth child, Francisco de Paula, in 1780. The similarity of the technique used here and that of Domenico Tiepolo is, as has frequently been noted, striking (compare illustration 14).

Mention has been made of the Spanish Church in the Via Condotti by Giaquinto which contains a large altarpiece, *The Holy Trinity,* as well as various notable paintings by Antonio González Velázquez. All those hoping to discover a painting by the youthful Goya in this focal point of Spanish rococo have come up against the inexorable evidence of the dates furnished by the community's archives. The Marquis of Lozoya even tried, with the aid of ingenious hypotheses, to reconcile the reality of the documents with his desire to find in the vault of the choir the first daubs of the Master of San Antonio de la Florida, but all in vain — none of this was convincing, and Antonio González Velázquez is still the artist whose name is most closely associated with the little church of the Spanish Trinitarians.

On the other hand, some curious discoveries, unfortunately not yet published, were made a few years ago by a Polish scholar, Dr. Zagorowski. They relate mainly to Thaddaüs Kuntz, a Polish artist, who spent nearly all his life in Rome where he died in 1793. Working in the style of Giaquinto and the painters of the Via Condotti, this prolific artist is mainly known for his decorative work in various churches of the Latium, notably at Cave di Palestrina and Soriano. But more interesting from our point of view are his relations with Spain to which he made at least one journey, visiting Barcelona and Valencia. It seems that he even married a Spanish woman, and documents discovered by Zagorowski have irrefutably established that it was in his house near the Piazza de Spagna that Goya stayed during his sojourn in Rome. This fact is of the greatest importance, since it definitely establishes the setting in which Goya lived and probably worked. It would not have been unnatural if he had helped his host with his work and learned the technique of fresco painting from him. The links of the Kuntz family with Spain do not end there; in 1809 his daughter Elizabeth married the Spanish painter José de Madrazo who had come to Rome to complete his training. From this union was born the celebrated Federico de Madrazo y Kuntz, who would play a major role in the artistic life of Spain in the nineteenth century. The Kuntz family thus had an extraordinary destiny, starting by welcoming the still unknown Goya to Rome and going on to flourish in the next century through their brilliant descendants the Madrazos and Fortunys, renowned as connoisseurs and collectors of the works of the great masters.

With regard to Goya's friends, apart from Thaddaüs Kuntz, one can only engage in rather shaky conjecture. Two notable Spaniards from Aragon were living in Rome at the time, the first being Don Tomás Azpuru, representative of Charles III *vis-à-vis* Pope Clement XIV, with special responsibility for artists supported by the Academy of Fine Arts in Madrid. One detail about this prelate may have some connection with Goya; he was appointed Archbishop of Valencia in 1770 and left Rome on the arrival of his successor the following year, José Moñino, future Count of Floridablanca. Had he suggested to the young painter that there might be a possibility of commissions in his new diocese? This is not unlikely and would explain why Goya asked the authorities in Parma to forward his picture to Valencia. From du Tillot's letter we learn that there was a sub-

16. *Circumcision,* detail. 1774. Oil on plastering. Hermitage Aula Dei (in the vicinity of Saragossa).

In this scene from the multipartite illumination of the church of Aula Dei — Goya executed it prior to his departure to Madrid — we can already see the roots of the qualities that were soon thereafter to come to full bloom in the tapestry cartoons. The painting in the Hermitage was heavily damaged during the 19th century because the cloister was intermittently abandoned and the illuminations were later restored in an improper manner.

sequent change of address and that the picture was finally sent from Genoa to Saragossa.

As well as Azpuru, there was one of the most enlightened men of his time, Nicolas Azara, who had been in Rome since 1766 as Agent General and Procurator of the King *vis-à-vis* the Pope. A man of culture and a great art lover, he carried on a remarkably free correspondence with Manuel de Roda, Charles III's so-called "philosopher-minister," who also came from Aragon. The presence in Rome of this great humanist and diplomat was certainly known to every visiting Spaniard, and particularly to the artists since he was a close friend of Mengs whose works he would edit in 1780, prefacing them with an excellent biography. He might well have advised and helped Goya in his approaches to the Parma Academy, choosing the motto from the Aeneid and writing the letter to Count Rezzonico in Italian for him. He could even have recommended him to the Spanish Ambassador at the Court of Parma, namely the Marquis of Llano whose wife, wearing her picturesque Manchega costume, was immortalized in a portrait by Mengs (Madrid, Academy of San Fernando) probably painted during the period in question, i.e., some time between 1770 and 1774.

As for the artists, it is certain that Goya was acquainted with Kuntz' circle of collaborators and friends, in particular Ermangildo Costantini and Giovanni Battista Marchetti, who worked with him at the Polish Church of St. Stanislas and at the Church of St. Catherine of Siena in the Via Giulia. Did he have an opportunity of meeting Piranesi whose collections of prints were already celebrated in Rome and beyond Italy? All that is known is that much later Goya would have copies of them in his cartoons, and it is unnecessary to point out the similarities between Piranesi's *Prisons* and many of the scenes painted or engraved by Goya after 1792. Finally, it is worth mentioning — if only to quash it — the very old and persistent legend that Goya might have met David in Rome. This would have been perfect indeed, but unfortunately such a meeting was impossible since David did not arrive at the Academy of France, accompanied by his master Vien, the new Director, until November 4, 1775. The two great masters — two opposite poles one might say — of European painting never saw one another, either in Rome at the outset of their careers or in Paris at the end of their lives, since Goya did not arrive in the latter city until 1824, eight years after David went into exile in Brussels.

A final question arises, just as difficult as all the others. During this stay in Rome, which must have lasted at least a year, what works were painted by Goya? Admitting that the large-scale work submitted for the competition at the Parma Academy must have occupied him for several months, there must be other works of his dating from this period, either oil paintings or frescoes executed in collaboration with other artists such as Kuntz or on his own. The identification of Goya's early works is rendered particularly difficult by the absence of all relevant documentation and, in particular, by their very impersonal style which makes them indistinguishable from so many other anonymous works. Nevertheless, there are half-a-dozen small paintings which Goya very probably executed in Italy; one of them, *Sacrifice to Vesta* (Fig. 10), signed and dated 1771, and its

pendant, *Sacrifice to Pan* (Gudiol Collection, Barcelona) are very typical of the small mythological scenes painted in Rome by Vien's pupils at that date. The repetition of the second in a larger format suggests that these first attempts enjoyed a measure of success. These slight works would have enabled Goya to make up for the absence of a scholarship, about which he would complain later on. The portrait of *Manuel Vargas Machucho* (Sao Paulo, Bardi Collection) may also belong to this period about which so little is known and may even have been painted in Naples, the home of the distinguished military family to which the sitter belonged.

While there are no grounds for thinking that Goya visited Venice and the great cities of northern Italy, it is clear even though so few of the facts are known that his stay in Rome and the results of the competition in Parma had sufficed to change the unlucky young man of 1763 and 1766 into a recognized artist who would be inundated with commissions on his return to Spain. The sort of halo conferred by Italy on all young painters returning from it was enough, particularly in the provinces, to make a career. In Saragossa where Goya was living from the summer of 1771, the mere fact of being able to show a historical painting that had been praised by one of the most illustrious academies in Italy, his familiarity with Kuntz and the Roman painters in Kuntz' circle and, above all, with Mengs whose influence at court was universally known, and finally the very name of the distinguished Aragonese Nicolas Azara — all these things would serve to open the same doors that were opened for Antonio González Velázquez when he returned from Rome: those of the most sacred basilica of Nuestra Señora del Pilar (Our Lady of the Pillar).

Ever since 1750 expensive transformations had been in progress at this shrine under the direction of the architect Ventura Rodríguez. New surfaces, vaults and cupolas awaited the fresco-painter's brush. The leading Spanish artists of the time would take part in this long-term project, notably the Bayeu brothers and on two occasions Goya.

It was, however, surprising that Goya was called upon to paint at El Pilar before Francisco Bayeu despite the latter's meteoric rise at court from 1763 on. Since that date Bayeu had no doubt devoted his time completely to the service of the King and especially to the decoration of the Royal Palace. But, in the preceding years, i.e., between 1758 and 1762, while he was responsible for a number of works in various churches in Saragossa, he had not had a single commission from the Building Committee of El Pilar. This "absence" of Bayeu appears to have been due to his disagreements with Antonio González Velázquez, officially the principal painter for the basilica who probably barred his way. It took the support of Mengs and all the weight of his position at court to persuade the authorities of El Pilar to approach him which they finally did in the summer of 1772. The autumn of the previous year, however, had seen two painters competing for the vault of the Coreto (little choir): Goya, just back from Rome, and once again Antonio González Velázquez, Academician and Painter to the King who enjoyed a considerable reputation in Madrid. The former was only twenty-five years old and had no work to point to in Spain; the latter, twenty-three years

17. *Aesop* (based on Velázquez). 1778. Etching. 30.5 by 22 cm.

The etching is part of the nine sheets Goya published in 1778. The preserved preparatory etching is the only known pen-and-ink drawing for this series; in view of the painting by Velázquez we are able to follow the individual steps of Goya's "copying work" in this etching.

18. Diego Velázquez de Silva: *Aesop.* Around 1639-1640. Oil on canvas. 179 by 94 cm. Madrid, Museo del Prado.

The two paintings of Aesop and Menippos were painted as counterparts for the former hunting lodge Torre de la Parada that Philippe IV had rebuilt and decorated with paintings, mainly by Rubens and Velázquez.

19. *Aesop* (based on Velázquez). Around 1778-1780 (?). Oil on canvas. 180 by 93 cm. Madrid, Museo del Prado.

This faithful copy of the famous work of Velázquez has a Menippos as a counterpart as well. Generally, both are attributed to Goya; thus they would be the most direct witnesses to the attention he paid to the paintings that were located in a hall of the Palacio Real at the time. The catalogue of the Prado quotes the evaluation of the work given by Frederico de Madrazo on August 16, 1886, in which it is classified as a copy based on Velázquez: "I believe that it is by the hand of the famous painter Goya; I am familiar with other copies of his based on Velázquez."

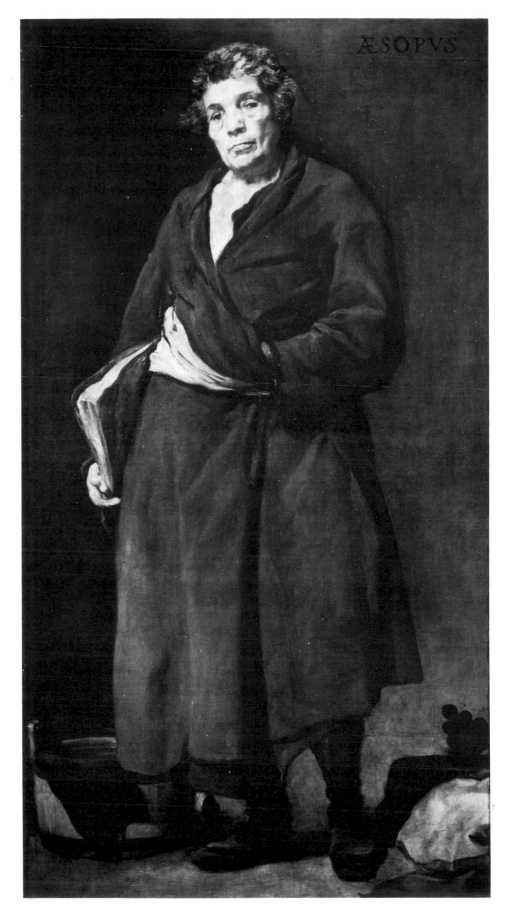

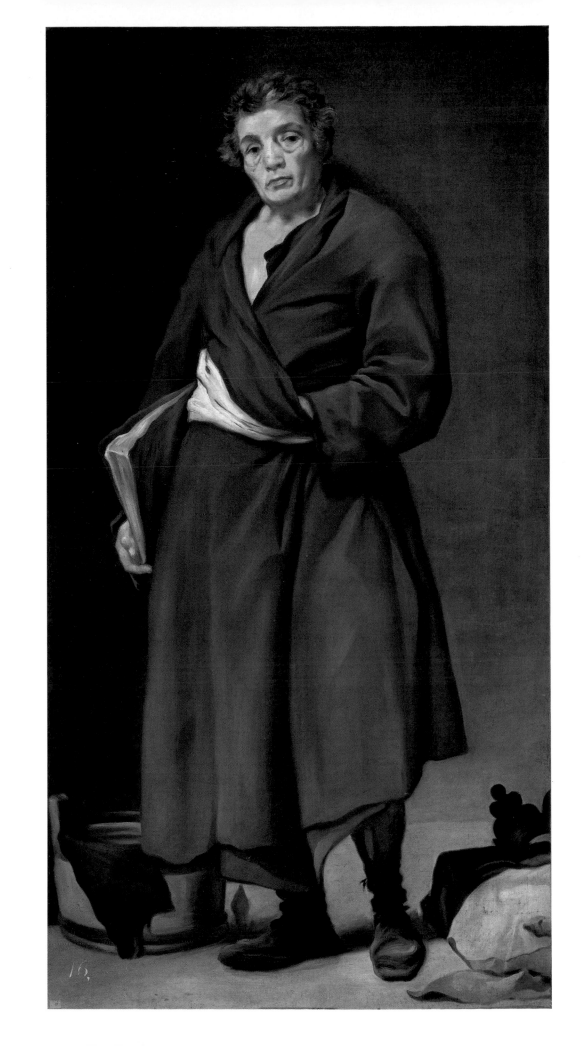

20. Diego Velázquez de Silva: *Equestrian Portrait of Prince Baltasar Carlos.* 1635-1636. Oil on canvas. 209 by 173 cm. Madrid, Museo del Prado.

The painting is part of five royal equestrian portraits that Velázquez painted for the *salón de Reinos* in the Buen Retiro palace in Madrid. It was located on one of the narrow walls of the drawing-room above the door between the portraits of his parents, Philippe IV and Queen Isabel de Borbón. This and the painting of the King are the only ones that were painted without interruption at the time of the decoration of the room.

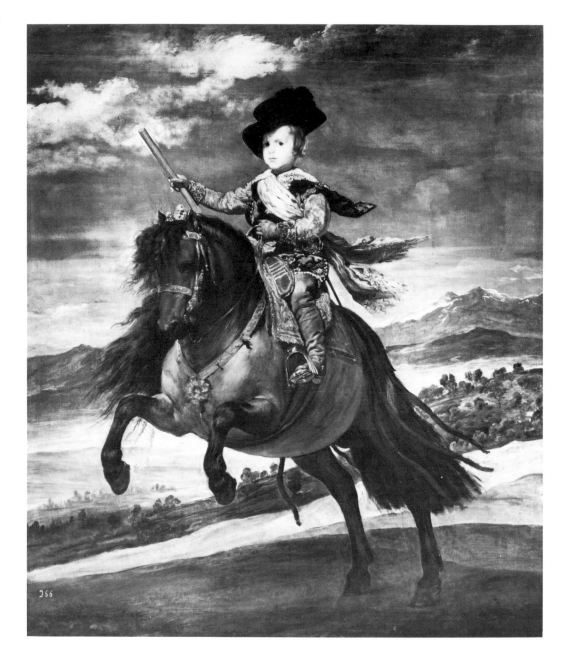

21. *Prince Baltasar Carlos* (based on Velázquez). 1778. Etching. 35 by 23 cm.

This etching based on one of the most famous equestrian paintings by Velázquez was published in December of 1778 simultaneously with the *Borrachos* (The Intoxicated). We know of no preparatory drawing. The principal difference between Goya's painting and the etching is in the complete transformation of the landscape; it has been considerably simplified.

his senior, had painted numerous frescoes, not only for El Pilar but also in the Royal Palace and in the principal churches of Madrid — the Salesas Reales, the Encarnacíon and the Descalzas Reales. Before deciding between the two candidates whose merits seemed at first sight to be so unequal as to preclude any hesitation, the Building Committee of the basilica asked Goya to provide them with proof of his ability as a fresco-painter. This wise precaution clearly suggests that prior to his visit to Italy he had painted only in oils. On November 11, 1771 he submitted a sample which satisfied the Committee; in addition, he was prepared to do the work for only 15,000 reals, as compared with the 25,000 demanded by González Velázquez. This consideration seems to have prevailed and the Committee accordingly offered him the job, the only proviso being that his sketches should be submitted to the Academy of Fine Arts in Madrid.

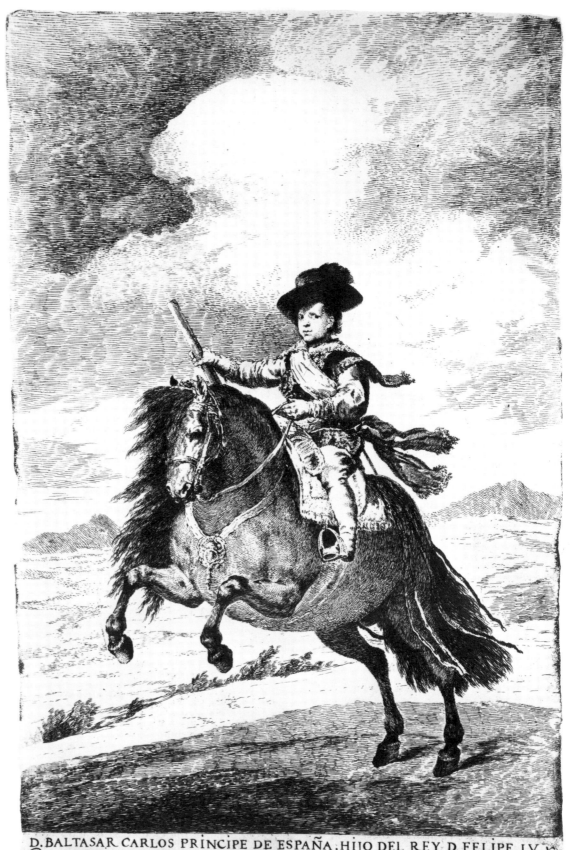

D. BALTASAR CARLOS PRÍNCIPE DE ESPAÑA. HIJO DEL REY D. FELIPE IV.
Pintura de D. Diego Velazquez del tamaño natural, dibujada y grabada por D. Francisco Goya, Pintor. 1778.

In this affair it is obvious that apart from the appreciable saving of 10,000 reals, the choice of the authorities of El Pilar was based on some other consideration that the documents could not divulge — probably a very strong recommendation. Did it come from Nicolas de Azara? Or from some wealthy nobility of Saragossa such as Juan Martín de Goicoecha, the intimate friend of Goya and Zapater? It seems, however, that we must seek the answer in Rome. It is certain that at the moment of his return to Spain, after the announcement of the results of the competition in Parma, Goya hesitated between Valencia and Saragossa. If he finally decided for the latter it must have been because he had been assured before leaving Italy that an important commission would be available for him in his native town.

On January 27, 1772 the Building Committee of El Pilar did a surprising thing. Because they liked the sketch submitted by Goya for the vault of the Coreto so much — *"pieza de habilidad y de especial gusto"* ("a clever piece of work in particularly good taste") to quote the minutes of the meeting — they decided that the contract with the painter should be signed immediately and the work started without seeking the approval of the Academy as originally stated.

On the next day, January 28, the contract was signed and Goya received an advance of 5000 reals. The subject prescribed was *The Adoration of the Name of God*. Four months later the administrator of the Building Committee, Don Matías Allué, reported to the Committee that the fresco was finished. This was remarkably quick for a young painter working on his own (the "peon" provided for in the contract confined himself to the most elementary tasks: grinding colors, cleaning brushes, sizing, and the like), considering that the area decorated came to at least a hundred square yards. This extraordinary demonstration of skill — confirmed in the composition — makes it clear that Goya did not graduate directly from the small paintings he is believed to have done in Rome to the vast undertaking at El Pilar. The only hypothesis that would serve to bridge this unacceptable gap in his career is that Goya had been working in close collaboration with Thaddaüs Kuntz on the latter's great frescoes in the churches of Rome and, in particular, of the Latium. It must have been there that Goya really learned his trade just when the last rays of Italian rococo were being shed in Rome in the great tradition of Corrado Giaquinto — a tradition that survived before his very eyes as he worked at El Pilar in the neighboring frescoes painted twenty years earlier by Antonio González Velázquez. The painting itself and, perhaps even more, the admirable sketch now in the Gudiol Collection in Barcelona show how rapidly Goya assimilated the style of the great decorative works by Giaquinto and his followers: the positioning of the figures in the sky with its piled-up clouds, the effect of depth and *sotto in su,* the pearly light in which the whole composition is bathed, the strong touches of color in the foreground — all the classic features of baroque construction come together here. One need only compare this *Adoration* with the cupola painted by Giaquinto in 1755 in the chapel of the Royal Palace in Madrid (a painting that Goya could already have seen before his stay in Italy) to be convinced of a close kinship between the two works. Three large studies of heads drawn by Goya for his fresco have also sur-

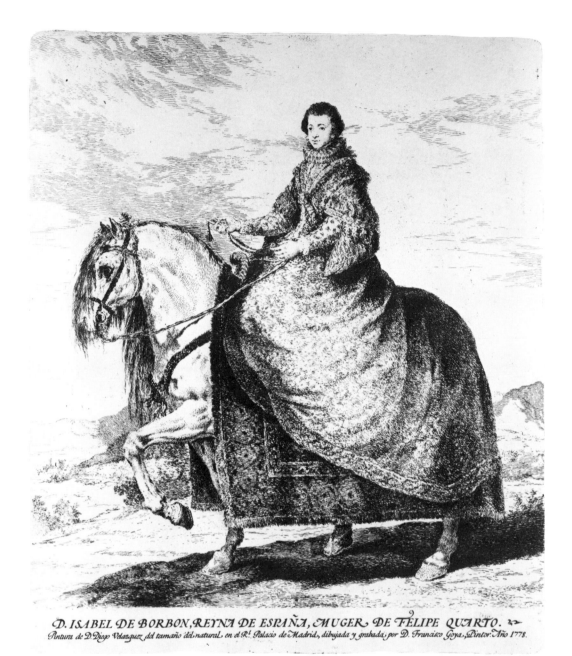

D. ISABEL DE BORBON, REYNA DE ESPAÑA, MUGER, DE FELIPE QUARTO.
Pintura de D. Diego Velazquez del tamaño del natural, en el Rl. Palacio de Madrid, dibujada y grabada, por D. Francisco Goya, Pintor. Año 1778.

22. *Isabel de Borbón* (based on Velázquez). 1778
Etching. 38 by 31 cm.

This etching is part of a set of nine sheets, the appearance of which was announced in the *Gaceta de Madrid* of July 28, 1778. We know of no preparatory drawings. Several years later, his exhaustive study of the painting by Velázquez helped Goya during his work on the equestrian portrait of Maria Teresa de Vallabriga, the wife of the Infante Don Luis de Borbon.

vived. One of them which was acquired by the Louvre not long ago is a fine example of these "Italian-style" preliminary studies on colored paper — a type of drawing that would not be found again in his graphic work, abundant as it was.

Thus, in 1772 the El Pilar fresco marked the real starting point of Goya's career. Its context is that of an eighteenth-century Spain still dependent on the great foreign schools of painting, especially as here, the Italian school. In addition, it was born under the dual sign of its province and the most sacred Virgin of the Pillar — that is, on a road that for Goya led from Rome to Madrid passing through Saragossa. It is also noteworthy that this first great work of Goya's was a mural, a vast decorative painting of a religious nature. When one considers the

23. *The Infante Don Fernando* (based on Velázquez).
1778-1779. Etching and aquatint. 28.5 by 17.5 cm.

This sheet is one of the two published without a date.
For the first time Goya uses the recently invented aqua-
tint process that was known from France on both sheets.
He did not use this technique again until 1797-1799 in
the execution of the *Caprichos;* by then he had completely
mastered it. The preparatory red pencil drawing for this
sheet can be found in the Kunsthalle in Hamburg.

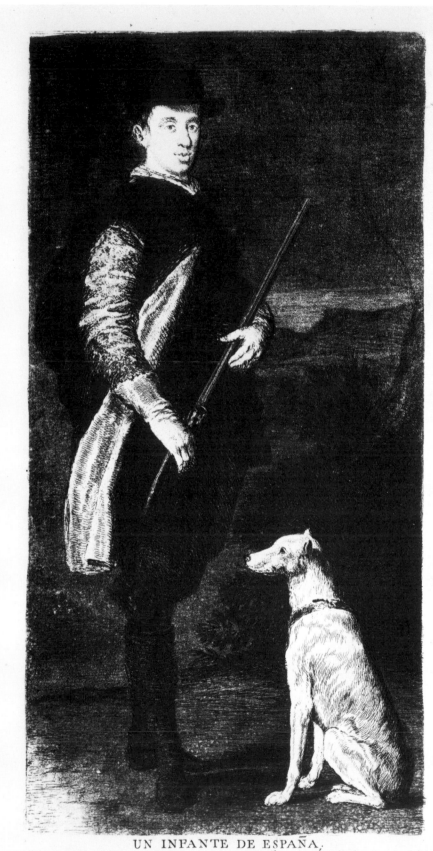

UN INFANTE DE ESPAÑA.
Pintura de Velazquez del tamaño natur.^l en el R. Palacio de Madrid.
Dibux.º y grabado p.^r Fran.^{co} Goya Pintor.

long itinerary that was to end fifty years later, in the *Black Paintings* of the Quinta del Sordo and that was marked midway by the prophetic frescoes of San Antonio de la Florida, it can be seen that the fresco at El Pilar already demonstrated two important features of Goya's art which at times appear to be inseparable: the projection of a decorative composition (fresco, oil-painting, canvas, or tapestry) on a wall, and religious themes.

As for the immediate future, *The Adoration of the Name of God* (Fig. 11) gave him a reputation in the well-defined field just referred to, that of decorative religious painting. It did not, however, open the doors of the Court to him, but it at least furthered his career in his native Aragon where up to 1775 his situation was lucrative enough to permit him to live on practically the same level as certain renowned fellow-artists in the same province, notably José Luzán, whose studio he had left ten years earlier, and Juan Antonio Merklein, teacher and father-in-law of Francisco Bayeu. The names of the three painters are listed in the tax registers of Saragossa: in 1772 and 1773, Merklein paid 450 reals in taxes, Luzán 400, and Goya 300. In the year 1774 the corresponding figures were 400, 400 and 300. This, admittedly rather rough and ready, way of estimating the success of their artistic endeavors puts Goya in a very honorable position relative to the two old studio-masters who were now in charge of painting at the Saragossa Art School.

Between 1772 and 1775 a number of works, all on religious subjects, were executed by Goya in Saragossa and the immediate neighborhood. Unfortunately, many of these are in a poor state of preservation and in most instances there is no means of dating them. One important set of paintings was commissioned by the Counts of Gabarda to decorate the chapel of the Sobradiel Palace in Saragossa. It comprises three large scenes and four small figures of saints which were painted directly on the walls and ceilings after they had been covered with a coat of plaster. The paintings were later detached from their backing and mounted on canvas. They all have one thing in common: they are derived, whole or in part from Italian and French paintings through the intermediary of engravings. *Joseph's Dream* (Museum of Saragossa) and the *Descent from the Cross* (Madrid, Lázaro Foundation) are taken from two canvases by Simon Vouet, engraved by Dorigny; the third large composition, the *Visitation* (Florence, Contini Bonacossi Collection), is after a painting by Carlo Maratta, engraved by himself. This procedure which eliminated the always difficult stage of invention made it possible to carry out a commission more rapidly and cheaply. Goya was not alone in using it and in every academy of art recourse to collections of engravings after the old masters constituted the ABC of the painter's apprenticeship. There was no need to know the actual picture; the engraving was enough. It has been observed that in José Luzán's studio among others the students engaged in this kind of exercise which served in the long run to give them a vocabulary of forms and subjects. Later on it would be noted that Goya seemed ill at ease when he had to compose a religious scene; an engraving would then be used to make up for his deficiencies of invention, allowing him to give free rein to the wholly personal virtuosity of his brushwork.

24. Diego Velázquez de Silva: *El Aguadór de Sevilla (The Water Merchant of Sevilla).* Around 1618. Oil on canvas. 103 by 81 cm (patched onto 106 by 81 cm). London, Wellington Museum, Apsley House (Crown Copyright).

It is the only work by Velázquez from his first period in Seville from which Goya attempted to execute an etching. Of this attempt we only have the drawing in the Kunsthalle in Hamburg; we do not have a print of the etching, however, although the traces of the plate are still clearly visible on the drawing.

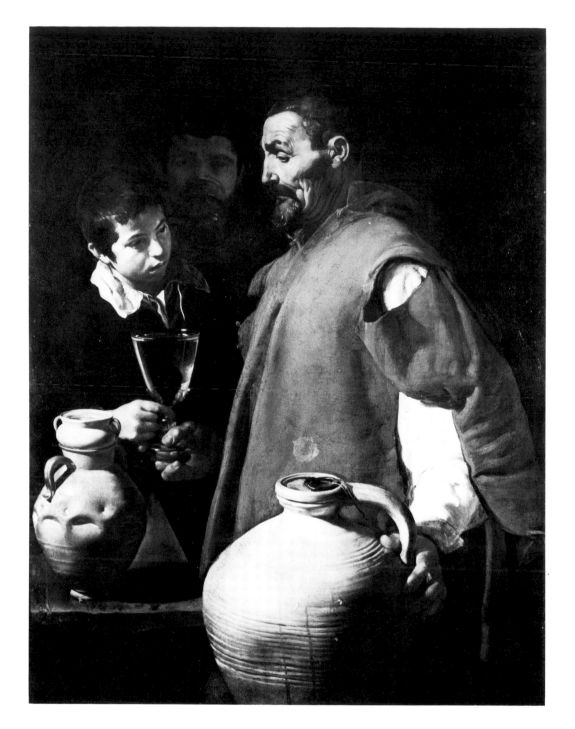

Other paintings by Goya have been found in the little Sanctuary of the Virgin of the Fountains at Muel (Saragossa); representing the four *Fathers of the Church,* they decorate the pendentives of the cupola and are executed in oils on a backing of plaster. Goya recopied the same figures on canvas for the parish church at Remolinos which shows how successful these early works must have been since he was asked to repeat them. Incidentally, it is worth noting that both in the Sobradiel Palace and at Muel he used the rather special technique of oils on a

46

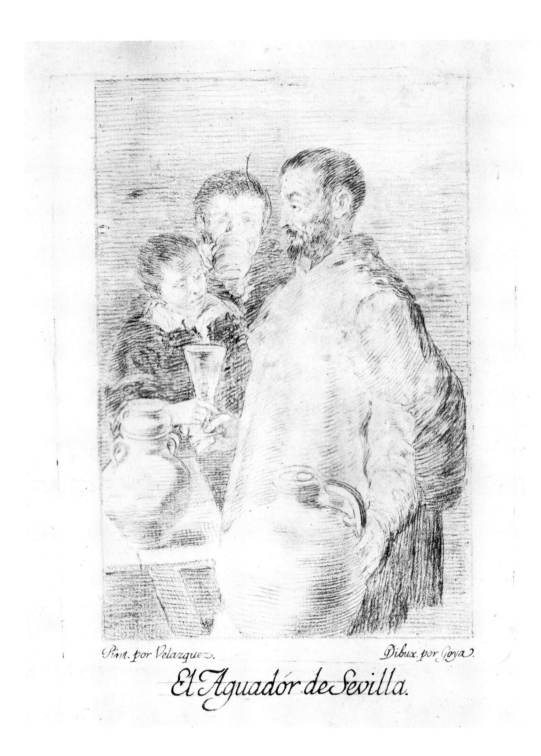

25. *El Aguadór de Sevilla (The Water Merchant of Seville)*. 1778-1779. Red chalk drawing. 25.2 by 18.6 cm. Hamburg, Kunsthalle.

The Kunsthalle in Hamburg possesses four red chalk drawings by Goya based on Velázquez. However, we do not know of a corresponding etching to any of them. The traces of the engraving plate can be seen clearly on this sheet; but we do not have any documentation of this printing.

wall. Since the color was applied to the plaster when it had dried, the artist had the immense advantage of being able to work without the haste demanded by the fresh mortar of the fresco, and then of being able to go over his work again as much as he wished, as with any painting in oils. It seems that Goya reserved this technique for vertical walls — as though he were painting a canvas set before him — and preferred to use the fresco technique when painting ceilings or cupolas.

26. *Philippe IV* (based on Velázquez). 1778-1779. Red chalk drawing. 27.7 by 18.9 cm. Hamburg, Kunsthalle. No etching of this drawing is known and it shows no traces of a plate. These very elaborate red chalk drawings prove how thoroughly Goya studied the paintings of Velázquez. Later he preferred red chalk for the preparation of his etchings *(Caprichos, Desastres de la Guerra, Tauromaquia, Disparates)*.

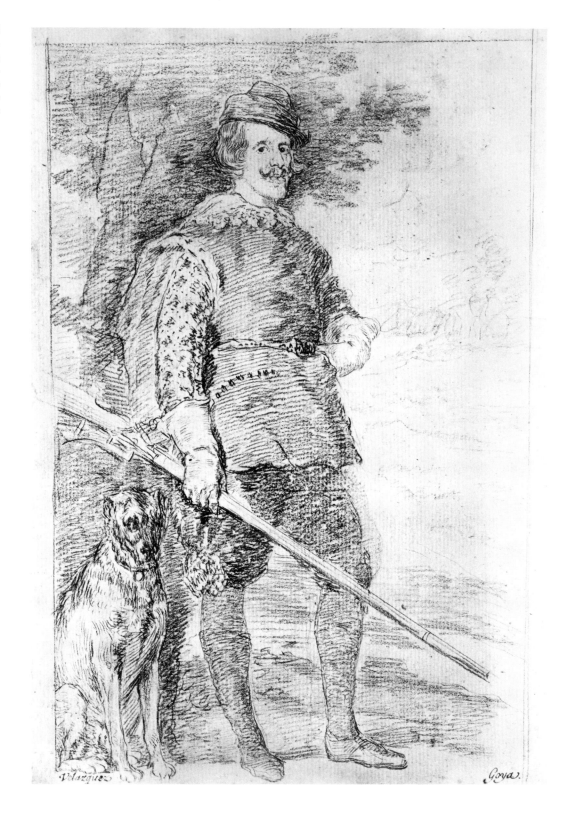

Two very important groups of paintings employ this technique: the large-scale frescoes at the Carthusian Monastery of Aula Dei and the *Black Paintings* (Figs. 171-176) executed on the walls of his house at the end of his life. Apart from their dates, they differ on one important point: while the latter, all of which

are on display at the Prado Museum, are justly famous, the former have fallen into undue oblivion. Their isolation in the hush of the little monastery near Saragossa and the mishaps of their unfortunate restoration are certainly largely responsible for this disfavor. To enter the church at Aula Dei is to be at once surprised and dismayed — surprised by the imposing dimensions of the paintings on the upper part of the walls which form a complete cycle illustrating the life of the Virgin in a series of vast scenes painted directly on the surface of the walls and carefully framed; dismayed, on looking at them more closely by their dilapidated state. In 1835 at the time of the secularization laws the monastery was deserted by the monks who took refuge in France and did not return to Spain until 1901. Sixty-five years of water infiltration and rotting walls, mainly on the left hand side, resulted in the partial — and in some instances total — destruction of Goya's paintings. In a laudable effort to restore their church the monks called on the services of two French painters, the brothers Amédée and Paul Buffet, who had already worked for their community. Faced with such extensive damage, these artists, who enjoyed an honorable reputation in Paris but were probably not very familiar with the techniques of restoration, resorted to drastic remedies; on the left hand side which was most affected by the damp they repainted the scenes completely and signed them; on the right hand side they were fortunately less enterprising and confined themselves to redoing the most damaged areas rather clumsily. While saving part of Goya's paintings they ruined their general appearance and mutilated about half of them.

Only seven paintings have survived the mishaps of the last century, whereas originally there was a set of eleven scenes, three meters high, making up more than two-hundred-and-forty square meters of painted surface — a gigantic work and by far the largest the painter ever had to execute. It still makes an extraordinary impression; working on a vertical backing Goya adopted a comletely new style that marked a break with the El Pilar fresco and the school of Giaquinto. There is evidence of a determination to adapt his style to quite another kind of subject and — one should not forget — to the unfussy, countrified atmosphere of a Carthusian monastery. Sánchez Cantón carried out a lengthy investigation into the possible sources used by Goya in this early *Life of the Virgin,* but all his erudition, though considerable, was of no avail. The work remains unique in its monumental aspect, its voluminously draped figures in hieratic poses, its massive yet sober architectural features, and the way in which the vertical perspective is heightened still further by the steps on which the figures are placed like actors performing in a solemn setting. Taking into account the present condition of the work, four panels are outstanding: the *Betrothal of the Virgin,* the *Presentation at the Temple,* the *Circumcision* (Fig.16) and the *Visitation.* Having given the sacred and the profane their due, one cannot fail to be struck by the kinship between some of these scenes and the cartoons for tapestries on which Goya started work immediately afterwards. The resemblances are not so much in the figures as in their setting: the leafage of the trees, the patches of sky with cloud effects, the visionary architectural features. Once transposed into the agreeable setting of the royal residences, the world projected by Goya on the walls of Aula Dei would

become that of the amusements of the Court. This link between two great series of works, apparently very different from each other, has been further confirmed with the discovery by Gudiol in the account books of the monastery of items obviously relating to Goya's paintings; the entries between April and November 1774 mention expenditure on the installation of extensive scaffolding and the purchase of eleven large gilt frames which could only have been intended for the eleven scenes from the life of the Virgin painted by Goya. It was immediately after this at the end of 1774 that the painter was called to Madrid to enter the service of the Royal Tapestry Factory of Santa Barbara.

In the meantime on July 25, 1773 Goya married Josefa Bayeu, sister of his master Francisco and his schoolfellow Ramón. The wedding took place in the parish church of Santa Maria in Madrid; the young couple was sponsored by Francisco Bayeu and his wife Sebastiana Merklein. This marriage was the culmination of the many years of friendship between the two families, both belonging to Saragossa — a friendship that the master-student relationship between the elder Bayeu and the youthful Goya had only served to strengthen. The extremely self-effacing role of Josefa Bayeu in her husband's life has often been noted; of a married life lasting thirty-nine years, there remain only a few fleeting allusions to "La Pepa" in Goya's correspondence with Zapater; a portrait now in the Prado that is probably of someone else; and one little drawing in black chalk dated 1805 which shows her in profile, wearing a bonnet and already quite shrunken with age. Was it a marriage of convenience or self-interest? This might have been so on both sides. For the Bayeus it was certainly useful to have such a promising young painter join the family — recall, for instance, the notable precedents of Mantegna "swallowed up" by the Bellini clan and of Velázquez marrying the daughter of his master Pacheco. As for Goya, it is obvious that this marriage amounted to a real promotion into the circle of the court painters. Francisco Bayeu was already an Academician and Painter to the King; since Mengs' first return to Rome four years earlier he and Maella had been the white hopes of the younger school of Spanish painting. At that time, it would probably have been impossible to find any better protector in Madrid for a young painter as yet unknown at Court. Needless to say, as head of the family and guardian of its reputation, Bayeu would never have permitted his daughter to marry Goya, had the young painter been the adventurer depicted by various biographers with a weakness for romantic hearsay. And Goya would not have married Josefa Bayeu if the Bayeu clan — recall that the three brothers were painters and that father-in-law Merklein was Director of Studies at the Saragossa Art School — had not judged him worthy of entering the family, of painting with them, and of sharing the royal largesse.

On marrying Goya seems to have returned with his wife to Saragossa where important commissions awaited him, notably the paintings at the Carthusian Monastery of Aula Dei. Scarcely had he finished his commission when, at the end of 1774, he was summoned to Madrid by Mengs who had just returned from Italy. A petition in his handwriting dated July 24, 1779 and addressed to King Charles III confirms this: "Sire Francisco Goya...having practiced his art in

Saragossa, his home, and in Rome where he went and lived at his own expense, was called by Don Antonio Rafael Mengs to devote himself to the royal commands of Your Majesty...." But behind the action of Mengs, that all-powerful figure at Court, was no doubt the recommendation of Francisco Bayeu in favor of his young brother-in-law. Goya and his wife arrived back in Madrid in December 1774 and went to live with the Bayeus at No. 7-9 Calle del Reloj. Their first child was born there in the following year and they stayed there until 1777 when increased prosperity made it possible for them to rent an independent dwelling in the capital.

Before considering the extremely important work carried out by Goya in the service of the King from 1775 on, one important factor remains to be examined in order to gain a completely clear idea of the painter's relationships with the artistic circles of his time — the role that Mengs might have played in the early years of Goya's residence in Madrid. After five years' absence the First Court Painter returned to Spain in December 1774 to resume his duties there. This second stint at the Court of Charles III proved to be a short one since Mengs left for good in January 1777, returning to Rome where he died two years later. During the two years in Madrid he witnessed Goya's early efforts and quickly discerned his extraordinary gifts despite the limitations imposed by the kind of decorative painting he was obliged to do. There is evidence for this in several surviving documents. First of all, there is the statement by Father Tomás López of the Monastery of Aula Dei in his note on Goya: "Mengs was astonished by his abilities and got him to do the drawings for several works." Goya's son Javier, in his celebrated biography of his father, corroborates this: "The first works produced by his genius were the cartoons he painted for the Royal Tapestry Factory, and his facility was so extraordinary that it astonished Mengs who was responsible for the inspection of such works." Finally, from the pen of Mengs himself, there is the following verdict on Goya dated June 18, 1776: "Don Francisco Goya has also worked for the Royal Tapestry Factory; he is a talented and intelligent artist who could make great progress in the arts if he were supported by the royal bounty and who has been doing useful work in the service of the King."

As for Goya himself he was now more than thirty years of age. He did not look for models in the small circle of court painters but for the encouragement of his deepest aspirations. After undergoing the influence of Corrado Giaquinto and coming, from necessity rather than conviction, under the thumb of his brother-in-law Francisco Bayeu, what could he expect from the admirably calculated and self-contained art of the great Mengs? Goya never said what he thought of it, and all the hypotheses that hindsight might render attractive strike us as rather illogical. To use the *Black Paintings* (Figs. 171-176) or the *Shootings of the Third of May* (Fig. 126) to prove him a staunch adversary of Mengs back in 1775 is ridiculous. Some writers have even gone as far as to depict the great Bohemian artist as a limited person who did not understand "good painting," his own very obviously being considered *a priori* as bad. Indeed, Aureliano de Beruete, quite an estimable critic, writing on the works of Velázquez in 1917 had no hesitation

in stating that "almost forgotten at the time…, they naturally did not appeal to Mengs, nor probably to anyone else…." The suggestion is that with the intuition of genius Goya discovered and admired the works of Velázquez, thus becoming the "anti-Mengs" *par excellence* which would have suited everybody. The truth was quite different; Mengs, a man of exceptional culture and taste, understood the art of Velázquez perfectly well and deeply admired it. In 1776 before leaving Spain he wrote to his friend Antonio Ponz, Secretary of the Academy of San Fernando, about "the merit of the most remarkable pictures kept in the Royal Palace of Madrid." This text which Ponz had requested for insertion in the sixth volume of his *Spanish Journey* could be considered as the spiritual testament of the First Court Painter. In it, all those interested in the future of Spanish painting — Goya included — could read these words: "The best examples of this natural style are the works of Don Diego Velázquez; and, if Titian was the better colorist, Velázquez was far superior in his awareness of light and shade and in the use of aerial perspective, these being the most necessary parts of the style in question. Most of the works of the Spanish masters — notably those by Don Diego Velázquez, Ribera, and Murillo — hang in the King's dressing-room. But what a difference there is between them. What truth, what skill in chiaroscuro are to be observed in the pictures of Velázquez! How well he captured the effect of the air between objects in order to make them appear distinct from one another! And what a lesson the pictures by Velázquez in the room in question (painted at three different periods) offer any artist who studies them by showing how nature may be imitated with the utmost excellence…! But undoubtedly the picture in which he gave the most accurate impression of truth to nature is the *Spinners,* belonging to his last phase, which is painted in such a way as to suggest that it was created not by the artist's hand but by his will…" Finally came this recommendation, the master's ultimate lesson: "It would be desirable for a number of young artists to study with application and profit the fine examples of art I have just described, not only by copying them, but by imitating them which to me means something very different for not all those who copy a work are capable of producing similar ones, unless they seek out the reasons that guided the author of the original, which is the only way of making a study of other people's works." And, pursuing the subject of copying and imitation with authority, Mengs strongly urged young painters to engage in the tireless quest for Nature through the great masters of the past headed by Velázquez.

The joint efforts of Mengs and Ponz to bring to light the art treasures hidden away in the royal palaces of Spain was not in vain. Soon afterwards three young Spanish painters — Ramón Bayeu, José Castillo, and Goya — began to make etchings of a number of pictures in the royal collection. But whereas the first two left us only a few clumsy engravings after Ribera, Guercino, and Cerezo, it is significant that Goya devoted himself exclusively to Velázquez and by the end of 1778 had put twelve plates on sale, including five large equestrian portraits. In his dictionary Ceán Bermúdez states that Goya did engravings of eighteen paintings by Velázquez. This was an ambitious undertaking and one that is still

27. *Cristo crucificado (Christ on the Cross).* Oil on canvas. 255 by 153 cm. Madrid, Museo del Prado.

Goya submitted this picture to the Academy of San Fernando when he applied for admission. He had succeeded in perfecting the academic style and was chosen a member unanimously. This was the beginning of a long, honorable career parallel to his career at the court in the service of the King.

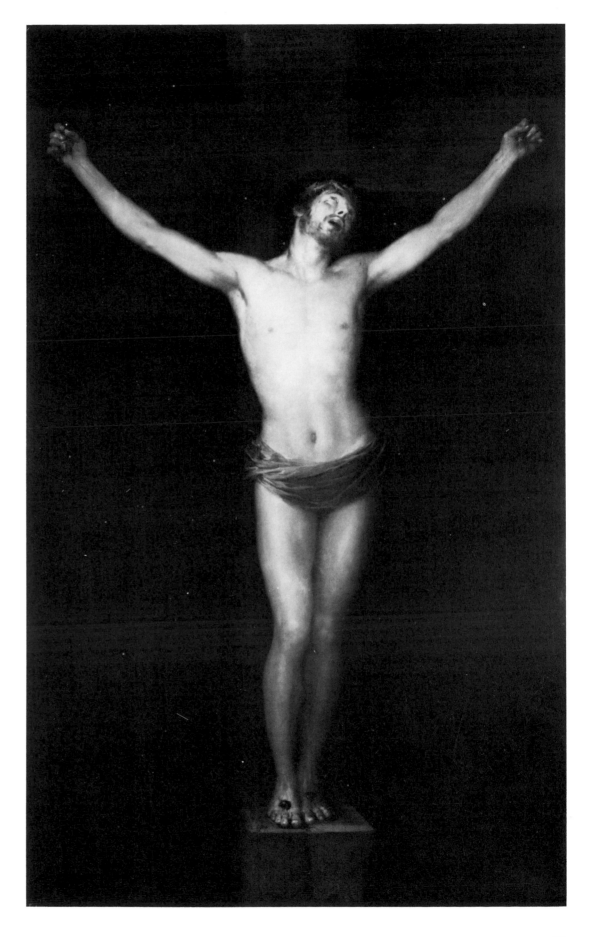

unique in the annals of engraving in Spain. Even if the results were often disappointing, notably in the case of certain large plates such as that of the *Meninas* because of deficiencies in the aquatinting, a technique that the painter had not yet mastered, this first large series of engravings by Goya is important for its deeper significance, namely, the illumination brought to Goya by his encounter with Velázquez. So far, the great painters on whom he and his contemporaries modeled their work had been limited to Giaquinto, Tiepolo, Mengs, and Bayeu — in short, the decorators of the new Royal Palace in Madrid. But now at the age of thirty he suddenly discovered the "painter of painters," as Mengs called him. The vibrancy, deftness and lightness of the brushwork, the sense of the air circulating quite naturally between the objects depicted (as Mengs had so pertinently observed), the way in which the paintings appeared unfinished when observed close to, but were the most truthful, the most perfect of all paintings when viewed from a distance — all this was a revelation of something he had never found in any other painter, something that he would later define as "the

magic of the atmosphere." At the Royal Palace he could admire at leisure that veritable peak of the painter's art, the *Meninas,* which was then more generally known as "The Family" and which has been strikingly defined by Luca Giordano as "the theology of painting." In his despair at not being able to make a proper engraving of it Goya seems to have confessed himself defeated by all the complexity hidden under such apparent simplicity. The undertaking exceeded his powers and the series of etchings remained unfinished, pruned of its finest pieces though not without implications for the future. Goya had discovered his kind of painting which he confusedly felt to be true painting, though it offended against the taste that had prevailed in Madrid since 1760. Thanks to Mengs and Ponz the lesson of Velázquez would be the most important lesson he ever learned, and it may confidently be said that from 1778 on, all his efforts would be devoted to taking his place beside the great Spanish painter of the Golden Age from whom he had learned that, contrary to what the academies taught, painting was much more than a trade or a career.

II

A Time for Pleasure and Amusements

II A Time for Pleasure and Amusements

Tapestry cartoons and royal residences — choosing subjects for the royal family — the role of "the common people" in Madrid society — Goya's election to the Academy — Cartoon work halted 1780-1786 — Goya, Court Painter — a time of complacency and pleasure: carriages, horses, hunting — toreros and corridas

How much had Goya achieved by the time he arrived in Madrid in December 1774? Some fifty paintings if we are to go by the most recent catalogues, some of them, like the El Pilar fresco and the Life of the Virgin at the Carthusian Monastery of Aula Dei, are very large paintings. This record of his youthful *oeuvre,* of which there is still such incomplete knowledge in spite of all the research done by historians, is certainly far from complete; Goya must have done far more work by his twenty-eighth year, both in Aragon and Rome, but the works have either been lost or swallowed up in anonymity from which it simply is impossible to rescue them. One single hypothesis is permissible; if the present catalogue of that early period contained twice as many titles, this would probably make very little real difference. In fact, the surviving works deal mainly with religious or mythological subjects; those that have disappeared cannot have been very different. The gaps in our present knowledge affect the quantity rather than the quality of the young Goya's work.

It was suddenly given a wholly new direction by circumstances entirely outside the painter's control. For the moment the religious scenes, composed laboriously,

Pitimetra Española, con manto, segun se bisten en la Semana Santa

based mainly on engravings, were finished; now he had to prepare cartoons to be woven into tapestries for the royal residences. The major building works and extension undertaken by Charles III created a considerable demand for them, and several painters were commissioned with this task of decoration, regarded as minor at the time and thus entrusted to young artists and remunerated as piece work. Today practically all the cartoons painted by Goya between 1775 and 1792 are the pride of the Prado, but we must remember that for almost a century they lay stored in the cellars of the Royal Palace in Madrid where they risked serious deterioration. The fact that they played only an intermediary role in the execution of the tapestries — however important that role may have been — did not originally lend them the status of works of art. It was Frederico de Madrazo, the director of the Royal Museum at the time and a great collector of Goya's work, who first raised the alarm at the deplorable neglect of these masterpieces.

Some of the sixty cartoons by Goya which Sambricio catalogued in 1946, luckily minor ones, have disappeared from the Royal Palace. The remainder, some fifty canvases (the word "cartoon" in this context does not apply to the painted mount), together with the *Black Paintings* (Figs. 171-176) constitute the most comprehensive ensemble of Goya's surviving decorative paintings. After the cycle of "edifying" works dating from before 1775, we now have an entirely new kind of commission since its purpose was the renovation of the great rooms in the royal residences which were to be made as pleasant as possible. The golden rule governing the execution of these tapestries and therefore of the cartoons, can be summed up in the one word — to please. The subjects were obviously chosen with this aim in mind. But this was not the only consideration Goya would have to take into account. The technique of tapestry — despite the infinite possibility of multiplying tints, thanks to artificial dyes — always stipulated that the cartoons to be followed by the loom masters should have an uncluttered drawing and consist of sparsely broken up color planes. The staff and director of the Royal Factory of Santa Barbara were anxious for obvious reasons of economy to maintain this working tradition. Whenever the painter allowed himself to be carried away by his natural fugue and, forgetting these basic principles, launched into an excessively complicated composition with a wealth of detail, delicate embellishments and plays of light and shade, the factory workers would protest

28. Manuel de la Cruz y Cano: *Pitimetra Española, con manto, segun se bisten en la Semana Santa (A Spanish Lady of fashion with her veil, as they dress during Holy Week).* 1777. Wash drawing. Madrid, Museo Municipal.

The *petimetra* (lady of fashion) and her partner, the *petimetre* (dandy), are representatives of that group of Spaniards that adopted French styles and customs; their counterparts are frequently the *maja* and the *majo,* the *manola* and the *manolo,* who descended from the Spanish tradition. This drawing was used for an engraving of a series of Spanish costumes published by Juan de la Cruz Cano y Holmedilla in Madrid in 1777.

29. *Maja taking a walk.* 1796-1797. Drawing from the album of Sanlúcar (A.g.); Chinese ink, wash. 17.2 by 9.7 cm. Madrid, Museo del Prado.

The slender and elegant figures of the *majas* that Goya painted based on real life in Andalusia, in Sanlúcar or in Cadiz take up a significant amount of space in his first two portfolios of sketches and in the *Caprichos.* Here the assumption is correct that the Duchess of Alba is shown in the costume of a *maja* as in the portrait in New York (The Hispanic Society of America).

30. *Sitting majas on the Promenade.* 1796-1797. Drawing from the album of Sanlúcar (A.p.); Chinese ink, wash. 17.2 by 10.1 cm. Private collection.

Goya sketched this scene on the promenade in Andalusia quickly. The sheet is the starting point for etching number 15 of the *Caprichos: Bellos consejos* (Good Advice).

even to the point of forcing the director to reject the cartoon. The best example of this conflict between the artist and those who executed the work is found precisely in a famous cartoon by Goya, delivered on Arpil 27, 1778, *The Blind Guitarist.* The first version of this huge scene, over eight meters square, aroused the opposition of the tapestry workers; despite the favorable reception it was given by Mariano Salvador Maella, who was in charge of the paintings and who praised its "pleasant composition," the cartoon was returned to Goya on Sabatini's order "for everything that made it impossible to reproduce it as a tapestry to be revised and changed." The painter had to submit and, bearing this warning in mind, he was careful from then on to keep the drawing and colors in his cartoons simple, as he had been told to do. This pressure from the outside certainly con-

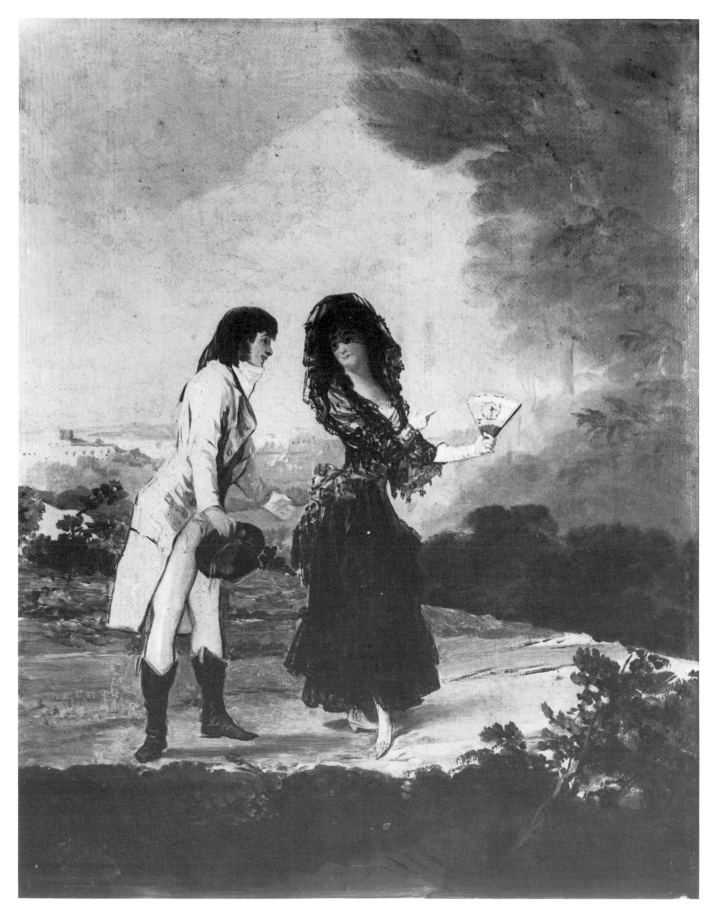

31. *Coloquio galante (Galant Conversation)*. Around 1793-1797. Oil on canvas. 41 by 31 cm. Madrid, Marques de la Ramon.

The *maja* and the *petimetre,* a typical, representative Madrilenian couple of the time, are represented on numerous sheets of the Madrid Album and in the *Caprichos*. The startling similarity between this young, elegant woman and the portrait of the Duchess of Alba in a black dress (New York, The Hispanic Society of America) has been noted on various occasions.

32. *Old Beggar with a maja*. 1796-1797. Drawing from the Madrid Album (B 6); Chinese ink, wash. 23.4 by 14.5 cm. Madrid, Biblioteca Nacional.

A characteristically gallant scene for the period of *majismo* in Spain. The old beggar, wrapped in her shawl, holds the rosary common to matchmakers in her hand. The drawing served as a preparation for etching number 16 of the *Caprichos: Dios la perdone: Y era su madre* (May God forgive her: That was her mother). The moment the old woman becomes the mother of the *maja,* the meaning of the scene changes tangibly and the problems of a mother-daughter relationship are placed in the forefront.

tributed to perfecting his new style which was both sparse and incisive with a freedom that left room for poetry.

There was another factor that played a vital part in the creation of these cartoons which has not yet been given sufficient emphasis — the close relationship between the subjects treated and the apartments, and thus the people, for whom the tapestries were intended. The whole ensemble of these paintings was executed in three stages: from 1775 to 1780, the most prolific period, Goya delivered thirty-nine cartoons to the Santa Barbara Factory which were paid for as piecework after one of the court painters had prepared a memorandum, which had to be subsequently approved by Sabatini, describing and assessing them. In 1780 as a measure of economy necessitated by the war against England, a royal

33. *Lady's Maid grooming the Hair of a Young Woman.* 1796-1797. Drawing from the Madrid Album (B. 25); Chinese ink, wash. 23.4 by 14.5 cm. Madrid, Biblioteca Nacional.

The sheet served as Goya's preparation for sheet number 31 of the *Caprichos: Ruega por ella* (She prays for her). The etching derives its critical edge through the addition of the old matchmaker letting her rosary glide through her fingers while her "protegee" is being prepared.

34. *Duo with Clavichord.* 1796-1797. Drawing from the Madrid Album (B. 27); Chinese ink, wash. 23.5 by 14.5 cm. Madrid, Museo del Prado.

As with most of the drawings of this album — from number 49 and the first handwritten picture titles — the sheet catches a scene from the gallant life of the *majas* and the *petimetres* as Goya had been able to observe it in Cadiz and Madrid. The same theme appears again in the second part of the album (B. 65), but there it is treated as a caricature and in a biting manner in the spirit of the *Caprichos.*

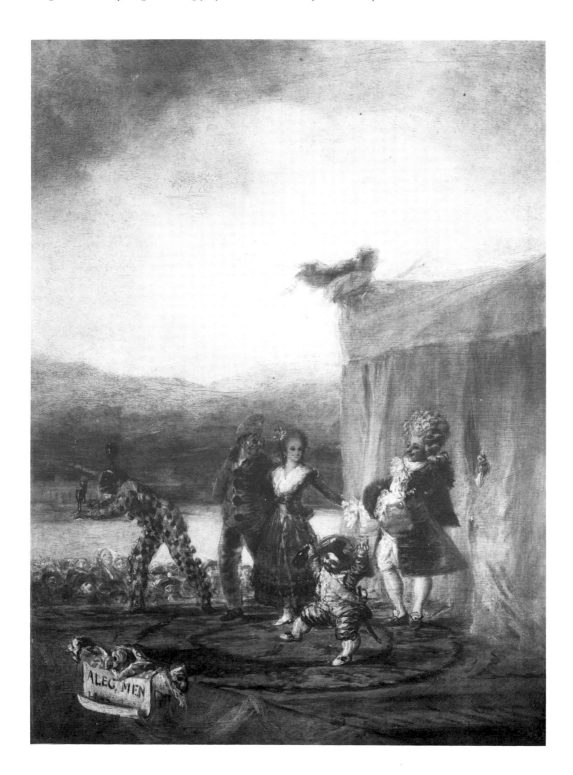

35. *Los comicos ambulantes (Traveling Comedians).* 1793. Tin-plate. 43 by 32 cm. Madrid, Museo del Prado.

The world of the theater takes up a significant place in Goya's work. Not only did he depict famous actors of his time — Tirana, Lorenza Correa, Isidro Maiquez — he also showed scenes from individual pieces and of theater troups. The legend in the front left ALEG. MEN. (Alegoria menandrea) refers to the Commedia dell'arte.

edict suspended any commission for cartoons and tapestries that were not absolutely essential. For Goya this meant an interruption in his cartoon work that lasted until 1786. A second section was executed from 1786 to 1788. Then came the death of Charles III, when work on decorating the royal residences was again suspended. Under the new sovereign, Charles IV, Goya painted, not without demurring, a final series of cartoons in 1791-1792. His work for the Factory of Santa Barbara finally ceased at the end of 1792 when he fell seriously ill in Andalusia.

For which of the royal residences were these tapestries intended? For only two — the palaces of the Escorial and the Pardo. But it is interesting to note that the first thirty-nine cartoons which were divided between the two residences were reserved entirely for the apartments of the Prince and Princess of the Asturias, that is, the future Charles IV and his wife, Maria Luisa of Parma. This princely couple, aged 27 and 24 respectively, thought only of enjoying themselves and wanted to live in a decor illustrating the pleasures which the rigid etiquette forbade them. Maria Luisa especially, who was vivacious and impulsive by nature, suffered from the semi-seclusion in which her position as princess of the Asturias confined her. In her private correspondence with Father Eleta, Charles III's confessor, she made a touching appeal to this stern Jesuit when refuting the slanders rumored about her: "I want you to know that, as we are so cut off, the Prince and I like to gather a few people around us in our apartments during the long winter evenings and on summer days at times when other people are enjoying themselves or relaxing after work…" and Maria Luisa alluded to the innocent pleasure they took in listening to songs or playing the guitar, arranging party games and other kinds of amusement.

It was for them that Goya created these thirty-nine subjects of decoration: the first nine, delivered in 1775, for their dining room in the Escorial; the following ten (1776-1777) for another dining room in the palace of the Pardo. To this long list could also be added the seven cartoons painted in 1791-1792 for the King's study in the Escorial; the king at the time was none other than Charles IV, the former Prince of the Asturias. The total number of cartoons executed for the apartments of the young sovereigns before and after their ascension amounted to forty-six. In this the royal clients demonstrated an exceptional and significant faithfulness to the man who, almost unknown in 1775, later became their favorite painter.

But before going any further in the study of these cartoons, it should first be established how their subjects were chosen and by whom. It has been tempting to think that it was Goya himself who chose the scene to be shown; but this is only another of those myths in the long list of legends kept alive by some rather unscrupulous biographers. According to these the still-youthful painter was turned into the brilliant creator of a wholly new genre in which popular subjects occupied the foremost place. The reality is far more complex, and Goya's genius lay elsewhere. A document published by Sambricio gives us very precise information on the sequence of events that preceded the actual weaving of a tapestry for the royal residences. To begin with, once the rooms to be decorated had been

36. *La Caza de la codorniz (The Quail Hunt)*. 1775. Tapestry cartoon. 190 by 226 cm. Madrid, Museo del Prado.

This cartoon is the best example of Goya's early style as it is expressed in the tapestry cartoons that he supplied for the decoration of the dining room of the Prince of Asturia in the palace of Escorial between May and October of 1775. The hunting scene in the Spanish-Flemish tradition is executed in such an impersonal manner that it was attributed to Francisco Bayeu for a long time (see illustration 7).

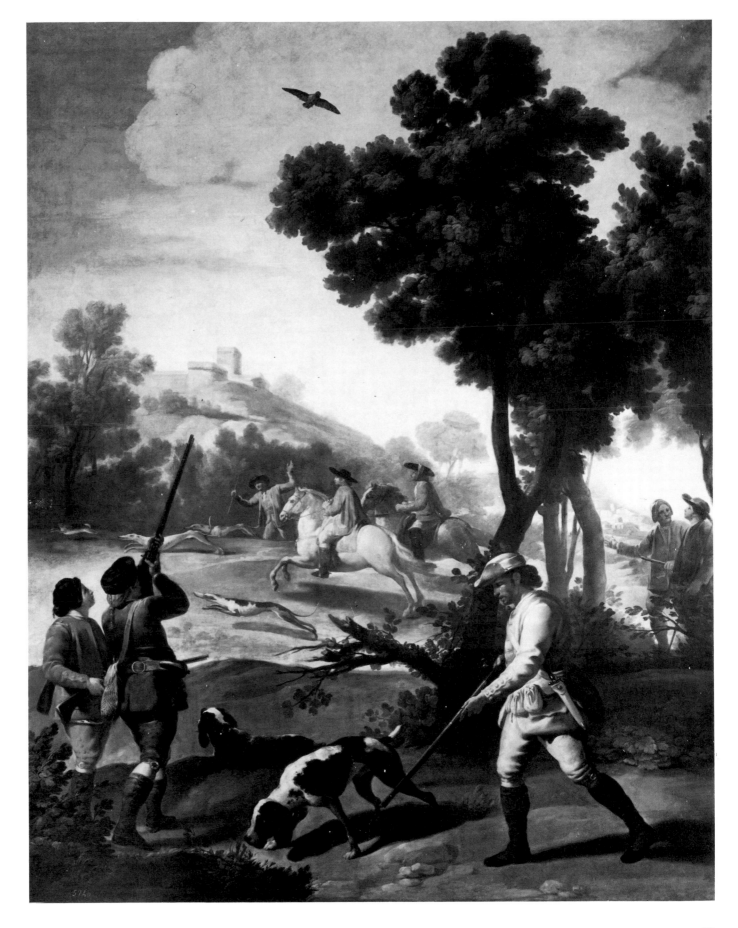

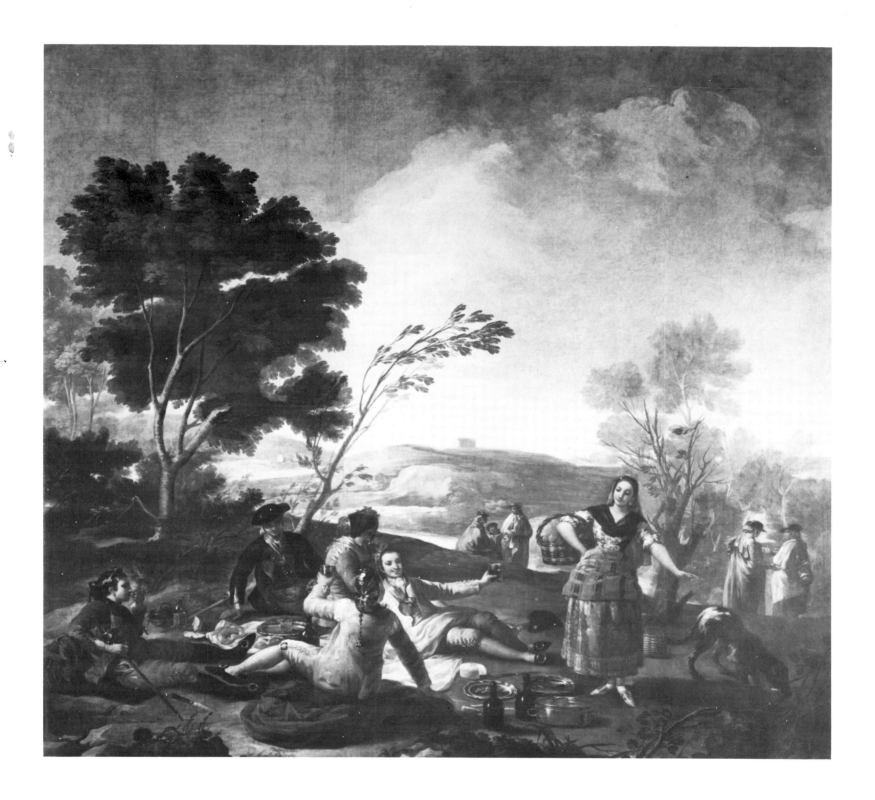

37. *La merienda (The Picnic)*. 1776. Tapestry cartoon. 272 by 295 cm. Madrid, Museo del Prado.

A completely new topic in the repertoire of the factory of Santa Barbara; certainly based on the wishes of the Prince of Asturia, popular national topics with *majas* and *majos* are making their entry here. The freshness and the abundance of colors of the cartoon are characteristics of a decisive change in Goya's painting.

chosen and the panels measured, it was the king himself who condescended to "decide on the subjects he wanted to see, whether heroic, drawn from History, or allegorical, drawn from Mythology; or perhaps dealing with military expeditions by land or sea, or scenes of country life; or lighthearted subjects, or just pure ornament. Once His Majesty had settled that point, the painters made sketches which they submitted to the king for approval. Then they executed the

paintings in the precise dimensions of the tapestries and submitted them again to His Majesty before sending them to the factory..."

In the case under discussion it is clear that it was not the old king who chose the subjects and approved the sketches but the prince and princess themselves as they would clearly have the closest interest in deciding what subjects should decorate the walls of their apartments. The history of the reign also provides ample proof that Maria Luisa had the determining vote in all the decisions made by the royal couple. Thus the petulant young princess' love of all kinds of amusement must have had the predominant influence on the choice of subject. Gone were the heroic and allegorical scenes, the military expeditions by land or sea which had previously been prescribed to the painters; gone, too, the imitation of Flemish pictures, preferably of Teniers or Wouverman that had been used by the Santa Barbara Factory for most of its tapestries before 1760. At Court, as in town, a new fashion had conquered, that of simple popular Spanish scenes; this was only one aspect of a far deeper social phenomenon peculiar to Spain in the last third of the eighteenth century. It was more than simply a liking for subjects drawn from the life of the common people which had in any case been treated for a long time in European painting, and in Madrid by Michel-Ange Houasse at the beginning of the century; more recently, by Lorenzo Tiepolo in his pastels; it was a lifestyle adopted by the Spanish aristocracy with wild enthusiasm. The great Spanish writer José Ortega y Gasset in his essay on Goya described in a masterly fashion what he called the "plebeyismo" of that *fin de siècle:* "Enthusiasm for the ways of the common people not only in painting but in everyday life gripped the upper classes...We must imagine this craze applied to the clothes, dances, songs, manners, to the amusements of the 'masses.' And if we can imagine this game of imitating the ways of humble folk not played in moderation but with an ardent, total commitment, a veritable passion that made it nothing less than the most dynamic mainspring of Spanish life in the second half of the eighteenth century, then we shall have described a great event in our history which I would call 'plebeism.' We must not attempt to underrate these facts: to our eighteenth century ancestors plebeism seemed to be the discovery of the road to happiness." And Ortega y Gasset shows, for the first time, that this typically Spanish development runs precisely counter to the trend in most other countries where the "lower orders regarded the lifestyle of the aristocracy with admiration and tried to imitate it. To reverse that norm clearly is an absurdity. Well, that absurdity was the pillar of Spanish life for several generations."

The theatre and bullfighting played a leading part in this craze for "plebeism." In the years preceding Goya's move to Madrid, Ramón de la Cruz' playlets were all the rage on the Madrid stage and continued to enthrall the public for over twenty years. Far from being works of literature, these rudimentary sketches, on the basis of which actors and actresses improvised very freely, featured *majos* and *majas, petitmetres* and *manolas* in a setting of everyday life in the capital. These shows were full of fandangos, boleros, seguidillas and tiranas in the purest tradition of Madrid and Andalusian folk festivals. A few titles will give an idea of the kind of picturesque world these sketches depicted, so like that of Goya's cartoons:

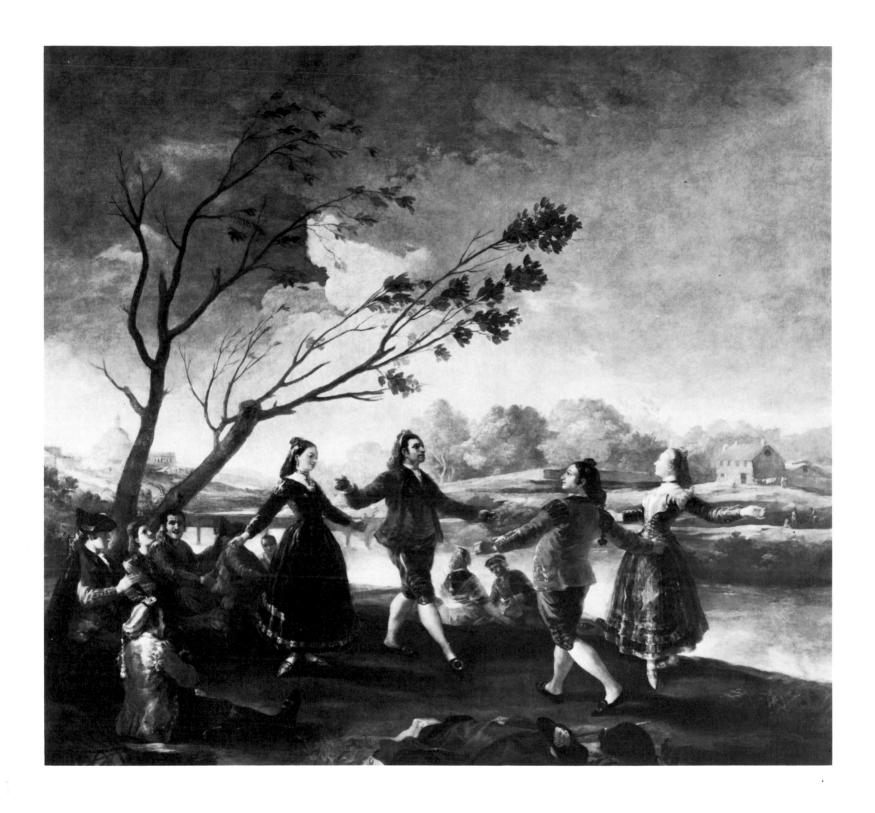

38. *El baile a orillas del rio Manzanares (Dance on the Banks of the Manzanares).* 1777. Tapestry cartoon. 272 by 295 cm. Madrid, Museo del Prado.

One of the ten cartoons created for fitting the dining room of the royal couple of Asturia in the palace of El Pardo. This representation of a topic that is Spanish in its essence is the counterpart to *La merienda.* Both have the characteristic landscape surrounding Madrid very close to the palace of El Pardo in common.

39. *La riña en la Mesón del Gallo (Fight at the Cock Inn).* 1777. Oil on canvas. 41.9 by 67.3 cm. Switzerland, private collection.

The highly detailed sketch served for the cartoon *La riña en la Venta Nueva* (The Fight at the New Inn) belonging to the cartoons for the decoration of the dining room of the royal couple of Asturia in the palace of El Pardo. The differences between the sketch and the cartoon are considerable; this is frequently the case with Goya who had the habit of changing his compositions during the course of working.

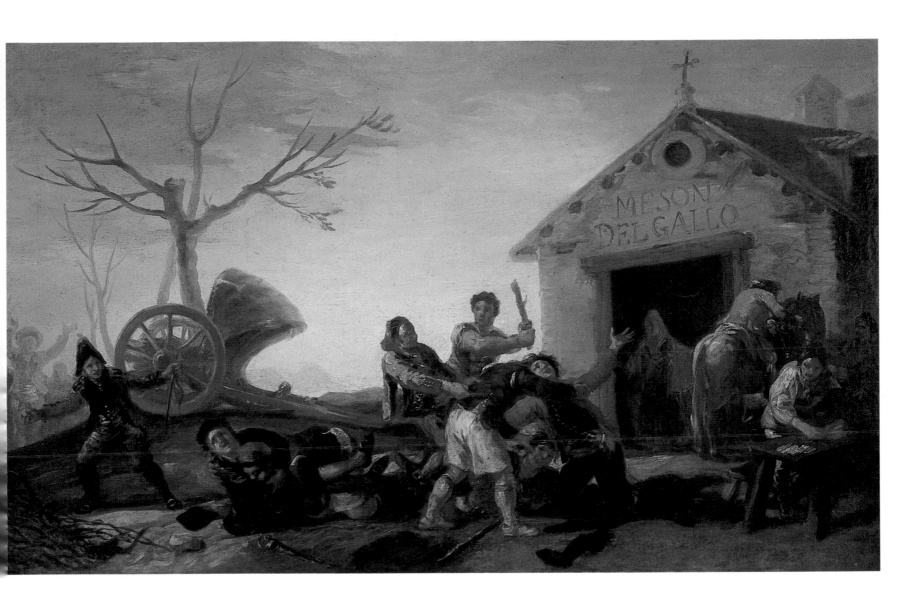

40. *El paseo de Andalucia (Promenade in Andalusia).* 1777.
Tapestry cartoon. 275 by 190 cm. Madrid, Museo del
Prado.

This cartoon as well was intended for the decoration of
the dining room of the royal couple of Asturia in the
palace of El Pardo. According to Goya's description in
his notebook, the representation depicts gypsies. Prob-
ably this is the only scene that takes place in Andalusia.

41. *La cometa (The Kite).* 1778. Tapestry cartoon. 269 by
285 cm. Madrid, Museo del Prado.

The cartoon is one of the ten intended for the decoration
of the dining room of the royal couple of Asturia. From
here on the *majos* and rural scenes form the preferred
topics of the future reigning couple; the style of the *ma-
jismo* prevailing at the time fits to their youth exceedingly
well.

El Rastro por la mañana (Rastro in the morning), *El Prado por la noche* (El Prado at night), *El Petitmetre* (The Fop), *El Manolo* (The Manolo), and especially *La Pradera de San Isidro* (The Meadow of San Isidro), shown in 1766. This kind of play whose literary quality was well below average appealed to a very wide public precisely because it corresponded to the deep-felt needs of plebeism and also expressed a national reaction to the invasion of French manners.

A similar development can be found in the same period in the domain of bullfighting. For centuries the prerogative of the nobility who fought and killed the animal on horseback, bullfighting underwent a radical evolution from about 1740. It gradually became the exclusive preserve of professionals, generally drawn from the lower classes of Andalusia who formed the first "cuadrillas" (company of toreros). Fighting on horseback gave way to fighting on foot, the nobility to the common people. At the same time matadors acquired a new fame and became popular idols. In 1775 when Goya was painting his first cartoon Pedro Romero fought for the first time in Madrid; in the following year his great rival Costillares made his first appearance in the arenas of the capital; two men, two opposing styles, who shared the favors of the "aficionados" (fans) and even the protection of the most illustrious families. A scholar of the time Tomas de Iriarte in a letter to a friend discussed, not without irony, the base passions thus aroused: "You may laugh at the factions of Gluckists, Puccinists and Lullists. Here we tear each other to pieces as Costillarists and Romerists. There is no other talk, from gilt interiors to the humblest huts, from the moment we first cross ourselves in the morning till the nightcap is donned in the evening. The rage of the spectators during the fight is such that they come to blows; we shall soon need genuine athletes on account of the bullfights." Goya himself joined in this craze with all his might; several of his letters to his friend Zapater show that he was a fervent spectator of bullfights. Whereas his correspondent admitted to being a Costillarist he himself opted for Pedro Romero in 1778. We shall see below how this *"afición,"* which went back to his youth at Saragossa, subsequently led to major works, like the portraits of Pedro and José Romero, the etchings of Tauromachy and the bullfights painted in Paris and Bordeaux at the end of his life.

There is no doubt that the tapestry cartoons, as Sambricio has already shown so convincingly, were to a large extent part of that current of populism. The Court did not escape from this all-pervasive fashion, and Maria Luisa, young and avid for pleasure and entertainment but fettered by etiquette, undoubtedly wanted at least to be able to look at their dazzling images woven for her since she lacked the means of tasting the forbidden fruit. The first nine cartoons, delivered in two installments in May and October 1775, were still only tentative trials; the first five were mentioned in the receipts of Don Cornelio Vandergoten, the director of the Tapestry Factory, as painted by Goya "under the direction of Francisco Bayeu, Court Painter to His Majesty." They were five hunting scenes: *The Boar Hunt, Dogs on the Leash, Hunt with Owl and Net, Hunter Loading His Gun,* and *The Hunter and His Dogs.* The series, intended for the dining room of the Prince and Princess of the Asturias in the Escorial Palace, was to be completed in the autumn by four scenes, three of hunting and one of angling. The receipt

42. *El cacharrero (The Crockery Vendor).* 1779. Tapestry cartoon. 259 by 220 cm. Madrid, Museo del Prado.

The series of nineteen cartoons to which this scene belongs was created only after Goya published his etchings based on Velázquez. As with the liveliness of the characters, the treatment of space and atmosphere show the influence of Velázquez, whose masterpieces Goya had been able to study in detail in the royal palace of Madrid.

of the Factory refers to them as "painted by his hand," without help from his brother-in-law, which suggests that within a few months Goya had acquired sufficient mastery of the genre to be able to stand on his own feet.

However, it is difficult to comment on these hunting scenes which are treated with great care but have nothing to distinguish them from the cartoons of the other painters of the factory. They are obviously rather banal, in the new *"majismo"* fashion. The Prince of the Asturias was content to decorate his dining room with tapestries of the favorite pastime of all Spanish kings. (Cf. the famous portraits Goya did later of Charles III and then Charles IV in hunting costume.) The choice of these subjects was all the more apt as the Court took up residence in the Escorial Palace from the beginning of October to the beginning of December for the hunting season. They simply expressed the taste of men and hunters with no concession to the new fashion or the taste of the Princess of the Asturias.

In the following year a dramatic change took place in the choice of subjects. The scenes were still intended to decorate the dining room but this time in the palace of El Pardo in the immediate vicinity of the capital. Goya was commissioned to produce a series of ten cartoons; the prince and princess had firmly opted for a *castizo* ensemble (of pure Spanish origin), comprising only folk subjects. It is generally thought that on this occasion Maria Luisa asserted

43. *El juego de pelota a pala (The Game of Bat and Ball).* 1779. Tapestry cartoon. 261 by 470 cm. Madrid, Museo del Prado.

This large representation was intended for the northern wall of the bedroom of the Prince of Asturia in the palace of El Pardo; it is one of the most beautiful scenes of popular amusement created by Goya. The realistic topic derives an imaginary trait from the two buildings towering up in the background. A similar juxtaposition of the real and the imaginary reappears in a later cartoon, *The Summer* (or The Harvesting).

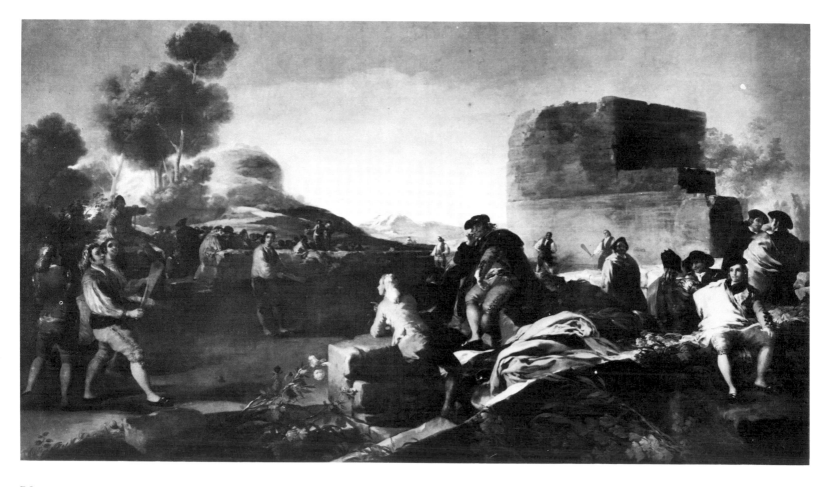

her personal taste after accepting the hunting scenes in the dining room of the Escorial. The titles of the cartoons, delivered in several instalments between October 30, 1776 and January 25, 1778, speak for themselves: *La merienda* (The Picnic), *El baile a orillas del río Manzanares* (Dance on the Banks of the Manzanares) (Figs. 37,38), *La rina en la Venta Nueva* (The Fight at the New Inn), *El Paseo de Andalucía* (Promenade in Andalusia) (Fig.40), *El bebedor* (The Drinker), *El quitasol* (The Parasol), *La cometa* (The Kite), *Los jugadores de naipes* (Card Players), *Niños inflando una vejiga* (Boys Blowing Up a Balloon), and *Muchachos cogiendo fruta* (Boys Picking Fruit). But even more evocative of the colorful world of the common people of Madrid is Goya's own description of the *Dance on the Banks of the Manzanares,* one of the loveliest cartoons of that series:

"Representa un bayle a orilla del Río Manzanares; dos Majos y dos Majas que baylan seguedillas, y otros dos que hazen Música uno de ellos canta con la guitarra, otro acompaña con una bandurria y otro en el mismo término que con las manos lleva el compás. Detrás de estos hay otra Maja y otros dos que se ven por entre medio que están en el mismo grupo: más cerca del río hay un militar con una Maja en conversación y otra que de el Bayle ha hido a vever al Río: hay varios despojos de Capas y Sombreros a primer término y a lo lexos se vé un poco de Madrid por San Francisco."

("It shows a dance on the banks of the Manzanares; two *majos* and two majas are dancing *seguedillas* and two others arc playing music, one of them singing to the guitar, the other accompanying him on the mandola while yet a third figure on the same plane is beating time with his hands to the music. In the background there is yet another *maja* and two other people who are half glimpsed and form part of the same group. Nearer the river is a soldier talking to a *maja* and another who has left the dance to have a drink at the river. In the foreground the capes and hats that have been discarded and in the distance there is a glimpse of Madrid from the San Francisco side.")

It is impossible to find a more perfect, a more *castizo* picture of this form of popular diversion in Spain in the actual setting in which it was held, below the city and the royal palace down on the very banks of the Manzanares. But if Goya's description is touchingly naive it is preceded by an entirely new piece of information, when he wrote in the same document telling us about this series of cartoons: *"Un quadro que yo Francisco Goya he executado de mi invención."* ("A picture which I, Francisco Goya did out of my own head.") This shows that he had now freed himself entirely from the tutelage of his brothers-in-law and worked completely on his own. This document is invaluable but even if it did not exist it is evident that these cartoons merit his signature (although in fact none of them bear it); the colors are lively, applied with freedom and harmoniously adapted within a consistently dense composition. Even more noteworthy is the limpidity of the air surrounding these figures which gives each of them a depth that enhances the wide luminous skies. There can be no doubt that the quality that suddenly appears in the cartoons of 1776-1778 can only be explained by the lesson learned from Velázquez; Goya must have seen the pictures hung in the rooms of the Royal Palace, as the letter from Mengs to Ponz was dated

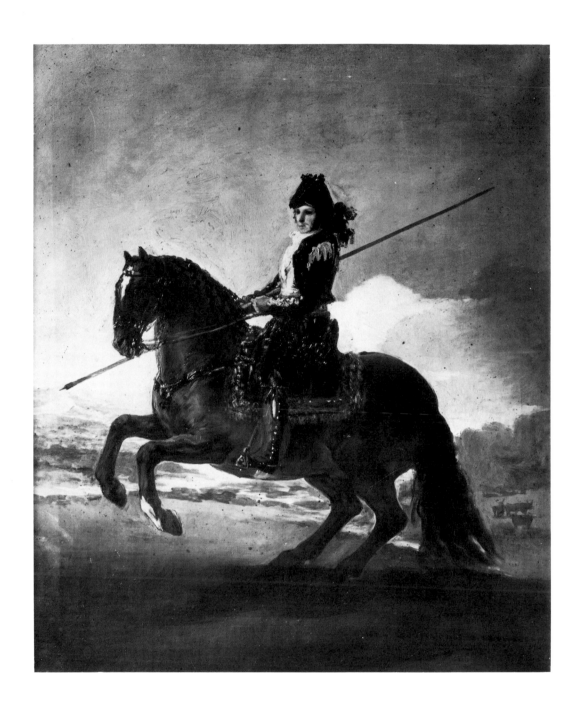

44. *El Picador (The Picador)*. Around 1786-1787. Oil on canvas. 56 by 47 cm. Madrid, Museo del Prado.
The painting is — an exception — already listed in the catalogue of the Prado in the year of Goya's death in 1828 under the name *Retrato de un torero al caballo* (Equestrian Portrait of a Torero). The figure of the rider, heavily influenced by Velázquez, in front of a sweeping landscape appears to be a study for the large painting *Los*

toros en la tablada (The Selection of the Bulls in the Tablada) painted for the Alameda de Osuna by Goya in 1786-1787.

45. *Death of the Picador*. 1794. Tin-plate. 43 by 32 cm. Private collection.
The small painting belongs to the series of "various

scenes of national entertainments" presented to the Academy by Goya in 1794. Eight scenes from the world of the bullfight that are a part of this series form — and this twenty years before the *Tauromaquia* — a complete sequence to this topic. Goya's remark in a letter to Bernardo de Iriarte that he had been able to leave a free rein to "inspiration and invention" refers to these small cabinet paintings.

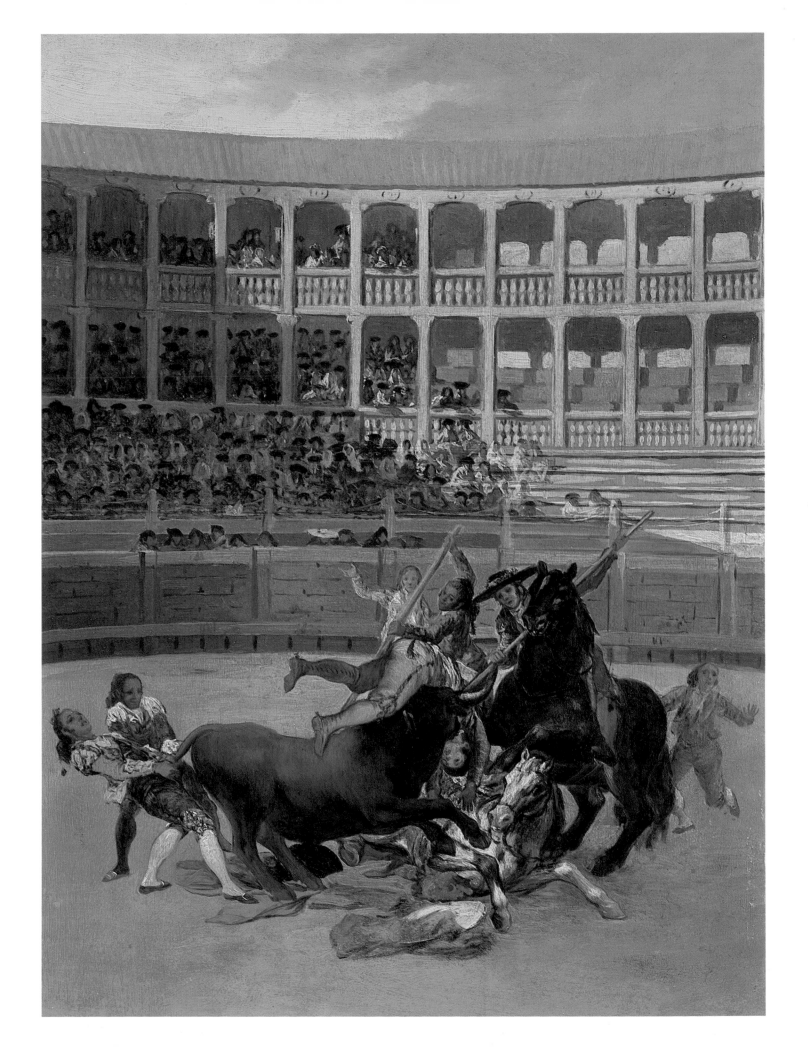

from the end of 1776 just before he left Madrid for Rome (January 27, 1777); the plan to make etchings after Velázquez must have taken shape around that period, following repeated visits to the Royal Palace. The impact on Goya's painting was immediate and must have had an incalculable effect on his career as a painter the most spectacular consequence being his partial breach with Francisco Bayeu at the beginning of 1781 during work on the fresco executed under his direction in the basilica of El Pilar in Saragossa. Velázquez had opened Goya's eyes; not only did his dependence on his brother-in-law become intolerable but he now realized that his own course ran counter to that of Bayeu, i.e., counter to the current of academic art which reigned supreme in Madrid. A solitary path along which he would still have to make concessions and endure bitter snubs before he finally managed to gain recognition for his art! But Velázquez was there, ever-present, like a fixed star in the firmament of painting by which he could measure his progress, no matter what the *estos vilos* (these horrid people) as he called them in one of his letters to Zapater, said or did to try and trip him up.

It is fortunate that these series of cartoons can be admired in the Prado today, whereas so many prestigious works by other Spanish painters — Zurbarán, Murillo and others — have been dismantled and dispersed haphazard in private or public collections. But it is also worthwhile to try and reconstitute the decoration of the dining room of the Prince and Princess of the Asturias in the Palace of El Pardo so that we can visualize the ten scenes created by Goya in the actual setting for which they had been conceived. This work of synthesis has been undertaken most skillfully by José Pita Andrade; the largest of the cartoons, *The Fight at the New Inn* (275 x 414 cm) occupied one of the long sides of the room flanked by the *Promenade in Andalusia* (Fig. 40) and *The Card Players.* On the wall opposite where the balconies were *The Kite* was to occupy the central part; on each side above the windows there probably were *The Drinker* and *The Parasol.* *The Picnic* (Fig. 37) and the *Dance on the Banks of the Manzanares* (Fig. 38) which formed a pair were opposite each other on the two side walls. The *Boys Blowing Up a Balloon* and *Boys Picking Fruit,* two companion pieces, served as overdoors to the entrance of the dining room. A fascinating reconstitution which gives a better idea of the extraordinary richness of the decoration in the extensions of the royal residences built by Charles III. A single shadow is cast on this bright picture — the gulf that separates the tapestries woven by the Royal Factory from the cartoons painted by Goya. The canvases in the Prado are exhilarating; the corresponding tapestries are disappointing for the powerful brilliance of the palette is lost in a drabness that almost does violence to the original. A clear indication of the irreversible decline of tapestry in the eighteenth century — in trying to imitate painting at all costs the formerly robust art of the loom masters took a wrong turn and, challenged by Goya's assertive brush, had to admit defeat.

A document of the period gives us a particularly interesting insight into the preparation of the cartoons. Under the administrative system of the palace the Court Painter had to give his comments on the bill presented by the artist. For

46. *Pedro Romero.* Around 1795-1798. Oil on canvas. 85 by 64 cm. Switzerland, private collection.

After his illness in 1793, Goya appears to have spent a lot of time in the circles of bullfighters. He had always been an *aficionado* but had not known the great toreros personally. The Romeros, creators of the modern form of the bullfight, became his friends; at least two portraits of Pedro, the most famous, have been transmitted to us. This one here, the best preserved one, is especially noteworthy due to the richness of the gradations of the color, mainly in the black and gray of the costume.

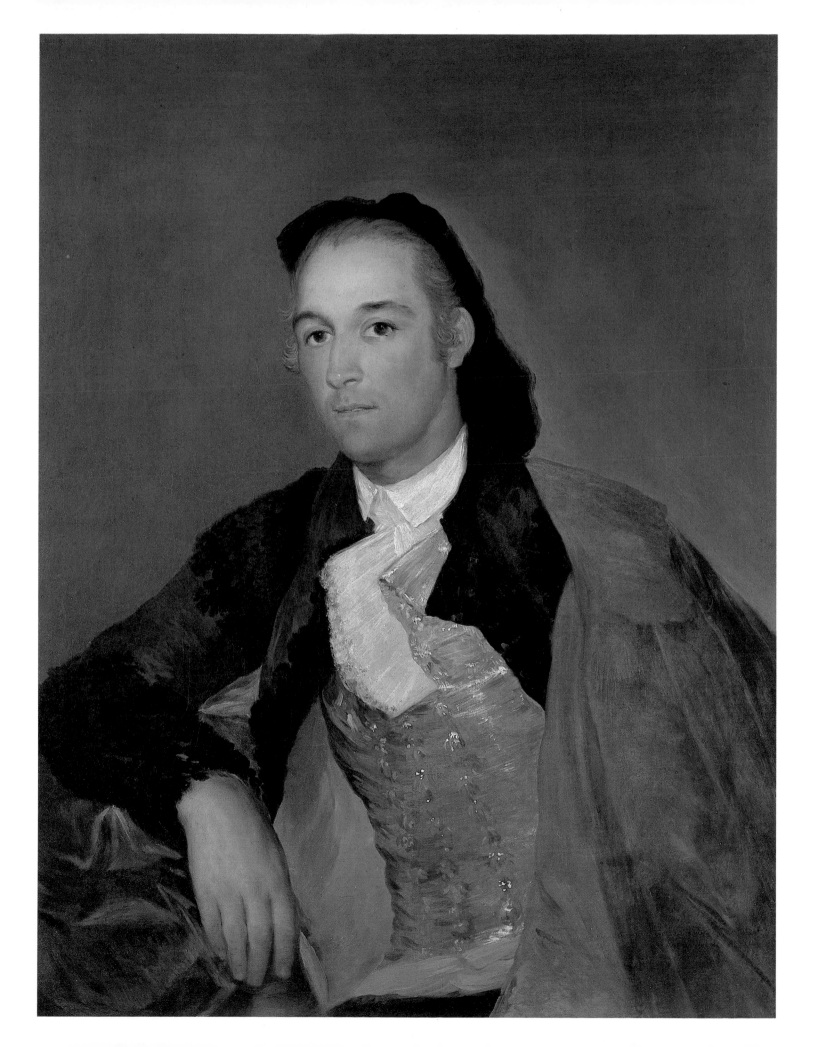

the *Fight at the New Inn,* the largest cartoon of the series, Goya had asked for 10,000 reals. In his report, Andres de la Calleja who was in charge of the paintings reduced this to 9,000 reals although he emphasized how much work there was in the execution of the four cartoons. "Considering their dimension, the nature of the work and the fact that it is all his own invention which is the reason why he had to spend far more time on sketches and studies from life than one might think and was probably also involved in some expense…" The allusion to "sketches and studies from life" is interesting for it confirms what is already suggested in the artist's letters, namely, that the execution of each cartoon was preceded by extensive preparatory work. From those *borroncillos* and *diseños por el natural,* Goya went on to set up his composition and executed a more elaborate *boceto* (sketch) in oil for the approval of the king or the prince and princess. Some of the preparatory drawings on tinted paper have been preserved (Prado and Valencia de Don Juan Institute, Madrid); so have some very fine sketches, like that of the *Fight at the Cock Inn* (Fig. 39), which was part of the Charles Yriarte collection last century and discovered more recently, that of the *Promenade in Andalusia.* A letter from Goya to his friend Zapater (December 1778), for whom he had kept some sketches, tells us that important people like Sabatini were already very much struck with them and collected them. This interest taken by contemporaries in even the preliminary studio work shows that the sketches were recognized even then as works of art — the first sign of the artist's fame which was to grow year by year until at the end of the century it was such that it led the Duke of Osuna to purchase a series of exceptional *bocetos*, including the famous *Meadow of San Isidro* now in the Prado.

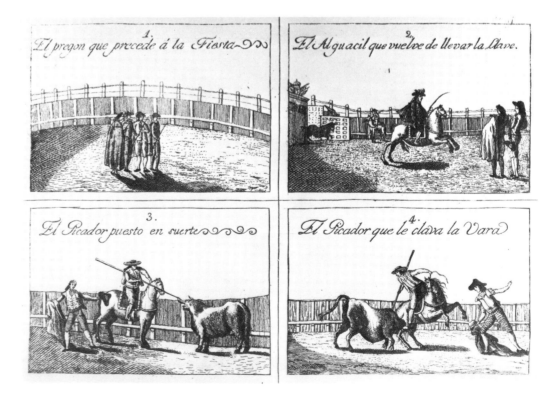

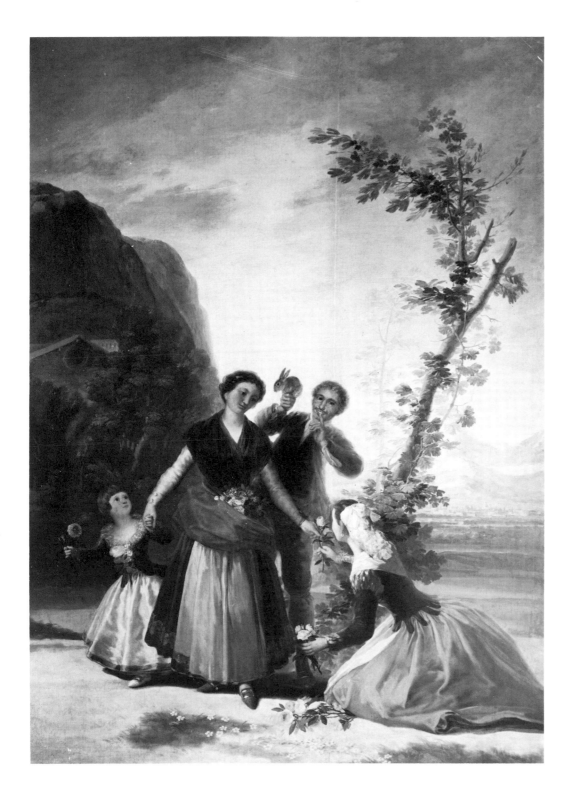

47. Antonio Carnicero: *Colección de las principales suertes de una corrida de toros (Collection of the most important Phases of a Bullfight)*. 1790. Etching. Madrid, Biblioteca Nacional.

Antonio Carnicero's career as a painter and an etcher was parallel to Goya's, but was less brilliant. The small sequence of etchings on bullfights was published in 1790 and was thus created three years prior to Goya's painting on tin-plate (see illustration 45) and twenty-five years prior to the *Tauromaquia*. Thanks to their simplicity, formalism and objective correctness, Carnicero's etchings were exraordinarily successful. Along with the treatise illustrated with thirty mediocre pictures by Pepe Illo in 1804 they were part of the source Goya used for his poetic depictions of the bullfight.

48. *Las Floreras (The Flower Girls)* or *The Spring*. 1786-1787. Tapestry cartoon. 277 by 192 cm. Madrid, Museo del Prado.

After an interruption from 1780 to 1786 Goya, who had been appointed Court Painter in the meantime, started working for the Tapestry Factory of Santa Barbara again. The group of the *Four Seasons* is part of the cartoons intended for the dining room in the palace of El Pardo.

49. *El columpio. (The Swing).* 1786-1787. Oil on canvas. 169 by 100 cm. Madrid, Montellano collection.

In 1785 Goya had received his first commissions from the Duke of Osuna and his wife, who were to be his biggest customers and, above all, the first real collectors of his works until the end of the century. *The Swing* is one of seven paintings of rural scenes Goya executed for the country house El Capricho — it was named after Alameda de Osuna — of the ducal couple.

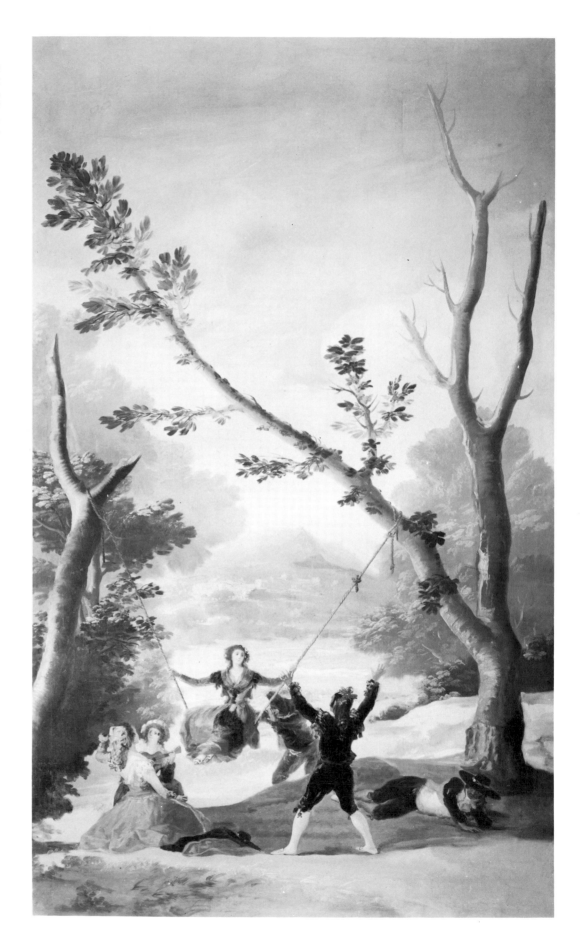

50. *The Swing.* 1796-1797. Drawing from the Madrid Album (B. 21); Chinese ink, wash. 23.7 by 14.6 cm. New York, The Metropolitan Museum of Art.

Here Goya draws upon a topic that was very prevalent in European paintings of the 18th century and that he himself had already depicted in 1786-1787 in one of his paintings for the Alameda de Osuna (see illustration 49). It reflects the light-heartedness of the years prior to 1780, a very happy time for the painter. During his last years in Bordeaux, Goya once again treated the topic in a drawing and in two etchings, however in a gloomy, fantastic transmutation.

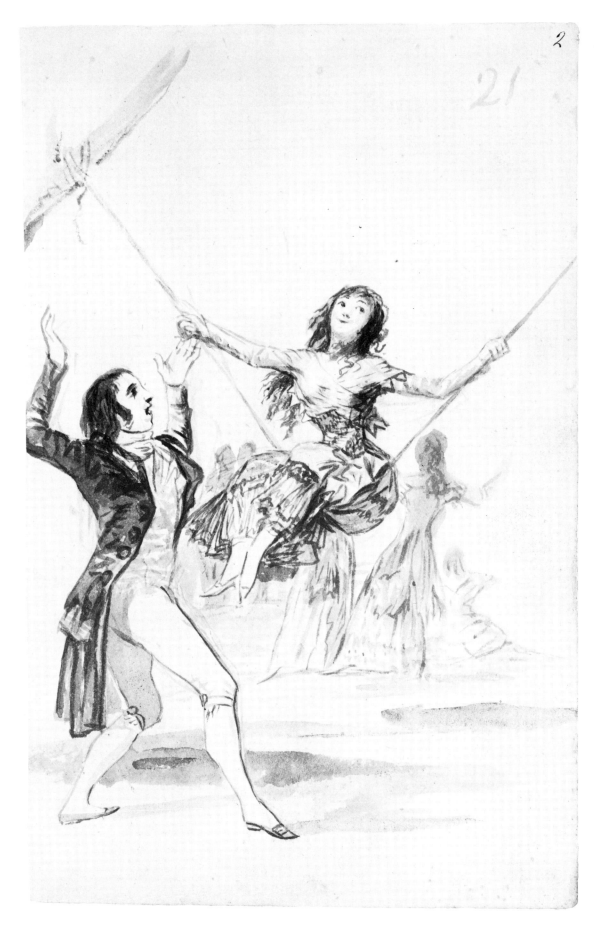

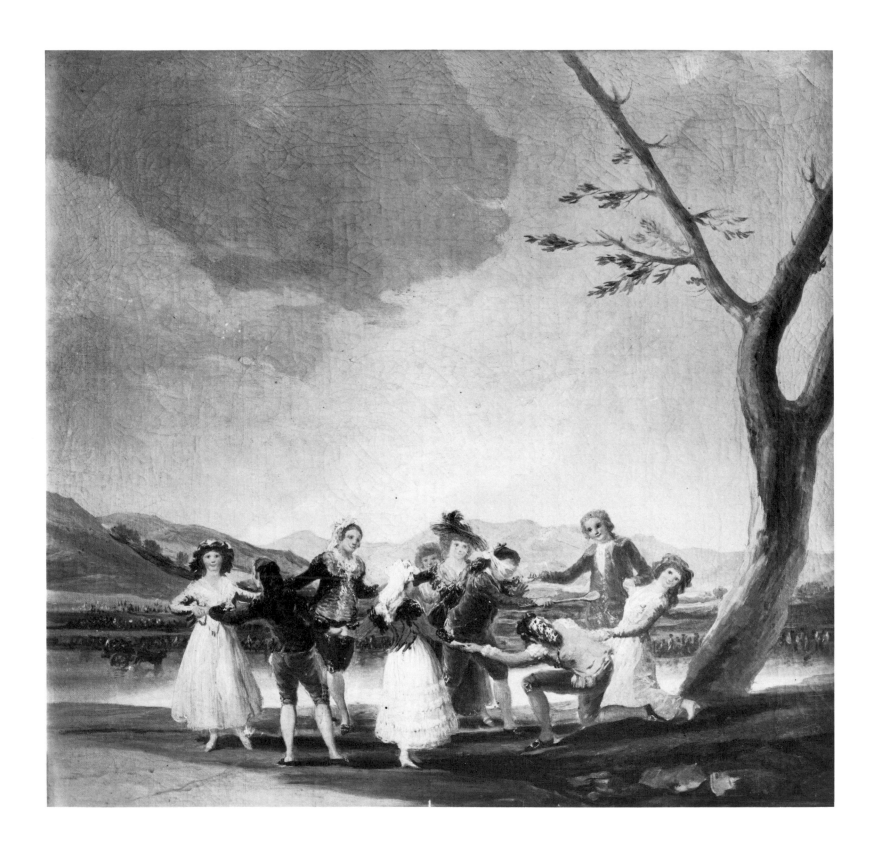

51. *La gallina ciega (Blind Man's Bluff).* 1788. Oil on canvas. 41 by 44 cm. Madrid, Museo del Prado.

La gallina ciega is the only completed cartoon of the series, the execution of which was interrupted by the death of Charles III. The measurements of the sketch shown here are nearly identical with those of *La ermita de San Isidro* (illustration 53); thus we can suppose that the two scenes were to oppose each other on the western and eastern walls of the bedroom of the Infante in the palace of El Pardo.

These ten cartoons, painted for the dining room in the Pardo, were so much to the liking of Charles and Maria Luisa that the painter was commissioned to do twenty more to complete the decoration of their apartments in the Pardo palace; seven for their bedroom (1778-1779) and thirteen for the ante-chamber (1779-1780). All the subjects were drawn from *diversiones y trajes del tiempo presente* (present-day entertainments and costumes), according to the definition by Antonio Ponz in Volume V of his Spanish Journey, published in 1776. At the Court, the new fashion had become a craze and even, in the words of Ortega y Gasset, "a real passion." Other painters working for the Factory of Santa Barbara, like Ramón Bayeu del Castillo or Maella, also did cartoons on popular subjects. Those by Goya's brother-in-law particularly showed very similar scenes: hunters, anglers, dances, picnics, and country promenades.

But Goya had very quickly acquired such mastery of this decorative genre that he alone seemed capable of endowing these unremarkable everyday characters of Madrid with dignity and liveliness — this special something that made his rivals' figures seem dull and stiff in their attitudes by comparison. He felt that he was becoming indispensable at Court; the king and the prince and princess singled him out and were already openly expressing their appreciation. On January 5, 1779, he delivered to the Factory six of the seven cartoons for the princely bedroom. The last one, which was much bigger, *(El juego de pelota a pala* — The Game of Bat and Ball) (Fig. 43) was not finished until July of that year. New scenes drawn from the easy-going life of the common people of Madrid revealed the painter's inexhaustible powers of invention. *La feria de Madrid* (The Fair of Madrid) and especially *El cacharrero* (The Crockery

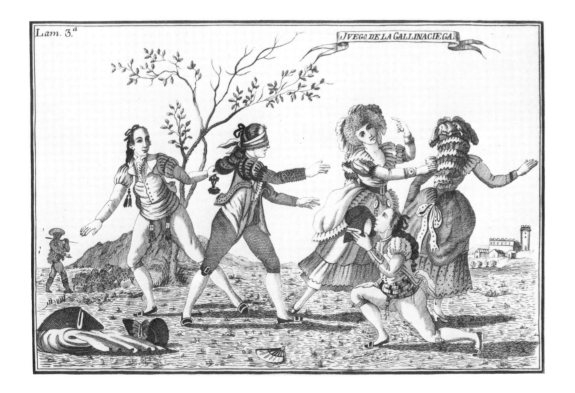

52. *Juego de la gallina ciega (Blind Man's Bluff)*. 18th century. Popular print. Madrid, Biblioteca Nacional.

A comparison between this print and Goya's tapestry cartoon of 1788-1789 is interesting; the somewhat dry and unorganized print is in contrast to Goya's harmonic composition in a sweeping landscape. As is proven by the print, he succeeds in imbuing some life and charm into this surely popular and widespread game.

Vendor) (Fig. 42) made it seem as if the very life of these men and women drawn from all manner of people and conditions, had been transposed onto canvas by Goya's magic brush. No one had ever painted with such freedom and naturalness at Court, not since Velázquez; and, significantly, Goya had just published eleven etchings after Velázquez. The royal family, Maria Luisa undoubtedly in the lead, were curious at last to get to know the artist who produced such delightful works. At the beginning of 1779 he had the single honor of being invited in person to show four paintings to Charles III and his family before delivery to the factory. The letter to Zapater in which he tells him the great news is dated January 9; thus we may fairly safely assume that these were the four largest cartoons of the series he had just finished for the bedchamber of the Prince and Princess of the Asturias: *The Fair of Madrid, The Crockery Vendor* (Fig. 42), *The Officer and the Lady* and *Girl Selling Azaroles*. All his friends in Saragossa had to be told of this first meeting between the painter and his sovereign and everyone in his home town had to know that the son of the humble master gilder had had the honor of kissing the hand of His Most Catholic Majesty: "If I were not in such a hurry I would tell you the honor that the King, the Prince and Princess bestowed on me in allowing me — praise be to God — to show them four pictures and to kiss their hands. I have never been so happy, and I assure you there is nothing I could have wanted more than the way they appreciated my work if I am to judge by the pleasure they took in seeing it and the praise I received from the King and even more from their Highnesses; and then from all the grandees, praise be to God, me, who hasn't deserved any of this, and neither has my work. But, dear friend, we have the joys of the countryside and the good life, no one can take that away from me and even less now that I am beginning to have more powerful and embittered enemies. Adieu, ever your Goya."

Everything in that letter, bubbling over with legitimate pride, reveals the contentment of the young provincial who, after "going up" to Madrid suddenly sees himself singled out from among so many others, as if somehow marked by a divine sign that permitted every hope. On July 24, 1779, determined not to let any grass grow under his feet, Goya sent a letter to the King with no recommendation except that of his own merit and of Mengs, who had just died in Rome, petitioning to be named Court Painter. This document provides one of the best sources for his past life: "Don Francisco Goya, painter...sets down the following with the deepest respect: having exercised his art in Saragossa, his home, and in Rome, where he went and lived at his own expense, he was called by Don Antonio Rafael Mengs to enter Your Majesty's service, and having given satisfaction to all the Masters and even to Your Majesty in the last six pictures that have been shown, begs Your Majesty to deign to favor him with the position of Court Painter to Your Majesty, with such emoluments as have the royal approval."

This petition was not granted, but the documents which have been preserved in the archives of the Palace in Madrid show us how the royal administration felt about Goya. The report of the Registrar General of the Royal Household

53. *La ermita de San Isidro (The Hermitage of San Isidro).* 1788. Oil on canvas. 42 by 44 cm. Madrid, Museo del Prado.

This sketch to a tapestry cartoon that was never completed was presented to the king and the princes during the summer of 1788. After the death of Charles III, on December 14, 1788, the work on decorating the bedroom of the Infante in the palace of El Pardo was not continued. Only the cartoon for *La gallina ciega* (illustration 51) was completed. The Duke of Osuna later purchased the sketches from Goya.

on whom the final decision depended recalled the view expressed by Mengs in 1776 on the occasion of Goya's first application, and added that the person in question "has continued to work on the cartoons for the tapestries (for which work he has been paid) and that his works have given consistent proof of his progress, his success, and his good taste..." Thus it was admitted that Goya had certain qualities as a painter, but for the moment he could only be encouraged to persevere and succeed in the path on which he was launched, especially as the seven painters regularly appointed by the king more than sufficed for the needs of the palace. So Goya had to content himself with painting cartoons for the Factory of Santa Barbara. When he received the reply to his petition in autumn 1779 he was busy painting the last series of eleven subjects for the antechamber of the Prince and Princess of the Asturias, still at the palace of El Pardo. These have the same verve and originality as the previous cartoons. *The Washerwomen,* with its graceful figures again on the banks of the Manzanares, formed a companion piece to *The Swing* (Fig. 49), which had already been delivered in July 1779; the pair of paintings consisting of *The Tobacco Guard* and *La Novilla* (The Bullfight) not only has the most *castizas* scenes created by Goya but *La Novilla* probably contains a strikingly vigorous and youthful self-portrait. As the painter admitted in his old age, with a sword in hand, face to face with a bull, he feared no one; here he showed himself in the company of some *majos* fighting a *novillo* (young bull) in a landscape crowded with strange buildings, his head turned sharply towards the spectator as if to draw attention to himself, the author. This was also his first encounter as a painter with bullfighting; there would be many more and much of his fame is due to them.

By submitting his petition to the king, Goya hoped to be able to free himself from that work of decoration which had occupied him for five years and which was beginning to bore him. Thirty-nine cartoons executed exclusively for the apartments of the Prince and Princess of the Asturias: that, he felt, was enough. By now he had shown that he was capable of painting as well, if not better than, his rivals. He wanted to use his talents for works of greater scope, to raise himself to the top rank of the court painters. A lucky chance released him for a time, six years precisely, from the tapestry cartoons. The royal edict, you may recall, suspending these works was signed at the Pardo on March 15, 1780. Thus Goya was able to devote himself to loftier tasks more apt to bring him the recognition needed to further his career. His future looked bright, after the first successes of his cartoons, but above all thanks to the able support of his brother-in-law Francisco Bayeu, who was considered at Court as the heir-apparent of the great Mengs who had not yet been replaced.

Unable to obtain the position of court painter, Goya turned to the Academy of San Fernando. On July 7, 1780 he was elected unanimously. This honor, great as it was, was small compensation for the advantages he would have derived from the post of Court Painter, and far too much was demanded for the modest salary. However, by entering the Academy he would rub shoulders with distinguished intellectuals for the first time in his life and deal on equal terms with the best painters at the Court as well as with architects like Ventura

Rodríguez who worked for the Infante Don Luis de Borbón. Gaspar Melchor Jovellanos, a brilliant man of letters, was also elected to the Academy in 1780. Finally, according to its statutes, the Academy came under the protection of the Secretary of State. The Count of Floridablanca had held that office for the three preceding years and would continue to be the all-powerful master of Spanish politics until 1792. It can thus be said that Goya's election inaugurated a new phase in his social life; we shall call this "the time of the protectors." His long and patient search for the ideal patron was not without its disillusions and disappointments. Its course will be traced in the next chapter.

The interlude of six long years spent on cartoons for tapestries was dominated by an important factor to which we shall return: the ill feeling between Goya and his brother-in-law Francisco Bayeu. This placed him in a doubly disagreeable situation, first of all from the family standpoint; fortunately the young couple had not been living with the Bayeus since 1777 but were at No. 66 Carrera de San Jeronimo where they lived alone, their first children having died in infancy. The effects on his career were more serious; Francisco Bayeu, who was both irritable and jealous of his prerogatives, was anxious to push his younger brother Ramón in the hotly disputed competition for jobs at Court. When friction developed between the two brothers-in-law — the trouble started on the scaffolding at El Pilar in 1781 — Bayeu put all the weight of his influence behind his brother, who was the same age as Goya.

In 1783, the Santa Barbara Factory which had been operating on a reduced basis for three years was about to close down. Eighty families of workers faced ruin. On learning how serious the situation was, the king ordered the resumption of work on the tapestries for the Palace of El Pardo where fifteen rooms were without tapestries or hung with worn old ones. Thus there was still a considerable amount of work to be done. The king put Francisco Bayeu and Mariano Salvador Maella in charge of the paintings which meant that they were responsible for distributing the work between themselves and painters placed under their orders. Goya received no commission — did Bayeu involuntarily "forget" him or was he offered commissions which he then refused? We do not know. One thing is certain, however. In 1783 with the slights of Saragossa still rankling, Goya had no desire to work under his brother-in-law. In any case he had important commissions for portraits, as well as great expectations from the all-powerful Count of Floridablanca and also, during the summer, from the Infante Don Luis de Borbón, the King's brother.

The altar paintings at San Francisco el Grande would be unveiled in 1784. Meanwhile, Goya worked on his own, pending the outcome of the veritable battle for position among the principal painters of the Court. It seems, however, that Goya became reconciled with Bayeu early in 1785 since on March 18 of that year he was appointed Deputy Director of Painting at the Academy and on July 7, 1786 was at last able to give Zapater the following good news: "My dear Martin, I am now Painter to the King with fifteen thousand reals. Although I have hardly a moment I must tell you how the King ordered Bayeu and Maella to find two of the best painters available to paint cartoons for tapestries and

54. *La pradera de San Isidro (The Meadow of San Isidro).* 1788. Oil on canvas. 44 by 94 cm. Madrid, Museo del Prado.

As is the case with *The Hermitage of San Isidro,* the cartoon for which this sketch was to serve was not completed due to court mourning. The radiant light not only reflects the clarity characteristic for Madrid in May, but also underlines the cheerfulness of the carefree crowd celebrating the feast of their patron saint in front of the gate of the city.

all that might be needed at the Palace in the way of frescos and oils. Bayeu proposed his brother and Maella did the same for me. Their proposal was submitted to the King, who granted it, and I didn't know a thing about it. When I got the news I didn't know what was happening to me. I expressed my thanks to the King, to the Prince, and to all the authorities — to Bayeu too who says that it was because of him that Maella had proposed me, and finally to Maella because I was proposed by him. Goodbye — I'll write to you. Yours again and again."

This eagerly awaited appointment brought with it a radical change in Goya's material situation; for the first time he received regular wages as a proper official of the Palace whereas all the work he had done for the Tapestry Factory since 1775 had been paid for item by item. He thus had not only an assurance of security but a chance of rising to the highest levels of officialdom. Goya had just turned forty and fortune seemed to smile on him all round. First of all he had an enviable financial situation. Shortly before his appointment he had calculated his income in a letter to Zapater (March 11, 1780) and pronounced himself already content with the twelve or thirteen thousand reals brought in by his work, his shares at the Bank of San Carlos and his duties at the Academy. As Painter to the King he would have an income of between twenty-seven and twenty-eight thousand reals, whatever happened — a princely sum! As one who had always lived without any thought for tomorrow, he felt that his fortune was made.

As a person Goya had never been a model of refinement, and there was more than a hint of the parvenu in the way he tried to impress his acquaintances

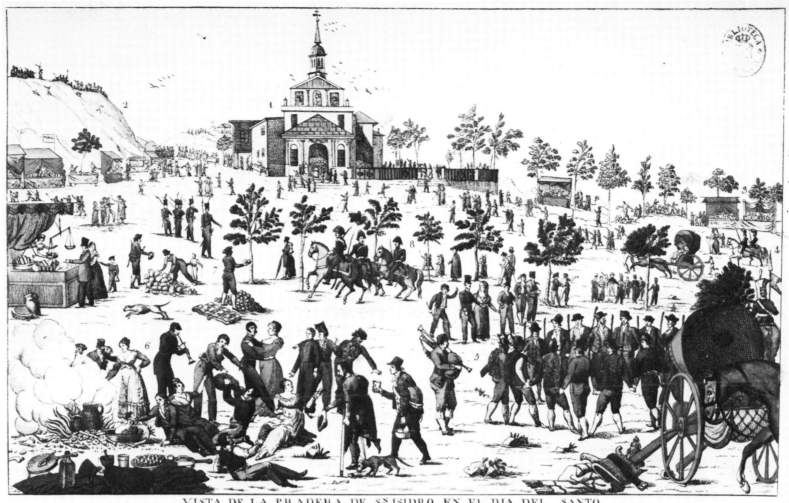

VISTA DE LA PRADERA DE Sᴺ ISIDRO EN EL DIA DEL SANTO.

1. *Hermita del Santo.* 3. *Puestos de dulces y frasquetes* 5. *Dansa prima deGallegos y Asturianos* 7. *Puestos de Cantarillas y Naranjas*
2. *Montaña inmediata.* 4. *Camino de Madrid.* 6. *Comida de Campo.* 8. *Patrullas*

with a rather childish display of luxury. Ortega y Gasset considered that up to the age of forty (and even perhaps beyond it) he was not so much an artist as a kind of handyman of painting. Painting for him, as for many others including his brothers-in-law, was primarily a career in which one had to work hard and fight hard to succeed. Goya the man had remained rather uncouth and uneducated. One need only read his letters to Gasset with their total lack of affectation. In them he shows himself quite frankly, exactly as he is. Ortega y Gasset concluded that "Goya's letters are the letters of a cabinet-maker." In other words the painter of delightful cartoons for tapestries was more like a manual worker than an intellectual in his tastes. What were these tastes? First of all, he was fond of hunting and consequently of dogs. At every available opportunity, he would go out to shoot partridge or quail in the country between Madrid and Toledo. The charms of painting were as nothing beside those of a good gun and a *perdiguero* (a dog for partridge-hunting). His other pleasures

55. *Vista de la pradera de San Isidro en el dia del santo (View of the Meadow of San Isidro on the Day of the Saint).* 18th century. Popular print. Madrid, Museo Municipal

The festival of the patron saint of Madrid, San Isidro, is certainly the most important and popular of the capital. On this day one and all wandered — as they still do today — to the other bank of the Manzanares to have a picnic, to dance, to sing and to have fun late into the night. Goya immortalized this festival in two extraordinarily beautiful sketches (see illustrations 53 and 54), while this print merely recounts the happenings.

were those of the ordinary Spaniard who lived *a la buena de Dios* (i.e., nonchalantly) without a thought for tomorrow. Besides such simple pleasures as chocolate, chorizos, and flamenco-singing (which he adored), the bullfight held a special place in his affections. He had known the most glorious period of that "national festival," which outsiders may prudishly call a "sport," but which is actually the most dramatic of all confrontations between human intelligence and the brute strength of the beast.

It was in the second half of the eighteenth century that bullfighting became a popular art and the prowess of Romero, Costillares, Pepe Hillo, Mariano Ceballos, Martincho, and so many others was displayed in the arenas of Madrid, Saragossa and Seville. In 1815 Goya would immortalize the delicate silhouettes of these kings of the *ruedo* (bullring) in a series of etchings that are undoubtedly his most masterly graphic works. Here it should be noted that when he embarked on the preliminary drawings for this large-scale series, he could no longer witness actual bullfights since they had been banned since 1805. His *Tauromaquia* ("Art of Bullfighting") is thus a series of reminiscences of Spain's "national festival," an album of dazzling souvenirs of his youth. Many of the feats described in it date back to the years he spent in Saragossa long before. For example, why such stress on Martincho who alone takes up four plates (Nos. 15, 16, 18 and 19) of the series? The answer is: mainly because he was from Aragon. Here again we have an example of the clannishness of the Aragonese which played a capital role in every branch of Spanish life in the eighteenth century. Politics, the economy, diplomacy, industry, the arts — wherever one turned, the Aragonese were there, playing an active part and above all sticking together. Even in the sphere of bullfighting, Goya could not resist giving first place to this torero, who was not, however, among the greatest of his time. Martincho had, moreover, appeared in Saragossa in 1764 at the spectacular festivities that celebrated the opening of the new bullring. He had also worked in Madrid and Pamplona in Goya's youth. Were the etchings based on memories going back more than half a century? It is very possible that they were. This appears to apply also to Apiñani who took part in numerous bullfights in Saragossa between 1764 and 1770.

Another extraordinary example is that of Mariano Ceballos, an Argentine Indian, who was the subject of two etchings notable for their wealth of chiaroscuro effects. His daring in the arena had so impressed Goya that he made him the hero of one of the large-scale lithographs he did in Bordeaux at the end of his life. Now, it is known that this idol of the Spanish public was killed by a bull in 1784; so here too the painter is harking back to his youth. The picador Fernando del Toro was dead by 1802. Finally, of the two great masters portrayed by Goya, one Pedro Romero retired from the *ruedos* in 1799 while the other, Pepe Hillo, suffered a gory death in the arena at Madrid on May 11, 1801.

For Goya, therefore, the great period of bullfighting was not the time at which he made his etchings but the last third of the eighteenth century. We have already seen that this was the most glorious period of Spain's "national festival." Goya

had experienced it to the full and, later on, cut off from the world of the bullfight by circumstances and age, he recorded his treasured memories of the great moments he had spent in the arenas of Saragossa and Madrid.

The presence and the role of the *corrida* in his paintings have a more complex motivation. Setting aside the cartoon *La Novillada* which is no more than a decorative work, the pretext for a self-portrait placing the artist among the *aficionados* of the bullfight. At that time — and his letters prove it — he was no more than one spectator among thousands, occasionally joining the ranks

56. *Los Zancos (The Stilts).* 1791-1792. Tapestry cartoon. 268 by 320 cm. Madrid, Museo del Prado.

This representation of one of the popular entertainments is one of the last cartoons that Goya delivered to the factory of Santa Barbara in 1791-1792. The series, intended for the study of the king in the palace of El Escorial, remained unfinished due to Goya's illness at the end of 1792. In all probability this scene was to be placed between the two balconies opposite *La boda* (The Wedding) that was created at the same time.

57. *Los zancos (The Stilts)*, detail (see illustration 56).

of those young amateurs who amuse themselves in the country by teasing a small bull with a cape. Such youths are still to be seen today solemnly practicing on the outskirts of Madrid, the beast in the arena being represented by bull's horns attached to a bicycle-wheel manipulated by a friend.

But it was much later, probably after 1790, that Goya made the acquaintance of the great *espadas* ("swords") of his time. The portraits of Jose and Pedro Romero (Fig. 46) date from the years 1795-1798 and not before. Did he approach them through the Duchess of Osuna? It is known that she was the protectress of Pedro Romero, while her rival the Duchess of Alba supported Costillares whom Goya never depicted even in the *Tauromachia,* which is rather surprising in view of the importance of this torero. Be that as it may, it was not until 1793 that Goya's genuine interest in the *corrida* became apparent in his work. After the very serious illness that almost struck him down in Cadiz at the home of his friend Sebastián Martínez, he painted a series of pictures on tin, eight of which dealt with bullfighting. These constitute a small but systematically organized treatise on the *corrida.* All the main stages of a bullfight are illustrated: the *banderilleros,* the use of the cape, the picadors, the death, and finally the *arrastre* (removal of the dead bull by mules). The successive *suertes* (stages) are presented even more methodically and logically than in the 1815 series of engravings, which are characterized by a certain disorder attributable perhaps to the vagaries of memory.

The appointment of Goya, together with Ramón Bayeu, as Painter to the King meant first of all that he would have to start working on tapestry cartoons again. A number of rooms at the Palace of El Pardo still needed redecorating. For the large royal dining-hall he executed ten cartoons, including the rustic scenes representing the four seasons which are among his most successful works. *Summer* (or *Harvesting*) alone is a veritable fresco nearly six and a half meters wide (the largest picture he ever painted) which was to occupy the wall with the southern exposure facing the balconies. *Winter,* on the other hand, occupied the opposite wall (appropriately facing north) and was accompanied by two works, *Poor People at a Fountain* and *The Injured Mason,* that have been qualified as "social" although the social aspect of the latter seems to have been rather superficial to start with since the original sketch (now in the Prado) was supposed to depict a *Drunken Mason!* The lateral walls to the east and west were assigned the intervening seasons *Spring* (or *The Flower Girls*) and *Autumn* (or *The Grape Harvest*).

In addition to these works for the Palace, Goya, whose success was spreading from the Court to the town, was asked to provide similar decorative works for the Alameda de Osuna, the country house (now destroyed) of the Duchess of Osuna. Here the cartoons themselves were used in place of tapestries and most fortunately so for the group of four panels (out of a total of seven "rustic paintings") preserved until recently at the residence of the Duke of Montellano in Madrid have given some idea of what the royal apartments would have looked like if, instead of tapestries, they had had Goya's actual cartoons on their walls.

These scenes painted between 1786 and 1788 are almost entirely redolent of the joy of living, an expression of sheer happiness — 1789 was yet to come! However, there are a few hints of drama, even of tension, in this easygoing, cloudless universe; at El Pardo, for example, there are peasants battling their way through a snowstorm, *The Injured Mason,* and the *Poor People at a Fountain.* At the Duchess of Osuna's, there is the same contrast between *The Fall* and *Attack on a Stagecoach,* on the one hand, and *The Swing* (Fig. 49) and *The Greasy Pole,* on the other. The rural pleasures of the latter are set against the dangers of a countryside that was often far from secure.

The eight tapestry cartoons executed by Goya for the bedchamber of the Infantas (Doña Carlota Joaquin and Doña Maria Luisa Josefina, daughters of the Prince and Princess of the Asturias) were never completed, and only *La gallina ciega* ("Blind Man's Bluff") was delivered. Of the others there remain only three sketches, but these are among Goya's masterpieces: *La pradera de San Isidro* ("The Meadow of San Isidro"), *La ermita de San Isidro* ("The Hermitage of San Isidro"), and *La merienda* ("The Picnic"). The Duke of Osuna was well aware of this when he bought them from Goya in 1799 to decorate the boudoir of his Duchess. This series, which had started so auspiciously in Goya's happiest vein, was discontinued as a result of the death of Charles III in December 1788. As a token of mourning it was decided to give up El Pardo as a family residence and no further decorative work was undertaken there during Goya's lifetime.

The last series of cartoons commissioned from the artist by the Santa Barbara Factory dates from 1791-92 — seven scenes for the study of Charles IV at the Escorial Palace. Goya's final work for the decoration of the royal apartments was not without its problems for the painter and his brother-in-law Ramón Bayeu. Both had been appointed Painters to the King at the same time, i.e., in 1786, and Goya, thanks to the favor of the new sovereign and Maria Luisa, was created Court Painter in 1789. This was a well merited reward for all his work for the Court, in particular the large portraits he painted on the occasion of the coronation of Charles IV and his Queen. Goya, who was nothing if not

temperamental, considered the important responsibilities with which he had been honored to be incompatible with such menial work as the production of cartoons for tapestries. Although pressure was put on him he went as far as to refuse to carry out the commission for the Escorial. He was even threatened with the stoppage of his salary, but with the proverbial pigheadedness of the Aragonese he persisted in his refusal. It finally took a highly diplomatic intervention by his brother-in-law, Francisco Bayeu, to make him go back on his decision and bow to the orders of the Palace. It was thus with great reluctance that he set to work on this concluding series even though it was intended for the study of his greatest patron, the King himself. It does not, however, betray any sign of the agitation that marked his first days as Court Painter. These final cartoons, the culmination of his fantastic output in the service of the Santa Barbara Factory, are executed with incomparable mastery and show no weakness, no slackening off due to resentment. *The Wedding, The Manikin,* and *The Stilts* (Fig. 56) complete this superb fresco of sixty-three cartoons with the same vigorous draftsmanship and color as before, in addition to which there is perhaps, in the larger compositions, a monumental quality that foreshadows the work of the painter's maturity. From the records of Goya's suppliers it appears that thirteen stretchers for the final series had been bought and paid for; that the work was finally suspended was due this time not to some external cause, but to Goya himself. At the end of 1792 he left Madrid for Andalusia without requesting leave. In the case of such a high-ranking official, this was contrary to every rule of the royal administrative system. Was his intention to pay a rapid, discreet visit to some friends in Seville, such as Céan Bermúdez? It is hard to say with certainty. However, the well-known facts are there: Goya fell seriously ill in Seville and had to be removed to Cadiz to be looked after more comfortably in the home of another friend, Sebastián Martínez. These dramatic events marked the end of Goya's work for the Court. A long chapter in his history had concluded. With his illness and its crushing sequelae, with age too (he was now forty-six), and with the new world born of the French Revolution, he would become a different person.

III

The Time of Protectors and of Court Life

III The Time of Protectors and of Court Life

The frescoes of El Pilar in 1781 — dispute with Francisco Bayeu — commission for a painting for the Church of San Francisco el Grande — portrait of the Count of Floridablanca — Infante Don Luis de Borbón, Goya's protector — paintings for the Arenas de San Pedro in 1783 and 1784 — death of the Infante — new protectors: Osuna, Altamira, the Albas — Goya and Godoy.

When he became a member of the Academy at the age of thirty-four Goya was still little more than an uncouth provincial and his only supporter at the Court was his brother-in-law Francisco Bayeu. On his arrival in Madrid it was Bayeu who guided his steps into the new field of cartoons for tapestries. Bayeu dreamed of becoming the undisputed head of a Spanish school of painting of which the most gifted and at the same time most submissive members would be his younger brother Ramón and his brother-in-law Goya.

The most striking example of Bayeu's family feeling, amounting almost to clannishness, is offered by the decorative work carried out at El Pilar. The Building Committee of the Basilica had made him their official painter in 1771 when they decided to entrust him with the decoration of all the main cupolas. He did the first large section of the work by himself in 1775-1776; there was a second section still to be done but this was always held up by Bayeu's duties at Court.

Finally, on May 5, 1780, the King granted his leave to go to Saragossa; the Chapter of El Pilar, showing every confidence in his judgment, agreed to entrust

two of the four cupolas — the smallest ones — to his brother and brother-in-law. The decoration of El Pilar was thus converted into a veritable family business under Bayeu's management. Goya, for his part, placed himself entirely in his hands, since he felt that his status as an Academician would give him some rights vis-à-vis his brother-in-law whatever his duties towards him. The three painters established themselves in Saragossa in June 1780 and started the preliminary work. During the summer Goya returned to Madrid where his wife was expecting their fourth child (like the first three it was not destined to survive). In August he informed his friend Zapater that he had finished the sketch for his cupola but that he expected to spend another two months at home waiting for everything to be ready at El Pilar. In the autumn it was possible to start work on the fresco proper. All went well until December when the Chapter of the Basilica was informed by the administrator Don Mathias Allué that Goya was refusing to make certain amendments requested by his brother-in-law. This was the first rift between the young Academician and the art of the Establishment represented by Bayeu; at the same time it marked the beginning of serious friction within the family. To the Building Committee whose main concern was that the work should proceed smoothly, Goya's attitude was unacceptable since it threatened to spoil the stylistic unity of the work as a whole. It therefore instructed the administrator "to see the above-mentioned D. Francisco Goya and his painting frequently and to point out to him anything that might appear defective and also how he should show himself grateful for the good offices of his brother-in-law D. Francisco Bayeu in having him take part in this work."

By the beginning of February 1781, Goya had finished the fresco on his cupola, representing *The Queen of Martyrs;* all that remained was to select the Virtues to decorate the four pendentives. A month later the break was complete. The sketches submitted by the painter for the figures of Faith, Fortitude, Charity, and Patience were turned down by the Building Committee — there was particular disapproval of the figure of Charity which was considered somewhat immodest. In addition, we know that the public did not approve of the painting on the cupola. The sketches confirmed "the lack of study and taste" already shown in the large fresco, and the El Pilar authorities were afraid of being exposed to even stronger criticism. Finally, the affair was put back into the hands of Francisco Bayeu who had managed to gain the confidence of the whole Chapter "in the hope that he will kindly take the trouble to see these sketches and to examine whether the reservations of the Committee are justified, with the aim of ensuring the decoration of the pendentives in such a way that they can be presented to the public without fear of censure."

Goya's reaction was violent; he wrote a long memorandum to the Building Committee defending himself against what he considered to be an utter slander. As he observed, "the honor of an artist is a very delicate thing." In the difference between Bayeu and himself, only the arbitration of such well-known and impartial Academicians as Mariano Maella or Antonio Velázquez would be acceptable to him. He proposed to have them brought from Madrid at his own

58. *The Count of Floridablanca and Goya.* 1783. Oil on canvas. 262 by 166 cm. Signed and dated. Madrid, Banco Urquijo.

Goya's actual career as the portrait painter of the court and of the important personalities of his time begins with this official portrait of the First Secretary of State of Charles III. Here he represents himself as an artist attentively catering to the pleasure of his employer whom he hoped to attract as a patron. This hope was soon shattered even if this rigid portrait did certainly help him as an introduction to the aristocracy of Madrid.

expense. But the Chapter, abiding by the contract signed with Bayeu who had sole responsibility for all the work at El Pilar, stuck to its guns, even demanding approval in his own handwriting. It finally took the intervention of Brother Felix Salcedo, a monk from the Carthusian Monastery of Aula Dei and a friend of Goya's from the time he decorated the monastery church, for him to agree to comply not so much with the wishes of his brother-in-law as with those of the Chapter of El Pilar.

At the end of May 1781 Goya completed the new decoration on the pendentives and amended the *media naranja* (the cupola) according to Bayeu's instructions. It was with rage in his heart that he ultimately redid his work in these humiliating circumstances. In a final interview with the administrator of the enterprise, Don Mathias Allué, he could not restrain his anger against those "vile people who had cast so much doubt on his merit," as he wrote later in a letter to Zapater. For their part the El Pilar authorities took two very firm decisions; first of all, that Goya should be paid what was due to him, and then above all, that he should not be permitted "in any capacity nor in any manner to continue to paint in this church." However, they did present his wife with a few medals, which was the custom but only out of solicitude for the sister of Don Francisco Bayeu, who was praised anew for the quality of the work he had carried out in the Basilica. On the very next day Goya signed a receipt for the 45,000 reals agreed upon by his brother-in-law and set out at once for Madrid, determined to forget if possible the slight that he had just received.

This unhappy episode in Goya's career is interesting from two points of view. First of all, it meant a drastic break by Goya with the new school of Spanish painting of which Bayeu was the most distinguished representative. The minutes of the Building Committee for March 28, 1781 show very clearly the points on which the public of Saragossa and the authorities of the basilica were in complete disagreement with Goya. "The sketches for the pendentives," it states, "displeased the Committee because they were unfinished and contained the same effects of drapery, color and conception that had so shocked the public." "Unfinished paintings" — in using this term which amounted to a condemnation — the author of the document was not aware that he was putting his finger on the most revolutionary aspect of Goya's art which was precisely the aspect that would make him the real precursor of modern painting. In his rejection of "finished" painting, of perfectly smooth surfaces in the style of Mengs, Bayeu and all the champions of Neo-Classicism (including his illustrious contemporary David), Goya showed himself radically opposed to the taste of his period.

What was the source of the strength, the incredible daring that enabled this ambitious young painter to swim against the stream? First of all, undoubtedly, his own genius whose mighty thrust could no longer be contained but also his discovery of the paintings by Velázquez at the Royal Palace in 1777 or 1778. The singularly free brushwork of his illustrious predecessor had opened his eyes to the path he should follow. The attentive study of the *Meninas* and the *Spinners,* among other works, had confirmed him in the sketchlike style that was so reprehensible in the eyes of his Aragonese compatriots. What in 1781 was the

59. *Equestrian Portrait of Doña Maria Teresa de Vallabriga.* 1783. Oil on canvas. 80 by 60 cm. Florence, Galleria degli Uffizi.

A sketch for the now lost large equestrian portrait that was listed in all of the inventories of the palace of Boadilla del Monte, the possessions of the Infante Don Luis. The portrait is a clever conversion of the equestrian portrait of Queen Isabel de Francia (Isabelle de Bourbon) by Velázquez that Goya had already copied in an engraving in 1778. The large equestrian portrait was commissioned as a companion picture of an equestrian portrait of the Infante from the hand of the Genoese Francesco Sasso.

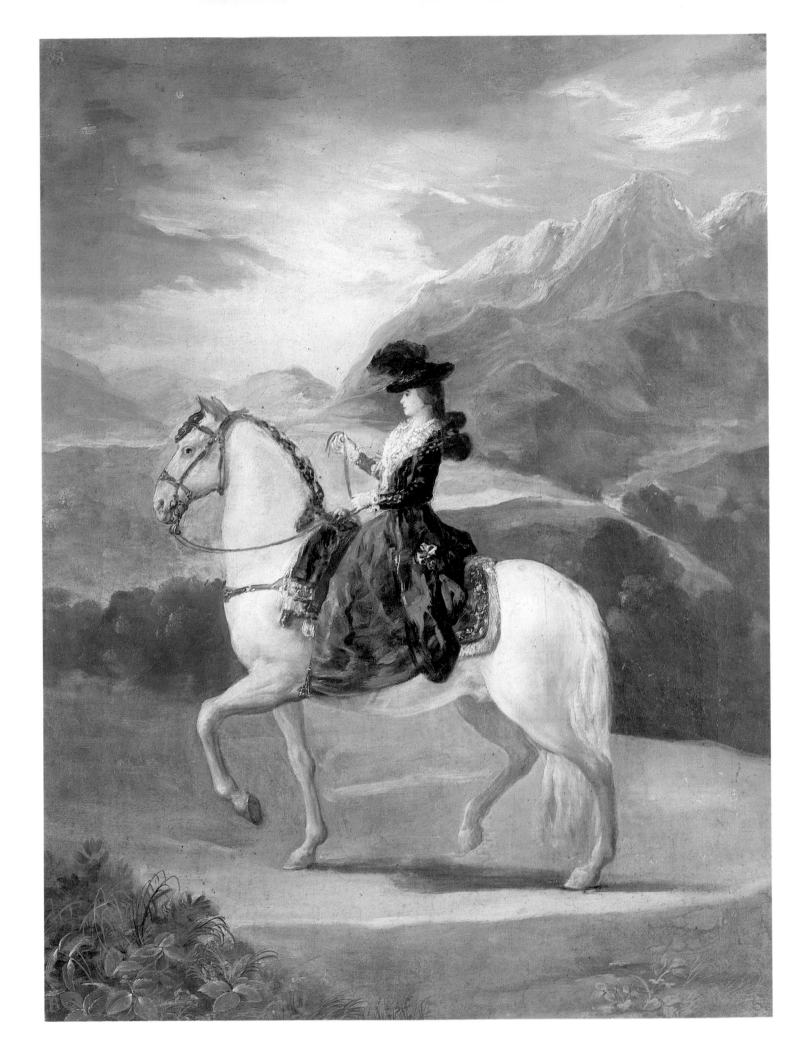

first manifestation of this *bocetismo,* as it has been felicitously called by Lafuente Ferrari, would shortly be transformed into certainty and become the mainspring of his art. At the end of his life in a celebrated letter to his friend Joaquin Ferrer (December 20, 1825) he would say, on the subject of the miniatures he had just painted, that "they were closer to the brush of Velázquez than to that of Mengs." This neatly sums up all his work, starting with those youthful years when he made his choice once and for all.

Finally, the incident in Saragossa had another consequence — the feud with Bayeu — "Bayeu the Great," as he ironically called him — which would last for some five years. All at once Goya was deprived of the support of his brother-in-law of whom he had been the proud disciple and who had always championed him at the Court. Until his appointment as Painter to the King in 1786, he was compelled to look for new patrons whose commissions would make up for the cessation of his work at the Tapestry Factory. Before discussing the influential protectors he sought at Court, mention must be made of an Aragonese — of Basque origin like himself — who played a decisive part in his career just when the El Pilar incident seemed to have seriously endangered it. This was Juan Martín Goicoechea, through whose intervention Goya was commissioned to paint one of the seven altar paintings in the new Church of San Francisco el Grande in Madrid. This notable benefactor of Saragossa had been known to the King by repute since 1777. After studying the silkmaker's art in Lyons he had founded a "Vaucanson-type" spinning-mill in his native city. This venture was so remarkable that the municipality sent a report on it to the Court. Later on he started a school of drawing and became one of the most eminent members of the Friendly Society of the Province of Saragossa. In 1789 the enterprise and dedication of this great son of Aragon was rewarded by the Order of Charles III; on this occasion his friend Goya painted his portrait.

In a letter from the painter to his loyal friend Zapater (July 25, 1781) he freely expresses his malicious pleasure at the announcement of the royal favor towards him: "My friend, never before has there been such enthusiasm for painting in Madrid. His Majesty has decided to hold a competition for the execution of the pictures at the Church of San Francisco el Grande and has done me the favor of designating me. The letter giving me the commission has been sent by the Minister [Floridablanca] to Goicoechea so that he can show it to those vile people who have cast so much doubt on my merit. As for you, you must show it wherever it can strike home; not without reason, for Bayeu the Great is doing his picture too, like Maella and the other court painters. In fact, it is a regular free-for-all but it seems that God has remembered me... As you are so anxious for my welfare, you will know the use you must make of it and the cudgelling you can deal, with that Ramón whom nobody remembers..."

The large painting for the Church of San Francisco — *St Bernardino of Siena Preaching before Alphonso of Aragon* — occupied Goya for two years (1781-1783) and was unveiled together with the paintings of his rivals in the autumn of 1784. There was no immediate sign of the important consequences he expected it to have for his career, but as he wrote to Zapater (December 11, 1784), "It

60. *The Family of the Infante Don Luis de Borbón,* detail. 1784. Oil on canvas. 248 by 330 cm. Parma, private collection.

Based on the publication of Goya's letters it is known that he spent time with the Infante Don Luis in Arenas de San Pedro twice. Thus the equestrian portrait of Maria Teresa de Vallabriga and the family portrait were completed within an interval of one year. These two important works are in the tradition of the art of Velázquez and prove Goya's determination to compete with the one painter he recognized as his master.

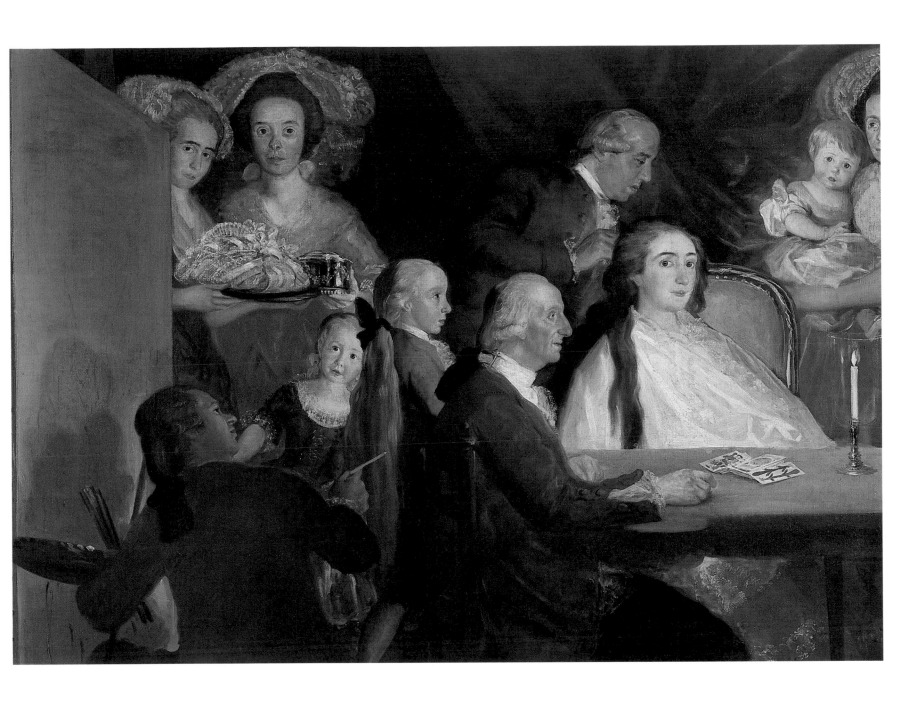

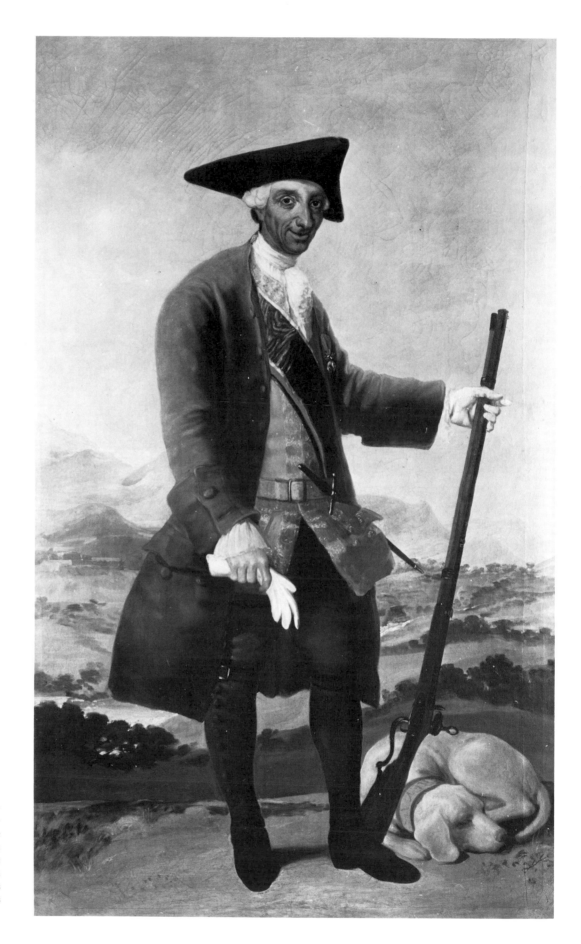

61. *Charles III in Hunting Costume.* Around 1786-1788. Oil on canvas. 206 by 130 cm. Madrid, Duchess of Arco.

Goya portrayed Charles III several times shortly before the latter's death. The representation of the king in courtly clothing for the San Carlos Bank was created at the same time as this one in hunting costume of which there are several, qualitatively different replicas. In this portrait, as well, the influence of Velázquez is unmistakable.

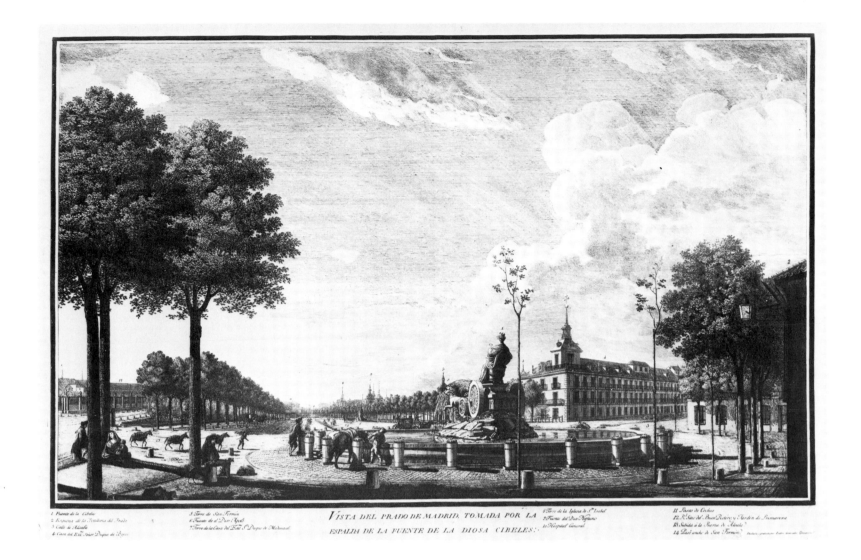

VISTA DEL PRADO DE MADRID, TOMADA POR LA
ESPALDA DE LA FUENTE DE LA DIOSA CIBELES:

is certain that in the eyes of art-lovers and the public as a whole I have succeeded with my San Francisco picture, for everyone is indisputably for me…" This critical triumph was accompanied by a personal sense of satisfaction since he had gotten the better of Francisco, his brother-in-law and fellow competitor, and of Ramón, who had not even been asked to compete.

Next, again on Goicoechea's recommendation, the Count of Floridablanca (Fig. 58), First Secretary of State, who had forwarded the King's order for the San Francisco altarpiece, commissioned Goya to paint his portrait. This news augured extremely well for the artist's future. He informed Zapater of it in a state of unusual excitement and in the greatest secrecy (January 22, 1783): "Although the Count of Floridablanca has asked me to say nothing, my wife knows about it and I should like only you to know about it too: he wants me to do his portrait which may bring me a number of advantages…" Goya even spent two hours with the Minister in Madrid, no doubt to decide on the pose of the sitter and the composition of the picture. He was well aware that he had to make a success of this portrait at any price since it was the first he had ever

62. *Vista del Prado de Madrid (View of the Prado in Madrid).* 18th century. Popular print. Madrid, Biblioteca Nacional.

In Goya's time the Paseo del Prado was the elegant meeting place of Madrid. The magnificent promenade, steeped in shade due to the many rows of trees, was started under the reign of Charles III as of 1775; its most important decoration is the Fuente de la Cibeles, the fountain with the antique goddess Cybele, a work of the architect Ventura Rodriguez.

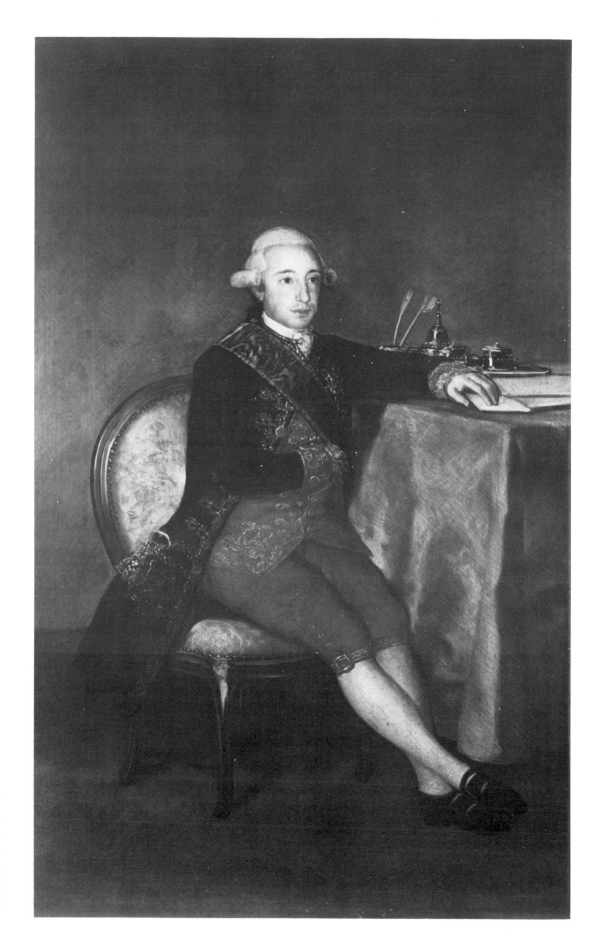

63. *The Count of Altamira.* 1787. Oil on canvas. 177 by 108 cm. Madrid, Banco de España.

One of the six portraits the San Carlos Bank — today the Banco de España — commissioned from Goya. The disproportion between the count and the table on which he is resting his hand is somewhat annoying; the main reason was certainly the diminutive size of the count, a further reason would be the incompetence of the painter who still had only limited experience with official portraits.

64. *Francisco Count Cabarrús.* 1788. Oil on canvas. 210 by 127 cm. Madrid, Banco de España.

Of French origin, Cabarrús had founded the San Carlos Bank — today the Banco de España — in 1782. Goya, who executed five other portraits for the bank along with this one, had received the order on recommendation of his friend Ceán Bermúdez who had headed the secretariat of the bank since its establishment. Cabarrús, a close friend of Jovellanos, remained true to the basic tenets of enlightened liberalism throughout his life and declared himself willing to become the Secretary of Finance of Joseph I shortly prior to his own death in 1810.

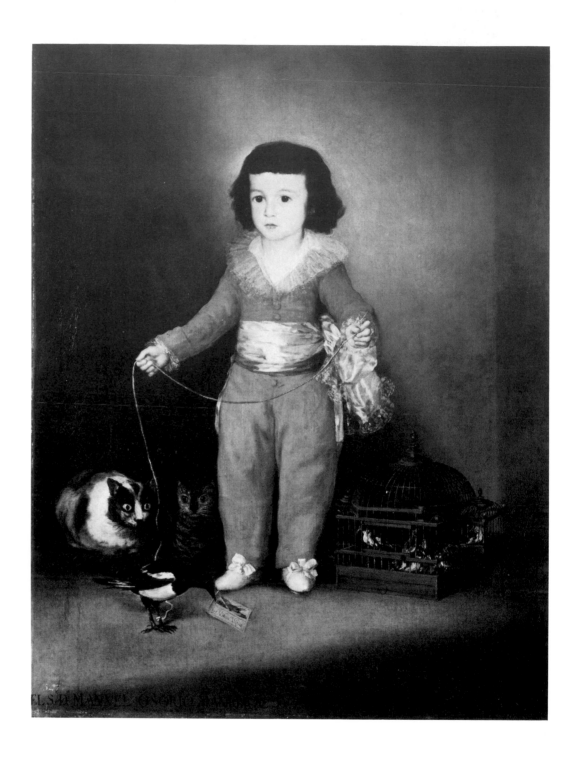

65. *Manuel Osorio.* Around 1788. Oil on canvas. 127 by 101 cm. New York, The Metropolitan Museum of Art.

The official portrait of the Count of Altamira (illustration 63) resulted in several commissions from this aristocratic Spanish family for Goya; they were among his first patrons. Manuel Osorio was the youngest son of the count. Shortly beforehand, Goya had completed the portraits of the eldest son Vicente Osorio (see illustration 66) and of the Countess of Altamira with her little daughter.

66. *Vicente Osorio de Moscoso.* 1786-1787. Oil on canvas. 138.5 by 104 cm. Switzerland, private collection.

This ten year old *senorito* was the oldest son of the Count of Altamira whom Goya portrayed at about the same time for the San Carlos Bank. The formal posture of the heir of the title, who is completely aware of his importance, is in complete contrast to the natural, childlike manner of his younger brother Manuel (illustration 65) with his favorite animals.

EL EX. S. D. VICENTE OSORIO CONDE DE TRASTAMARA Ð EDAD Ð DIEZ AÑOS.

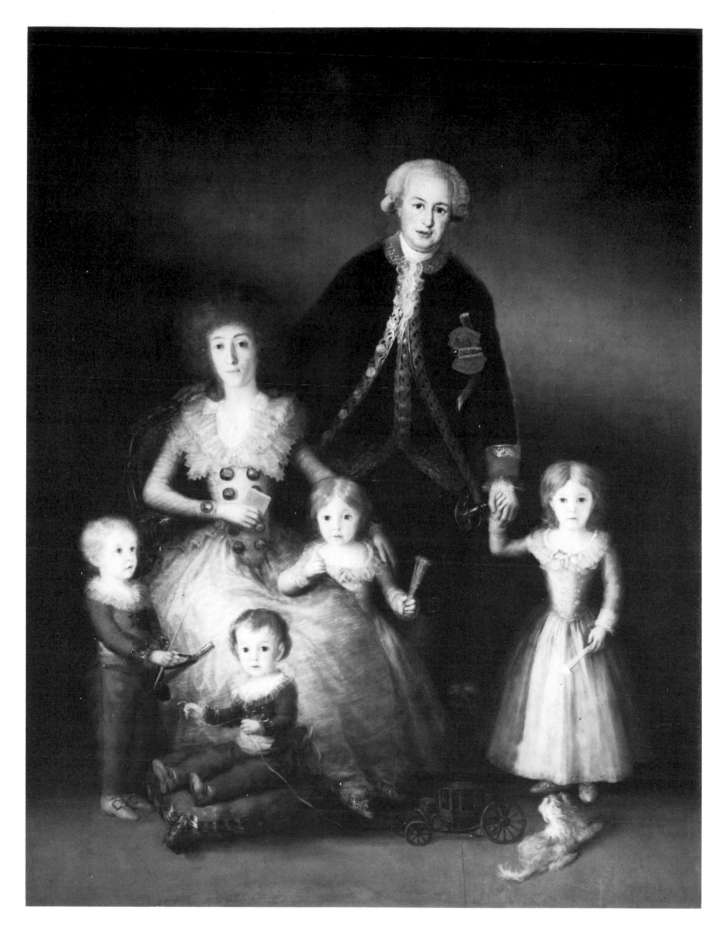

67. *The Family of the Duke of Osuna.* 1788. Oil on canvas. 225 by 174 cm. Madrid, Museo del Prado.

Goya worked for the 9th and 10th Duke of Osuna up to 1816. Apart from the royal family, the Osunas purchased the largest number of Goya's works of which most were portraits, but they also included paintings for decorating their houses and their family chapel in the cathedral of Valencia (illustrations 69-72). The 9th duke and his wife, the Countess-Duchess of Benavente, shown here with their four children, are the best examples of the enlightened Spanish high aristocracy.

68. *The Countess-Duchess of Benavente.* 1785. Oil on canvas. 104 by 80 cm. Madrid, Bartolomé March.

In the judgment of Lady Holland, who knew her well, the countess-duchess was "the most noble woman of Madrid due to her talents, her merits and her taste." The picture of her that Goya passed on to us imparts an idea of the elegance *à la française* of this great lady, the patroness of the arts and literature, who was so gifted and cultured that she was chosen as the president of the female group of the Economic Society of Madrid.

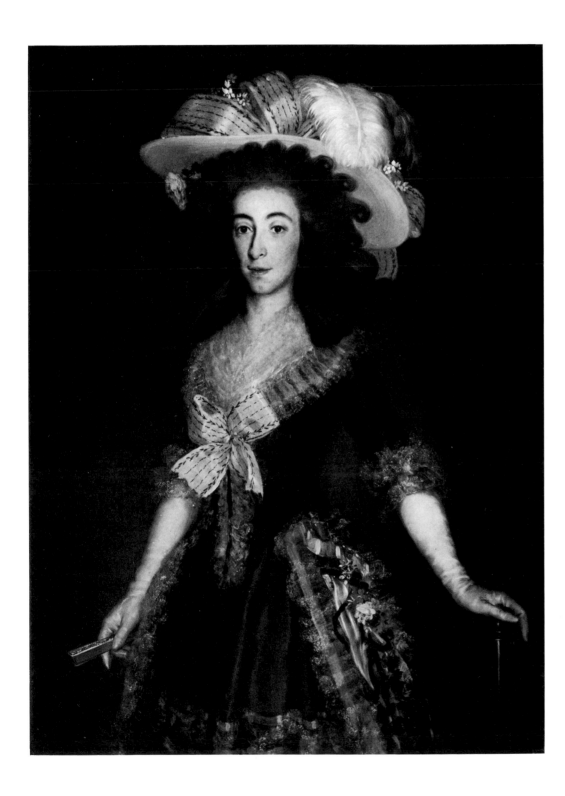

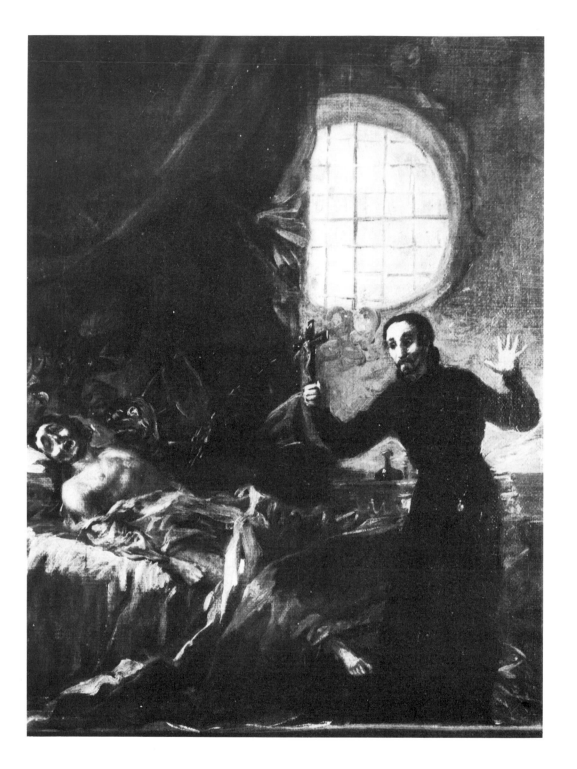

done of such an influential person. Until then religious works and tapestry cartoons had been almost the only kinds of painting he had practiced. Portraiture involved problems of a new kind, but also opened up the prospect of extremely lucrative commissions at the Court and in the city. The recent example of Mengs proved this. Goya thus pinned all his hopes on this commission which he carefully kept secret at the request of the Minister and also because he was uncertain how it would turn out. The painting, which has been preserved in the light

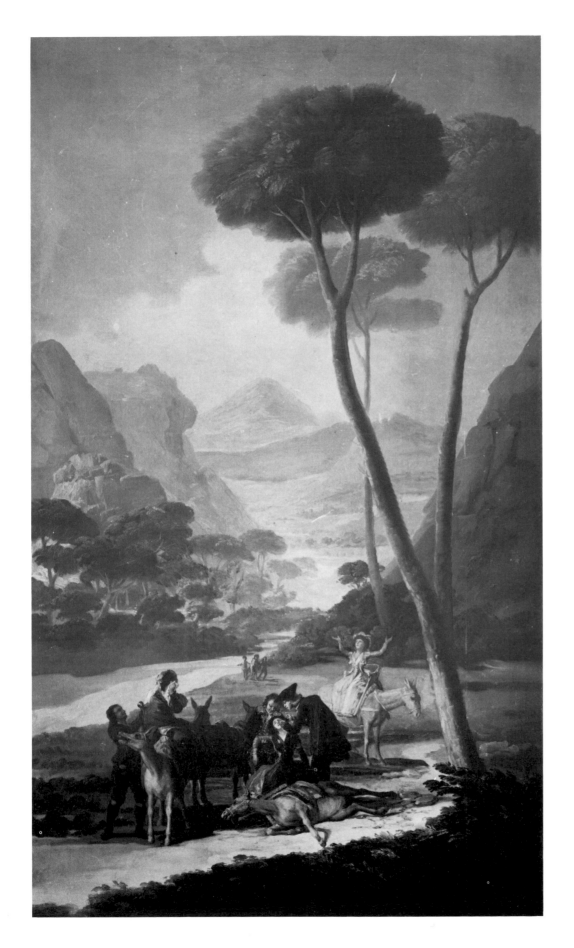

70. *La caida (The Fall)*. 1786-1787. Oil on canvas. 169 by 98 cm. Madrid, Montellano collection.

The country house El Capricho belonging to the Osunas — it was named after Alameda de Osuna — was located in Canillejas in the environs of Madrid. They had purchased it in 1783, and the duchess was occupied with decorating and making it more beautiful until the time of her death. Goya delivered "seven rural scenes" for this purpose on April 22, 1787. The topics and the execution are closely related to the tapestry cartoons executed at the same time for the palace of El Pardo.

that witnessed its birth, marks an extraordinary advance in the development of Goya's art. Though its total effect is clumsy, because of the artist's lack of experience, it already reveals many aspects of his genius as a portraitist. Out of this confused composition, with its superabundance of details, signs, and allusions, the imperial red of the coat of the First Secretary of State blazes forth — the same red that a few years later would triumph in one of his finest child portraits, that of *Manuel Osorio* (Fig. 65). Already scattered through a number of fine cartoons such as *Dance on the Banks of the Manzanares* (The *majo's* jacket), the *Parasol* (the boy's waistcoat and the girl's headdress), the *Crockery Vendor* (Fig. 42) (the coat of the seated figure viewed from the back), and others, here it becomes the dominant color, an affirmation of power by truly expressionist pictorial means. Goya himself appears in the picture: a humble and attentive shadow of his illustrious model, to whom he is showing a painting, or a sketch for one. The thirty-eight year old painter and courtier obviously expects the world from the impassive Floridablanca. All he would get was one of those polite little phrases with which the great of this world brush off tiresome hangers-on: *Goya, ya nos beremos más despacio* (Goya, we shall meet again more quietly).

There was no follow-up to this portrait, no offer of patronage from the Minister. On the other hand, Goya's name began to be known in circles close to the Court; he was spoken about, his talent was praised, and — curiosity aiding — new avenues began to open up for him. Starting with Goicoechea, the recommendations went up as to Floridablanca; thence they soared to a veritable Maecenas, a great epicurean and protector of the arts, the Infante Don Luis de Borbón, the King's brother. In 1776, the Infante had married Doña Maria Teresa Vallabriga y Rosa, daughter of an infantry captain from Aragon, and had been obliged by virtue of an Edict on Unequal Marriages promulgated by his brother in the same year to withdraw from the Court and the royal residences. Settling in Arenas de San Pedro at the foot of the Sierra de Gredos, he had created a peaceful existence for himself in which the joys of family life and the pleasures of hunting and long excursions on horseback took first place.

His wife, who was thirty years his junior, had presented him with three fine children: Luis Maria (1777-1823), future Cardinal and Archbishop of Toledo; Maria Teresa (1780-1828), who would marry Godoy in 1797; and Maria Luisa (1783-1847), who would become Duchess of San Fernando. The Infante, who was fifty-six years old when his youngest daughter was born, had inherited a taste for art from his mother, Elizabeth Farnese, and like her had assembled an important collection of paintings. Some idea of it may be gained from the enormous inventory of his property drawn up after his death in 1785. This lists many Flemish paintings (by Teniers, Velvet Breughel and others) still lifes by Pereda, and a number of Murillos, but also works by Velázquez, including a small version of the equestrian portrait of *Prince Baltasar Carlos* and an important *Sebastián de Mora,* both of which were sold in 1845 to the banker Salamanca.

A patron as well as a collector, the Infante Don Luis sponsored such painters as Luis Paret, Gregorio Ferró (Goya's rival in a number of academic competitions), and a little known artist from Genoa, Francesco de Sasso, whom the

71. *Summer.* 1786. Oil on canvas. 34 by 76 cm. Madrid, Fundación Lazaro Galdiano.

This sketch for the largest of all tapestry cartoons executed in 1786-1787 belonged to the Duke of Osuna to whom Goya had sold it together with five others of the same series. The series of tapestry cartoons was intended for the decoration of the dining room of the palace of El Pardo. The representation was part of a group of the *Four Seasons,* itself a part of the series.

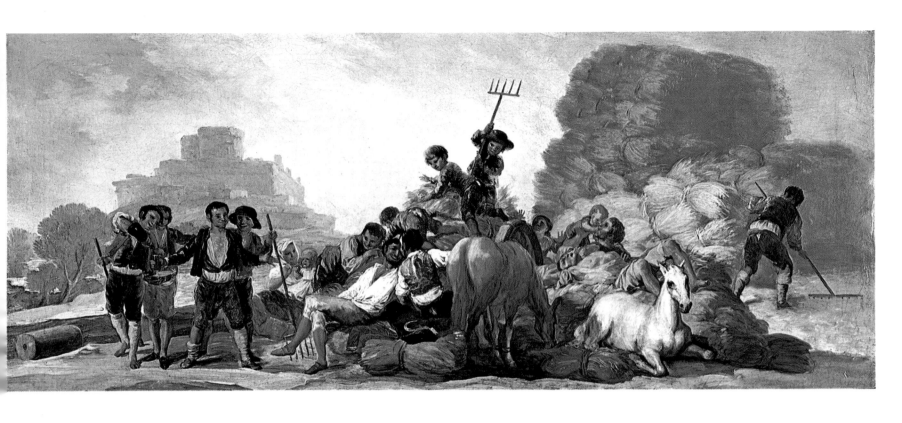

72. *The Enchanted.* 1797-1798. Oil on canvas. 42 by 30 cm. London, National Gallery.

Shortly before the departure of the Osunas for Paris — from there they continued on to Vienna, where the Duke had been named ambassador — Goya delivered six witches and sorcerors scenes intended for the personal private room of the Duchess in Alameda. Goya had received the stimulation for these paintings from a comedy by Antonio Zamaro, *El Rechizado por Fuerza* (By Force the Enchanted).

73. *Ferdinand Guillemardet.* 1798. Oil on canvas. 185 by 125 cm. Paris, Musée du Louvre.

This ambassador of the French Republic, who was hardly noteworthy for his diplomatic talents, did at least have enough taste to have his portrait painted by Goya during his stay at the Spanish court. In addition, he brought a sample of the *Caprices,* probably a present from the artist, back with him from Madrid. It is the sample that Delacroix, a school friend of Guillemardet's son Félix, was able to see in Paris in 1822.

Infante's mother had engaged as his drawing master and whom he later appointed as his official painter. As well as numerous genre scenes, de Sasso had executed a large equestrian portrait of the Infante before his marriage. As for Mengs, who had left Spain for good in 1777, it is now known — thanks to unpublished nineteenth-century documents — that his services to the Infante were more important than has hitherto been realized. In fact, it was Mengs

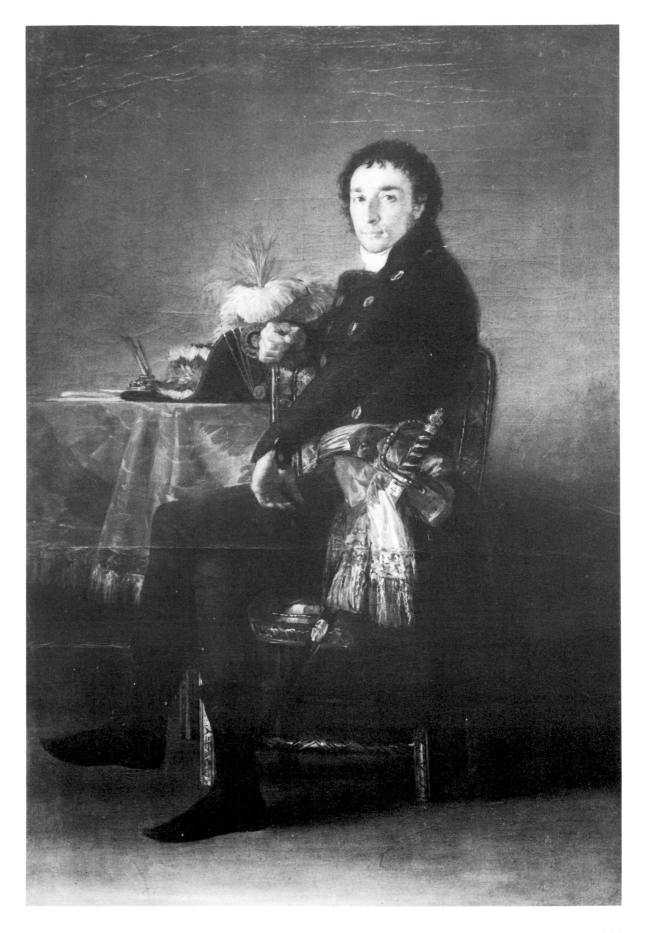

74. Esteban Boix based on J. Gomez: *Vista del Palacio del Duque de Berwich y de Liria en Madrid (View of the Palace of the Duke of Berwich and Liria in Madrid)*. Engraving. Madrid, Museo Municipal.

The Palacio de Liria was the Madrid residence of the Dukes of Alba. Destroyed in the Civil War of 1936-1939, the palace was rebuilt again on the same location.

Vista del Palacio del Duque de Berwich y de Liria en Madrid.

Vuë du Palais du Duc de Berwick et de Liria à Madrid.

75. *The Duchess of Alba.* 1795. Oil on canvas. 194 by 130 cm. Signed and dated. Madrid, Duke of Alba.

This first portrait of the Duchess of Alba by Goya's hand forms the counterpart to the portrait of the Duke from the same year (illustration 97). The famous Cayetana is thirty years old here — the same age as the Countess-Duchess of Benavente when Goya painted her in 1785 (see illustration 68) — and exudes youth and elegance. Her heavy black hair, undulating down to her waist in waves, was famous among all Madrilenians and traveling foreigners. The following year, Goya once again portrayed her in several drawings of the Album of Sanlucar.

whom the Infante sent to Italy to buy him works by the very greatest masters — Raphael, Michelangelo and Leonardo da Vinci — which were subsequently sold to Salamanca.

Since the Infante Don Luis went to live in retirement at Arenas de San Pedro, his choice of painters had become extremely restricted. On returning from Puerto Rico in 1778, Paret had been forbidden the capital, and he was not allowed to enter it again until his protector's death. Sasso had died in Madrid in 1776, a year before the departure of Mengs who would die in Rome in 1779. There remained only Gregorio Ferró, whom the Infante apparently wanted to appoint as portraitist to his new family. Among the pictures inventoried after the Infante's death, there is a large (206.8 x 121 cm) half-length portrait by Ferró of the Infante, his wife, and their son. The absence of any other child makes it possible to date the work at between 1780 and 1781 when the first daughter Maria Teresa was still too small to sit for a portrait. According to Goya himself, in a well-known letter to Zapater written on his return from Arenas de San Pedro (September 20, 1783), other painters before him — he carefully mentions no names — had unsuccessfully tried to do a portrait of the family. He is almost certainly alluding to the portrait by Ferró which had failed to please the Infante and his wife, perhaps because the figures were half-length. It can therefore be concluded that Goya, on the recommendation of Floridablanca, had been summoned to Arenas de San Pedro for the specific purpose of executing a large family portrait showing the couple with the three children born to them by 1783, together with an equestrian portrait of Maria Teresa de Vallabriga which would

124

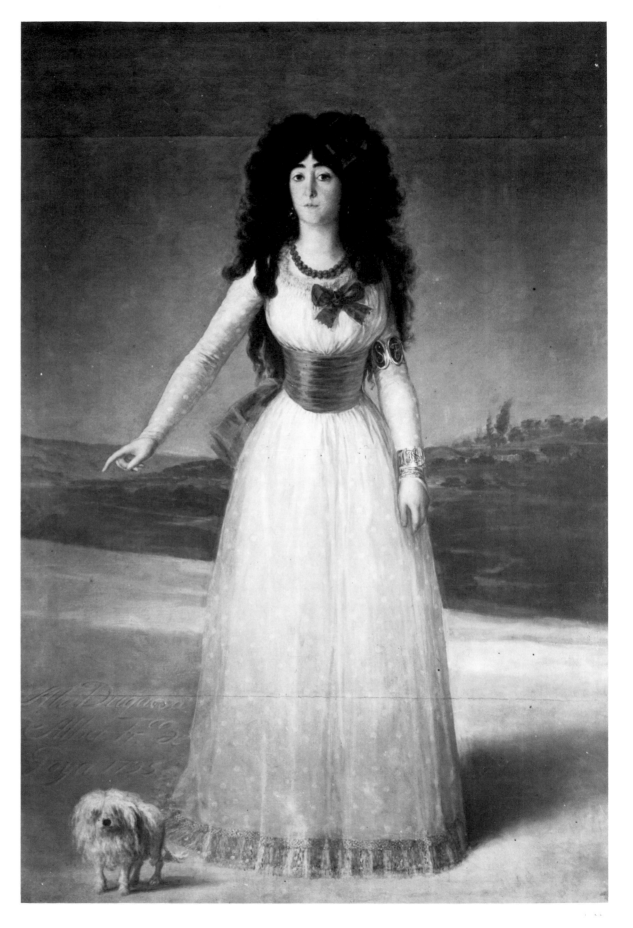

be a pendant to that of the Infante painted before 1776 by Sasso. In the inventory after the Infante's death, this pair of paintings, of identical impressive size (383 x 292 cm) are listed one after the other, the only difference being that Goya's picture is valued at 10,000 reals and Sasso's at 20,000 reals. Today both these equestrian portraits have disappeared; all that remains is Goya's admirable sketch which was acquired in 1973 by the Uffizi Museum, Florence, from the collection of Prince Ruspoli. Some have taken this little canvas to be the one referred to in Goya's letter of July 2, 1784 to his friend Zapater: "I have not yet finished the equestrian portrait of the Infante's wife but there's not much more to do." In reality, he is speaking of the full-size painting on which he had been working for almost a year.

Now that a complete edition of the painter's letters has at last been published, we know that his visit to Arenas de San Pedro in 1783 was not the only one for he returned there in the summer of the following year. In a letter dated October 13, 1784, he wrote: "The Infante gave me thirty thousand reals as a bonus for two pictures I painted for him." This considerable sum appears to be the remuneration for the family portrait and the large equestrian portrait of Maria Teresa Vallabriga — a very generous outlay on the part of the Infante when one compares it with the 15,000 reals paid to Goya for the El Pilar fresco and the 10,000 reals he received for one of his largest tapestry cartoons, *The Game of Bat and Ball* (Fig. 43), in 1779. Obviously, his new patron and his wife — do not forget that she came from Aragon — were very satisfied with his work and sought to hold on to his services by sheer munificence: a thousand duros and a dressing-gown worth 30,000 reals for his wife during the first visit in September 1783, not to mention the Chinchón hatter's for his brother Camilo; 30,000 reals for two pictures the following year. No wonder Goya exclaimed "They're angels" in one of his letters. He hastened to invest the 30,000 reals, purchasing fifteen 2000-real shares in the new National Bank of San Carlos (now the Bank of Spain) founded by Cabarrus in 1782. He announced this to Zapater at a particularly euphoric moment; the pictures at San Francisco el Grande had just been unveiled and the tide of opinion was running in his favor. He added: "I am very satisfied and wish I could embrace you. I have invested in fifteen shares in the National Bank on the advice of some friends I have there, and I shall probably go up to twenty-five, otherwise my money will vanish like smoke; that's the worst inconvenience of this country."

After experiencing the chilly disdain of the Count of Floridablanca Goya certainly had a much warmer welcome from the Infante and his wife. Their unaffectedly amiable nature, their monotonous, if happy existence in exile, and their taste for the arts certainly inclined them to treat painters very generously. In addition, the prince and the painter shared a passion for hunting, which brought them together in mutual admiration of one another's marksmanship. In 1783 during the full month Goya spent with his wife in Arenas he was able to indulge in his favorite sport in the Infante's company: "I went out hunting twice with His Highness; he is an excellent shot. Yesterday he said, after I had shot a rabbit, 'This dauber is even better at shooting than I am.'" The next year

76. *Queen Maria Luisa.* 1789. Oil on canvas. 126.6 by 93 cm. Switzerland, private collection.

One of the first official portraits, if not the first, that Goya executed on the occasion of the crowning of the new Spanish reigning couple. The proclamation had taken place on January 17, 1798; it is known that the commission was given out immediately and that Charles IV and Maria Luisa modeled for the painter as early as January. All later portraits were repeated based on the example of this first one.

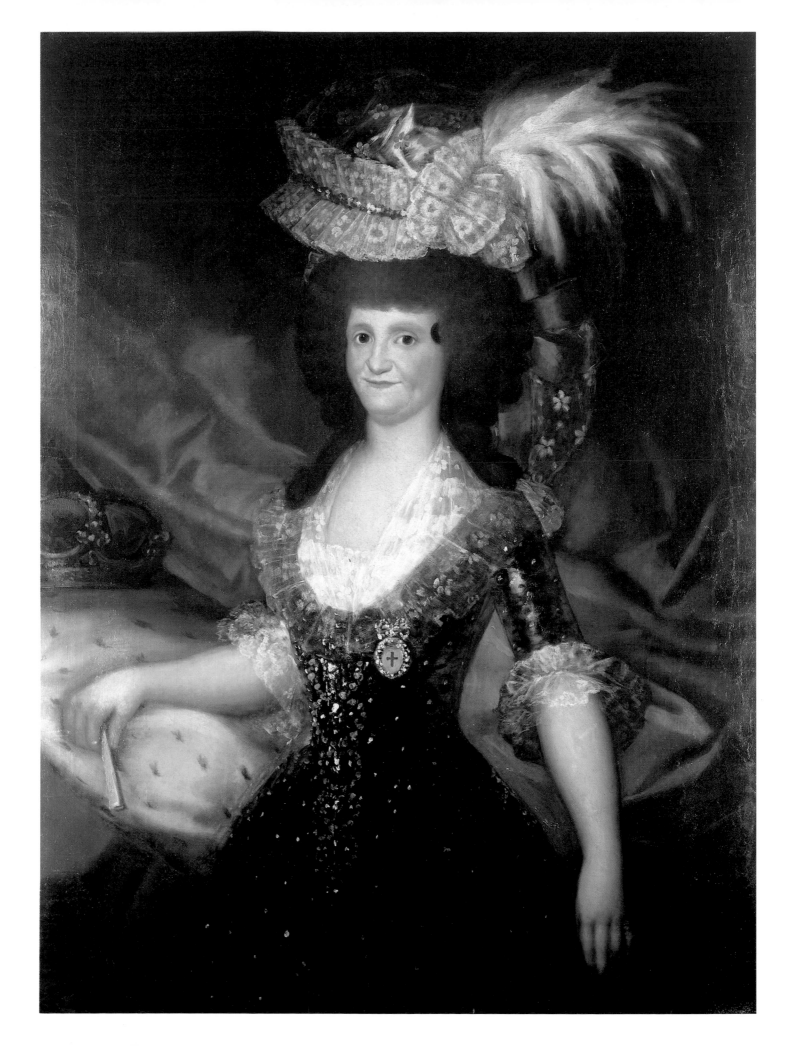

brought another visit to Arenas and further shooting-parties: "I have been working for His Most Serene Highness the Infante Don Luis. It would take too long to tell you all the satisfaction I have derived from it. Down there, I killed an enormous number of partridges with his permission. He was very sorry that I had to go back to Madrid at the command of the King to finish the job at the church of San Francisco."

The protection of the Infante Don Luis, though marginal because of his situation in relation to the Court, was extremely valuable for Goya's career in that it prepared him to cope with the enormous tasks that would face him as Court Painter after 1789. Nigel Glendinning has very appositely spoken of the way the Infante and his wife seem to have encouraged the painter to "work in a Velazquezian idiom." Goya had already prepared himself for this by 1778,

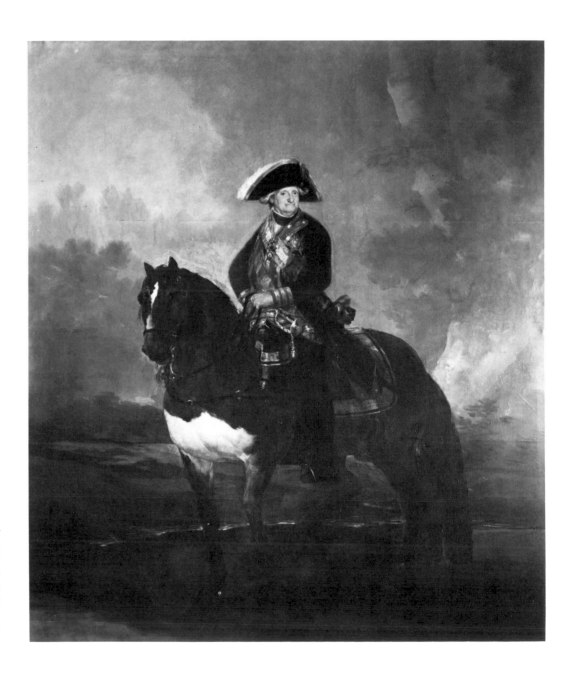

77. *Equestrian portrait of Charles IV.* 1799. Oil on canvas. 305 by 279 cm. Madrid, Museo del Prado.

The two equestrian portraits of Charles IV and of Queen Maria Luisa are still under the strong influence of Velázquez that started with Goya with the 1778 publication of the series of etchings based on paintings by Velázquez in the Palacio Real in Madrid. Based on two complete figure paintings, the equestrian portraits were executed in October 1799 and lead to Goya's nomination to the First Royal Court Painter on October 31, 1799.

78. *Casa real del Pardo (The El Pardo Palace).* Popular print. Madrid, Biblioteca Nacional.

The palace, located outside of the city, was one of the favorite residences of the Spanish Kings. A large part of Goya's tapestry cartoons was intended for the decoration of the rooms of the princely couple of Asturia.

the year in which his engravings after Velázquez were published. There can be no doubt that, as he tackled such ambitious canvases as the *Family Portrait* (Fig. 60) and the *Equestrian Portrait of Doña Maria Teresa Vallabriga* (Fig. 59) the painter of tapestry cartoons was conscious of following in the footsteps of the creator of the *Meninas* and the great equestrian portraits in the throne room at the Palace of Buen Retiro. A few years later he would paint the *Family of Charles IV* (Fig. 79) which contains exactly the same number of figures (fourteen) as there are in the *Family Portrait,* and the equestrian portraits of Charles IV and Queen Maria Luisa, which are the logical — but entirely personal — outcome of that "Velazquezian idiom" in which he started to express himself at Arenas de San Pedro.

All the hopes that Goya had placed on the friendly patronage of the Infante in 1783 and 1784 were dashed a year later by the death of his protector. A few months earlier there had been lavish festivities in Madrid on the occasion of the marriage of Don Gabriel and Doña Maria Ana Victoria of Portugal; Goya gave Zapater an account of this event, from the spectacular carriage procession at Atocha to the illuminations on the Plaza Mayor — "better than other times," he thought. But it all ends on a very sad note: "The poor Infante Don Luis was unable to go out, as he is very ill. Today I kissed his hand to bid him farewell; he returned home half an hour before the King went off to Aranjuez. From what I had been able to observe these last few days — he seemed to enjoy seeing me frequently — I don't think he will recover this time. Others are of the same opinion." Don Luis died on August 7, 1785 at Arenas de San Pedro.

Two years' work for the Infante Don Luis yielded a considerable harvest; although the equestrian portrait of his wife has been lost, as has its companion-piece by Sasso, the surviving works, all portraits, constitute a really remarkable record of Goya's evolution. The large family portrait, a little-known work, is

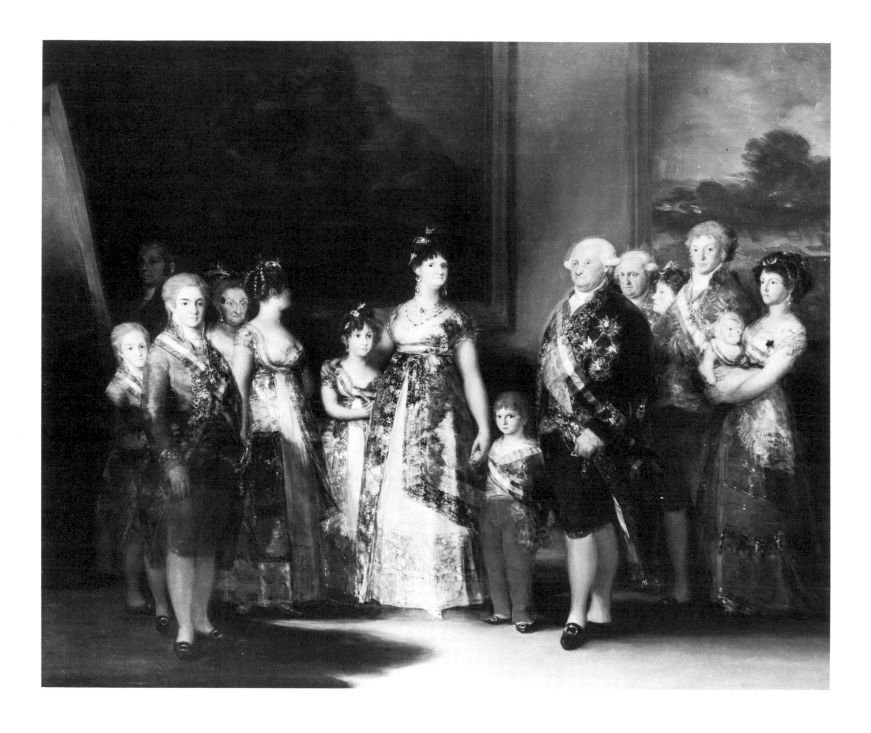

79. *The Family of Charles IV.* 1800-1801. Oil on canvas. 280 by 336 cm. Madrid, Museo del Prado.

This famous work of Goya's can be seen as the highpoint of his official activity for the Spanish court. In his *oeuvre* it corresponds to a certain degree to *Las Meninas* in the work of Velázquez. As there, here too the painter is standing at his easel and observing the royal family in a mirror. The people represented show themselves to be highly content: Did Goya make them prettier in the painting?

alone one of the great masterpieces of Spanish painting in a genre that had few exponents in the peninsula. Centered entirely on Maria Teresa Vallabriga and not on the Infante, who, yielding to the radiant beauty of his wife, only twenty-five years old in 1783, seems to efface himself behind her modest chair, the composition is set out like a "conversation piece" around a card table. Despite a careful attempt to arrange the figures as harmoniously as possible on either side of the princely couple, Goya has not succeeded in preventing the eye of the spectator from being drawn instinctively to the left side of the picture rather than to the respectful but rather stiff group of servants on the right. By contrast, the arrangement of the five main figures has a wonderful mobility, linked as

it is by a supple line starting from Maria Teresa Vallabriga, fully lit, to lead down gently towards the self-portrait of the artist at his easel. The two children in particular constitute one of Goya's first great successes as a portrait painter; the elder, in his fine cornflower-blue suit with the white lace frill fixes his serious profile on his father's while little Maria Teresa, the future Countess of Chinchón, looks with wide-eyed surprise at the painter's canvas.

Goya's deep tenderness is revealed again in the charming portrait he did of her with her favorite dog at Arenas against a background of a Velázquez-style sierra (Fig. 85). This was also the starting point of a long series of portraits of children in which Goya constantly marveled afresh at their innocence. The work at Arenas de San Pedro with models he loved marked the most prolific period of Goya's life.

80. *The Infante Francisco de Paula.* Around 1800. Oil on canvas. 74 by 60 cm. Madrid, Museo del Prado.

One of the five studies for the *Family of Charles IV* preserved in the Prado. In these portraits, painted with an incomparable mastery, the reddish grounding of the canvas — Goya used it frequently — gleams through the paint. The portrait fits into the long series of paintings of children that was a special forte of Goya's throughout his life.

It is not surprising therefore that, even before the Infante's death, commissions from the greatest Madrid families began to pour into the painter's studio; they were due to his new fame as a portraitist. At first, in 1785, he began a series of portraits of the directors of the Bank of San Carlos of which he was himself a shareholder. The first, of Don Jose de Toro y Zambrano, had been commissioned at the suggestion of his friend Juan Agustín Ceán Bermúdez, who had been working as chief of the secretariat in the Bank since its foundation in 1782 — an unexpected link between Goya and the world of finance and economy which would lead him to paint his first portrait of Charles III (1787) and those of the family of the Duke of Altamira in subsequent years.

During the same year 1785 the Infante Don Luis introduced Goya to one of the noblest families in Spain, that of the Count-Dukes of Benavente, Dukes of Osuna. And immediately he received a commission to paint their portraits for which he was paid on July 16. This was the start of the very special relationship between the painter and that illustrious house, but especially with the countess-duchess whose forceful personality dominated the life of the Spanish Court in the second half of the eighteenth century. Her palace of the Puerta de la Vega where she settled in 1781 was one of the most luxurious dwellings in the capital, decorated entirely in the most sophisticated French style, as is shown by the white and gold *boaseri* of her private study and the *cabriole* chairs with which it was furnished. This was the venue of the literary and musical *tertulias* (meetings), of dazzling receptions and theatrical *soirees*. The house was frequented by the foremost intellects and the most outstanding talents of the day: Tomas de Iriarte, poet and playwright, who composed at least two of his *zarzuelas* for the Duchess of Osuna; Don Ramón de la Cruz, famous for his playlets with their unrivaled folk spirit and also supplier to the duchess' small theatre; in the field of music, Luigi Boccherini, who had been in the service of the Infante Don Luis at Arenas de San Pedro before becoming the official composer to the Benaventes until 1799; and finally Goya, whose most important clients after the king of Spain were the Osunas.

In 1787 after painting the two portraits of 1785 — that of the duchess showed a virtuosity in the brushwork such as Spain had not seen since Velázquez — Goya decorated El Capricho, the Osunas' country house in the outskirts of Madrid. Seven pastoral scenes were contemporaneous with the new series of tapestries he had been working on since the previous year for the king's dining room in the El Pardo palace. Both these series enable us to assess the degree of mastery Goya had achieved in depicting the joys and tragedies in the lives of the common people. The Osunas, of course, had the tremendous advantage of having the actual paintings on their walls and not their transformation into tapestries. They were so keenly aware of this difference that in 1798 they hastened to buy from Goya the best sketches of his cartoons, including the famous *Meadow of San Isidro* and *Summer*. (Figs. 54, 71).

But the Osunas' patronage went far beyond genre painting. On October 16, 1788 Goya presented invoices for three major canvases he had just executed for his patrons: a family portrait (Fig. 67) and two large religious paintings

81. *Don Fernando, Prince of Asturia.* 1800. Oil on canvas. 83.2 by 66.7 cm. New York, The Metropolitan Museum of Art.

This study differs extremely from the representation of Don Fernando in the family painting. It is thought that this could be a portrait painted by Estève based on the original study by Goya.

for the Borgia chapel in the cathedral of Valencia (Fig. 69). It is tempting to compare the former with Goya's treatment of the family portrait executed for the Infante Don Luis; at first sight the Osuna picture seems pared down and sober compared with the complicated and rather unbalanced big composition painted five years earlier at Arenas. But it is possible that the painter had to humor the Infante who wanted to enlarge his family circle by including his servants, whereas in the later work the very classic pyramid-shaped arrangement was better suited to the six people facing the viewer from a neutral background. Although the conditions at the outset were certainly very different the evolution of Goya's palette between the two works can be clearly discerned,

82. *Manuel Godoy.* 1801. Oil on canvas. 180 by 267 cm. Madrid, Real Academia de San Fernando.

In 1801, at the time of the "Orange war," Godoy reached the peak of his fame. He soon became the generalissimus of the land and naval forces, convinced of his military genius that he actually lacked. The difference between the bloated, thirty-five year old *Principe de la Paz* and his assistant standing behind him is impressive.

especially the smoothness of tones in the Osuna picture dominated by delicate greys. As for the Valencia pictures, of which the sketches survive — executed as usual with far more verve and dynamism — the scene of the *Death-bed of an Impenitent* reveals a completely unexpected feature which was tremendously significant for the future: the apparition, in the half-shadows of the bed curtains, of grimacing monsters, the first in Goya's work. Ten years later *The Caprices* were filled with them but by then they were being exorcised by the sole figure of triumphant Reason and not by the crucifix of Saint Francis Borgia.

Later Goya executed a series of six paintings of scenes of witchcraft for the Duchess of Osuna and at her request as part of the decoration of the walls of El Capricho; they faithfully reflected a craze which around 1797 the duchess shared with Goya and his friend Moratin, an interest in witchcraft and in the world of the theatre which influenced at least two of these paintings. To these commissions add four sets of *Los Caprichos* which appeared in February 1799.

To conclude, it must be noted that something was quite exceptional in the relationship between the painter and the Osunas. Whereas all Goya's other patrons came to him to have their portraits painted or to commission work they needed for their palaces, the duchess loved his painting for its own sake, as modern painting, and was one of the few contemporaries who actually *collected* his works. Finally, to the Osunas Goya was not only a painter but a friend, on the same footing as Don Ramón de la Cruz, Moratin, Melendez, Valdes and Pougins. He became a regular guest at the *tertulias* at the palace of the Puerta de la Vega and in summer at El Capricho at the country promenades and parties

83. José Ribelles: *Equestrian Portrait of Manuel Godoy.* 1807. Etching. Madrid, Biblioteca Nacional.

In this etching, created one year before the fall of Godoy, he is represented in the manner of the equestrian portraits from the hand of Velázquez. It especially brings the portrait of the Count-Duke of Olivares, the favorite of Philippe IV, to mind.

84. *The Countess of Chinchon.* 1800. Oil on canvas. 216 by 144 cm. Madrid, Duchess of Sueca.

The elegant young girl painted by Goya in Arenas de San Pedro in 1783 (illustration 85) has turned into a young woman, the unhappy wife of the *Principe de la Paz* expecting her first child. Goya succeeded splendidly in expressing thoughtfulness, melancholy and the painfulness of the slight suffered.

85. *Maria Teresa de Borbón y Vallabriga.* 1783. Oil on canvas. 132.3 by 116.7 cm. Washington, National Gallery.

The small coquettish girl that is here walking her favorite dog became the wife of Godoy and the Countess of Chinchon in 1797 (illustration 84). Goya painted the picture in 1783 when he was staying in Arenas de San Pedro for the first time following the wish of the Infante Don Luis de Borbón. It is the first portrait of a child by Goya; in addition, it is the only one in which he uses a mountain range — the mountains of Arenas de San Pedro — as a background in the manner of Velázquez.

LA S. D. MARIA TERESA
HIJA DEL SR INFANTE

which were attended by the most brilliant members of Madrid society. But Goya still preferred hunting to all these pastimes. He knew he was a first-class shot and missed no opportunity to show it. A letter to Zapater dated August 23, 1786 shows that he was pleased with life and proud of his success: "My dear Martin, I walk, I eat and drink well and have as much fun as I can, but I still have a swollen ankle especially at night; it does not bother me a lot since I was able to go hunting twice, once with the Marquise of Penafiel and once with other enthusiasts; on both occasions I was the one who had the largest bag in spite of my sick paw and I covered myself with glory; to tell the truth the smartest don't do much better..."

"Marquise de Penafiel" was one of the titles of the Duchess of Osuna which he sometimes used in his letters. As for his "sick paw," as he jokingly calls it, this was an incident worth recounting for it reveals a parvenu Goya, exhilarated by his success and already dreaming of discovering that he is of noble descent. His official career had just made spectacular strides; on March 18, 1785 he applied for and obtained the appointment as Deputy Director of Painting at the Academy which put him on an equal footing with his brother-in-law. The material advantages were meagre — twenty-five doubloons a year for a fairly exacting job that consisted of taking a turn in correcting the work of the drawing classes for a month. But the added status more than compensated for these chores. Goya now became reconciled with his brother-in-law after four years of quarrelling and as family interests were stronger than past rancor he again accepted the patronage offered him, although he did not seek it. The king had instructed Bayeu and Maella who were in charge of painting for all royal residences to choose two of the best painters to help them. Bayeu suggested his brother Ramón and Maella proposed Goya. On June 25, 1786 the two brothers-in-law were appointed Painters to the King. Both were forty years old, but whereas young Bayeu was already past his prime and close to the end of his life — he died in 1793 — Goya was only on the first rung of a long and glorious career which did not come to an end for another forty years.

"Here I am, Painter to the King, with fifteen thousand reals." This cry of triumph with which he announced the news to his friend Zapater makes the main point: fifteen thousand reals! A short time previously he had done his accounts. With his work, his shares in the bank and the academy, he made twelve to thirteen thousand reals a year and considered himself very lucky. Now he had twenty-eight thousand — what more could he want? His new appointment meant definitive security. Commissions poured in from all sides — and what commissions! The Osunas, the Medinacellis, the Bank of San Carlos, the College of Calatrava of the University of Salamanca, the Count of Altamira. When he thought back to the events of El Pilar only five years earlier he felt as if he were dreaming. Here he was almost rich, and all of Madrid had to know it and see Don Francisco de Goya ride in a carriage. He thought of buying a *birlocho* (a kind of gig) of English manufacture, gilded and varnished to order, a veritable gem — there were only three to be found in Madrid. The owner of this little marvel took it out of the town so Goya could try it; Goya grasped

86. *Cardinal Luis Maria de Borbón.* Around 1800. Oil on canvas. 214 by 136 cm. Madrid, Museo del Prado.

Goya had already portrayed the older brother of the Countess of Chinchón as a child in Arenas de San Pedro as well as depicting him in the family painting as a charming small boy in a cornflower-blue garment and with long blond hair tied together at the nape of his neck.

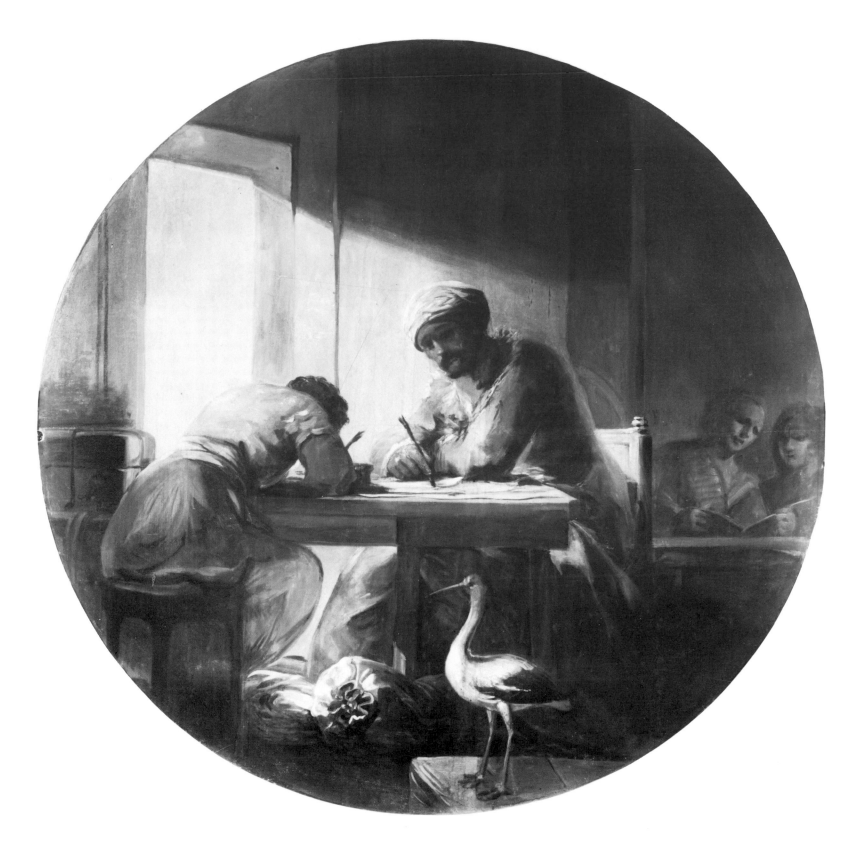

87. *The Trade.* 1797-1800. Oil on canvas. 227 cm. Madrid, Museo del Prado.

One of the four round paintings with allegorical representations that Goya created for Godoy's palace in Madrid. The others represent agriculture, industry and science. The *ilustrados* above all others turned their attention to these four categories. The stork in the foreground was an attribute of the god of trade, Mercury, according to the *Iconologia* of Cesare Ripa.

140

the reins; the horse which was included in the offer trotted gently. Goya was delighted. To convince him conclusively, the owner suggested that they should execute a half-turn "Neapolitan fashion." Always keen to try anything new, Goya agreed and yielded the reins. Catrastrophe ensued. Birlocho, horse and passengers did a series of somersaults which put an end to the demonstration. It was not serious but Goya had the worst of it with an injured right ankle. He decided against the birlocho and contented himself with buying a pair of good mules, "preferably already well trained!"

Appointed Painter to the King in 1786, Goya now had found the most powerful and most reliable patron; even the king's death could not deprive him of his position — indeed, the new king might be even more generous and make his protegé "his" painter to the exclusion of all others. Again Velázquez had provided the precedent; he had been Philippe IV's favorite painter, a high palace official, and was finally enobled by the king. Although the times had changed considerably, Goya in his turn became Charles IV's favorite painter. Before their accession to the throne, the Prince of the Asturias and Maria Luisa of Parma had found his talent precisely to their liking. In their apartments in the El Pardo palace they were surrounded by the brilliant compositions he had created for the Tapestry Factory ánd submitted for their approval. According to a letter written by Goya himself to Zapater (January 11, 1783), it seems that the prince took sides firmly against Bayeu over the pictures of San Francisco el Grande. When Juan de Villanueva, the architect, spoke highly of Bayeu's picture in the prince's presence, the latter replied: "You are an ass. That picture has neither chiaroscuro, nor any effect, nor the least merit. Tell Bayeu that he is an ass." And Goya added maliciously: "they said that the prince had talked it over with someone who knows something about it for he doesn't understand much about art." One may even wonder whether it wasn't Goya himself who whispered this harsh criticism of his brother-in-law — whom, incidentally, he called his "enemy" in the same letter — into the ear of the future Charles IV. It is hardly surprising that the successor of Charles III never granted Bayeu the title of First Court Painter which Bayeu felt should have been his almost by right. By contrast, Goya was commissioned with the official portraits of the new sovereigns in 1789, which immediately earned him as a reward for his services the appointment as *Pintor de Cámara* (Court Painter). He did not have to wait for signs of royal favor and in spite of all the political upheavals following the French Revolution and in spite of his illness in 1792, which put a halt to his work for the palace for a long time, the king continued to show his favor until in 1799 he granted him the supreme honor of appointing him First Court Painter.

Francisco Bayeu died in 1795 without ever achieving it, and Mariano Maella obtained it at the same time as Goya after waiting for twenty-five years and carrying a heavy burden of responsibility.

Now let us see how that final step in the painter's official career was prepared and smoothed by his enlightened friends, especially Jovellanos and Urquito. Goya's genius would have been recognized sooner or later in any case; what

is so extraordinary is the fact that his genius received such swift and conspicuous recognition at the Spanish Court at a time when that court was falling into abysmal decadence. This paradox can, perhaps, be explained very simply; the Duchess of Osuna had a profound appreciation of Goya's painting — as did many of his contemporaries — and Queen Maria Luisa also always expressed a great admiration for her painter from the time of the earliest tapestry cartoon. She also liked the portraits he did of her, first in 1789 at the time of the coronation, then ten years later in a black mantilla on horseback, or in court dress; finally, she liked the large official painting of the *Family of Charles IV* (Fig. 79). She says so in her letters to Godoy and always speaks flatteringly of Goya. When we realize how much weight was carried by the tastes, the wishes, and even the whims of the queen in affairs of state, either directly or through the intermediary of Godoy, the painter's rise at court until 1800 is hardly surprising. This also brings us to the question of the precise role played in Goya's life during the last ten years of the century by the Prince of the Peace and the Duchess of Alba.

It may seem superfluous to question the role of the famous duchess since there is not a single biographer of Goya who does not devote at least a chapter to her so that it seems incongruous to speak of Goya without evoking the sensuous, captivating beauty of the haughty Cayetana at his side. However, we must distinguish between the admittedly important place she occupied in the artist's love life between 1795 and her death in 1802 and the part the Duke and Duchess of Alba might have played as patrons to the painter which is of greater interest here. First, it seems that Goya did not receive any commissions from them before 1795, the date of the two famous portraits (Figs. 75, 97) of the duke and of the duchess in a white dress with red belt (Madrid, Duke of Alba collection). In the following year, the Duke of Alba died suddenly at Seville at the age of forty. His widow retired to her lands at Sanlucar de Barrameda at the mouth of the Guadalquivir for her period of mourning. Then a unique episode began in Goya's life, a real surge of passion and the torments of unsatisfied desire inspired by that incomparable "mistress of mistresses," whose imperious hand pointing to the sand of the river invites us to read the unvarnished avowal: *Solo Goya* (Only Goya). After 1797, the date inscribed on that canvas, the painter did not do any more work for the duchess. In fact, that indiscreet portrait almost certainly remained in Goya's studio where it was rediscovered during the inventory of 1812. In short, the relationship between the Albas and Goya lasted only two years (1795-1797), and only the two portraits of 1795 were executed for them. This is in no way comparable to the role played in his life by the Duke and Duchess of Osuna, his patrons and collectors for some fifteen years.

But the stormy passage of the Duchess of Alba through Goya's life must be reconsidered in a wider context albeit a very murky one because of its political and erotic embroilments in which Queen Maria Luisa and Godoy were the chief protagonists. An important clue is found in a letter from the queen to her favorite (April 1800): "D'Alba has taken leave of us this afternoon. She ate

88. *La maja desnuda (The Naked Maja)*. Detail (see illustration 89).

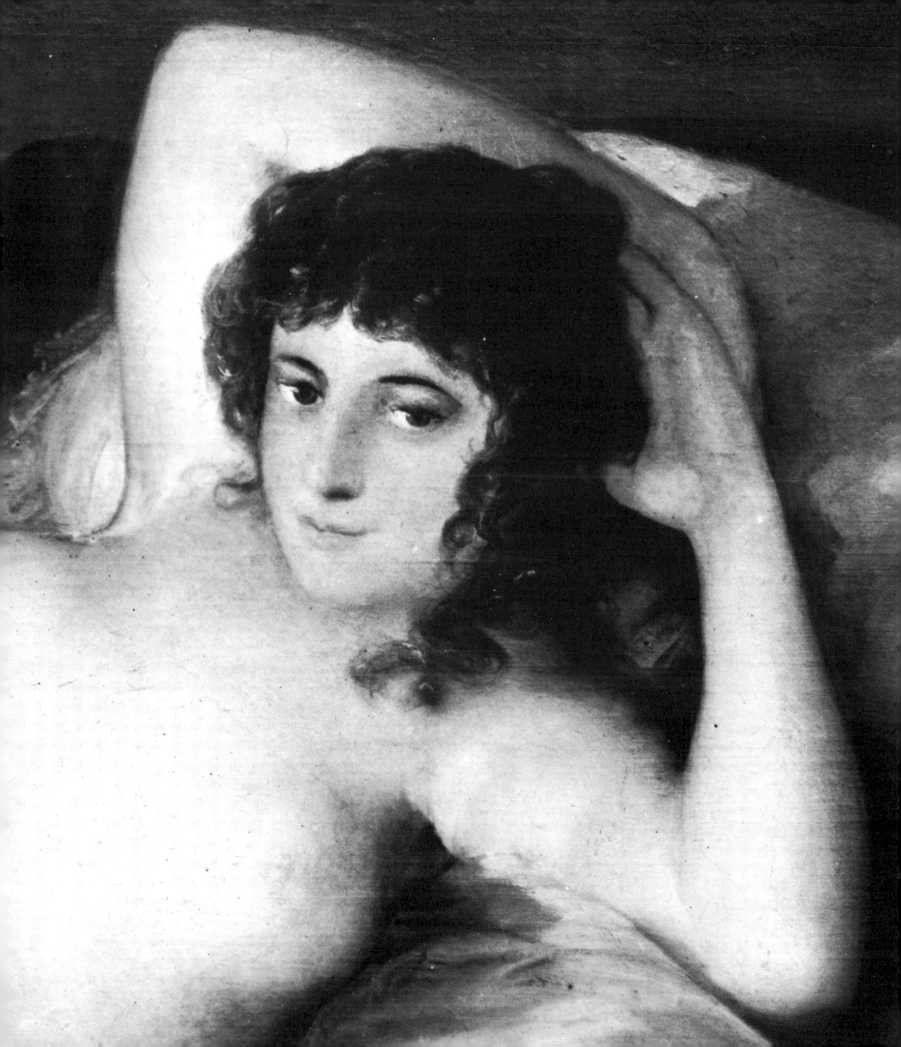

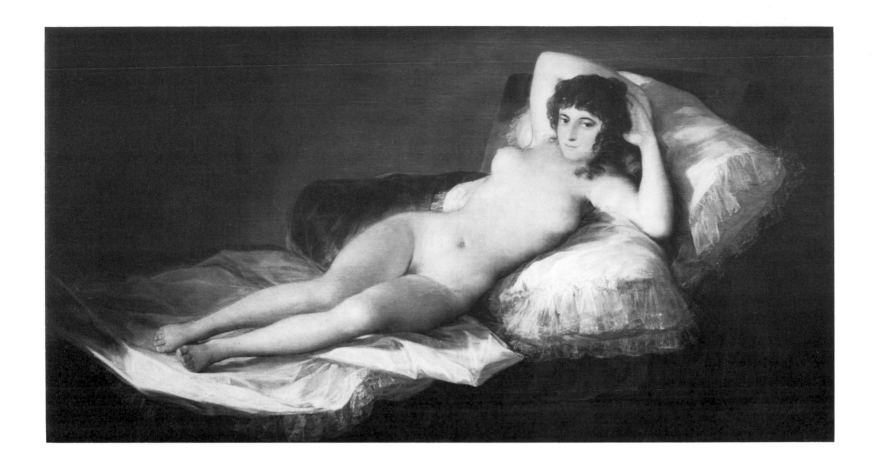

89. *La maja desnuda (The Naked Maja).* Prior to November 12, 1800. Oil on canvas. 97 by 190 cm. Madrid, Museo del Prado.

Since a few years it has finally been established that this famous painting that had been deemed to be scandalous for a long time was painted for Godoy. On November 12, 1800 it was in Godoy's Madrid palace when Céan Bermúdez paid a visit there with two companions. There Goya's *Naked Maja* was hung beside *Venus at the Mirror* by Velázquez that had been given to Godoy by the Duchess of Alba as a present.

with Cornel before going. She is a complete wreck and I don't think what happened to you before could happen now. I think too that you must regret it deeply." Thus Godoy had been La Cayetana's lover, which may explain Maria Luisa's fierce hatred of her — an implacable jealousy of that great court lady, infinitely more beautiful, more elegant, and — an unforgivable fact — eleven years younger than she. Nothing more is known of this infidelity — one of many — of the dashing Prince of the Peace. The only landmarks in his love life apart from his affair with the queen were in 1796 the beginning of his infatuation with Pepita Tudo whom he married later on when he was widowed, and in 1797 his exclusively political marriage to Maria Teresa de Borbón y Vallabriga, the eldest daughter of the Infante Don Luis.

However, Goya's work between 1796 and 1800 may help us get some idea — though perhaps not any real understanding — of the relationships between these people. It is accepted now that the *Naked Maja* (Fig. 89) was painted for Godoy in whose palace it was on its own without its companionpiece, the *Clothed Maja*, on November 12, 1800 according to the account of a visit made on that day by Céan Bermúdez and two of his friends. The document even states that she was in "an inner room or study" in the company of other Venuses, including the famous *Venus at the Mirror* by Velázquez — an important fact at that time when such nudes were considered obscene and hunted by the Inquisition. But the all-powerful Prince of the Peace could afford that kind of secret room in

his palace where forbidden paintings were hung, like the *Maja* commissioned from Goya, which was not as had long been thought painted originally for the Duchess of Alba and acquired subsequently by Godoy. And we also know now that the *Venus at the Mirror* was not pillaged by him at the death of the Duchess of Alba in 1802, as had been believed, but was actually in his palace two years previously; in fact, we learn from the same document that it had been given to him by the duchess herself.

This throws an altogether new light on the relationship between these two people which appears now to have been very close. When? Obviously after the duke's death; thus after 1796, the very year in which Goya spent the summer with the duchess at Sanlucar de Barrameda. A comparison of some of the very free drawings in the little Album of Sanlucar with the *Naked Maja* seems to suggest an erotic link between Godoy, Goya, and the Duchess of Alba, and this may have been the starting point of the famous picture in the Prado. It is no longer disputed that neither the *Naked Maja* nor the somewhat later *Clothed Maja* were actually portraits in the Duchess of Alba. But why did Goya not take his model from among the young women in the immediate circle of the duchess at Sanlucar whom he sketched quickly from life, nude or scantily dressed on unmade beds? And why did Godoy, the intimate friend of the duchess, not want to have, beside the chaste *Venus* by Velázquez she had given him — a present fraught with hidden meanings — a more provocative modern Venus by the great Goya? Finally, if we may speculate a little further, what was the part played in this passionate imbroglio by the lovely Pepita Tudo who came into Godoy's life that same year — 1796? She came from Cadiz, that is from the surroundings of Sanlucar, and we know from Moratin's diary that Goya stayed almost three months in Cadiz after his stay with the duchess, and continued to sketch elegant manolas in his albums, soon to be used for numerous plates in the *Caprices.*

Other works by Goya testify to the patronage and even the friendship the Prince extended to him. For his library he painted four round allegories of *Trade* (Fig. 87), *Industry, Agriculture* and *Science,* and probably other great allegorical subjects now in the National Museum in Stockholm. He also received commissions for several important portraits. First that of Maria Teresa de Borbón y Vallabriga who became Godoy's wife in 1797 at the demand of the queen. This is the picture recently acquired by the Uffizi. A second portrait of her, a far more touching one, was executed with incomparable mastery in 1800 when she was expecting her first child. There was also a companion piece of the *Prince of the Peace,* mentioned by the visitors of November 12, 1800; this painting has disappeared. After the War of the Oranges (1801) Goya also painted the large official picture of the Academy of San Fernando and, finally, in 1802 an allegorical portrait of Godoy for the town of Murcia. Add to this already impressive list the magnificent copy of the *Caprices* containing the ex-libris of the Prince of the Peace which is in the Library of the Institute of Art and Archaeology of the University of Paris, and we must admit that between 1795 and 1802 Godoy was one of Goya's chief patrons, perhaps his last one before the great sufferings of the Napoleonic invasion of 1808.

IV

The Time of Friendship and the Enlightenment

IV The Time of Friendship
and the Enlightenment

First contacts with the ilustrados — *a lifetime friendship with Martín Zapater — Jovellanos in Spain — repercussions of the French Revolution in Spain — Goya's friendship with Cabarrús, Ceán Bermúdez and Moratín — persecution of the* ilustrados — *Goya's intellectual transformation — Goya's illness in Cadiz: Sebastián Martínez — Goya returns to Madrid: a new art form, the "Caprices" engravings — Goya's second visit to Andalusia — Sanlúcar de Barrameda and the Duchess of Alba — first album of drawings — drawings for the "Caprices" album — protraits of the* ilustrados *and royal portraits — Goya leaves the Court.*

From the time of his arrival in Madrid at the end of 1774 and his first cartoons for the Santa Barbara Factory all Goya's efforts had but one goal: to gain the enviable posts of Painter to the King, then Court Painter, and finally First Court Painter. At the same time he continued with his much less lucrative, but extremely honorable career as an academician which was complementary to his career at court. Recall that Goya was elected to the Academy in 1780 on presentation of his *Christ on the Cross* (Prado Museum), becoming Deputy Director of Painting five years later and Director on the death of Francisco Bayeu in 1795. In 1797 he resigned from this post due to ill health. There was still, however, one more rung to be climbed if he was to reach the top of the academic ladder. In 1804 he stood as a candidate for the post of Director-General of the Academy but was unsuccessful. The result of the voting speaks for itself: 29 votes for his opponent Gregorio Ferró — who had already beaten him in the Academy's scholarship competition in 1783 — and only 8 for Goya. This failure set the seal on Goya's withdrawal from all official duties at the Court.

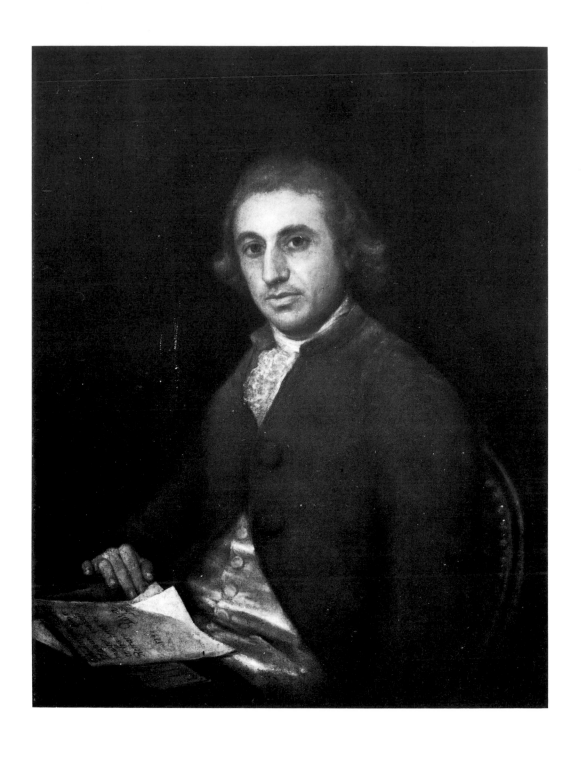

90. *Martin Zapater.* 1790. Oil on canvas. 83 by 65 cm. Signed and dated. Switzerland, private collection.

Zapater, from Aragon like Goya, had been his school mate in the school of Father Joaquin in Saragossa and became his closest friend. The exchange of letters between the two — Zapater always lived in Saragossa —

includes the years from 1775 to 1799; it is the most important source for our knowledge of Goya's life and work.

91. *Gaspar Melchor de Jovellanos.* 1798. Oil on canvas. 205 by 133 cm. Signed. Madrid, Museo del Prado.

In this portrait of Jovellanos at the height of his political success Goya depicted his friend and protector in the bearing of a thinker, not as the statesman and minister he had become in November 1797. The statue of a Minerva behind the desk underlines the wisdom and liberalism for which the important *ilustrado* was known throughout his life.

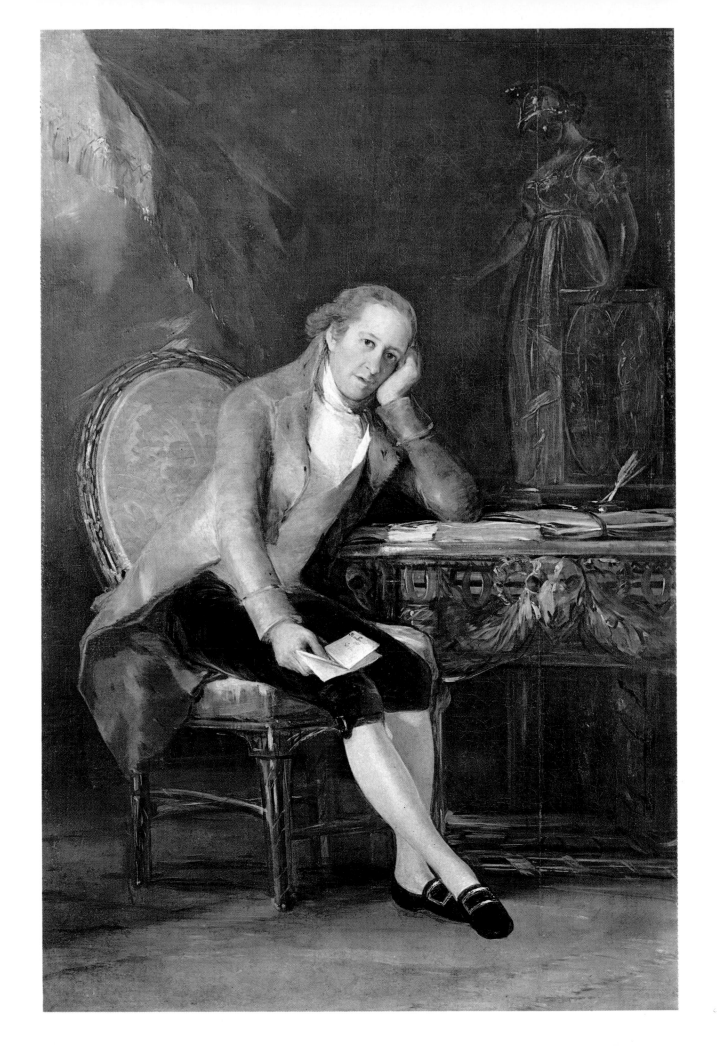

What may be termed the "upward" phase of this part of Goya's career lasted exactly from 1775 to 1799, that is, from the delivery of his first cartoons to his appointment as First Court Painter. It coincides fairly closely with the last quarter of the century, a period that was extremely important in the internal development of Spain. A report of the Madrid Economic Society observes that about 1785 there was "a general ferment in all the provinces." This was primarily an intellectual ferment, characteristic of the century of the Enlightenment in which Spain played an important part just as England and France which had led the way. In Madrid the spirit of innovation had been encouraged in particular by the publication in 1774 of the *Discurso sobre el fomento de la industria popular* ("Disser-

92. *Juan Agustin Ceán Bermúdez.* 1798-1799. Red pencil drawing. 12.2 by 9.8 cm. Madrid, Carderera collection.

Ceán Bermúdez, who was supported by Jovellanos, was one of the most important art historians of his time. This certainly accurate portrait was to be the front cover for his most significant book, the *Diccionario Histórico de los mas ilustres Profesores de las Bellas Artes en España,* however, the book was then published in 1800 in Madrid without the illustration.

93. *Juan Agustin Ceán Bermúdez.* Around 1790-1797. Oil on canvas. 122 by 88 cm. Madrid, Marques de Perinat.

This portrait of Goya's and Jovellanos' close friend adheres to the conventional type of the French *portrait de bibliothèque.* Since Ceán Bermúdez was banned to Seville in 1790 — at the same time Jovellanos was sent into exile in Asturia — he could have sat for this portrait for Goya in Seville before the painter fell ill, or it could have been in Madrid either prior to 1790 or after 1797, when he was once again in favor.

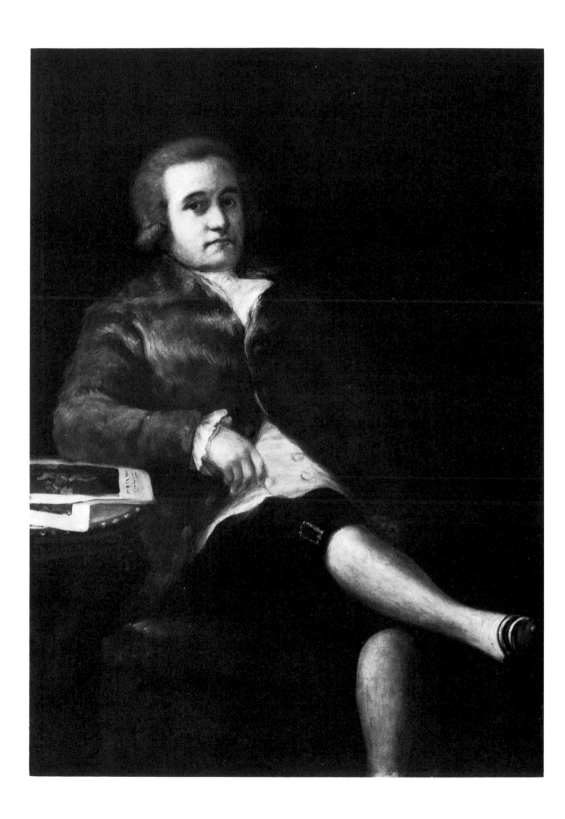

tation on the development of popular industry") by the Count of Campomanes, Procurator of the Supreme Court of Castile, which was followed by a frenzied rush to set up Economic Societies in every town, large or small, throughout the kingdom. The example had been set by the Basque country where the first Economic Society, modeled on the Academy of Sciences in Toulouse, was established in 1765. Although the main emphasis was on the applied sciences that were indispensable to the development of the economy (especially through agriculture and industry), these societies could deal with a whole range of subjects — from mathematics to literature and the fine arts, and even modern languages.

In June 1775 the Council of Castile approved the foundation of an Economic Society in Madrid and Campomanes agreed to be a member. The King himself in token of his support endowed the new society with three thousand reals a year. Its statutes were to serve as models for all such societies in Spain; it was the ultimate channel through which the Council of Castile was informed of all the requests submitted by the provincial towns. Madrid was thus particularly active as an official center of the Enlightenment under the protection of Charles III and the all-powerful Council of Castile.

Goya delivered his first tapestry cartoons for the Santa Barbara Factory just when the Spanish capital in its turn was entering this great movement of renewal in which some of the country's most brilliant minds would take part. Did his work as a painter at the side of his brother-in-law Francisco Bayeu under the direction of Mengs give him the entry to enlightened circles in Madrid and if so what effect did this have on his art? From the surviving documentary evidence, notably Goya's own correspondence with his friend Martín Zapater, Goya's real personality during his first ten years in Madrid (1775-1785) is revealed. Ortega y Gasset sums it up very well in the quip already quoted when he says that his letters are those of an *ebanista,* that is, the opposite of the artist — or at least of the conception of the artist that has prevailed since the nineteenth century. In fact, just like a cabinet-maker, Goya considered his occupation a trade, a sort of "superior craftsmanship" from which he might derive not only moral satisfaction but even more important enviable material satisfaction.

The artistic circles in which he lived, first in Saragossa then in Rome and in Madrid, closely linked with the Bayeu clan, could only have confirmed this attitude. He does not seem to have picked up any "culture" in the sense in which we understand it today. His parents, his childhood and the Fathers of the Escuelas Pías had not endowed him with the means of doing so; his letters show him at the age of thirty, and even at forty, to be as uncouth in his style as in his tastes and pleasures. His main interest was hunting and he never missed an opportunity to inform his friend Zapater of his prowess as one of the best shots in Madrid. He gives routine news of his health and his family — with his wife Pepa taking up no more than a few lines on the occasion of each birth — and deals with painting only in terms of work and in connection with the occasionally squalid rivalries in the small world of the Court. There is never

94. *Leandro Fernández de Moratin.* 1799. Oil on canvas. 73 by 56 cm. Madrid, Real Academia de San Fernando.

Just like Jovellanos, this famous author belonged to the circle of the *ilustrados* in which Goya was at home, as well. Being versed in the witch trials, he played a decisive part in the conception of the *Caprichos.* The diary and the correspondence of this friend and protegee of Godoy are indispensable for an understanding of Goya's times.

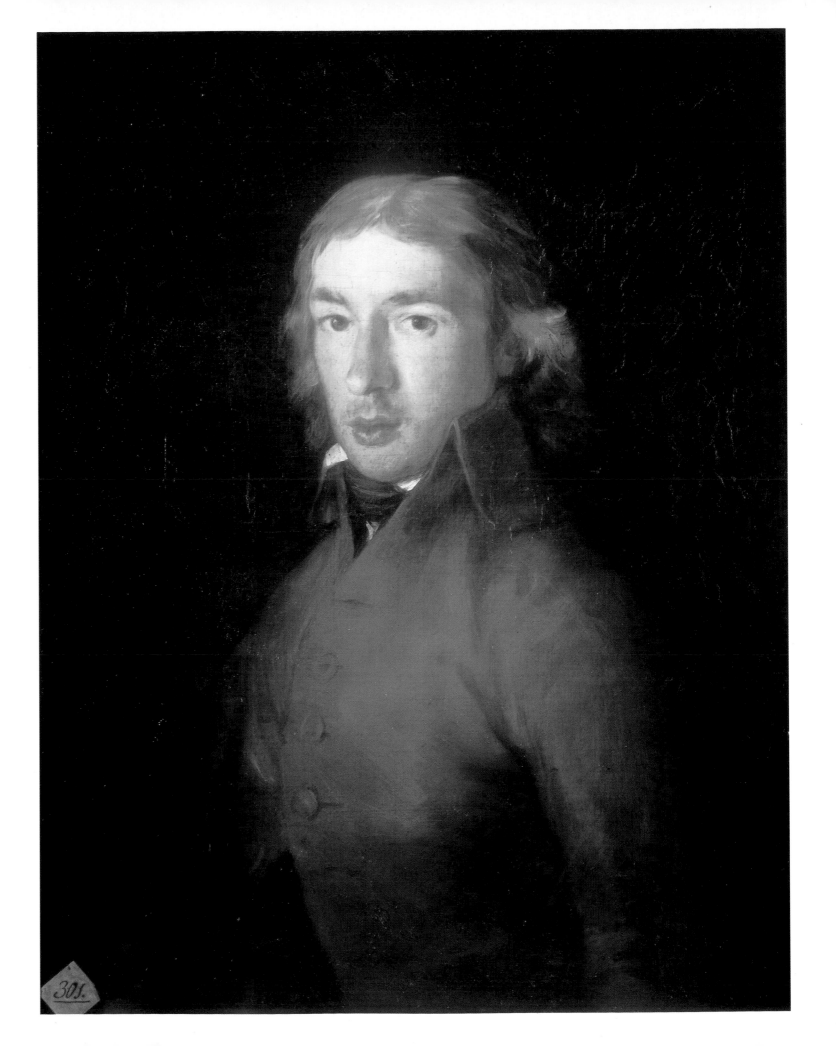

a reflection, a phrase, a word that indicates some interest, however fleeting, in anything other than the trivial incidents of daily life. His writings show not the slightest trace of all the new ideas that were spreading to the remotest province. He lived, like thousands of Spaniards, *a la buena de Dios* (by God's grace) — that is, without venturing in spirit beyond his own little circle of friends and relations.

During his early years in Madrid his most faithful friends were those that he had left behind in Saragossa — notably Martín Zapater whom he had known and liked ever since they attended Father Joaquin's school together, and also Juan Martín Goicoechea, one of the most distinguished minds of his time, a great benefactor of his province and the attentive protector of the painter during his early days at court. Up to 1780 Goya associated mainly with his fellow designers of cartoons for the Santa Barbara Factory whose interests were much the same as his own. The only glimpses of a world beyond the confined circle of craftsmen was provided by Mengs and by people like Antonio Ponz, Secretary to the Academy since 1776, who urged him to publish the series of etchings after Velázquez in 1778. It is possible that for Goya the reflections on painting in the letter from Mengs to Ponz that prefaced *Viaje de España* constituted a starting-point not only for his first important engravings but also for a more exacting conception of art.

Goya's admission to the Royal Academy of Arts of San Fernando in 1781 marked a significant advance socially and introduced him to artistic considerations of a different order. As an academician he had to take an interest in the teaching of drawing and painting, to consider the comparative merits of works submitted to him, and to attend the meetings of the Academy and listen to the speeches. His new associates were notables whom, at the Santa Barbara Factory, he had not been permitted to meet, let alone deal with on equal terms.

In July 1781 he attended a public meeting at which Mélendez Valdés read his poem "To the Glory of the Arts" and Jovellanos delivered a "Eulogy of the Arts." It is difficult to establish when the painter first became acquainted with these two eminent figures of the Spanish Enlightenment. Their official participation in the work of the Academy to which Jovellanos was admitted as an honorary member in the same year as Goya certainly facilitated their meeting if it did not actually bring it about. This occurred just when Goya had hastened back from Saragossa after the affair of the El Pilar frescoes and was more than ever in need of genuine support and friendship in Madrid. That the King commissioned him to paint one of the seven altarpieces at San Francisco el Grande (July 20, 1781) was in itself a marvelous revenge for his humiliation in the Aragonese capital, and the esteem of people like Jovellanos and his friends gave him the moral support and encouragement he needed for the road that lay ahead.

There is no need to stress the important part played by Gaspar Melchor de Jovellanos in Spanish history in the concluding years of the century. In the troubled often chaotic period that followed the French Revolution he represented the enlightened conscience of his country. Concerned above all for the welfare

95. *Sebastian Martinez.* Oil on canvas. 92.9 by 67.6 cm. Signed and dated. New York, The Metropolitan Museum of Art.

Goya had already met Sebastian Martinez in Madrid, in other words, before his departure to Andalusia in 1792. This explains why the painter, who fell ill in Seville, was taken to Cadiz and Martinez, who held the office of the General Treasure of the Financial Council there. During his long period of recovery Goya had the opportunity to study Martinez' important collection of paintings in depth.

Dn Bernardo Yriarte. Vice-prot.r de la R.l Academia de las tres nobles
Artes. retratado por Goya. en testimonio de mutua estimac.n y afecto. año de
1797

96. *Bernardo de Iriarte.* 1797. Oil on canvas. 108 by 84 cm. Signed and dated. Strasbourg, Musée des Beaux-Arts.

The name of this important *ilustrado* remains tied to a series of small pictures by Goya. After his recovery, the painter sent them to the then Viceprotector of the Academy of San Fernando in early 1794. Iriarte was a minister in 1797 simultaneously with Jovellanos and Saavedra; later, he strongly sided with Joseph Bonaparte and, upon the return of Ferdinand VII, he went into exile in Bordeaux.

97. *The Duke of Alba.* 1795. Oil on canvas. 195 by 126 cm. Madrid, Museo del Prado.

The portrait is the counterpart to that of the Duchess in a white garment that is in the collection of the Duke of Alba (illustration 75). The proud young woman is contrasted with the almost dreamy Duke leaning on a piano and leafing through a score by Haydn. The Duke died suddenly during the following year, just as Goya arrived in Andalusia for the second time.

98. *Sueño Primero. (First Dream).* Drawing; pen and sepia. 24.7 by 17.2. Madrid, Museo del Prado.

Goya used this drawing for sheet 43 of the *Caprichos,* originally it was to have served as the front cover for the series of the *Sueños.* The long legend — Goya was probably inspired by the *ilustrados* — is essentially a confession of faith; it introduces the series as a "universal language" intended to "ban harmful superstitions" and to give the "reliable testimony of the truth" durability.

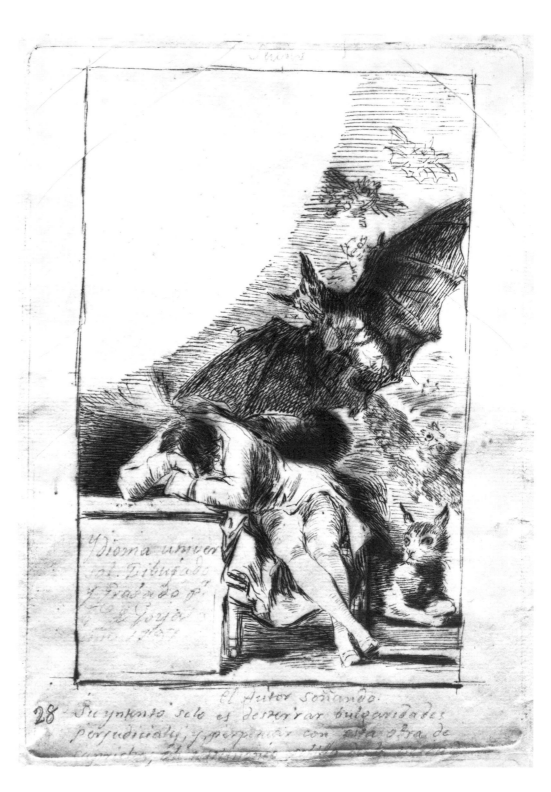

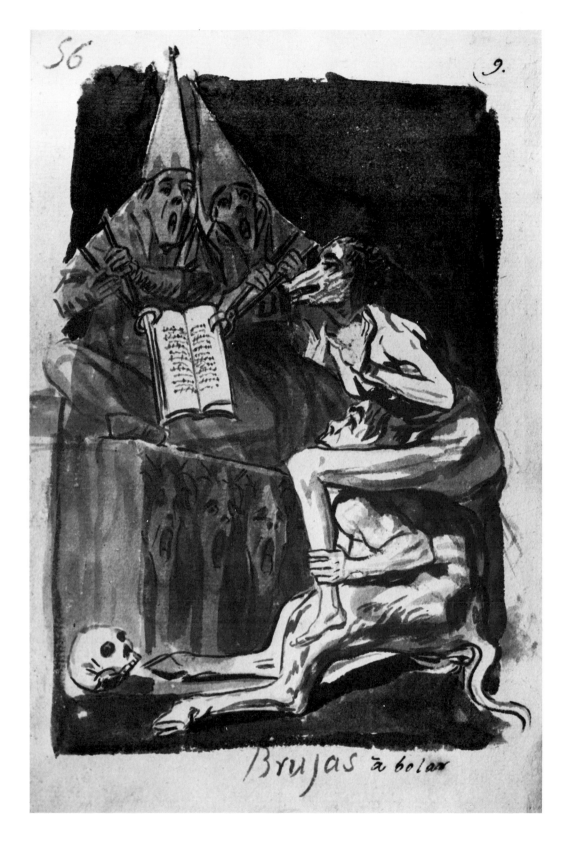

99. *Brujas a bolar (Witches ready to Fly.)* 1796-1797. Drawing from the Madrid Album (B. 56); Chinese ink, wash. 23.7 by 15 cm. Switzerland, private collection.

This first representation of a witch scene in Goya's *oeuvre* was his basis for sheet 70 of the *Caprichos;* with its ambiguous title *Devota profesión,* however, it is probably more inclined toward religious satire.

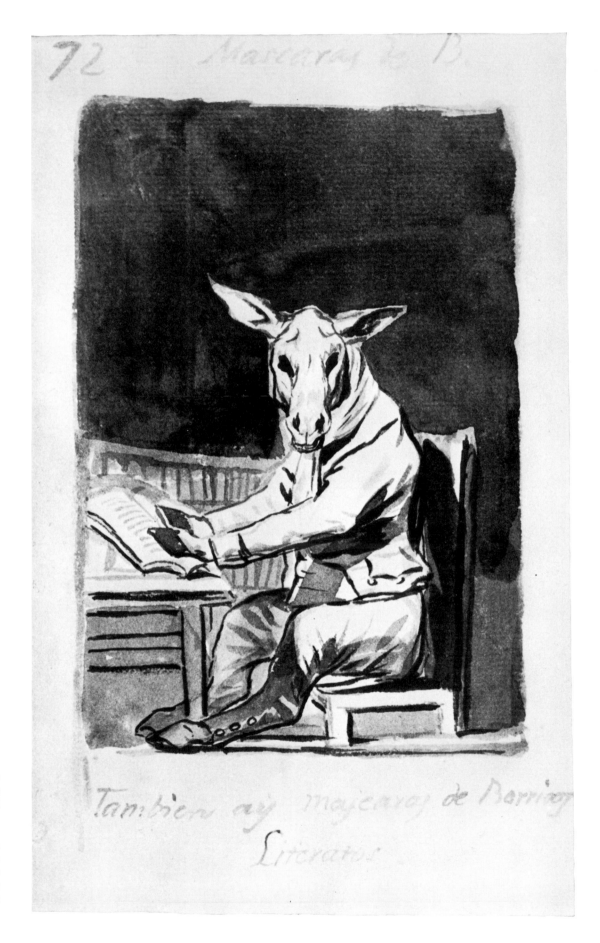

100. *Máscaras de B. También ay máscaras de Borricos Literatos (Masks of A. There are also Asses who put on the Mask of the Literati).* 1796-1797. Drawing from the Madrid Album (B. 72); Chinese ink, wash. 23.5 by 14.5 cm. Switzerland, private collection.

In 18th century satire critical of the society, humans were frequently replaced by asses. Goya adapted this mode of representation for six successive sheets of the *Caprichos* (Nos. 37-42). He used this drawing on sheet 39, *Asta su Abuelo* (Back to his Grandfather), a satire on the aristocracy infatuated with their pedigree.

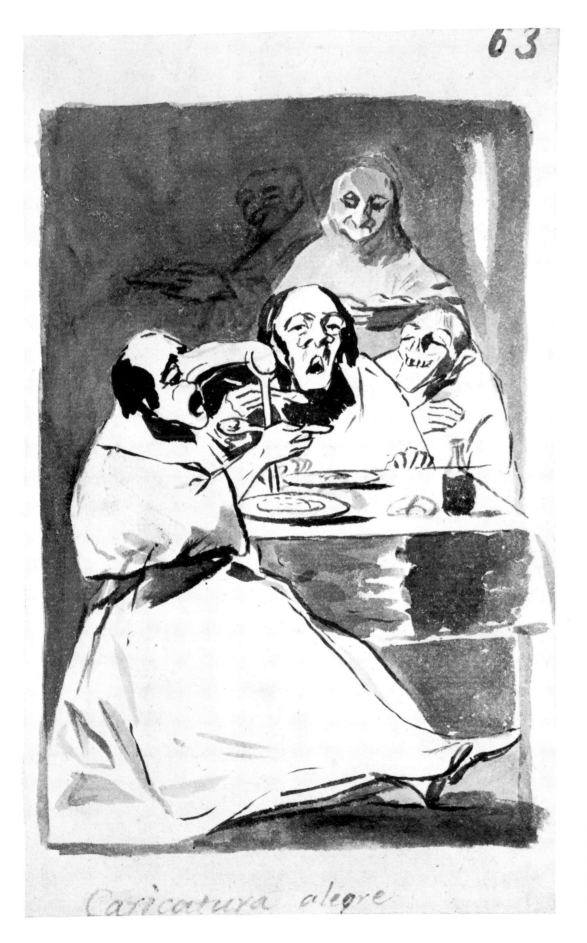

101. *Caricatura alegre (Funny caricature)*. 1796-1797. Drawing from the Madrid Album (B. 63); Chinese ink, wash. 23.2 by 14.2 cm. Madrid, Museo del Prado.

Goya adds the grotesque characteristic of the enormous nose, he uses it to express their lasciviousness, to his first satire against the monks gorging themselves with food in their refectory. On sheet 13 of the *Caprichos,* that is based on this drawing, he adapts this allusion in the ambiguous legend *Estan calientes* (see illustration 109).

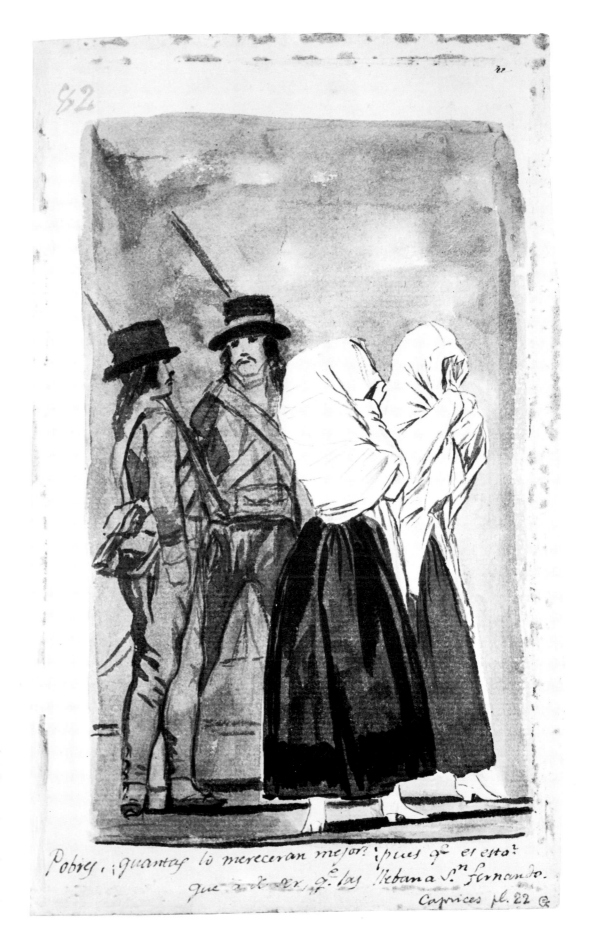

102. *Pobres ¡quantas lo mereceran mejor! Pues ¿que es esto? que a de ser, que las lleban a San Fernando (The unfortunate wretches! There are so many who would deserve it more! But what is happening? They are being taken to San Fernando).* 1796-1797. Drawing from the Madrid Album (B. 82); Chinese ink, wash. 23.4 by 14.8 cm. Paris, private collection.

The topic of this drawing reappears on sheet 22 of the *Caprichos* (illustration 110) with the title *Pobrecitas* (Poor Little One!). As do the *ilustrados,* Goya deplores the fate of the poor prostitutes being taken to prison. In addition, the caption indicates that much more severe crimes remain unpunished.

of his fellow citizens, this "quiet man" from the Asturias devoted the best part of his career to the foundation and development of his Asturian Institute at Gijon. In 1797 he served for a short time as minister almost against his will; later he was to experience the bitterness of an unjust exile, followed by imprisonment in the harshest conditions at Bellver Castle in Majorca. His life was exemplary from start to finish for its integrity and honesty, sometimes pushed to heroic extremes. When he came to live in Madrid in 1778 Jovellanos had just spent ten years in Seville where he demonstrated his many-sided talents as a jurist, economist and writer. He served with authority as criminal judge at the Royal Tribunal of Seville, making friends with the celebrated "assistant" Pablo de Olávide, organizer of the agricultural colonies of the Sierra Morena and university reformer. This well known *afrancesado,* a reader and correspondent of Voltaire, thus had a profound influence on the future author of the *Informe sobre la Ley Agraria* ("Report on the Agrarian Law"), whom he met at the gatherings of the Seville Friendly Society to which both men belonged. The dramatic condemnation of Olávide by the Inquisitor and his public retraction in 1776 during an exemplary *autillo-da-fé* led Jovellanos to meditate on religious intolerance and establish his own line of conduct for the future.

In Madrid where Jovellanos took up his functions as judge *(Alcade de Casa y Corte)* in 1778, his new circle of friends included the Count of Campomanes and the French-born Cabarrús, who became a naturalized Spanish subject in 1781 and went on to found the Bank of San Carlos, now the Bank of Spain. In due course they were joined by Agustín Ceán Bermúdez, head of the bank's secretariat. It was between 1780 and 1783 that Goya came to be on familiar terms with these men who were much more cultivated than any with whom he had personally associated. They were all enthusiastic participants in that great crusade of "enlightenment" which sought to bring both economic prosperity and social justice to Spain. The novelty of their talk opened up a new and unsuspected world for Goya though it was one that seemed very remote from his immediate preoccupations for he was fully engaged in the contest at San Francisco el Grande and also seeking an influential patron. Snowed under with important commissions, he was intoxicated by his success with the most notable families of Madrid such as the Osunas, the Altamiras and the Medinacellis.

He was now entering the period of worldly success that would culminate in his appointment as Painter to the King in 1786. His friends gave him their unqualified support in his struggle for a position at court. In 1784 Jovellanos was instrumental in getting him a commission to paint four large pictures for the College of Calatrava in Salamanca. In the following year it was through the good offices of Ceán Bermúdez that he started the series of portraits of the directors of the Bank of San Carlos which would conclude in 1788 with that of Cabarrús — a particularly successful work, perhaps because artist and sitter were already friends. Goya's social position was thus very different in 1786 from what it had been ten years earlier. He summed it up for his friend Zapater in his own direct and lively way: "I made myself an enviable life style, I cooled

103. *Francisco de Saavedra.* 1798. Oil on canvas. 196 by 118 cm. London, Courtauld Institute Galleries.

Saavedra was designated Secretary of Finance in November 1797, the same time Jovellanos was made Secretary of Justice. In August of the following year both of them had to quit their offices due to a severe poisoning. The portrait must have been created during the first half of 1798 prior to the strange illness of the minister.

166

104. *Mariano Luis de Urquijo.* Around 1798-1800. Oil on canvas. 128 by 97 cm. Madrid, Real Academia de la Historia.

Urquijo was thirty when he replaced Saavedra in August 1798. In December 1800 he was removed from office and placed under arrest; the following year he was taken to Pamplona at the same time that Jovellanos was deported to Mallorca. This portrait of the young minister could be a replica of a different, now lost original; the replica was commissioned by the Real Academia de la Historia.

my heels in nobody's waiting room, anyone who wanted something from me had to run after me; I made myself even more sought after and would not work for anyone who was not of exalted rank or recommended by a friend." From this moment, Goya was no longer in need of a protector since he had not only ceased to be a petitioner but was himself sought after.

With the accession of Charles IV and Maria Luisa of Parma to the Spanish throne in 1789 their patronage made him the country's most prominent painter. He was commissioned to do the official portraits of the King and Queen on the occasion of their coronation and at the instigation of Jovellanos he was also asked to do copies for the Academy of History. On April 25 in the same year he was appointed Court Painter and was sworn in "swordless and hatless" at

the Palace of Aranjuez, but — as he noted in a letter — "with the same emolument as before," i.e., fifteen thousand reals. He was certainly given a cordial welcome by the royal pair for he states in a postscript that "I kissed Their Majesties' hands and I was received with some ceremony."

Goya's fame was not confined to the Court and the narrow circle of painters belonging to the Academy. His talent was recognized outside Madrid and even foreigners cited him as one of the masters of the modern Spanish school. For example, the Baron de Bourgoing in his *Tableau de l'Espagne moderne* ("Picture of Modern Spain") published in 1789 mentions the painters who decorated the chapels of San Francisco el Grande. Maella and Bayeu, "otherwise known as 'el Aragonés," head the list, and it concludes with "Don Francisco Goya who has the talent to render the customs, costumes and pastimes of his country faithfully and agreeably." The author, who lived in Madrid from 1777 to 1787, thus states that Goya was already renowned for his tapestry cartoons. Later on in the third edition of his *Tableau* he added a note pointing out that "Goya now excels in portraiture."

Bourgoing had in the meantime returned to the Spanish Court on an important diplomatic mission to Charles IV in February 1792; the little addition just quoted is a measure of the rapid development of Goya's reputation in Madrid between 1787 and that date. The portraits of the King and Queen painted in 1789 certainly did much to bring about the change recorded by Bourgoing. They were also at the origin of the honors bestowed upon the painter in the following year: first, in his homeland where the Saragossa Friendly Society made him an honorary member in October 1790; then, in Valencia where he became an associate of the Royal Academy of San Carlos. It was a far cry from the time when the records of the tapestry factory confused him with his brother-in-law Ramón Bayeu. Now he had made his name and was not unduly modest about it: "I have become such a celebrity that from the King to the humblest in the land everybody knows me," he wrote to Zapater between two letters crammed with almost untranslatable obscenities and observations on quail-shooting, chocolate, and the gross of sausages for which his friend had asked him.

While the reign of Charles IV had started under the most favorable auspices for Goya, the wind of revolution from France soon stirred up political passions in Spain and radically changed the climate of contented opulence in which the painter had hoped to pass the rest of his days. The insidious spread of revolutionary ideas across the Pyrenees began to disturb the authorities and even those enlightened circles that had originally quite welcomed the constitutional reforms in the neighboring country. A number of political refugees (mainly monks) flooded into Spain and by their very presence gave people in the provinces where they took refuge some idea of the magnitude of the events responsible for their plight. In addition, Frenchmen living in or passing through Spain spoke with the greatest approval of the new political developments in their country, even urging young people to support the ideas of the revolution. Spain was particularly favorable ground for the spread of this dangerous contagion since the mass of the people were suffering considerable hardship because of the country's

105. *Pedro Mocarte*. Around 1805-1806. Oil on canvas. 78 by 57 cm. New York, The Hispanic Society of America.

Goya's circle of friends was not limited solely to the *ilustrados* as this portrait of a singer of the Cathedral of Toledo proves; the writing by an unknown person on the back of the canvas states that the singer was an *intimo amigo* of the painter. Goya's sympathy for his model is completely apparent in the lively face and in the warmth of the expression.

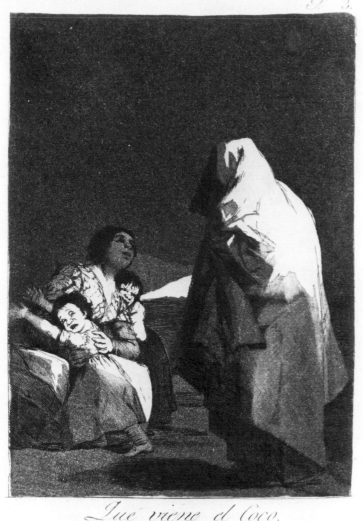

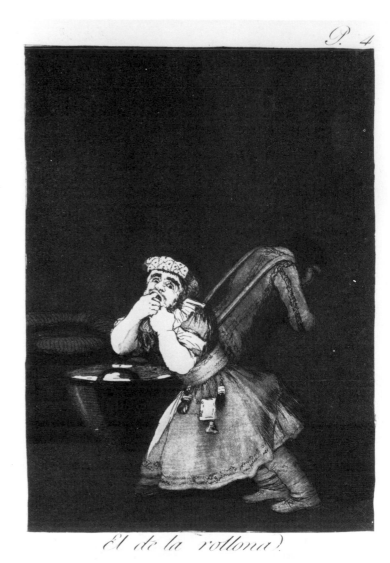

Que viene el Coco.

El de la rollona?

106. *Capricho 3: Que viene el Coco (There comes the Bogy Man).* 1797-1798. Etching and aquatint. 21.7 by 15.3 cm.

This sheet of the *Caprichos* that is especially successful in the effects of light and shadow that can be obtained through the use of the aquatint technique is directed against mothers who rear their children in senseless fear of phantoms.

107. *Capricho 4: El de la rollona (That of the Governess.)* 1797-1798. Etching and aquatint. 20.7 by 15.1 cm.

Another terrible consequence of a bad upbringing: the spoiled, prematurely aged, child is being dragged about by a domestic servant as though it were some kind of strange animal.

economic difficulties and there had even been riots in some of the provinces. In 1789 the first attempts to spread the gospel of revolution happened to coincide with a state of famine due to the poor harvest in the preceding year. During the summer the provision of food for the cities was a serious problem for the government, and hostile demonstrations took place in the country districts of Old Castile where corn was being appropriated. In other regions riots were caused by the increase in the price of bread. Practically everywhere feelings were running high and the example of Paris, based on news that was inevitably distorted as it spread by word of mouth, became more contagious than ever.

This situation obliged Charles IV to change his attitude towards the *ilustrados* (men of the Enlightenment) at the outset of his reign. The economic, industrial and educational reforms that had seemed so desirable in the reign of Charles III who encouraged them now seemed to be dangerous incitements to disorder and even anarchy. It is therefore not surprising that the authorities did everything in their power to restrain the Enlightenment in Spain and then with the escalation of revolutionary violence to suppress it.

At that time three men embodied the enlightened despotism of Charles III's reign, namely Campomanes, Jovellanos and Cabarrús, the last-mentioned being particularly noted for his very liberal opinions and French origins. Although Charles IV bestowed the title of Count on him in 1789 his many enemies at the Court succeeded in denouncing his *Eulogy of Charles III* to the Inquisition with the result that he was sent to prison in June 1790. This resounding fall led to others; many people in his circle were exiled or put under supervision. But the principal victim was Jovellanos who had not hesitated to rush to the aid of the man always referred to as "the friend" in his correspondence. While in Salamanca visiting the College of the Immaculate Conception of Calatrava at the behest of the King, he learned of the arrest of Cabarrús (on the pretext of irregularities in his administration of the Bank of San Carlos) and at once returned to intercede for him with Campomanes, Governor of the Council of Castile which was responsible for the bill of indictment.

Ceán Bermúdez, who acted as intermediary, has left an account of this dramatic episode in Spanish affairs. Campomanes' reply was unworthy of his past renown and sheds light on the character of the two men. He informed Ceán Bermúdez "that Jovellanos was his friend, that he could consider his [Campomanes'] house as his own and that, if he came to speak to him about the affair of his friend [Cabarrús], he would not be able to tell him anything because he knew nothing about it, but that even if he had known something he would not have told him anything, that Jovellanos wished to be a hero and that His Excellency could not emulate him in this." So Jovellanos, for having tried to save his friend and as Campomanes said to be "heroic," was sent into exile four days later. Or rather he was cunningly sent on an information mission to the coal mines in his native province of the Asturias. This "mission" was to last until 1797 when he returned to public life as Minister of Grace and Justice. During this period other lifelong friends of Goya's suffered to a greater or lesser extent. Ceán Bermúdez, a colleague of Cabarrús at the Bank of San Carlos since its foundation and an intimate friend of Jovellanos, was likewise banished from court — in other words he was sent by the King to Seville to tidy up the General Archives of the Indies. He returned to Madrid only in 1797 at the same time as Jovellanos to become a member of the latter's secretariat. Finally, Leandro Fernández de Moratín, already well known as a brilliant writer, was also affected by the events of the time though to a lesser degree. Since 1786 on Jovellanos' recommendation, he had been employed as secretary to Cabarrús whom he accompanied to France the following year. When his protector went to prison he lost his job and decided to leave Spain. He spent the next few years (1792-1796) traveling around Europe.

Cabarrús, Jovellanos, Ceán Bermúdez and Moratín are all names that remind us of famous portraits painted by Goya at various dates; the first portrait of Ceán Bermúdez, about 1795, probably to thank him for an important commission for portraits on behalf of the Bank of San Carlos and for his advice on the purchase of shares in that bank; the portrait of Jovellanos (Fig. 91) (Valls y Taberner Collection, Barcelona), perhaps about the same time, a forerunner

of the fine melancholy portrait of 1798; that of Cabarrús, as one of the directors of the bank, in 1788 (Fig. 64); and finally that of Moratín (Fig. 94) in 1799. All these *ilustrados* had known and respected Goya as a man and as an artist before 1790. They then disappeared from Madrid for political reasons, not to return until Cabarrús was restored to favor with Godoy and appointed Jovellanos as Minister of Grace and Justice.

What was Goya's attitude towards the persecution of the members of his set? There are no documents giving precise details on this point, and it should not be forgotten that the very serious illness which struck him down in Seville at the end of 1792, the total deafness that ensued, and a second stay in Andalusia in 1796-1797 prevented him from taking any part in public life until the spring of 1797. But as early as 1790 at the time of Cabarrús' imprisonment and the

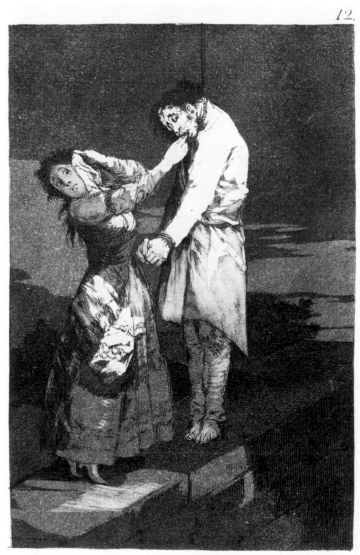

A caza de dientes.

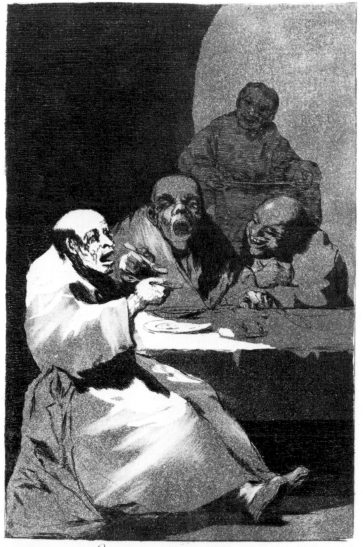

Estan calientes.

exile of his friends Jovellanos and Ceán Bermúdez, a very curious observation in one of Goya's letters to Zapater shows that he had become aware of the need to base his life on criteria other than money, success, hunting and flamenco singing. The facts are as follows. Goya had received the scores of four *tiranas* and of four *seguidillas* and *boleros,* which he sent to Zapater to copy on condition that they should not be lent to anyone. After posing this condition he went on: "With what satisfaction you will hear them. As for me I have not yet heard them and I probably never shall for I no longer go to those places where I could hear them because I have got it into my head that I must be resolute and maintain the degree of dignity that befits a man; with all that, as you can imagine, I am not very happy."

One is struck by the change of tone and by the inner struggle in this man of forty-four between the easy pleasures to which he was accustomed and that "dignity" of which his friends had given him an example in their adversity. But there was undoubtedly more to it than that; Goya's plebian tastes were the complete opposite of those of the *ilustrados.* For them, *majismo* and all its manifestations were reprehensible. Jovellanos took the lead in protesting against the barbarity of Spanish customs; in his *Memoria sobre la policia de los espectáculos y diversiones y su origen en España* ("Memorandum on the policing of public entertainments and amusements and its origin in Spain"), he took violent exception to public dances — "What are they but a miserable imitation of the unbridled and indecent dances of the common people? In other nations, dancers represent gods and nymphs on the stage; here they are *manolos* and fishwives." He also condemned bullfighting and was full of praise for Charles III for having banned it in 1785. "It is thus very clear that the Government was quite right to forbid this kind of spectacle and that when it has perfected this salutary measure by abolishing the exceptions that are still tolerated it will have earned the respect and esteem of all men of good repute and good sense."

Ortega y Gasset has already drawn attention to the dividing line in Goya's development represented by his transition, not without difficulty, from an unreflecting life style to the much more exacting one of the *ilustrados.* He even speaks of a veritable conversion, a radical change in social attitudes affecting the artist's whole being. When this intellectual metamorphosis, which (as his letter to Zapater shows) he experienced about 1790, is set beside the very serious illness that shattered his life physically and spiritually at the end of 1792, it is understandable how the occurrence of two such major upheavals during such a short interval created a different Goya and with him a body of work that could not have been foreseen in the light of his earlier development. Between 1792 and 1797 in circumstances that are still far from clear, there was a reorientation in Goya's life towards Andalusia, in particular the Cadiz region. As regards his first stay in southern Spain and the illness that obliged him to remain there for six months, all that could reasonably be said has been said.

Nevertheless, many of the details of this period of his life are still shrouded in mystery. What was his real motive for leaving Madrid without permission at the end of 1792? What was the exact nature of the illness from which he

Pobrecitas!

2 3.

Aquellos polbos.

110. *Capricho 22: Pobrecitas! (Poor Little One!)*
1797-1798. Etching and aquatint. 21.8 by 15.2 cm.
The legend of the picture is an exclamation of sympathy
with the poor girls who are sent to prison because they
prostituted themselves. In Goya's opinion there is
something wrong with the society for there are others
more deserving of being imprisoned who remain free.
The text on the drawing from the Madrid Album (B. 82)
is much clearer (see illustration 102).

111. *Capricho 23: Aquellos polbos (This Dust).* 1797-1798.
Etching and aquatint. 21.7 by 14.8 cm.
The title is derived from the Spanish saying *Aquellos
polvos traen estos lodos* (A lot of dust creates a lot of dirt),
whereby *polvos* can mean dust as well as magic powder.
The picture shows a witch trial at the moment of the
reading of the accusations; the accused is wearing the
pointed hat, the *coroza,* as demanded of its victims by the
Inquisition tribunal.

nearly died? What did Martín Zapater mean in a letter to Bayeu when he referred to the "lack of reflection" that had thrust Goya into the situation in which he still found himself at the end of May 1793? Why did nobody in his family, not even his wife nor his brother Camilo who owed so much to him, come to his bedside in Cadiz, however well his friend Sebastián Martínez was looking after him? It is extremely difficult if not impossible to answer any of these questions.

Quite apart from the problems relating to the illness itself, one of the most interesting aspects of this dramatic episode in Goya's life is his actual stay with Sebastián Martínez. This rich businessman lived with his three daughters in a vast house in Calle Don Carlos, Cadiz. There he had assembled a remarkable collection of paintings, engravings and drawings which was valued at almost 400,000 reals at the time of his death in 1800. It is thus appropriate to ask oneself whether the daily sight of this regular art gallery over a period of six months contributed to the transformation in Goya's work. There can be no doubt that his lengthy convalescence was spent in a setting that was extremely propitious for a thorough reconsideration of his art. Also, his hypersensitive state following his illness would have made him particularly receptive to the wide variety of pictures surrounding him in his friend's house — paintings by Mengs, Murillo, Velázquez, Pieter de Hooch, Titian, Ribera and Guido Reni, as well as thousands of engravings, including Piranesi's *Vedute* and *Antichità*. However, it should not be forgotten that Goya had had an opportunity to study an even more impressive collection a few years earlier on the two occasions when he stayed with the Infante Don Luis at Arenas de San Pedro.

Sebastián Martínez' personality is known to us mainly from Goya's portrait of him, a masterpiece of naturalness, combining intense humanity with classical dignity. It is known now that Martínez had played a part in Goya's life before the latter turned up at his house in Cadiz. He had stayed in Madrid in the spring of 1792, and it was there that the portrait was executed and not at Cadiz where Goya was in no fit state to work. Thus they were already on friendly terms before Goya's journey to Andalusia, and letters have survived showing that Martínez also knew Martín Zapater and Antonio Ponz. Recalling that Ceán Bermúdez had been living in semi-exile in Seville since 1790 and had probably accompanied the seriously ill Goya to Cadiz to settle him in Martínez' comfortable home, it is evident that this veritable network of friends played an important role in Goya's life in the years 1792-1793. In fact, it may have had much to do with his almost clandestine departure from Madrid.

Had he planned this during the previous spring — at the time of the portrait — in agreement with Martínez? Was it only, as a letter from Martínez to Pedro Arascot (March 19, 1783) suggests, a sightseeing trip to the cities of Andalusia? Or did the "lack of reflection" mentioned by Zapater relate to some hazardous undertaking of the painter's in connection with the political upheavals in Spain during 1792? Among the events of that year were the fall of the Count of Floridablanca followed by his exile and imprisonment, his replacement by the Count of Aranda, and the irresistible rise at court of the young Godoy who

Tu que no puedes.

Lo que puede un Sastre!

112. *Capricho 42: Tu que no puedes (You, who cannot do it).* 1797-1798. Etching and aquatint. 21.7 by 15.1 cm.

The title of the picture is the beginning of a Spanish saying: *Tu que no puedes, llevame a cuestas* (You, who cannot do it, carry me on your back). The accusation is directed at the vain and narrow-minded aristocracy crushing the peasants under their weight. The sheet is part of the group of the *asinaria,* the first example of which is a drawing from the Madrid Album. (B. 72) (see illustration 100).

113. *Capricho 52: Lo que puede un Sastre! (What a Tailor can do.)* 1797-1798. Etching and aquatint. 21.7 by 15.2 cm.

This figure, dressed in a cowl with a hood, its face hidden, is a clear allusion to the monks who are honored more for their garment than for their religiosity by the ignorant masses. Later, at the time of the secularization of the cloisters, this biting satire on superstition and useless ecclesiastical orders is included in the drawings of the albums.

was created Duke of Alcudia and Grandee of Spain in the month of April, Lieutenant-General of the Armed Forces in July, and then at the age of twenty-five, First Secretary of State. What little information there is on Goya's stay in Andalusia comes from a few letters exchanged between Sebastián Martínez, Martín Zapater and Francisco Bayeu; they deal only with his state of health and throw no light on the underlying motives or the immediate effects on his work.

By July 1793 Goya had returned to Madrid, barely recovered from his illness, but capable nevertheless of taking part in the meetings of the Academy. He rejoined his family which had been sorely tried in his absence; his young brother-in-law Ramón Bayeu had died in Aranjuez on March 2 and his wife had fallen seriously ill at the same time. The circle of his friends had also diminished with the death in 1792 of the painters José del Castillo and Antonio González Velázquez. As for Goya himself a completely new life dominated by deafness began. Not only was his deafness total but, even worse, it was accompanied by noises in the head. From the age of forty-seven until his death thirty-five years later, he could no longer communicate with those around him except by signs and in writing. This plunge into painful solitude and physical disability came very shortly after his recognition of the need for a radical change in his way of life. He thus experienced two shattering crises in the space of a few years, with results that have succeeded in creating the impression that there were two Goyas with nothing in common; up to 1793, a superficial painter lacking in genius, and then after his illness, the essential Goya revealed at last. However, so spectacular a break belongs not only to the realm of pathology but also to that of romance. The reality is much more subtle and much more human. The illness and its dramatic consequences did no more than complete the "conversion" of the years 1786-1790.

The painter's "rebirth" was signaled by the appearance of a series of small pictures painted on metal which have been very thoroughly studied by Goya's principal biographers. Their importance is considerably enhanced by the fact that Goya presented them to the Academy of Fine Arts as though he wished to prove to his peers that he was not only still capable of painting — contrary to what had been stated in a report by the Director of the Tapestry Factory — but, moreover, of painting *differently*. He explained himself in a famous letter to Bernardo de Iriarte, Vice-Protector of the Academy. The novelty for him of these little pictures resided in the fact that in them he had succeeded in "making observations that normally have no place in commissioned work where caprice and invention cannot be given free rein." From this phrase which is justly considered as one of the keys to Goya's art, it has been customary to pick out the word "caprice" as if it heralded the famous series of etchings published five years later.

The notion of "caprice" has accordingly come to be associated with Goya's name and has commonly been used to explain the change in his behavior after his illness. In actual fact, the term "caprice" was used in Spain and elsewhere, long before Goya, to designate a type of work springing entirely from the artist's

114. *Manuel Garcia de la Prada*. Around 1804-1808. Oil on canvas. 212 by 128 cm. Des Moines, Art Center.

A close friend of Goya and Moratin, with whom he lived in Barcelona, bequeathed five scenes of everyday life to the Academy of San Fernando at an unknown time; he had probably purchased them from Goya or his son after the former's death; *Inquisition Scene, Procession of Flaggelants, Madmen's Yard, Bullfight in a Village, The Burial of the Sardine.*

imagination. Many examples exist, but perhaps the most relevant are the fifty little engravings by Jacques Callot dedicated to Prince Lorenzo dei Medici in 1617 under the title *Caprices*. Nearer Goya's time are Gianbattista Tiepolo's *Capricci* published by his sons in 1775 and widely circulated in Spain. The abridged Dictionary of the Academy in its 1780 edition applied the term to artistic productions due to "the force of talent rather than observation of the rules of art." This expresses much the same idea as the passage in the letter to Iriarte in which "commissioned work" is set in contrast to the "free rein" of the artist's talent. In fact, up to 1792 all Goya's work had been commissioned, consisting as it did of religious paintings, tapestry cartoons and portraits. On the rare occasions when he tried rather timidly to introduce a certain freedom, some imaginative touch of his own, into a painting (for example, in the El Pilar frescoes in 1781), he was very soon called to heel. Thus the Chapter of the Basilica and his brother-in-law Bayeu, demonstrating their conformity with public taste, harshly reminded him of "the rules of art" that had to be adhered to in any commissioned work.

Thanks to his illness and lengthy convalescence and also to his authority as both Academician and Court Painter, Goya was able for the first time to give "free rein" in his painting to "caprice and invention," that is, to paint what and as he pleased. This is precisely the significance he intended these little easel paintings to have when he presented them to the Academy in January 1794. What counts most is that he sought quasi-official publicity for these new productions, first by submitting them to "the authority and singular intelligence" of Bernardo de Iriarte, to use his own words, and even more, by submitting them to the judgment of the members of the Academy, and by presenting them finally to the Marquis of Villaverde and his daughter. If these "aspects of national amusements" — including eight bullfighting scenes, a prelude to the great series of engravings of 1815 — had remained in the studio like so many other sketches and studies, they would have had quite a different significance. Goya's gesture was an affirmation of something hinted at in his style as early as 1781, namely that the freedom proper to a sketch could and indeed should become the essential quality of a finished work. He was, in fact, determined to have academic authority underwrite this radical change in the scale of pictorial values — a change that already contained the germ of one of the most significant characteristics of nineteenth century painting.

It might, however, be objected that these little paintings on metal are exceptional in Goya's work, the product of a passing pathological episode — that they are in other words a momentary "caprice" confined to a brief period of his life. This is, in fact, quite wrong. A careful examination of the variety of works he painted between 1794 and 1800, to take only the years immediately following his illness, shows that whether they are portraits, religious scenes, allegories or genre scenes, he approached practically all of them with a freedom of conception and execution that is quite new. Perhaps the most striking examples are commissioned works such as the three "half-moon" paintings for the Church of Santa Cueva, Cadiz (1796-1797), the allegorical paintings for Godoy's palace

115. *Isidro Máiquez*. 1807. Oil on canvas. 77 by 58 cm. Signed and dated. Madrid, Museo del Prado.

The actor Máiquez was as famous and as well liked in Spain as François Joseph Talma was in France. He was a part of the group of theatre supporters surrounding Goya and Moratin; his liberal ideas resulted in his imprisonment and exile.

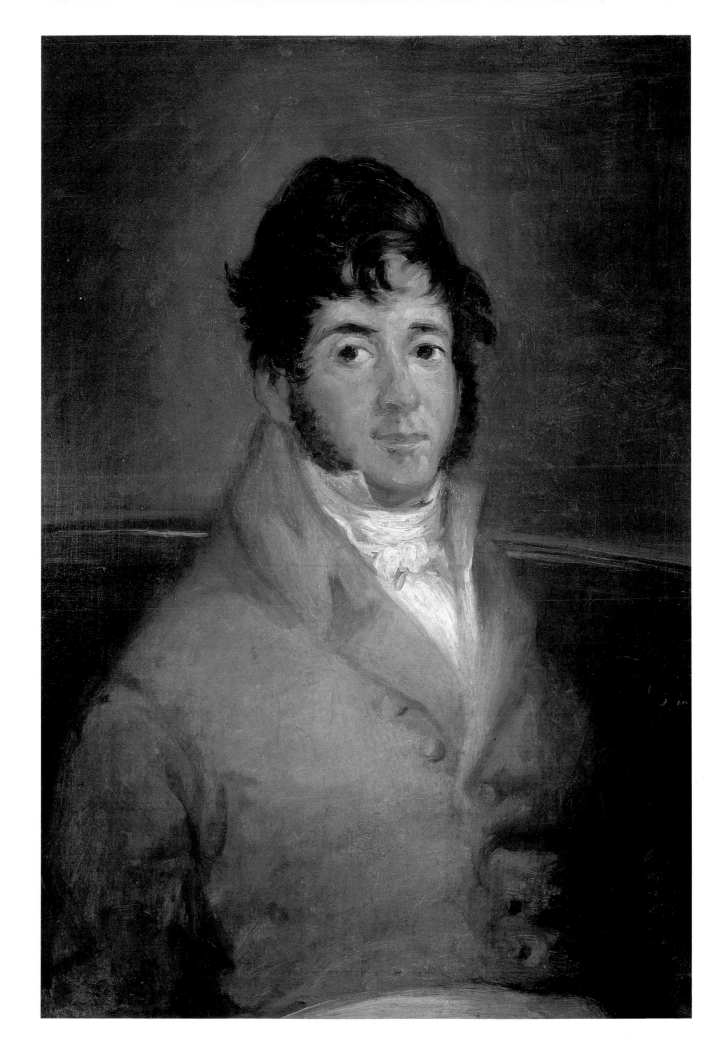

116. Rados: *Lorenza Correa.* Etching. Madrid, Biblioteca Nacional.

The long legend, written in Italian, praises the incredible voice of the famous singer who conquered the Italian stage after she left Spain in 1803.

LORENZA CORREA

La bellissima maravigliosa voce di questa Ispana virtuosa cantante sorprese gli Italiani allorchè qui giunse preceduta da fama verace ch'essa giustificò; e raccolse quindi meritate palme sulle scene Italiane.

117. *Lorenza Correa.* Around 1802-1803. Oil on canvas. 80 by 58 cm. Paris, Erben de Noailles.

It appears that Goya created the portrait of the famous singer simultaneously with the one of Manuel Garcia to which it forms the counterpart. The tenor Garcia, father of Marie Malibran and Pauline Viardot, was the first to sing the Barber of Seville in Rome.

(1797-1800), the frescoes for San Antonio de la Florida (1798), and that apotheosis of official portraiture, *The Family of Charles IV* (1800).

Goya returned to Madrid at the beginning of July 1793 and remained there for another three years before setting out for Andalusia again (probably in May 1796). During that period he gradually resumed his activities as a painter, restricting himself almost exclusively to portraits. All his best friends were living elsewhere; either they were residents of Saragossa like Zapater or Juan Martín Goicoechea, or they had been banished from Madrid for political reasons. However, by 1794-1795, the central government showed a marked change in its attitude towards the latter group. The all-powerful presence of Godoy at the head of affairs certainly played a major part in this. With his appointment as First Secretary of State on November 15, 1792, the first signs of indulgence towards the *ilustrados* began to appear. Cabarrús was freed and a royal decree approved the foundation of the Asturian Institute of Gijón whose creation by Jovellanos was one of the most remarkable achievements of the period of the Enlightenment in Spain. His correspondence with Godoy, starting on September 23, 1793, proves that the latter was quite ready to protect him and use all his influence at the Court on his behalf. In December 1794 the King made Jovellanos a Member of the Royal Council, and by the following year Godoy — now known as "Prince of the Peace" — had become fully reconciled with Cabarrús whose influence in affairs of state started to prevail once more. In his diary Jovellanos notes with pleasure everything pertaining to his best friend's return to favor: thus, on September 10, 1795, "the friend [Cabarrús] announced that the Duke [i.e., Godoy, Duke of Alcudia] showed friendship and interest, praising his talent and his views." On November 19, 1795, "the Prince of the Peace told [Cabarrús] that morning [probably November 17] that 'the decision concerning your pardon has been transmitted and I am very happy to know that your difficulties and troubles are at an end.'"

Finally, on November 30, 1795: "Mail: the decree in favor of my friend sent from all quarters; here it is." This decree, signed by Charles IV, wiped out five years of repression and injustice. It was the prelude to the entry of the *ilustrados* to the Government two years later. At the same time the *Report on the Agrarian Law,* entrusted to Jovellanos by the Madrid Friendly Society, had just been printed, despite fierce opposition (mentioned by Godoy in his memoirs) from the Church and the big landowners. While the support given by the Prince of the Peace to men of the Enlightenment like Cabarrús and Jovellanos from 1795 on is worth emphasizing because of its repercussions on Goya's behavior in the years to come, it should not be forgotten that powerful adversaries were already at work in the shadows, waiting only for the moment when they could come out into the open. At the beginning of 1796 the report was denounced to the Inquisition; the qualificators of the Holy Office declared that Jovellanos' ideas were the same as those that had destroyed Catholicism in England and recommended that the Agrarian Law should be abolished as being "not only anti-ecclesiastic but also destructive of hereditary rights and capable of stirring up ideas of equality as regards ownership of goods and land." Proceedings were

suspended in 1797 but the inquisitors would not forget the man who had dared to publish the notorious report.

The year 1795 brought Goya many consolations for his physical sufferings. While he kept up good relations with the Duchess of Osuna (to whom he recommended a porter formerly employed by the Infante Don Luis), a dazzling figure made her appearance in his correspondence for the first time, namely the Duchess of Alba. The letter is remarkable for its hidden implications: "You would have been better helping me to paint the Duchess of Alba (la de Alba), who turned up in my studio with the intention of getting me to paint her face and was successful; obviously I prefer doing that to painting on canvas. I am also to do a lifesize portrait of her." Such a highly original entrance was well worthy of the great and capricious lady celebrated by the chroniclers of the day. Goya making up the Duchess of Alba's face; this historical detail is worth all the legends fabricated after the event. But in the same letter it is revealed that the Duchess was going to return and pose for a lifesize portrait; it would be the first of her portraits by Goya, the one in which she is wearing a white dress with a red sash. This probably marked the beginning of the friendly relationship with the Albas attested to by the portrait of the Duke and two small intimate scenes, now lost. The following year, the sudden death of the Duke in Seville would lead to the well known episode at Sanlucar de Barrameda.

The same letter, however, also brings us back to Godoy and indirectly to the *ilustrados:* "[the Duchess] will come when I have finished a sketch I am doing of the Duke of Alcudia on horseback...I can assure you that this is one of the most difficult subjects that could be presented to a painter." The letter is dated August 1795; in September of that year Goya was elected Director of Painting at the Academy, replacing his brother-in-law Francisco Bayeu who had died in August. Thus the painter was hard at work again, not only presiding over life classes and correcting students' work at the Academy, but also executing important commissions such as the above mentioned equestrian portrait of the Prince of the Peace, the portraits of members of the House of Alba, and those of Bayeu (unfinished) and of the exquisite Marquesa de la Solana (Louvre Museum), painted shortly before her death in November 1795.

Among these works which bear witness to the artist's recovery and to an even greater dexterity than before, the portrait of Godoy is of particular interest. It is striking that this commission, the first of many from the same source, should have coincided with the return to favor of Cabarrús and Jovellanos. It suggests in fact that Goya's position at the Court in the concluding years of the century was closely bound up with that of the *ilustrados*. Godoy's protection — and even, one might say complicity, recalling the *Naked Maja* (Fig. 89) was secured by 1795 and continued until 1806, shortly before the Napoleonic invasion.

Goya's second stay in Andalusia lasted from May 1796 to the end of March 1797. To say that he went there in order to join the Duchess of Alba is to be influenced by the romantic aura surrounding the famous couple. In reality he was already there before the Duke of Alba's sudden death in his palace in Seville on June 9, and his journey may in fact have had something to do with the

execution of the painting at Santa Cueva in Seville and a desire to visit such close friends as Ceán Bermúdez and Sebastián Martínez. The romantic episode with the Duchess of Alba at Sanlucar de Barraneda, a visit to Seville and a prolonged stay in Cadiz — these made up the Andalusian crucible from which the *Caprices,* published in 1799, would emerge.

Goya's first great series of engravings was, in fact, developed and elaborated from drawings in Indian-ink wash executed at Sanlucar. It has been possible to study and describe the process in minute detail, thanks to Sánchez Cantón who published the album of these drawings under the title *Cuaderno pequeño del viaje a Sanlucar* (Little Album of the Journey to Sanlucar). These small, almost clumsy drawings constitute the erotic element in the *Caprices.* While the Duchess of Alba can be immediately recognized in some of them and other young women (possibly belonging to her suite) furnished Goya with the first of the subjects based on direct observation, it was with scenes subsequently witnessed in Cadiz and Madrid that he filled the more crowded pages of the album now known as the *Madrid Album.* These drawings were the basis for the plates in the *Caprices* illustrating the frivolous, flirtatious world of the *majas* and their companions *(Caprices,* 5, 6, 7, 15, 16, 17, 27, 28, etc.). What may be called the "second wave" of the subjects treated in the series of engravings was conceived later on under the influence of his friends among the *ilustrados.* It constitutes the moral, philosophical and political side of the *Caprices;* both types of subject are so interwoven that it is sometimes difficult to disentangle them. A study of the preparatory drawings in the Prado Museum has made it possible to reconstitute a preliminary series of *Sueños* (Dreams) which represent the *Caprices* in their original form, the frontispiece being the famous plate 43: *The Sleep of Reason Engenders Monsters.* The *Dreams* start with a very coherent group of six scenes of witchcraft, "harmful popular beliefs" that the artist dreamed of banishing forever to ensure the victory of truth (GW 537). It may be wondered how this important sequence on witchcraft suddenly turned up among the erotic scenes. The answer is to be found in the influence of the *ilustrados* among Goya's friends, notably people like Moratín, but also Jovellanos, the veritable mentor of the Spanish Enlightenment.

Moratín left Spain in 1792 to visit other European countries. In December 1796 he disembarked at Algeciras and immediately went on to Cadiz. As soon as he arrived he called on Goya's friend Sebastián Martínez with whom he too had been friendly for many years. The next day he visited the ailing Goya. During the eighteen days he spent in Cadiz he went to see Martínez every day and visited Goya a number of times, either alone or accompanied by Martínez. He then proceeded to Seville where he spent his time sightseeing with Ceán Bermúdez. Moratín learned that through the intervention of his old friend Abbé Melon Godoy had appointed him Secretary to the Office of Translations in Madrid. He returned to the capital at the beginning of February 1797. Both in Cadiz and Seville, as later on in Madrid, his circle of friends, the *ilustrados,* regrouped around him under the protection of Godoy who was unstinting in his favors towards them.

118. *La Tirana (Maria del Rosario Fernandez)*. 1794. Oil on canvas. 112 by 79 cm. Signed and dated. Madrid, Juan March.

This first portrait of the great actress was created the year she retired from the stage. Her nickname "La Tirana" is attributable to the tyrant roles of her husband, but probably also to her own authoritative character, expressed here very well by Goya; he did an even better job, however, in her last portrait in 1803, four years before her death.

When Goya eventually returned to Madrid prior to April 1797 Moratín visited him frequently. The latter had started to annotate a seventeenth century work, which had been widely circulated ever since it first appeared, namely the *Account of the Auto-da-Fé in the Town of Logrono on November 6 and 7, 1610.* This had been one of Spain's most famous trials and the details in the *Account* constituted a veritable treatise on witchcraft. Moratín's interest in the document, at a time when the Inquisition was no longer burning anyone, is linked with the battle

waged by all the *ilustrados* against every form of obscurantism, in particular the superstitions that were still widespread in rural areas.

Jovellanos too was interested in the subject of witchcraft; in May 1795 he noted in his diary that he had bought a copy of *Malleus Malificarum,* "the famous book against witches" which was published at the end of the sixteenth century. A later entry written when he was on the road to exile is very much in the same spirit as Moratín's annotations. "Read the memoirs of the gypsy Pepita la Ezcurripa — an excellent idea for banishing vain beliefs in witches, spells, gnomes and the like." About the same time Goya was using similar language to express similar preoccupations in the caption to his first *Dream* which states that his "only design was to banish harmful popular beliefs." It is very probable that in their first form namely that of the *Dreams* dealing with witchcraft, the *Caprices* were suggested in 1797 by Moratín or at least by a joint reading with him of the *Account of the Auto-da-Fé* of 1610. In fact, it has been asserted that Moratín's annotations to the text of the *Account* are very closely related to some of Goya's engravings that are perfect illustrations of scenes at the *auto-da-fé.*

When Goya rejoined Moratín in Madrid in 1797 his second album of drawings (the *Madrid Album,*) on which many of the *Caprices* would be based underwent a sudden change of tone and subject matter; after scenes mainly peopled by *majas, majos,* and dandies, the first witches made their appearance (GW 416), to be followed by satirical portrayals of married life, charlatans, monks, pride, avarice, prostitutes and men of letters (GW 432). The whole ideological arsenal of the *ilustrados* thus came to find its most striking expression in Goya's work, and the ambitious idea of a veritable pamphlet in pictures gradually took shape in the minds of those *tertulias* of friends who met regularly in Madrid. Despite its systematic concision Moratín's diary shows the close links that existed between Cabarrús, Abbé Melon (whom the writer saw every day), the Prince of the Peace (his loyal protector), Goya (whom he frequently visited), Jovellanos (on his triumphant return to Madrid as Minister of Grace and Justice), the lawyer González Arnao, the painter Luis Paret, Juan Tineo (Jovellanos' nephew), Ceán Bermúdez (who returned with Jovellanos), Meléndez Valdés, and many others who, thanks to the protection afforded by Godoy and Jovellanos, once more played a leading role in Madrid in the political, literary and artistic circles faithful to the ideals of the Enlightenment.

Goya's work in the three concluding years of the century faithfully reflects the return in force of the *ilustrados* to the Spanish scene. The *Caprices* are its pamphleteering aspect and, according to Goya's own statements at the end of his life, were rapidly a target for the thunderbolts of the Inquisition. But there is also a whole series of portraits, painted in 1797-1799, of his friends among the intellectuals: *Bernardo de Iriarte* (Fig. 96), *Meléndez Valdés, Jovellanos* (Fig. 91), *Francisco de Saavedra* (Minister of Finance during Jovellanos' term of office, Fig. 103), *Moratín,* and *Mariano Luis de Urquijo* (translator of Voltaire who became Prime Minister in 1798, Fig. 104). At the same time Goya worked on several commissions for the Prince of the Peace: a series of allegorical paintings for his library, a sketch for an equestrian portrait, a portrait of Godoy's young wife

who became Condesa de Chinchón on their marriage (Florence, Uffizi Museum), and for his private quarters the *Naked Maja* (Fig. 89) followed by the *Clothed Maja*. This was already a considerable amount of work for one who had resigned from his post as Director of Painting at the Academy on the ground of ill health. In 1798 through the good offices of Jovellanos he was commissioned to paint frescoes for the little Church of San Antonio de la Florida where he could cast off all constraints and give "free rein to caprice and invention" by transposing a miracle by St. Antony of Padua into a world of unreality akin to that of the *Caprices*.

After the last official commissions of 1799-1800 — portraits of the King and Queen and the large painting of the *Family of Charles IV* (Fig. 79) — Goya was suddenly and surprisingly dismissed from Court and relieved of all public activities relating to his title as First Court Painter. There seem to have been two main reasons for this: the rapid rise of the *ilustrados* to power and their abrupt downfall with its sequel of exile or harsh imprisonment. All of them were ousted, starting with Jovellanos who was expelled from Madrid, then locked up in Bellver Castle, Majorca from 1801 to 1808. Melendéz Valdés was exiled to Medina del Campo, Urquijo stripped of office and imprisoned in December 1800, and Ceán Bermúdez expelled from the capital and sent back to Seville. Only Moratín as a friend of Godoy's, managed to hold his own. Goya, without being directly attacked, was nevertheless the shocking author of the *Caprices*. The watchful Inquisition was more powerful than ever under the new Minister of Justice, the devious José Antonio Caballero, and Goya preferred to cede the blocks and remaining copies of the *Caprices* to the King, rather than have them seized by the Holy Office (vulgarly known as the *Santa*).

Then in 1802 came the sudden death of the Duchess of Alba at the early age of forty. It was rumored in Madrid that she had been poisoned but nothing was ever proven. The Queen took possession of her finest jewelry and Godoy of part of her art collection. Was this the vengeance of a jealous woman or a political revenge? Perhaps it was both. For Goya it marked the end of an era of the most passionate years of his life and — despite his illness — the most exciting part of his official career. Until the Napoleonic invasion in 1808 he completely withdrew from public life and worked only for himself, doing a great many drawings, or for private clients who commissioned some of his best portraits. His preferred sitters were close friends, notably figures from the world of the theatre (whom he no doubt knew through Moratín) such as *Manuel García*, father of Madame Malibran and Pauline Viardot; *Lorenza Correa*, who played opposite him in the *Marriage of Figaro* in 1802; and *Isidro Maíquez*, the Spanish equivalent of Talma.

The final indication of the disfavor of court circles and the Academy towards their greatest painter came in 1804 when he stood for the post of Director-General of the Academy. Only eight votes were cast in his favor as compared with twenty-nine for his persistent rival Gregorio Ferró. He was fifty-eight and his official career was over. But a new day would open up the way to heights that few have scaled.

V

The Time of War and Persecution

V The Time of War and Persecution

Goya's situation on the eve of the French invasion — Goya and the War of Independence, May 2 and May 3 — Goya's politics — trip to Saragossa after the first battle — the Disasters of War — Goya's wife dies — inventory of possessions and division of property with son (1812) — Ferdinand VII returns to Madrid: liberal repression — the Inquisition and Goya.

The invasion of Spain by the troops of Napoleon remains engraved in the minds of the Spanish people as the "War of Independence" — the only name that really describes it. The second of May is a national holiday and Goya, who immortalized that unforgettable day and the night of horror that followed it with his two pictures in the Prado, remains forever identified with his country's history. Like so many others, he is not just a Spaniard; he is Spain, and every Spaniard whatever his rank, wealth or talent, identifies with him. And yet nothing in his life before that crucial day in 1808 foreshadowed this destiny. On the contrary, after the royal portraits of 1799 and the *Family of Charles IV* (Fig. 79), after the *Condesa de Chinchón* (Fig. 84) and the frescos of San Antonio de la Florida, his eclipse at court rather suggested that his career was starting to decline.

At sixty-two, stone deaf too, Goya lived quietly, a good husband and father, concerned with the welfare of his family rather than with vain ambitions. In 1805 his son Javier married Gumersinda Goicoechea — an alliance that provides another instance of his life-long links at Saragossa as well as in Madrid with

Basque circles or people of Basque descent. On that occasion he did a series of special portraits in very different media: first, delicate crayon profiles of the two mothers-in-law and the young couple; then a series of miniatures on copper showing Javier with all the in-laws, relatives and daughters. Finally, two large portraits in oil of the *Man in Gray* (Javier Goya) and of his young bride in which the subjects though their faces clearly are true likenesses thanks to the magic of Goya's brush achieve that quality of universality found in great masterpieces.

The following year was one of important changes in Goya's household. In January, after living with Javier's parents for six months, the young couple decided to set up on their own. Why? No one knows. Perhaps they did not get on or found coexistence difficult; perhaps it was because they were expecting a child, or Javier may have had an ulterior motive, hoping in this way to benefit as soon as possible from the advantageous terms of the marriage contract signed in 1805. However that may be, that separation from the parental home, confirmed by legal documents, enables us to assess Goya's material circumstances on the eve of the war and on that basis examine his true social position as he entered his sixtieth year.

To begin with, his real estate: at three years' interval he had bought two houses in Madrid, the first in 1800 at 15 Calle de Valverde for the considerable sum of 234,260 reals. Thus he left his home at 1 Calle del Desengaño which he had rented since 1779 — the house from which the *Caprices* were offered for sale in 1799 and which Godoy had bought for his mistress Pepita Tudo. It is interesting to note in passing the curious game of musical chairs they played with their homes, more or less contemporaneously with the *Naked Maja* (Fig. 89) and the portrait of the *Condesa de Chinchón* (Fig. 84); at its heart one always finds the Prince of the Peace. The new house was to be Goya's home until 1819 when he went to live outside the city in the Quinta del Sordo (House of the deaf man). The second purchase, in 1803, was a house bought for 80,000 reals at 7 Calle de los Reyes for his son Javier. It was included in the deposition made before a notary at the time of the marriage, "in case for whatever reason and contrary to all expectation, his above-named children want to leave him and have their own home..." Besides the house Goya settled the life interest on 84,000 reals from an insurance he took out on his life in 1794. The same document stated that Javier also benefited from two additional annuities of 12,000 reals and 3,000 reals granted him by the King and the Duchess of Alba respectively.

This resumé of Goya's possessions and those of his son Javier shows that in less than ten years (1794-1803) the painter had been able to spend almost 400,000 reals on houses and life insurance — the equivalent of eight years' salary as First Court Painter. These large sums came from private commissions, mainly portraits, which he received regularly between 1794, the end of his illness, and the start of the French invasion in 1808. Thus we might say that Goya was very comfortably off, a fact which is confirmed by the inventory of the family's property established at the time of his wife's death, in 1812.

119. *The Bookseller's Wife.* Around 1805-1808. Oil on canvas. 109.9 by 78.2 cm. Washington, D.C., National Gallery of Art.

Traditionally, the painting has been viewed as the portrait of the bookseller Antonio Bailó, whose store was in the Calle de las Carretas No. 4 near the Puerta del Sol and to whom Goya had friendly ties prior to the war. During the Purification Trials of 1814 Bailó testified in favor of Goya.

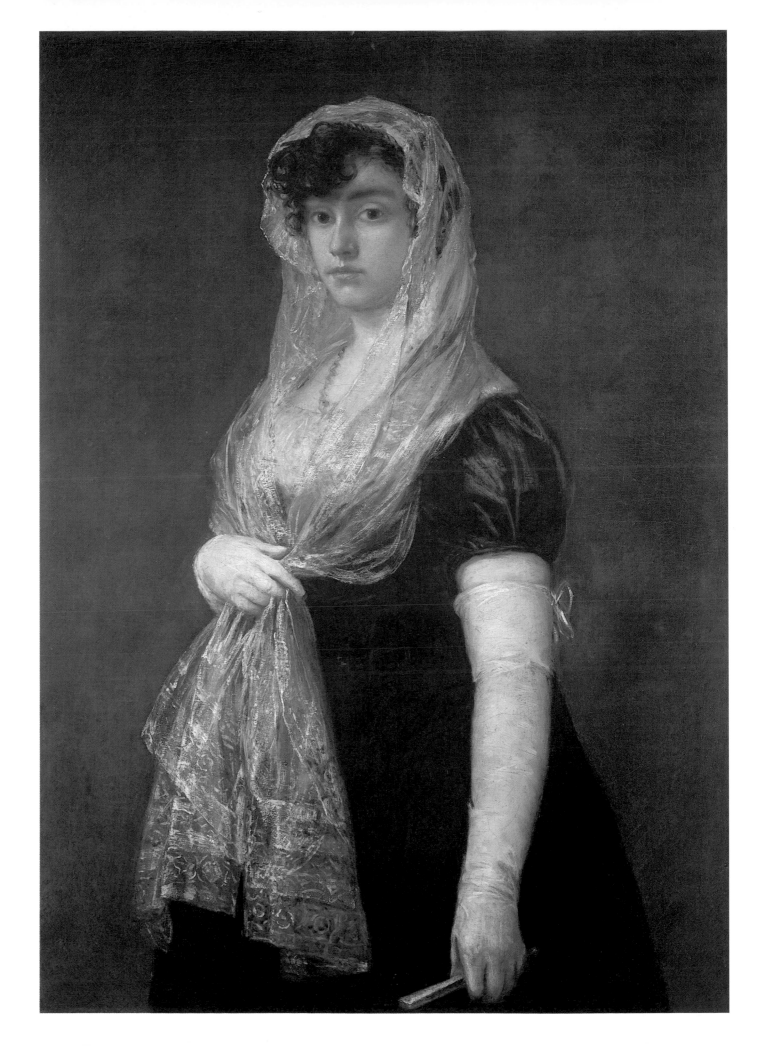

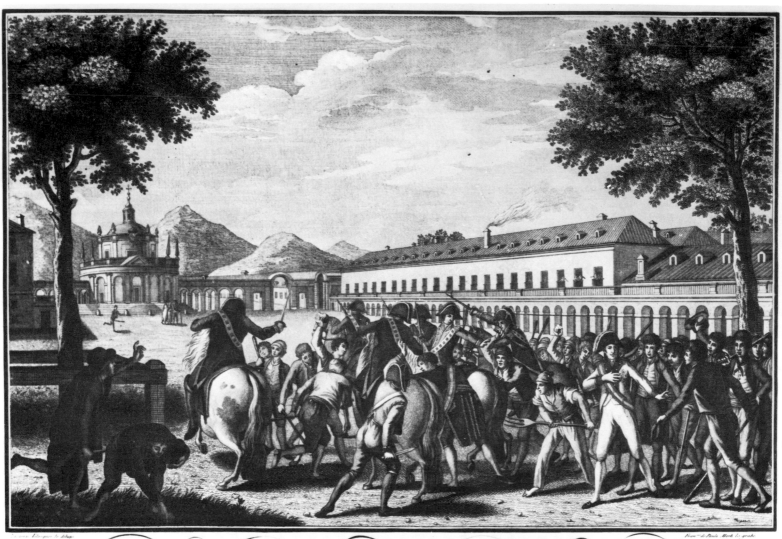

DIA 19. DE (MARZO DE 1808. EN) ARANJUEZ.

Caída y prisión del Príncipe de la Paz

120. *Dia 19. de Marzo de 1808 en Aranjuez. Caida y prision del Principe de la Paz (March 19, 1808 in Aranjuez. The Fall and Imprisonment of Godoy).* Popular print. Madrid, Biblioteca Nacional.

The sheet was published on the occasion of the fall of Godoy in the wake of the insurrection of Aranjuez and the resignation of Charles VI in favor of Ferdinand VII. The *Principe de la Paz* was in danger of being lynched by the mob and could only save himself by fleeing.

Once Javier Goya had left his father's house Goya's solitude deepened; he was left alone with his wife whose companionship seemed never to have played a very important part in his life. Friends were few since the exile of the *ilustrados* who formed Jovellanos' circle. The only one who managed to remain in Madrid, thanks to Godoy's friendship and protection, was Moratín, with whom Goya was still on the friendliest terms. From the playwright's diary we have some record of the meetings between the two men and also of the admiration Moratín felt for his friend's painting. By contrast, there is not a single letter to Zapater after 1799, and his oldest Aragonese patron Juan Martín de Goicoechea died in 1806.

It looked as if a melancholy old age filled with nostalgia for the past might be closing in on the old painter. In reality nothing of the sort happened. Even before the start of the war his private life contained the seeds of a revival of youth in two relationships that brightened the last twenty years of his life. First there was his grandson Mariano Goya for whom he felt a depth of affection neither his wife nor his son had ever inspired in him. The three portraits of him he has bequeathed us bear eloquent witness to this. But there was also a young woman, a relative of the Goicoecheas, whom he most probably met in 1805 at his son's wedding. Leocadia Zorrilla y Galarza was seventeen at the time; two years later she married a rich Madrid merchant, Isidoro Weiss. At that wedding Goya witnessed a repetition of the scene he had engraved in 1798: *El si pronuncian y la mano alargan al primero que llega* (They say yes and give their hand to the first comer) based directly on a poem by Jovellanos. In the bloom of youth and far from shy Leocadia aroused in him all the old demons of sensuality which gave life and warmth to his most beautiful portraits of young women: *Francisca Sabasa y García* (Washington, National Gallery), *Isabel de Porcel* (London, National Gallery), *Josefa de Garcini* (New York, Metropolitan Museum), *The Bookseller's Wife* (Washington, National Gallery), all dating from 1804-1808. And the burning image of his most outrageous creation was still alive in him, his *Naked Maja* — a *bizarre fouterie* Baudelaire called it — jealously hidden in the secret study of Godoy's palace.

March 1808: the peaceful, carefree past suddenly crumbled into political tragicomedy and bloodshed. The conspiracy of Aranjuez, the abdication of Charles IV, the imprisonment of Godoy and finally the proclamation of the new King Ferdinand VII: a whole wall in the edifice of Spanish history collapsed in shame and confusion. Meanwhile Murat's soldiers were entering Madrid. In the picturesque jargon of his diary Moratín noted succinctly: March 23 — "Vidi Galli. Ingreso of Galli..." He was in the streets of the capital at the time together with his friend the Abbé Melón, also a close friend of Goya's. The whole town was in turmoil and there was not a single citizen in Madrid who did not feel personally involved in the arrival of the French troops. Above all, people were extremely eager to get a close look at the famous victors of Austerlitz and Friedland whose deeds of valor were known throughout Europe; in the early days too there was a prejudice in favor of these men of the Grande Armée whom, the Spaniards believed at first had been sent by Napoleon to overthrow Godoy and drive out the infamous Maria Luisa. An edict signed by Charles IV on the eve of his abdication (March 18, 1808) — "the edict of shame" — recommended that the people of Madrid should welcome the French troops and treat them "with all the openness, friendship and good faith that befitted the alliance between your lord the King and the Emperor of the French."

Like his fellow citizens Goya certainly wanted to have a look. All his life he had been keen to witness events, always ready to seize the street scene, the famous personage passing unexpectedly, the momentary gesture that betrays the real character of an individual. It is hardly likely that he would have remained shut in and indifferent during these historic days. And even apart from curiosity,

121. *The Colossus.* Around 1810-1818. Mezzotint. 28.5 by 21 cm.

This is the only example of the use of the mezzotint technique in Goya's *oeuvre.* Goya takes up the figure of the older painting (illustration 122) again here, but the terror has been replaced by peaceful calm. The work could be called *The Resting or the Solitude of the Giant.*

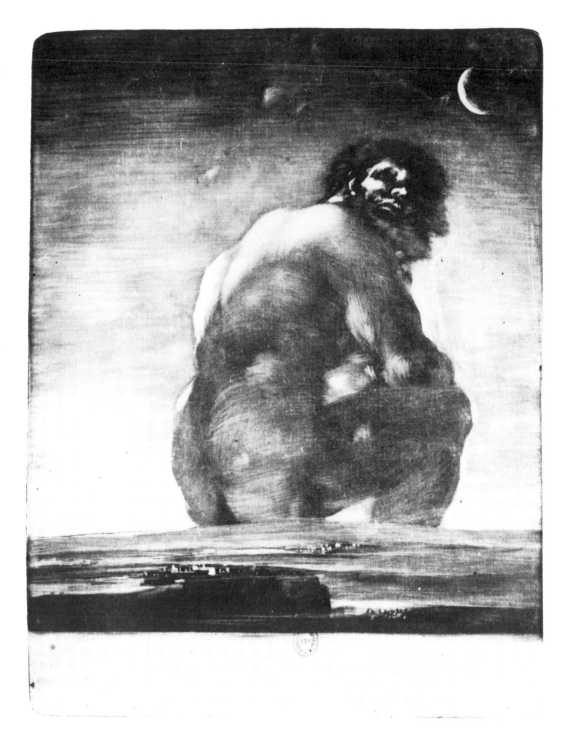

122. *El coloso (The Colossus).* Around 1808-1812. Oil on canvas. 116 by 105 cm. Madrid, Museo del Prado.

The painting was created before 1812 — it is registered in the inventory of goods in that year — and probably during the war. It is one of the most enigmatic works in Goya's creative output. Is the colossus to exorcize the war? Napoleon? Human brutality? The only thing that is certain is that his appearance causes panic in humans and in animals and that they flee in a desolate landscape.

some very specific duties would have brought him out into the streets of Madrid at that moment. In fact, on March 28 the Academy of San Fernando had commissioned a portrait of the new King Ferdinand VII to be hung in their meeting hall. Goya knew him well as he had shown him previously in the great portrait of the *Family of Charles IV* in 1800; at that time as Prince of the Asturias, a sixteen-year old adolescent completely overshadowed by the all-powerful Prince of the Peace, he embodied the secret hopes of all those who dreamt of one day sweeping away the infamous "Trinity" (the King, Maria Luisa and Godoy).

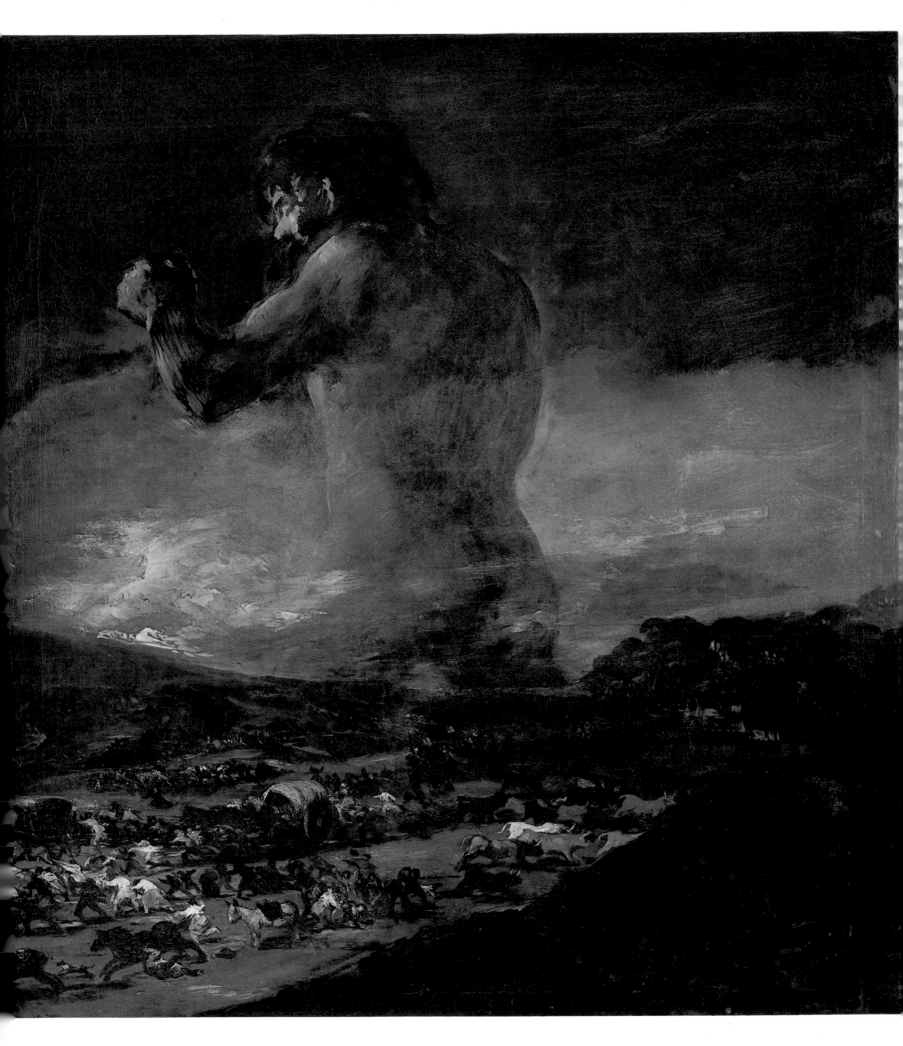

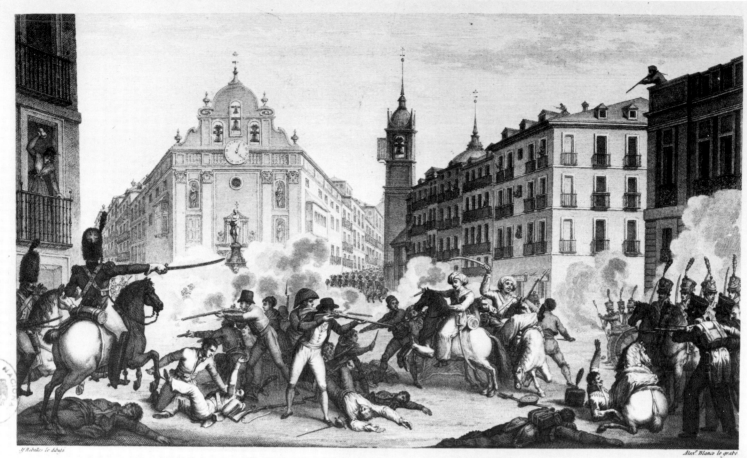

DOS DE MAYO DE 1808.

Pelean los Españoles con los *Franceses en la Puerta del Sol.*

123. José Ribelles: *Dos de Mayo de 1808 (Second of May 1808).* Engraving. Madrid, Biblioteca Nacional.

This popular print exemplifies the difference from Goya's work, in which the artist centered all his attention on the melée of humans and horses. The urban environment, as well, recedes behind the force of the battle.

124. *El 2 Mayo de 1808. en Madrid: la lucha con los mamelucos (Second of May 1808 at the Puerta del Sol).* 1814. Oil on canvas. 266 by 345 cm. Madrid, Museo del Prado.

One of the two paintings belonging together and recording the beginning of the Spanish revolt against the French. Goya drew the paintings six years after the events. It is possible that he used sketches made on the spot.

200

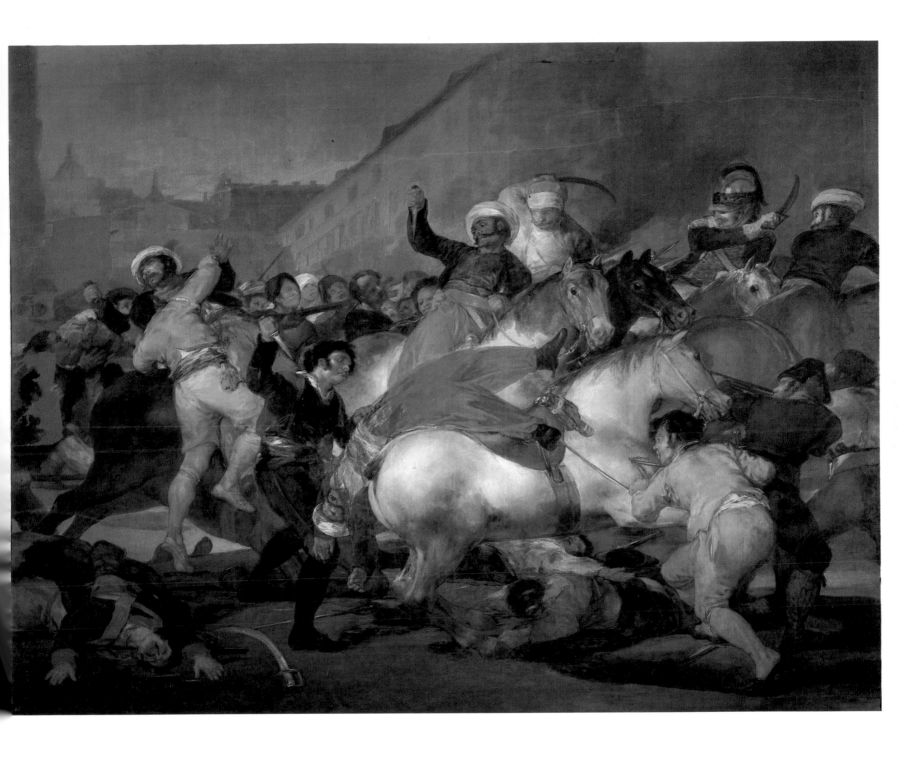

125. *Dia 2 de Mayo de 1808 en la Montaña del Principe Pio (Second of May 1808 at the Mountain of the Principe Pio).* Popular print. Madrid, Biblioteca Nacional.

Two events of these terrible days have been combined here with great naiveté; for one, the Madrilenean being chased by a French cavalryman in front of an edifice that could be the San Antonio de la Florida; for another, the shooting of Spanish patriots by French troops at the mountain of Principe Pio. There is no feeling of the tragic preponderance encountered in Goya's works here.

DIA 2, DE MAYO DE 1808 EN LA MONTAÑA DEL PRINCIPE PIO

Although Goya did not take sides openly, as First Court Painter of Charles IV he clearly seemed inclined towards the favorite who as late as 1806 had commissioned a major allegorical painting for the Pestalozzi Institute he had just founded. Goya had a deep aversion to Ferdinand VII which in time turned to loathing. At the same time he had to honor the confidence the Academy naturally showed him and create the most faithful image possible of the king. Goya asked his august model to sit for him. Ferdinand VII granted the painter's request and on April 6, 1808 he accorded two sittings of three quarters of an hour in all. That day Goya went from his home in Calle de Valverde to the Royal Palace; the street scenes must already have reflected the general excitement at insistent rumors that the royal family was about to leave for Bayonne. In fact, Ferdinand VII was the first to leave the capital of his own free will on April 10. Goya's portrait is thus the first one painted of him and the only one predating the exile of the *Deseado* (the "desired one," as the Spanish people called him) in France until 1814.

The events of the second of May swept Madrid first and then the whole of Spain into war and bloodshed. It all started at the esplanade of the Royal Palace where the crowd tried in vain to stop the departure of the little Infante Francisco de Paula. The first skirmishes broke out and then came the brutal intervention of Murat's soldiers. That was all it took to set off riots in all their murderous violence. In the defense of the artillery park two officers Pedro Velarde and Luis Daoiz became the first heroic victims of the armed resistance to the invader.

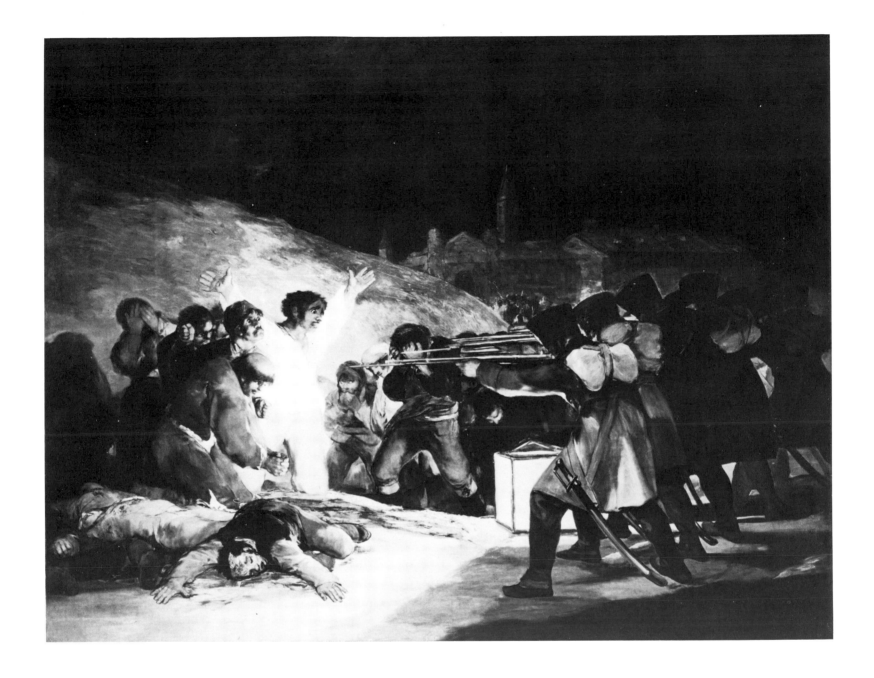

Shortly afterwards came the bloody confrontation of the Puerta del Sol when the people of Madrid, armed only with knives or with their bare hands, faced Napoleon's formidable Marmelukes. Could Goya have been an eyewitness? An idle question perhaps, but one that ought to be answered. In the first place he lived neither at the Puerta del Sol nor nearby, and if it is true that his son Javier had settled in Calle de Tres Cruces which was closer to the main scene of the fighting, then the facile idea — sometimes mooted — of the artist on a balcony, pencil in hand, watching the raging slaughter he would immortalize six years later in his great picture *The Second of May 1808* (Fig. 124) ought to be rejected. The same dubious hypothesis has been put forward in connection with the *Executions of the Third of May* (Fig. 126). There is a tendency to forget that the imagination and the memory of a great artist are often more powerful

126. *El 3 de Majo de 1808 en Madrid: los fusilamientos en la montaña del Principe Pio (Executions of the Third of May).* 1814. Oil on canvas. 266 by 345 cm. Madrid, Museo del Prado.

The revolt by the light of day is followed by the brutal suppression by night on the mountain of the Principe Pio (today the Moncloa district): a French platoon executes the Spanish patriots by the light of a lamp standing on the ground. Here, as well, the representation is completely composed; it is unlikely that Goya drew on his memory, for in all probability he did not watch the scene.

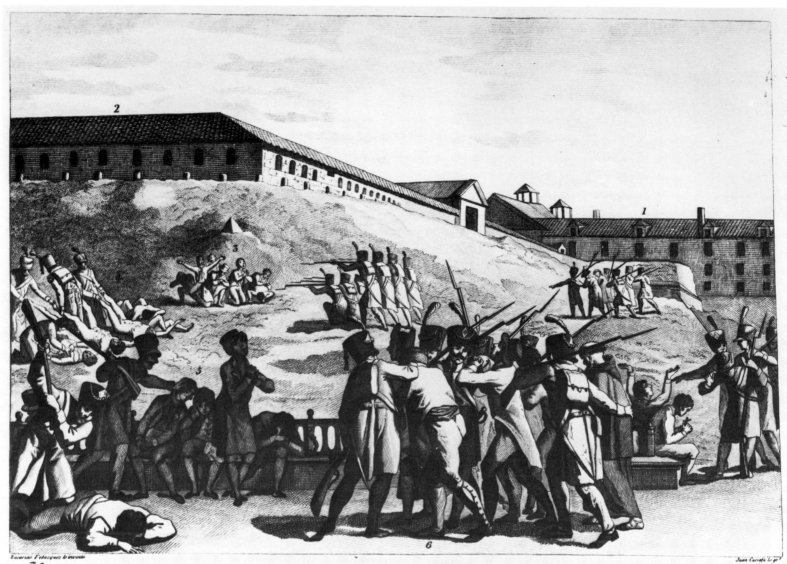

Horrible sacrificio de inocentes victimas con que la alevosa ferocidad francesa empeñada en sofocar el heroismo de los Madrileños, inmortalizó las glorias de España en el Prado de Madrid en el dia 2. de Mayo de 1808.

127. Zacarias Velázquez: *Horrible sacrificio de inocentes victimas con que la alerosa ferocidad francesa empeñada en sofocar el heroismo de los Madrileños, immortalizó las glorias de España en el Prado de Madrid en el dia 2 de Majo de 1808 (Execution of Madrileneans by French Troops on the Prado in Madrid on the Second of May 1808).* Copperplate engraving. Madrid, Biblioteca Nacional.
This is one of the scenes of the Second of May 1808 that

Goya never depicted. It was considered just as heroic as the battle at the Puerta del Sol and was reproduced and distributed in large numbers of popular prints.

128. *Equestrian Portrait of General Palafox.* 1814. Oil on canvas. 248 by 224 cm. Signed and dated. Madrid, Museo del Prado.

General Palafox, he was thirty-three at the time, had become famous due to his heroic defense of Saragossa during the two sieges during 1808-1809. After the first siege he — from Aragon as was Goya — had summoned the painter to "see the ruins of this city and to study them closely so as to paint the valiant deeds of its inhabitants." As with the events of the Second and the Third of May, the portrait was only executed six years later.

129. *Ruinas de Zaragoza (Ruins of Saragossa).* Popular print. Madrid, Biblioteca Nacional.

The battle for Saragossa was fought street by street, house by house, the city was left in ruins. The example of the heroic city — its fame was spread by popular prints and pamphlets — had a stimulating effect on the Spaniards in their fight against the invaders. There is no known work that Goya executed in Saragossa or in a direct temporal connection with the fighting and his visit.

130. *Powder Factory in the Sierra.* Around 1810-1814. Oil on wood. 33 by 52 cm. Madrid, Patrimonio Nacional (Published with the friendly consent of the Patrimonio Nacional, the owner of the painting).

Just as its counterpart, the *Bullet Factory in the Sierra,* this scene relates to events taking place a considerable amount of time after Goya's trip to Saragossa, as can be seen from an inscription on the back of the wood panel: *No. 1 / Fábrica de pólvora establecida / por don Josef Mallen en la / Sierra de Tardienta en Aragón / en los años de 1811, 12 y 13* (Powder factory established by Don Josef Mallen in the Sierra de Tardienta in Aragon in the years 1811, 1812, and 1813). Nevertheless, the landscape can be based on his observations during his stay in the mountains of Aragon in 1808.

RUINAS DEL INTERIOR DE LA YGLESIA DEL CARME

131. *Shooting in a Military Camp.* Around 1808-1812. Oil on canvas. 32 by 58 cm. Madrid, Marques de la Romana.

This war scene was identified as belonging to the *Twelve Horrors of War* that are listed as number 12 in the inventory of 1812.

than all the experience of reality. Other eloquent examples of this from the same period are the *Plague Victims of Jaffa,* the *Raft of the Medusa* and the *Massacre of Scios*.

However, it is plausible to suggest that he made live sketches under the impact of the dramatic events of May 1808 which he then used in 1814 to paint the two pictures in the Prado. This hypothesis is supported by a fact that seems highly surprising. Goya did not paint the other most popular scenes of that historic day, namely the first confrontation between Spaniards and French in front of the Royal Palace, the defense of the artillery park by Daoiz and Velarde and finally the massacre of the Paseo del Prado ordered by Murat. Contrary to what has sometimes been claimed, he chose only two scenes, *The Second of May 1808 at the Puerta del Sol* and the *Executions of the Third of May* and has left no others. The reason for this choice can probably be found in the fact that these pictures were painted six years after the event. In 1814 Goya judged on the basis of his memories and with the aid of earlier sketches that the epic of the people of Madrid could be summed up in these two symbolic moments of the second and third of May: the rioting and the repression; the indomitable courage of the Spaniards, the implacable cruelty of the invader; the first scene in full daylight, the second under cover of night — a veritable diptych in which for the first time history is being made by anonymous heroes of the modern world.

What was Goya's own attitude to the dramatic upheavals that shook his country in 1808? How he felt is not really known. But there is one definite clue: his decision to leave Madrid in the midst of the war at the call of General Palafox, to go to Saragossa "to see and examine the ruins of that town so as to paint the valiant deeds of its inhabitants." Saragossa had just suffered its first siege from June 15 to August 17, defended by the famous Palafox, one of the heroes of the War of Independence. In spite of the furious French attacks the town though half destroyed refused to capitulate. The courage of the population who took part in the fighting street by street, house by house, became the symbol of Spanish resistance. All the towns in the Peninsula wanted to emulate the heroic defense of Saragossa.

132. *Soldiers Attacking Women.* Around 1808-1812. Oil on wood. 30.5 by 39.8 cm. Frankfurt-on-the-Main, Staedelsches Kunstinstitut.

The painting is part of a series of six small, usually violent scenes that are listed under the number 9 in the inventory of 1812; it still bears the inscription "X.9."

Once the initial danger had passed the Aragonese decided to immortalize those glorious days. Goya, himself Aragonese, was the obvious choice. In a letter of October 2, 1808 to the Secretary of the Academy of San Fernando Don José Munarriz, he said that the portrait of Ferdinand VII was finished but that he would not be able to supervise its installation because he had to go to Saragossa. He added that he could not miss that journey because of his "intense concern for the glory of his Country."

There was Goya at the age of sixty-two torn from the peaceful life he had created for himself in Madrid, to become one of the rare eye witnesses to some of the bloodiest episodes in the War of Independence. The portrait of Ferdinand VII which he had finished before his departure was a concession to the U-turn in Spanish policy. His stay in Saragossa and no doubt at Fuendetodos at the beginning of the second siege of the town heralded his entry into the new era which the prodigious Napoleonic cavalcade had ushered in throughout Europe. With war and its "fatal consequences," as he headed his *Disasters of War,* the

133. *A Bandit Murders a Woman.* Around 1808-1812. Oil on canvas. 40 by 32 cm. Madrid, Marques de la Romana.

The painting is part of the series of the *Twelve Horrors of War* listed in the inventory of 1812. At the time, Goya was heavily preoccupied with all forms of murder and violence; he wanted to preserve the terrible events in his paintings so that they would find their place in history.

134. *Vista y situación del robo executado por una quadrilla se salteadores el dia 3 de Majo en las immedicaciónes de Villacastin (A Surprise Attack by highway robbers on May 3 in the environs of Villacastin).* Popular print. Madrid, Biblioteca Nacional.

Even if there had always been highway robberies, they did increase at the time of the war for independence. In addition, it was difficult to differentiate them from patriotic undertakings at times. As of 1786, Goya depicted this topic frequently.

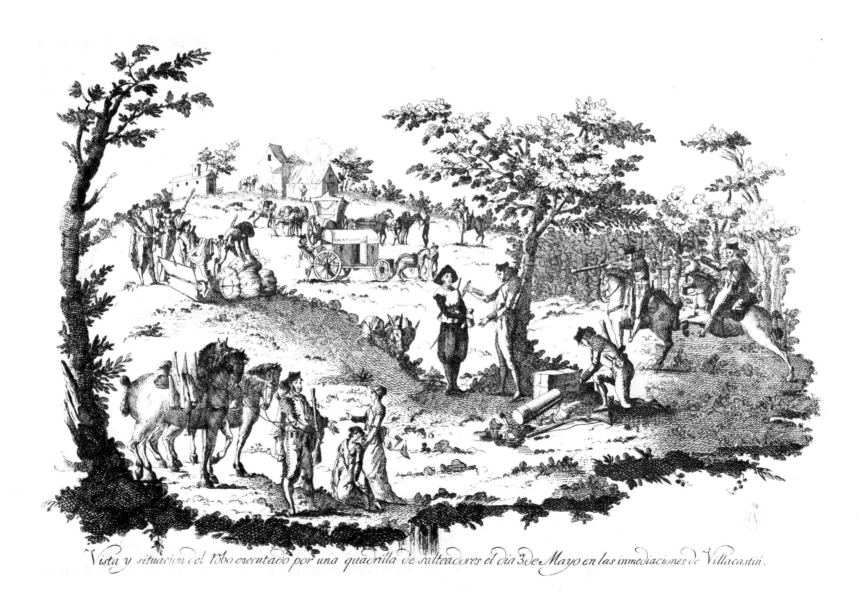

Vista y situacion del robo executado por una quadrilla de salteadores el dia 3 de Mayo en las inmediaciones de Villacastin.

Spain of the past, of the *majas* and his tapestry cartoons, together with the Spain of the *ilustrados* and their dream of a better life, was swept away forever. Goya who had loved that Spain of his youth so much could easily have been engulfed in the great cataclysm that ravaged his country. But he was not — on the contrary, one gets the impression that he was reborn to a new life and that his art as if made fertile by the martyrdom of his native land came to a fresh flowering, more powerful and more human than ever before.

The purpose of his journey to Saragossa was clear: after seeing the ruins of the town, "to paint the valiant deeds of its inhabitants." But we have not a single major painting that might refer to the scene of desolation he witnessed. Between 1808 and 1814 he did a series of small scenes of war and violence (assassinations, acts of banditry, rapes, executions), but nothing that could be taken as a direct homage to the people of Saragossa. Only the large equestrian portrait of Palafox (Fig. 128) recalls the Aragonese epic of 1808-1809, but in the traditional form of a State portrait comparable, if the verve is added, to the portraits of Charles IV and Ferdinand VII.

But as was so often the case with Goya these images of ruin and death were etched in his memory to emerge, sifted and rearranged in later works. It is highly likely that the series of engravings of the *Disasters of War* originated in Saragossa. Indeed, one plate refers specifically to one of the most heroic deeds of the siege — that of the famous Agustina de Aragon who was actually called Agustina Zaragoza and was not really Aragonese. When she saw that all the men of an artillery battery at the gate of the Portillo were dead she herself put fire to the loaded cannon and thus managed to repulse the attack of an enemy column. However, one important fact must be emphasized: Goya's etching based on the famous episode — which was widely circulated through popular prints — avoided any anecdotal allusion to the heroine herself so as to give the scene a far wider symbolic value. *Que valor!* (What courage!) is all the caption says. From this example, which is the closest to reality, the artist's aim becomes clear: his *Disasters of War* did not aim at accuracy of historical detail but at expressing the representative and universal value of each scene.

On his return to Madrid during the month of December 1808 Goya found the capital completely subject to the occupying power. After a lightning campaign Napoleon put his brother Joseph back on the Spanish throne and from his headquarters at Chamartin he published a series of edicts which accorded the

135. *Allegory of the Town of Madrid.* 1810. Oil on canvas. 260 by 195 cm. Madrid, Ayuntamiento.
The various changes in this painting are a true mirror of the events in Spain as of 1809. Originally, there was a portrait of Joseph Bonapart in the oval medallion. It was replaced with the word *Constitución,* then to be followed by a portrait of King Joseph again, then *Constitución* once more, then a portrait of Ferdinand VII, the legend *El libro de la Constitución,* and finally *Dos de Mayo.*

136. *General Nicolas Guye.* 1810. Oil on canvas. 106 by 84.7 cm. Richmond, Virginia Museum of Art.

Goya painted this beautiful portrait of the French general at the elbow of Joseph Bonapart — just like the one of his nephew Victor Guye in the uniform of a page of the king — at the same time he created the first sheets of the *Desastres de la Guerra.* An example of the schism many Spaniards lived in during the French occupation.

137. *Juan Martin Diaz, El Empecinado.* Around 1814-1815. Oil on canvas. 84 by 65 cm. Switzerland, private collection.
When Madrid was liberated in 1812, *El Empecinado* was celebrated as a symbol of the heroic Spanish resistance to the French invaders alongside the Duke of Wellington. His liberal ideas brought about his shameful death in 1825 at the time of the absolutist reaction.

214

138. *Desastre de la Guerra 15: Y no hai remedio (And it cannot be changed).* Around 1810-1811. Etching and aquatint. 14.1 by 16.8 cm.

Executions by firing squads were everyday events during the years of the war. Goya depicted them in paintings as well as in graphic sheets, most impressively probably in the *Execution of Rebels*.

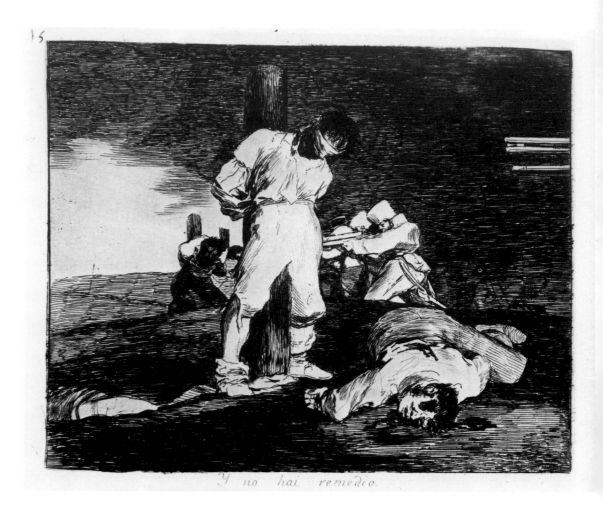

139. *Desastre de la Guerra 26: No se puede mirar (One can't look).* Around 1810-1812. Etching, wash. 14.4 by 21 cm.

Men and women are being shot in front of a grotto. Goya later used the title for a torture scene in Album C (C. 101) as well. No one else would have dared to depict such events in so explicitly realistic a manner.

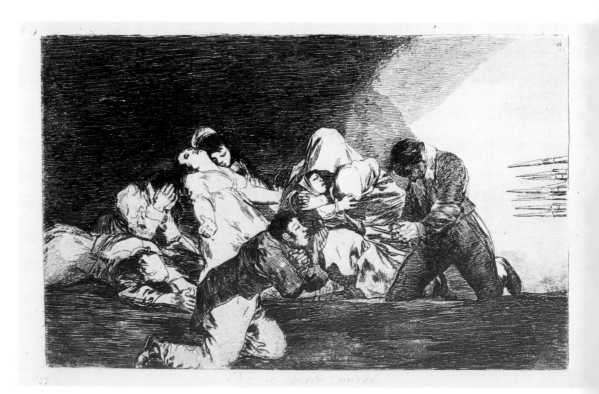

140. *Desastre de la Guerra 26: No se puede mirar (One can't look).* Detail (see illustration 139).

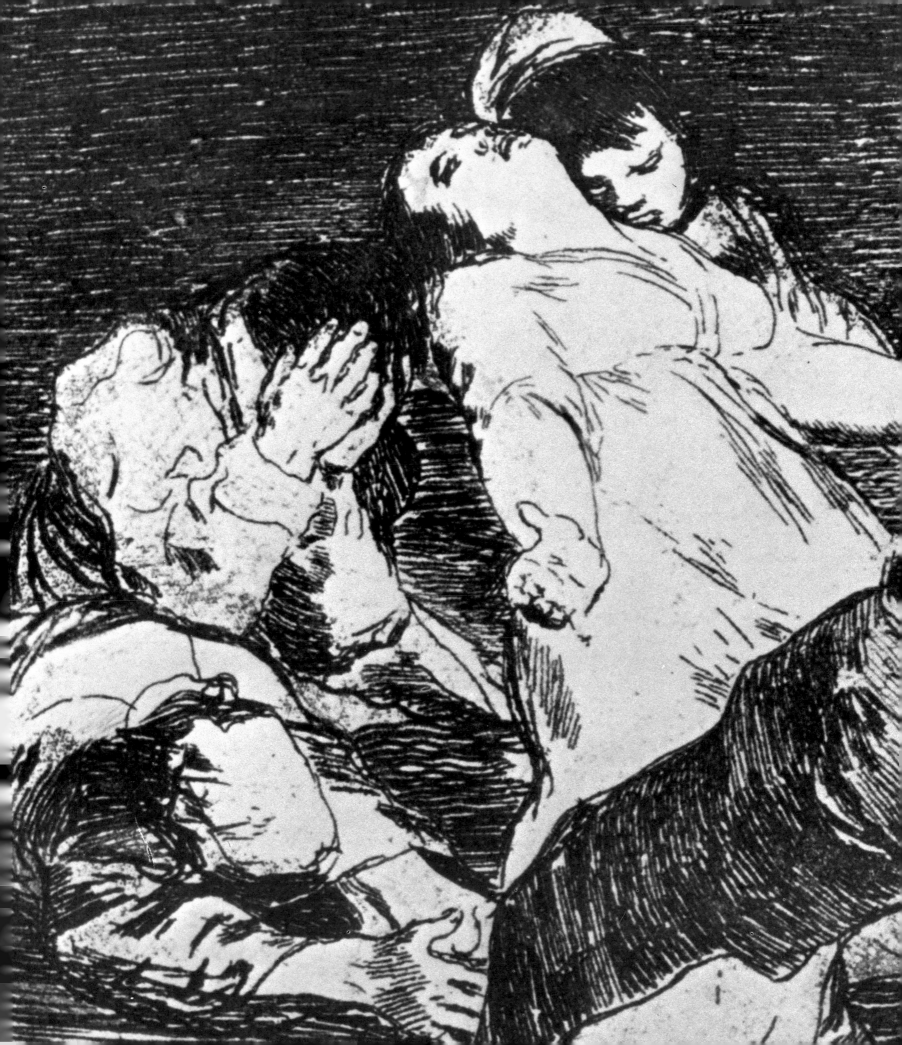

Spaniards greater liberty than they had ever dreamed of acquiring — a truly revolutionary program which suppressed the Inquisition, feudal rights and domestic customs duties and decreed that the religious communities were to be reduced by two-thirds and their property ceded to the State, besides other measures which achieved in a matter of days what the Cortes of Cadiz had spent three years debating and approving. At the same time Napoleon published a proclamation addressed to the Spaniards in an attempt to win their support by promising them "a liberal Constitution which would give them a tractable monarchy in place of the absolute monarchy..." On December 23, Goya as head of the family took the oath of allegiance to King Joseph I.

The edicts of Chamartin had made a deep impression on the "enlightened" who suddenly saw their most cherished ideas embodied and become reality. The capture of Madrid, after the lightning victory of Somosierra, had convinced many Spaniards of the uselessness of armed resistance. They believed sincerely that a new era had dawned for their country and placed themselves at the service of the new sovereign in the belief that their presence in the government or in the new administration would at least contribute to safeguarding the vital interests of their people. Thus, in April 1809 Cabarrús became Joseph Bonaparte's Minister of Finance; serving with him were men like Mariano Luis de Urquijo, Miguel de Azanza, Admiral Mazarredo and the Marquis of Almenara, all of them well known between 1700 and 1800 for their sympathy with the *ilustrados* and at that time directly or indirectly connected with Goya who had painted portraits of some of them. Many other friends of his swelled

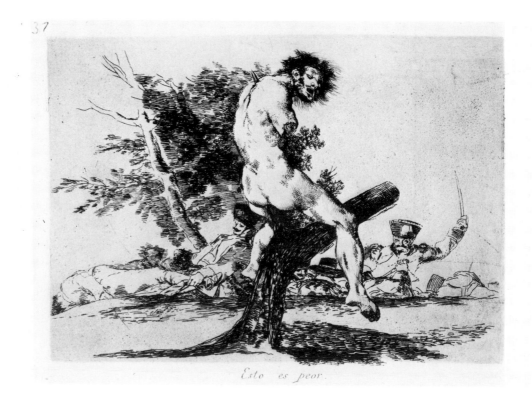

141. *Desastre de la Guerra 37: Esto es peor (This is worse).* Around 1812-1815. Etching, wash. 15.7 by 20.7 cm.

This horrible testimony hides none of the brutality of war. Goya hurtles his accusation at his contemporaries and coming generations. In connection with the other sheets, the title of the picture makes the increasing horror of the scene evident.

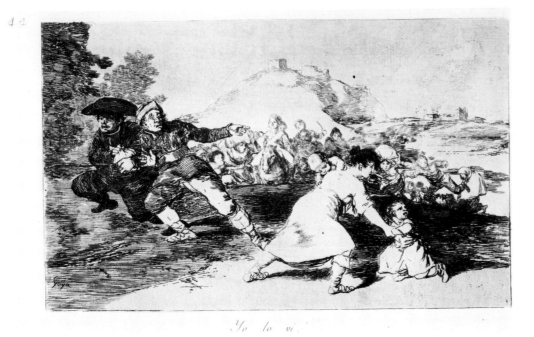

44

Yo lo vi.

142. *Desastre de la Guerra 44: Yo lo vi (I saw it).* Around 1810-1812. Etching. 16 by 23.5 cm. Signed.

The title of the picture states that Goya experienced this scene of general, horrified panic, that it is a first-hand account.

the ranks of the *afrancesados:* the actor Isidoro Maiquez, the writers Melendez Valdes and especially Moratín, who in 1811 became Director General of Libraries; the Abbé Melón, his faithful companion, was Cabarrús' collaborator at the Ministry of Finance, and such old acquaintances as Manuel Silvela with whom Goya met up again in 1824 in Bordeaux where he was with Moratín, and their common friend the lawyer Gonzales Arnao, who helped the old painter to settle in Paris.

Jovellanos alone remained unshakeable, rejecting in a letter that has remained famous, the blandishments of General Sebastiani and linking his fate with that of the model patriots of the Junta Central. Between these two extremes Goya seems to have tried to reconcile the irreconcilable. Without trying to ascribe to him feelings of which nothing is known and which it would be impertinent to guess at, it should be noted that his attitude throughout the war years was to say the least ambiguous. In 1810 at the time when he was starting to engrave the indictment of the *Disasters of War* (GW 1015, 1037, 1052 and 1064), he was also painting the *Allegory of the Town of Madrid* (Fig. 135), in which a portrait of King Joseph occupied a prominent place. If his patriotism, aroused by seeing the ruins of Saragossa, led him to condemn the atrocities committed by the French, he had no scruples in having General Guye (Fig. 136), the companion-in-arms of General Hugo for sittings in his studio, as well as his nephew the charming little Victor Guye in the uniform of a page to King Joseph. He also painted the portraits of Juan Antonio Llorente, the archivist and historian of the Inquisition, conspicuously wearing the Royal Order of Spain, of General Manuel Romero, Minister of Justice, and of the frail Marquise de Monte-hermoso whose mother was the mistress of the usurper king. In 1811 he himself

received the famous "Aubergine" (the Royal Order of Spain), but the fact that he never wore it suggests that he was reluctant to compromise himself publicly.

After the liberation of Madrid on August 12 he painted the portrait of Lord Wellington (Fig. 143), the great victor of the battle of Arapiles and at the side of the English general, perhaps at the same time, that of the redoubtable guerilla fighter Juan Martin Diaz, called *El Empecinado* (Fig. 137), whom the people of Madrid had acclaimed as the symbol of Spanish resistance.

To go solely by the works of that period, Goya would seem to have been both an ardent patriot and a real collaborator, an *afrancesado*. But it is equally true that times were hard, aggravated by his refusal to collect his salary as Court Painter, and he may have depended wholly on portrait commissions for his living. Undoubtedly, the most eloquent evidence comes from the inventory of his possessions at the time of his wife's death in 1812 and the way they were divided between father and son. Most of those who have studied the legal documents have concentrated solely on the list of paintings assigned to Javier *in toto* . It has indeed provided a precious means of identification and dating and its importance is undeniable. But the actual spirit in which the division was made is surprising — above all, the fact that the painter made over to his son the totality of pictures and prints in his studio, not even excepting the portrait of the Duchess of Alba in black. However, they were ceded in principle only for the numbers painted in white on the canvases preceded by the letter X (for Xavier) seem to prove that they actually remained in Goya's possession but could not now be confused with those he painted after 1812. The same applies to the house in Calle de Valverde where he had lived since 1800; it was assigned to his son but he continued to live there until 1819, the year he acquired the Quinta del Sordo. The real purpose of the division was to give each of them one half of the property while enabling Goya to keep almost all the ready cash and most of the jewelry and silver, i.e., his sole remaining means of subsistence apart from the very rare portrait commissions.

Few periods in Goya's life were as anxious and eventful as those war years of 1811-1812. To begin with, as a kind of backcloth the atrocious winter of hunger the people of Madrid had to endure claimed almost twenty-thousand victims. Whole families being decimated by famine and epidemics, the streets littered with corpses and echoing to the sinister rumbling of carts taking them to the cemeteries — all this the painter lived through and saw with his own eyes. Seventeen plates of the *Disasters of War,* some of the most moving ones, (GW 1074 and 1102) testify to this. In 1811 he was sixty-eight and had just heard of the death of Jovellanos, the good friend of the happy days of his youth. He and his wife made their will as if prompted by some obscure foreboding that one of them would soon depart from this world. Yet, we may wonder whether at that moment when he was beset by death on all sides, Goya did not in fact experience the most wonderful resurgence of youth, the most splendid renewal a man of his age could have. On October 2, 1814 Maria del Rosario Weiss was born, the daughter of that very Leocadia Weiss he had met at his son's wedding in 1805. Everything suggests that he was the child's father. But how far back

143. *The Duke of Wellington.* Around 1812-1814. Oil on wood. 60 by 51 cm. London, National Gallery.

All of the portraits of the Duke of Wellington by Goya's hand were executed after the battle of Arapiles (August 10, 1812). The victorious general sat for Goya after his entry into Madrid on August 12; a red pencil drawing based on the model has been preserved. The portrait shown here was revised at a later date.

did this adulterous relationship go? Discreet yet eloquent documents show that there had been a rift between the Weisses as early as September 1811 and that the following spring the husband had reiterated his complaints about his wife who was twenty-three at the time, on the grounds of her "infidelity, illicit relationships and bad conduct...." No more is known about it but this series of events, taken together with the fact that at the end of his life the painter lived in Bordeaux with Leocadia and her two children and above all his extraordinary fondness for Rosarito — all these tend to show that this last love affair preoccupied him right until his death.

It is impossible to form a clear opinion of Goya's social position after his wife's death in 1812 if we do not take his relationship with Leocadia into account. It obviously was a scandal from every point of view and one can imagine the disapproval it must have aroused in his son and in the Goicoechea family. Had he actually toyed with the idea of leaving Madrid and exiling himself? At the end of the war, one of the witnesses for the defense in his "purification" investigation revealed that "he had left Madrid for Piedrahita with the intention of going to a free country; but at the request of his children and after being notified by order of the Minister of Police of the embargo on all the family's possessions and their general confiscation if he did not return to Madrid by a certain time he did not carry out his plan." Thus it was a serious matter and threatened the family inheritance. The Minister of Police had intervened, actually issuing an ultimatum.

Was the intended flight motivated by political reasons? It is difficult to see what threats exactly could have led him to take such a decision between 1812 and 1814 when he was over sixty-six. It is of course possible that this crazy escapade had a dual purpose, political on the surface but sentimental in reality — the wish to live with Leocadia far from the family and from her husband Isidoro Weiss. This hypothesis cannot be ruled out if we remember two later steps in Goya's escape to freedom; in 1819 he settled with Leocadia at the Quinta del Sordo outside the city, and finally in 1824 he left definitively for Bordeaux where he joined her and her two children. To leave Madrid meant living with the woman he loved without causing a scandal and without being exposed to the disapproving eye of Javier and his wife. Soon it would also mean getting away from a detested political regime which had become particularly dangerous for Leocadia and her son who flaunted their ardent liberalism.

Lastly, an aspect of Goya's life during the war years and the French occupation that may prove to be the most important — the large part of his work that he kept hidden in his studio. First, numerous paintings, often small in size, which he executed as the spirit moved him or in indignation at outbursts of violence (GW 917, 921, 931); at the same time he continued to work on his engravings, accumulating over sixty plates of the *Disasters of War* which were subsequently published still in his lifetime. Even more secret were his drawings which enabled him to express in a whisper what he would have wanted to shout from the rooftops. Albums — or more precisely portfolios — were steadily filled with methodically classified and numbered sheets, drawn exclusively with a

144. *Prison Scene.* Around 1808-1812. Oil on wood. 31.5 by 40 cm. Guadalupe, cloister.
This picture is part of the six paintings on wood listed as X.9 in the inventory of 1812. Prison scenes grow frequent in Goya's work, especially among the drawings; they are the image of the freedom mocked by every Spanish government since 1808.

brush, sometimes in India ink, sometimes in sepia, so that they form a homogeneous series in spite of the variety of subjects. Beggars, cripples, monks, seductive young women, nightmarish figures, prisoners, grotesque or tragic visions, the whole vast fresco has a common denominator: Man. Pitiful, ridiculous, ill-treated, tormented or mysterious, Man in Goya's work, with a few rare exceptions, is always anonymous. Without a name in history he himself

145. *Hutiles trabajos (Useful Work).* 1803-1812. Drawing from Album E (E. 37); Chinese ink, wash. 26.3 by 18.6 cm. Paris, private collection.

The topic of washerwomen appears in the work of Goya several times, starting with the tapestry cartoon *Las Lavanderas* of 1780. Here the main focus is on the work and the exertion of the strong young women washing their laundry at the bank of a river, perhaps the Manzanares.

becomes history, the history of our modern age and undoubtedly its first real hero.

1814 was a crucial year for Spain and for Goya, as if their fate were now closely intertwined. The war was finished; Joseph Bonaparte, abandoning Madrid to return to France, had suffered his last and decisive defeat at Victoria. Wellington, now the conquering hero, crossed the French frontier in his turn.

Dios nos libre de tan amargo lance

146. *Dios nos libre de tan amargo lance (May God spare us from such a bitter fate).* Around 1808-1812. Drawing from Album E (E. 41); Chinese ink, wash. 26.7 by 18.7 cm. New York, The Metropolitan Museum of Art (Harris Brisbane Dick Fund).

Scenes of violence occur in Goya's drawings even more frequently than in his paintings and his graphic works, for here he need not subject himself to any restrictions. This sheet shows an attack by bandits at an entrance to a cave.

After six years of foreign occupation the soil of Spain was at last free again. For a few months the capital waited with intense impatience for the return of the legitimate king Ferdinand VII. The myth that the poor prince was a prisoner in French hands had been carefully nurtured for six years and had taken root firmly in all classes of Spanish society; the nickname alone, the *Deseado* ("desired one"), by which he was universally known on that side of the Pyrenees is enough to explain the events that took place in Madrid. First of all, on January 5, the Regency of the Kingdom made its official entry into the capital, presided over by the Cardinal-Archbishop of Toledo, Luis de Borbón y Vallabriga, the son of the Infante Don Luis and nephew of Charles IV, the man whose portrait Goya had painted on several occasions, first at Arenas de San Pedro in 1783, then in Madrid, ca. 1800, at the same time as that of his younger sister, the Condesa de Chinchón. A few days later it was the turn of the Cortes, a living symbol of the constitution they had prepared and promulgated in Cadiz in the midst of the war in 1812, to return to Madrid. For all Spaniards no matter what their political opinions a great new hope had been born after all these long years of suffering and bloody struggle — that of at last welcoming their young king back to Spain, a Spain grown in stature through its resistance to Napoleon and invigorated by the constitution they had purchased with their blood.

Goya joined spontaneously in this unanimous patriotic euphoria. On February 24, that is long before the return of the king, he informed the Regents in a now famous document of "his ardent wish to perpetuate with his brush the most outstanding and most heroic deeds and scenes of our glorious insurrection against the tyrant of Europe." His offer was accepted. It gave rise to two of his greatest masterpieces, the *Second of May* and the *Third of May.* In exchange, as Goya "informed them of his state of utter penury," he asked for a subsidy out of public funds. Due perhaps to the bad economic situation of Spain at the end of the war the Regency was not very generous; one thousand five hundred reals a month while he was working, his supplies to be paid for in addition. This means that the two splendid pictures in the Prado were painted for the derisory fee of five thousand reals at the most.

A little later he asked the new government to restore his salary as First Court Painter and boasted on that occasion "of having resisted all offers and proposals made" by the government of the usurper king, preferring to sell his jewelry at a low price. Thus it seems, according to his own declaration, that his financial situation had worsened since his wife's death. But ought we to believe him? Referring to the inventory of 1812 dated October 28, Goya received 142,627 reals as his share of the estate as well as jewels estimated probably below their true value at 18,400 reals. After their sale he must have had a sum of around 161,000 reals. How could he say then, fourteen months later, that he was in a "state of utter penury?" If his proposal to the Regency can be taken as a genuinely patriotic act, it nevertheless also smacks of someone protesting his *anti-afrancesado* sentiments, someone to whom the new regime had a lot to forgive.

Goya's position as regards Ferdinand VII was very delicate. Officially and until further notice he was still First Court Painter, thus a palace official attached

to the Royal Palace even if he had received no commission for fourteen years. As he had no means of livelihood apart from his painting, i.e., his salary — suspended for the duration of the war — and private commissions, he had no choice but to continue in office or to leave the country. His attempt to go to Piedrahita during the war had taught him a lesson. A First Court Painter could not abandon the court no matter what the regime without catastrophic consequences for his family. When he eventually tried to find a way of getting out without hurting anyone — which would be the ideal solution in 1824 — there was only a single card he could play, that of *anti-afrancesados* patriotism. But how could he eradicate the memory of the portraits of the occupying French, like General Guye and his nephew and the *afrancesados,* the collaborating Spaniards he had painted between 1808 and 1814? How could he hide that formidable *Aubergine,* the Royal Order of Spain, which had been bestowed on him by the usurper government? Goya used the best possible tactics. He denied all connection with the authorities of the preceding reign and proved that he had obtained no material advantage whatever from it. As for the *Aubergine,* it had been more or less forced on him in recognition of his talent as a painter. Words were not enough, but nothing could succeed better than shining acts in eradicating or at least dimming past indiscretions. Paintings — and what paintings! — exalting the heroic deeds of the *Second of May* and the *Third of May* went a long way to compensate for the *Allegory of the Town of Madrid* with its portrait of Joseph I prudently replaced in 1812 by the word *Constitution,* then by the usurper again on his return, was restored and finally in 1814 by the effigy of Ferdinand VII. Nevertheless, there can be no doubt whatsoever of Goya's sincere admiration for the heroes of 1808. The prodigious verve of his brush and the plates of the *Disasters of War* are ample proof of this. There is one fact that seems to throw light on the artist's secret thoughts. He did not execute these two stupendous paintings live in 1808 but six years later by his own choice at the time when the new sovereign returned. This delay seems to add a political dimension to these powerful works that is not without interest.

At the very moment when Goya was painting these two pictures Madrid was preparing to welcome the king. As the second of May approached the anniversary of the historic rising of the Spanish people against the French, the fervor in the capital reached its peak. This first patriotic celebration was to have a brilliance and solemnity that would do justice to the special circumstances of the liberated country. It had been decided to exhume the remains of Daoiz and Velarde, and the organization of the ceremony had been entrusted to the Royal Corps of Artillery to which they had belonged. That day the Cortes were to move into their new premises, and the full complement of deputies took part in the procession, accompanied by all the great bodies of the municipality of Madrid. The most famous personalities, some of them already almost legendary figures, received the homage of the people of Madrid from the invincible *guerillero El Empecinado* (Fig. 137) to the poet Martinez de la Rosa, the idol of the liberal youth of Spain. The ideal of this people, happy to be free again at last, was inscribed in stone on the façade of the palace of the Cortes. Between the statues

147. *Trabajos de la guerra (Consequences of War).* Around 1808-1812. Drawing from Album E (E. d); Chinese ink, wash. 24 by 17 cm. Paris, private collection.

Here Goya shows one of the "devastating consequences of the bloody war" against the tyrant of Europe about which he is talking in the hand written title to the *Desastres de la Guerra.*

148. *El ciego trabajador (Diligent Blind Man).* 1803-1812. Drawing from Album E (E. e); Chinese ink, wash. 23.8 by 17.1 cm. Vienna, Albertina.

A picture of the suffering and industrious people. Goya's works of this type show how heavily the terrible, turmoiled times weigh on the apparently peaceful people.

227

El ciego trabajador

149. *Two Prisoners in Chains.* Around 1820-1823. Drawing from Album F (F. 80). Sepia, wash. 20.6 by 14.3 cm. New York, The Metropolitan Museum of Art (Harris Brisbane Dick Fund).

One of Goya's finest drawings: Gigantic bars and huge stone blocks appear to be crushing the two figures huddling together — the whole horror of prison becomes obvious.

of Religion, Country and Liberty, carved in gold letters in the marble, shone a quotation from the Constitution: "The power to make laws is vested in the Cortes together with the King." This was a symbol and consecration of the union, achieved at last, of legislative and executive powers.

Alas, two days later the beautiful dream ended in a rude awakening. At Valencia Ferdinand VII signed an edict abolishing the Constitution, the Cortes

and all its decrees. In the night of May 10-11 before the publication of the edict in the *Gaceta,* all those who might be suspected of being liberals or supporting liberal views, whether they were deputies, journalists, writers, actors, Spanish Grandees or plain citizens, were arrested and imprisoned. Finally, on May 13 the king made his solemn entry into the capital to the well-orchestrated cries of "Long live religion," "Down with the Cortes," "Long live Ferdinand VII," and even "Long live the Inquisition!" All that had been done since 1798 to give Spain greater liberty was undone in the space of a few days — decrees against the liberals, against the partisans of Joseph Bonaparte, decrees restoring the convents and monasteries, exonerating the clergy from taxation, restoring the Inquisition and then suppressing all newspapers except for the *Gaceta* and the *Diario de Madrid,* and finally recalling the Jesuits.

For Goya, who had been the friend of Jovellanos, Moratín, Cabarrús and of many other *ilustrados,* the precursors of liberalism and who had pleaded their cause with his *Caprices,* regression was the worst of the "fatal consequences of the bloody war against Bonaparte," to use the autographed title of the *Disasters of War.* Worse still he felt personally threatened on the same grounds as some of his friends, like Moratín, Silvela, Melendez Valdes and Maiquez who had been exiled or imprisoned. He had not forgotten that the Inquisition — *la Santa* as he said in one of his letters from Bordeaux — had been interested in the *Caprices* from the time they appeared which led him to present the copperplates and the unsold copies to the king so as to protect them from possible destruction. Although this dated back some fifteen years the files of the Inquisition had certainly not forgotten. Besides there was his adulterous affair with Leocadia and the recent birth of Maria del Rosario, the offspring of their union. In May 1814 the Duke of San Carlos was instructed to prepare the investigation of "purification" of employees of the Royal Palace which included him as well as his son Javier, who received an income of 12,000 reals granted him by Charles IV in 1803. Goya knew that sooner or later he would have to produce witnesses in his defense to justify his conduct during the reign of the usurper. This was worrisome enough in the atmosphere of brutal repression that reigned in Madrid but matters took an even more dramatic turn in the winter of 1814-1815. Just as the witnesses called by Goya were submitting statements highly praising the painter's patriotic conduct, the Public Warehouse of Sequestration, where the goods seized from Godoy's palace in 1808 were kept, sent five allegedly obscene paintings to the Grand Inquisitor of the Court, including Goya's *Majas* which had been commissioned by the favorite. The prosecutor of the Inquisition immediately issued orders for "the appearance before the Court of the said Goya to identify them and say if they are by him, and why he painted them, who had commissioned them and for what purpose..." He was also asked to identify the other pictures and their painters.

Imagine the effect this summons to appear before the Inquisition must have had on the painter! The fearful spectre of the *Santa* was again raising its head and at a most difficult time. The uncertain period of the restoration hardly encouraged leniency, and not only would the obscenity of the *Naked Maja* risk

severe condemnation, but the close links with Godoy which he would have to admit would give the trial a positively political slant with unimaginable consequences. At best it would mean four to five years' confinement in a monastery or charterhouse far from Madrid, at the worst eight years in the presidios of Melilla or Alhucemas. Some, like the liberal poet Antonio Sabinon, died in prison before they reached the penal colony.

Luckily for Goya and for us the affair was not followed up. No document has been found dating from after the convocation of March 16, 1815. Was Goya heard by the court? Who knows? It has been suggested that an influential person intervened to stop a case that might — through the First Court Painter — reflect on Charles IV and Queen Maria Luisa who were still living in exile in Rome. This highly placed protector surfacing from the past could only have been the Cardinal-Archbishop of Toledo, Luis de Borbón y Vallabriga, the eldest son of the Infante Don Luis, whose position at the head of the Council of Regency awed his young cousin Ferdinand VII. How could he have forgotten the little boy in the cornflower-blue dress with long fair hair whom Goya had immortalized at Arenas de San Pedro in the *Family Portrait,* and how could he the Primate of Spain remain indifferent to the terrible threat from the *Santa* hanging over his father's favorite painter? Goya had been associated so closely with the courts of Charles III and Charles IV, the luster of the Spanish Bourbons was linked so inextricably with his, that any attack on him personally even if justified would inevitably tarnish the image of the two kings. Less than a month later the Committee for "Purification" of Officials in the Royal Household restored the painter and his son to all their rights and prerogatives. From that time on, in spite of the political storms that were to shake Spain, and in spite of the suspicions of liberalism that were still attached to him, Goya received his salary as First Court Painter until his death. Thus his security and that of his son were assured.

The granting of this certificate of good patriotic conduct to the aging master, now nearly seventy, in those difficult times and in the thick of political repression marked an important turning point in his life and even in his work. At once commissions began to pour in again. Although the Court remained closed to

him, his official title, reconfirmed, made him just the "right" portrait painter for some of the highly placed dignitaries of the new regime: the *Duke of San Carlos*, secretary of State of Ferdinand VII, *Miguel de Lardizabal* and *Ignacio Omulryan*, who succeeded each other at the Ministry of the Indies, *Miguel Fernandez Flores*, consecrated bishop of Marcopolis in 1815, and *José Luis Munarriz*, the secretary of the Academy of San Fernando, appointed director of the Royal Company of the Philippines in the same year. This cultured, sophisticated man, famous in Spain as the translator of Hugh Blair, was well known to Goya and to his friend Moratín. His portrait is linked with the major picture generally called the *Royal Company of the Philippines* (Fig. 179) which will be discussed later.

One point must be made about the relationship between Goya and Ferdinand VII. The two first met in 1808, shortly before the new king's departure for Bayonne. At that time the young ruler had accorded sittings of three-quarters of an hour to the painter. These, however, were for a portrait not commissioned by the king himself but by the Academy of San Fernando of which he was the Protector. After his return to Madrid in 1814 Ferdinand did not commission a single picture from the First Court Painter. The portraits of him done in 1814 and 1815 were executed for institutions outside the Court: *The Provincial Disputación of Pamplona*, the City of Santander, Canal Imperial of Aragon at Saragossa, and various ministries. All were painted with the aid of sketches made from the 1808 model which gives the face a certain uniform ugliness. These are a long way from the numerous official portraits of Charles IV in court dress, in hunting costume, on horseback, life size or head and shoulders, to which the pose gives a feeling of naturalness, a very different awareness of a human presence. Apart from the ceremonial reception of the king at the Academy on July 8, 1814, at which Goya in his capacity of Director was present, there is no record of any subsequent meeting between the painter and the sovereign. The antipathy, not to use a stronger term, was certainly reciprocal and although Ferdinand VII never did anything to harm Goya, this was probably due to consideration for his great age and especially for the tremendous talent he had placed at the service of the two preceding reigns.

VI

The Time of the Absurd

VI The Time of the Absurd

Restitution of Goya's rights and responsibilities — financial problems — Caprichos enfáticos — *the* Tauromaquia — *third and final trip to Andalusia — purchase of* Quinta del Sordo — *Leocadia Weiss and Goya — first lithographs — the* Disparates — *Albums of drawings: secret works — serious illness in 1819 — the* Black Paintings.

Despite the full restitution of Goya's rights after the "purification" of 1815 there are several indications that his financial situation may have changed considerably for the worse. He often alluded — perhaps exaggerating — to the penury in which he found himself, in particular in his persistent demands to the Academy of San Fernando for payment for the portrait of King Ferdinand VII painted in 1808. During the war the financial resources of the Academy had declined to the point where it could no longer pay the teachers and other staff. In 1814 in his first demand for the 9000 reals he had been promised, Goya pointed out that "during the French invasion and since the departure of the enemy troops, he had produced...no work that could contribute to his subsistence so that over that long period of six years he had exhausted all the resources at his disposal." It may be assumed that there was no response to his request since he renewed it two years later on October 14, 1816. He even proposed that according to the state of its finances it should pay him the sum due "in such manner and within such time as may be convenient."

It may seem surprising that the Academy of the Arts, of which, one must remember, Goya was Director, waited more than eight years before meeting

his demand. While the plea of hard times was acceptable when it was put forward in 1809 this was no longer the case once the war was over. Behind the painter's second letter lies an apparent misunderstanding. The Academy had mistaken the portrait of Ferdinand VII for the work that every new member of the Academy had to present following his election. As Goya had been elected in 1780 it seems highly unlikely that he would have waited twenty-eight years to observe this custom. He accordingly pointed out that at the time he had presented a *Christ on the Cross* (Fig. 27), but on the order of Count Floridablanca, the picture had been given to the monks at the Convent of San Francisco where, he affirmed, it still was albeit in poor condition. The Academy finally admitted its mistake, but being unable to pay the whole sum at one time, held out the hope of payment in installments "as circumstances permit and at the discretion of the First Vice-Protector."

Another source of financial worry for Goya was the full-length portrait of the *Tenth Duke of Osuna* — the eldest son of his old friends and protectors — which he had painted in August 1816. The agreed price was 10,000 reals for which the painter had to dun the Duke four months later. Unfortunately, the latter's assets had been seized by order of the King, and Goya had to present a new demand before a designated judge. He had to wait until March 1817 before he was paid.

In the thick of these financial uncertainties, the celebrated *Tauromaquia* series was put on the market. This was the third album of original etchings compiled by Goya for public circulation. The *Caprices* of 1799 had been a commercial failure, and in 1803 no doubt through fear of the Inquisition, he had let the King have eighty plates and the unsold copies in exchange for the payment of an annuity of 12,000 reals to his son Javier. The second series of engravings, afterwards known as the *Disasters of War,* was started in 1810 at the height of the war; its principle source was the terrible sights he had witnessed on his journey to Saragossa between the first and second sieges of the town. In 1814 these scenes of violence and barbarity so typical of guerilla warfare, together with plates dealing with the winter famine in Madrid in 1811-1812, were put together to form a homogeneous collection of some sixty prints.

It is difficult to believe that this series, the fruit of four years' work, was not intended for publication. To judge by the unique copy in the British Museum with its autographed title, Goya's actual intention was openly to denounce the "fatal consequences of the bloody war in Spain against Bonaparte." Why then was this shattering testimony to the tragic years that Spain had just lived through not put on sale as soon as the French occupation ended? The change in the political situation seems to be the main reason. Between the painter's original patriotic impulse in February 1814 when he offered to paint heroic scenes from the war for the Regency, and the anti-liberal repression decided on in May by the king and his *camarilla,* the eyes of many Spaniards — and those of Goya in particular — were opened. Whereas before May 1814 the people of Madrid would have considered the publication of the first sixty plates of the *Disasters* to be clearly a patriotic act, their publication once that date had passed would

150. *Head and Quarters of a Dissected Ram.* Around 1808-1812. Oil on canvas. 45 by 62 cm. Signed. Paris, Musée du Louvre.

Prior to 1812, and probably during the war, Goya painted a series of twelve still lifes that were listed in the inventory of his studio when his wife died. All of them depict edible substances, frequently in an extraordinarily realistic manner, at a time when the basics were lacking and the winter of hunger of 1812/1813 was lurking at the door!

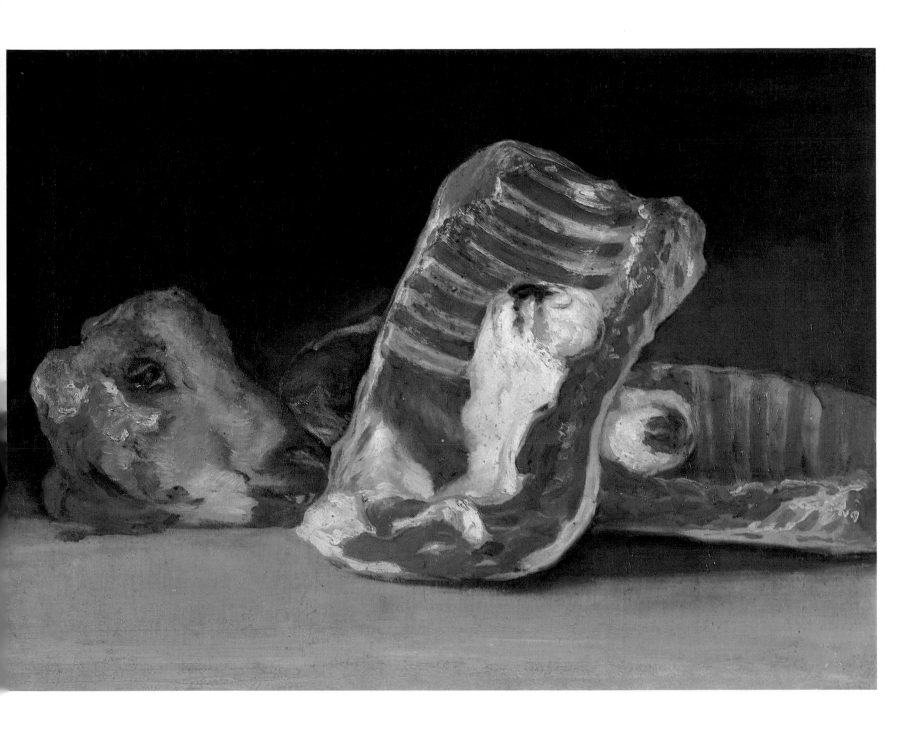

have risked throwing their creator back into the camp of the *serviles,* i.e., the partisans of an extreme absolutism that loathed liberals and *anti-francesados* alike. With the *Second of May* and the *Third of May* Goya had given an impressive guarantee of his loyalty, and he thought it would be unwise to push his luck by publishing the *False Consequences*. Note that in Goya's lifetime and for a long time after his death the general public knew nothing of these two famous canvases for they were still in storage at the Prado in 1834 and did not appear in the catalogue of that museum until 1872. Had these scenes been disseminated as engravings, they would have had an altogether different impact, akin to that of a political pamphlet.

Today the *Disasters of War* appear to hold up a faithful mirror to those chaotic times which had such an effect on life in Spain. After these uncompromising images of the horrors of war and of ignominious death in a winter of famine, Goya went on to attack the perverse and pitiless world created by Ferdinand's repressive rule after 1815. This is the third section of the most violent indictment that an artist has dared to launch against the men of his time. But whereas the first two sections could be produced openly in the heat of a just war, the third is carefully shrouded in mystery, allegory and symbolism so that it is sometimes difficult to interpret. Hence the strange titles of those last plates (eighteen in number, counting two unpublished ones): *Caprichos enfáticos,* of which there is no satisfactory literal translation. However, the word *caprichos* recalls the first great series of 1799 with its satirical tone, its caustic attack on the vices and injustices of the time in pictures created in a spirit of total freedom. To it is added the word *enfáticos* (emphatic), which is most ambiguous in the context since it is applied to pictures rather than language. No doubt it refers to the disproportionate degree of camouflage he uses to transcribe ideas that he could not express openly. Here we are very close to allegory but without the usual emblematic values; the method is entirely original and anticipates on the religious and political levels the enigmas of the *Disparates* (Follies).

Nevertheless, through the haunting imagery of the *Caprichos enfáticos,* it is possible to discern a violent attack on the institutions restored by Ferdinand VII and in particular on the Inquisition and the monastic orders. Indeed, the titles unequivocally underline or indicate the meaning of the etchings: *Contra el bien general* (Against the common good), *Estraña devoción* (Strange devotion), *Que se rompe la cuerda* (May the rope break), and so on until the two final plates in the series which are probably those that best reveal Goya's state of mind during the black years after 1815. There is a logical link between them such as was often found in albums of drawings at the time. The subjects are allegorical and explained by the titles which form a connected phrase. The central figure is the same in each: a young woman in white literally radiating light who represents Truth. This was an image dear to the artist who used it many times in his drawings of the same period, with a somewhat shifting symbolism; sometimes it represents Liberty, sometimes Justice or Truth — concepts that for Goya all seem to merge in a single vision of white femininity. It is also an antithetical vision, in which Good, associated with white, is opposed to the spirit

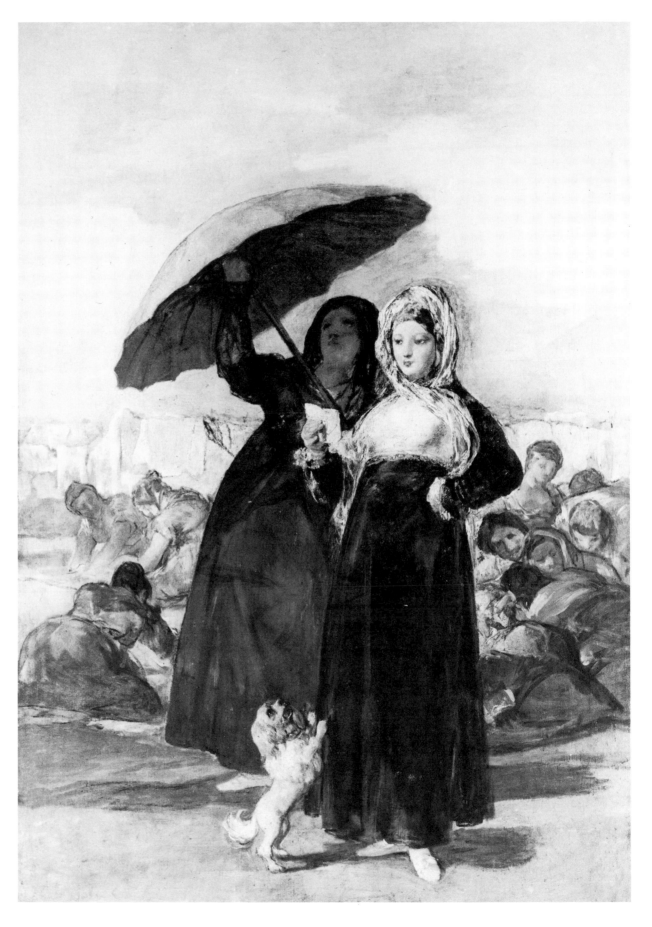

of Evil — injustice, oppression, and falsehood co-mingling in the sinister complicity of the shadows. *Murió la verdad* (Truth is dead, Fig. 153); Goya does not dare to say "murdered," but he implies it. By whom? Forming a sort of baleful wreath around the body, shapes crowd together in the darkness, vague at first, then quite recognizable; monks and a bishop stand out from the grinning delighted throng. This is the "black Spain" already condemned by the *ilustrados* and at their instigation by the series of *Caprices* — a nightmarish world to which Ferdinand VII, throwing common sense to the winds, had restored all its oppressive power. Though Goya was now an old man of seventy, his draftsman's hand was still steady enough to express the bitter indignation he felt at this relapse into the absurd so soon after a particularly bloody war. Under the yoke of absolute rule times were harder than ever. Nevertheless, Goya did not want to end his series of *Fatal Consequences* on a pessimistic note. The eightieth plate shows the same figures again, but their roles are reversed: *Si resuscitará?* (And if she were to rise again?), the caption reads. Terrified by the blinding light of Truth, all the figures that had been cackling in the background have taken flight and are scuttling like noxious beasts back to their lair. Hope for a just reversal of the situation had not been lost, and such a reversal was in fact finally achieved (or so the liberals believed) by Riego's rising in 1820.

It is obvious that these *Caprichos enfáticos* rendered the series of etchings unpublishable. Without them it would have been deprived of the most tragic of the "consequences" and as a result of his patriotism Goya would have run the risk of being consigned to the camp of the unconditional *afrancesados*. With them it would have been considered as the pamphleteering work of an unrelenting liberal, with the fearful risks that this would have involved for somebody as well known as Goya. This was probably among Goya's reasons for undertaking another series of engravings, one that could be published and therefore sold. This economic aspect cannot be neglected in view of the difficulties he experienced in the years directly after the war. What was needed was an apolitical subject, capable of interesting not only the Spanish public but foreigners as well, and above all one that would permit him to give free rein to his natural gusto. The *Tauromaquia* seemed to fulfill all these conditions. Motivated primarily by necessity, but also by a compulsion to forget the bitterness of the present by returning to the enthusiasms of his youth, Goya engraved the thirty-three plates of his new series in one fell swoop and in record time. Good quality copperplate imported from England was again available in Madrid. He chose the best he could find in an exceptionally large format (double that of the *Caprices* and the *Disasters of War*). Escaping from the contemporary world for the first time, he turned to the past and tried to show the history of bullfighting from its most distant beginnings. Then, evoking the great figures of the past, he recorded his own memories up to the tragic death of Pepé Illo in the arena in Madrid on May 11, 1801. Rarely did his rejuvenated genius express itself more movingly than in these nostalgic images of a happier time that, because of the intervening war, seemed to have receded still farther into the past. Heavy quality paper was used, and the printing was carried out extremely carefully

152. *La fragna (The Smithy)*. Around 1812-1816. Oil on canvas. 181.6 by 125 cm. New York, Frick Collection. This painting, as well, was in the Spanish Gallery of King Louis-Philippe. It is very similar to a drawing in Album F (F. 51) in which three men are digging a hole. The posture of the men displays the same strength and physical effort.

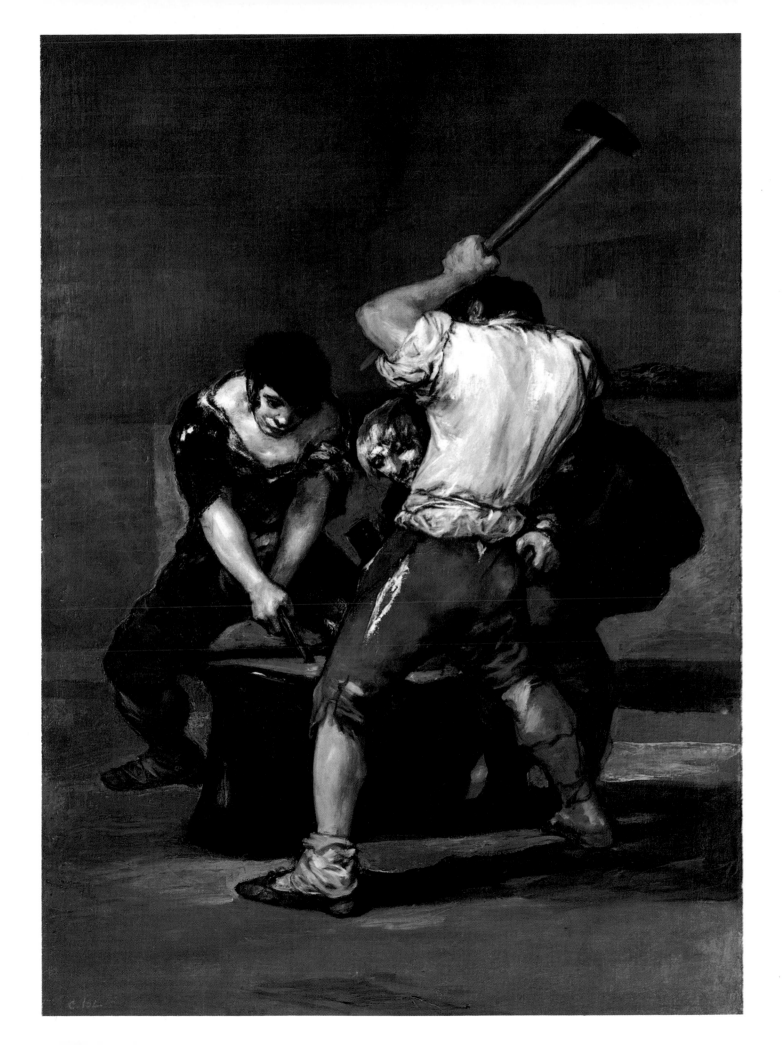

153. *Desastre de la Guerra 79: Murió la Verdad (Truth is dead).* Around 1815-1820. Etching. 17.5 by 22 cm.

The last two sheets of the *Desastres de la Guerra* (numbers 79 and 80) are closely related due to their political significance: the allegory of truth murdered by obscurantism and superstition is followed by the declaration of its radiant rebirth in the second sheet.

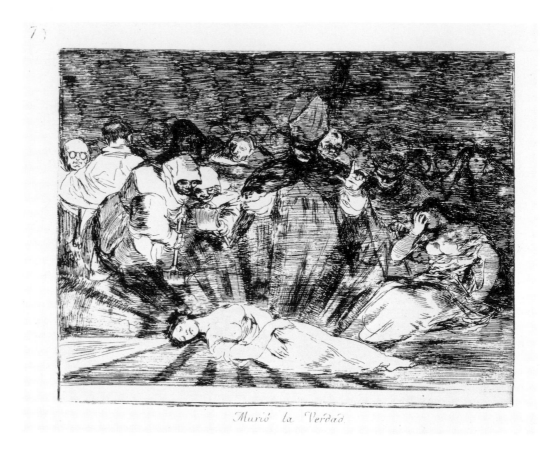

Murió la Verdad

(Rafael Estève probably helped), but the series was not a great success. The public wanted a clear, easily understood handbook on bullfighting but Goya gave them sumptuous scenes from the past, a sort of dream world inhabited by magnificent men and beasts.

The near-failure of the *Tauromaquia* in 1816 was compensated for by an important, totally unexpected commission. The Chapter of Seville Cathedral, at the instigation of Goya's loyal friend Ceán Bermúdez, entrusted him with the execution of a large painting celebrating the city's two patron saints, Justa and Rufina. This subject had previously been tackled by Murillo, and it was thus a great honor for Goya to vie with the most "Sevillian" of the painters of the Golden Century on his own ground. It also gave him the opportunity for his third (and last) visit to Andalusia — the others were in 1792 and 1796 — to plan the composition of his painting on the spot. While in Seville he stayed with a local painter José Maria Arango and his old friend Ceán Bermúdez played a major role in developing the subject. A very curious letter from the historian shows the extent to which he intervened in the painter's work: "I am now very busy inspiring Goya to restraint, modesty, devotion, respectable action and a composition that will be dignified and simple with regard to religious attitudes; I have in mind a large picture ordered by the Chapter of Seville for its Holy Church. Since Goya went with me to see all the great paintings in this magnificent temple, he has been working with great respect on a painting which

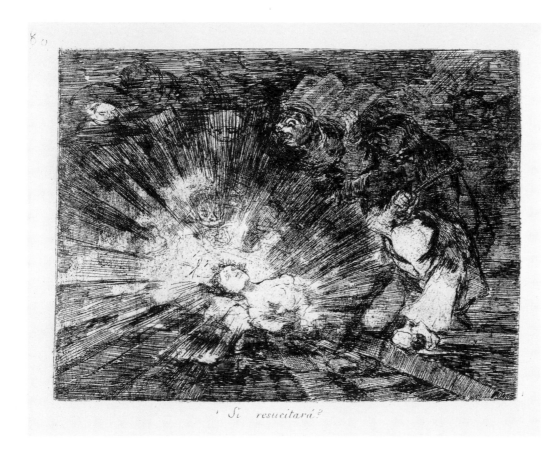

is to be placed beside them and which will be crucial for his reputation and fame. The subject is the holy martyrs Saints Justa and Rufina."

This visit to the cathedral with Ceán Bermúdez was of great importance for Goya. There he saw again pictures that he must already have known from 1792 and 1796. But a great deal had happened in the intervening period of more than twenty years. First of all, many of the paintings had been stolen during the war, but Murillo's great ensembles, like that of the Capuchins, had been hidden and by 1817 were back in the Cathedral. They included his *Saints Justa and Rufina* which originally formed part of the polyptych on the high altar. This confrontation with Murillo's work when he was about to paint the same subject seems to have led Goya to treat it in a determinedly personal style that owes little to his illustrious predecessor. The attitudes of the two saints, their clothes, and every feature of the composition (notably the Giralda) have been transformed as if the painter felt he was competing against his predecessor and was determined to assert his individuality. An unusual feature, unique in his work, bears this out: the picture is inscribed *Francisco de Goya y Lucientes Cesar-Augustano y primer pintor de Camara del Rey. Madrid ano de 1817,* with the unwonted "Cesar-Augustano," the Latin form of "zaragozano," solemnly proclaiming his Aragonese origins in the face of the eighteenth-century Andalusian school. At the time of his meeting with the Infante Don Luis when he was embarking on his career as a painter, Goya's ambition had been to equal Velázquez. Returning to Seville

245

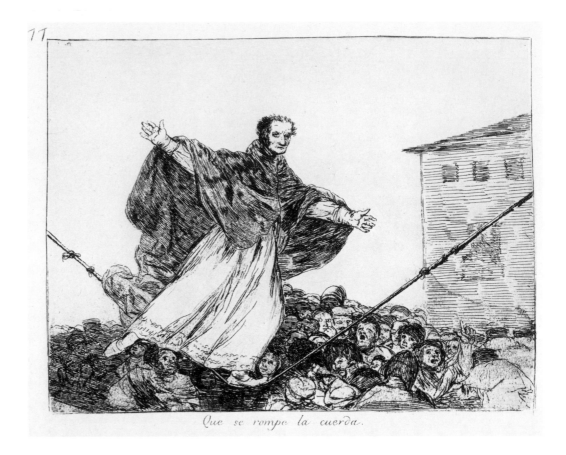

Que se rompe la cuerda.

late in life, it was Murillo with whom he vied. This would be the last Andalusian venture of his career.

The year 1819 was crucial for Goya, both personally and professionally. Just as illness had marked his decisive change of course in 1793, so the threat of death at the close of 1819 put an end to eleven years of turmoil and violence, which he had endured with dignity, and opened a new chapter in his life. But, in the February preceding this stroke of fate, Goya had taken a very important decision. He had purchased a large estate outside the city on the other side of the Manzanares past the Puente de Segovia. It was some ten acres in area and contained a rather modest two-story house. By a curious coincidence, this was known even before he bought it as the *Quinta del Sordo* (Deaf Man's House). The price was 60,000 reals.

It is known that Goya had lived since 1800 at No. 15 Calle de Valverde in a house that went to his son Javier in the division of property of 1812, though he seems to have retained the use of it. What could have impelled the aging master to move from the center of Madrid? It is generally alleged that he did so for political reasons. It is certain that his situation had considerably deteriorated since 1815; he was no longer First Court Painter, except in name, and had no duties at court. His liberalism was certainly known, as was his sympathy for the former *afrancesados*. The King exercised his power in such an

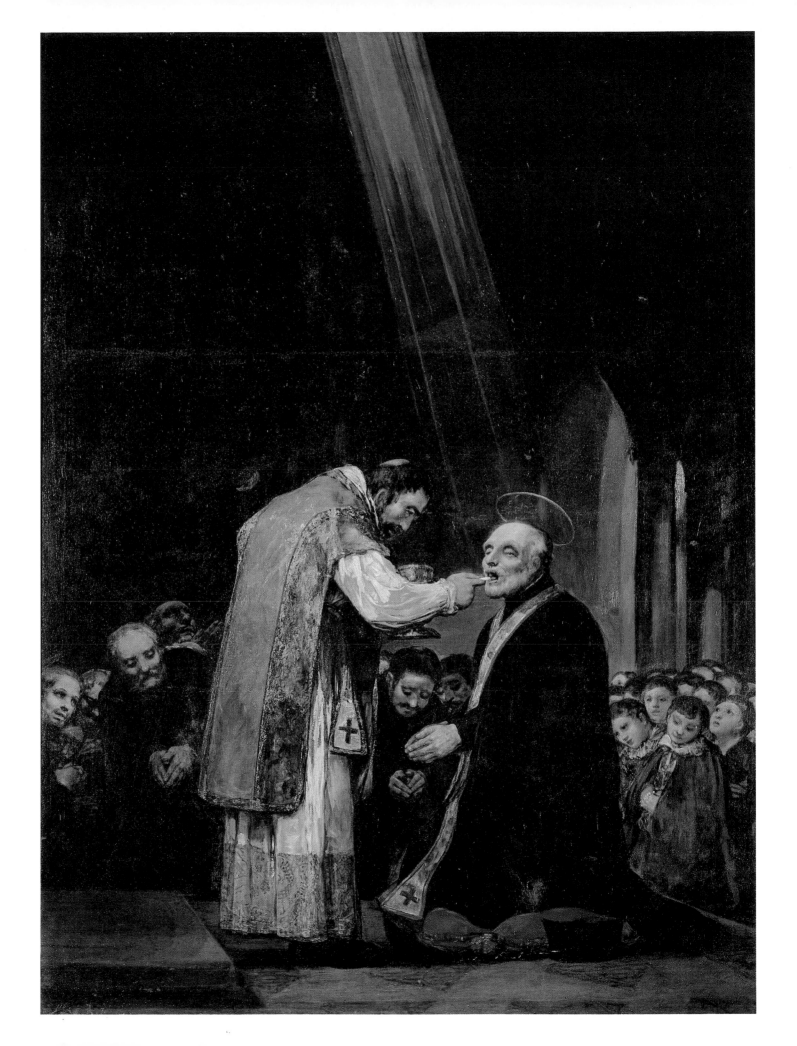

157. *Disparate 2: Disparate de miedo (Foolishness of Fear).* Around 1815-1824. Etching and aquatint. 24.5 by 35 cm.

With the series of the *Disparates* and the *Black Paintings,* Goya turns toward the world of the absurd and of nightmares. Once again a colossus appears, but the body and face are unrecognizable: the bowed figure is one of the monsters "engendered by the sleep of reason," as stated on the front cover of the *Suenos (Capricho 24).* The title of the sheet is not Goya's.

arbitrary fashion that the worst was to be feared at any moment. Taking warning from the persecution of some of his close friends, including the actor Máiquez, he withdrew from public life as much as possible and sought a retreat where he could end his days in peace.

In the years 1817 and 1818 there had been some hope that Ferdinand VII would become more liberal once the succession to the throne was assured. Unfortunately the two children born to Maria Isabel of Braganza did not live,

158. *Disparate 3: Disparate Riduculo (Ridiculous Foolishness).* Around 1815-1824. Etching and aquatint. 24.5 by 35 cm.

Through the use of the aquatint technique — Goya had previously used it in the *Caprichos* — the backgrounds obtain something of the unreal, something not belonging to this world. This intensifies the absurdness of the scene. Among the beings on the branch only the woman with the muff — is she Leocadia Weiss? — seems to be real. Goya originated the title.

159. *Disparate 3: Disparate Ridiculo (Ridiculous Foolishness),* detail, (see illustration 158).

248

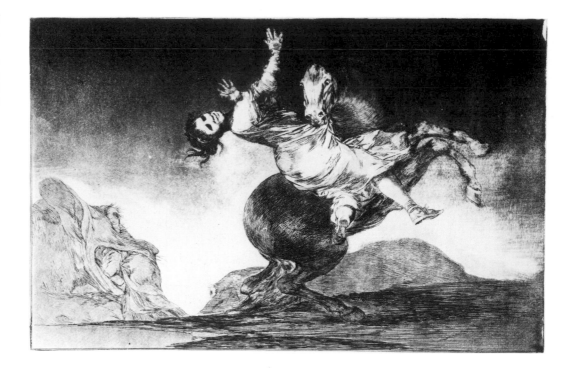

160. *Disparate 10: Disparate Desenfrenado (Unbridled Foolishness).* Around 1815-1824. Etching and aquatint. 24.5 by 35 cm.

A new version of the "Abduction of Europe." The scene with the wildly gesticulating woman takes place in an environment saturated with hidden hornyness implied by the monsters writhing in the background. The title is not Goya's.

and the second of them cost the Queen her life in December 1818. There was general grief, and hope was succeeded by the fear of even greater severity on the part of established authority. Was Goya's decision precipitated by anxiety over the political situation? It is possible; rather than go into exile, as so many of his friends had done, he hoped that he could become a forgotten man simply by crossing the Manzanares.

In addition to this political motive, there were others of a less obvious kind, namely his relationship with Leocadia Weiss. Although it was considered quite

161. *Disparate 13: Modo de volar (A Way to Fly).* Around 1815-1824. Etching and aquatint. 24.5 by 35 cm.

This sheet differs from the rest of the series based on its title alone; Goya named it and created it at the same time as the *Tauromaquia*. He included a copy of it in the sample of the *Tauromaquia* he gave to Ccán Bermúdez. Flying has been one of man's dreams since the times of Icarus and in to the present.

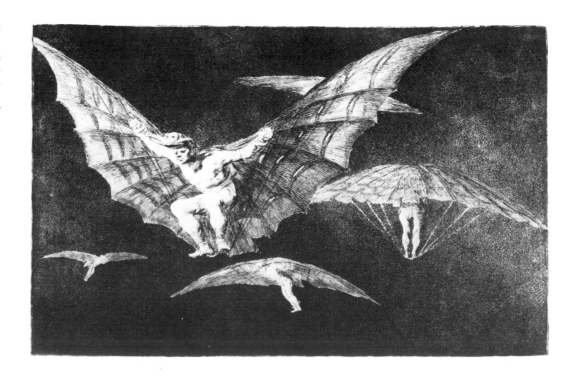

162. *Disparate 13: Modo de volar (A Way to Fly),* detail (see illustration 161).

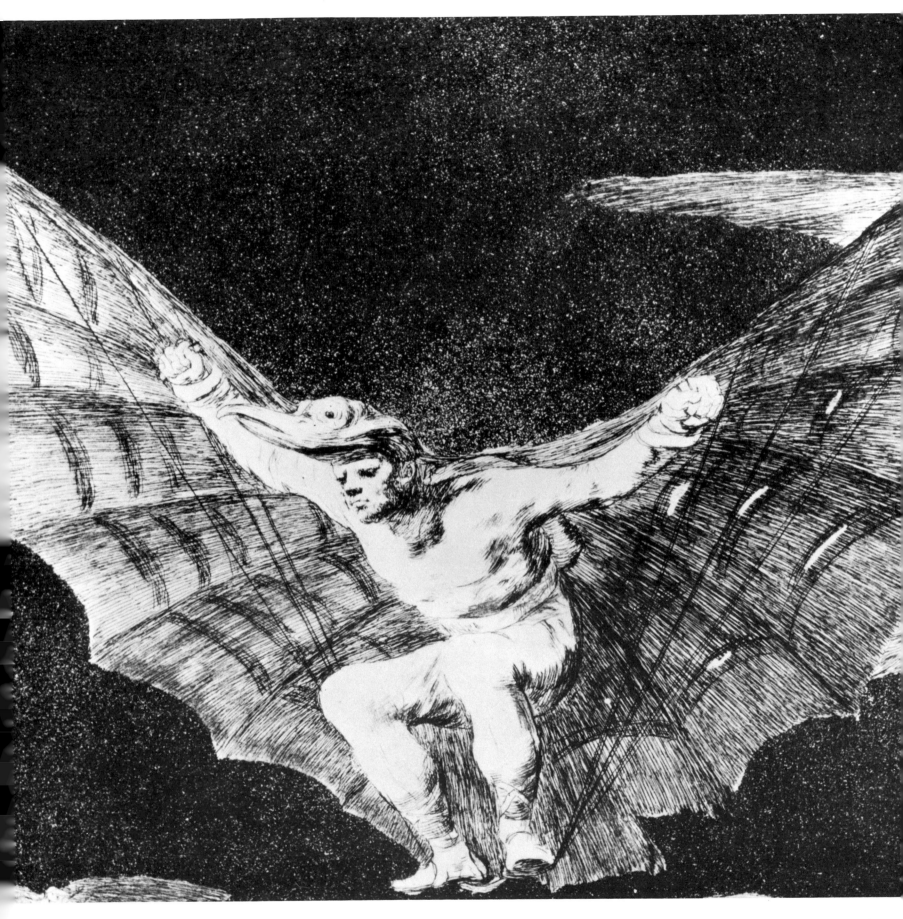

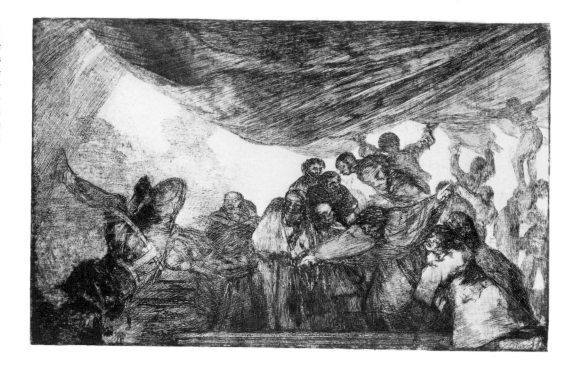

163. *Disparate 15: Disparate Claro (Obvious Foolishness).* Around 1815-1824. Etching and aquatint. 24.5 by 35 cm.

One of the most mysterious sheets of the series; the greatest nonsense of the scene is probably the enormous cloth billowing downward; it threatens the people desperately attempting to hold it above their heads. The fall of the soldier on the left could impart a political-military meaning to the sheet: the end of the French occupation and the senseless fighting among the Spaniards at the moment when the pressure of the reign of Ferdinand VII is increasing.

usual for a widower of his age and rank to have an *ana de llaves* (housekeeper) in his household, the presence there of this woman of thirty-one, at the height of her beauty, certainly caused tongues to wag. The scandal broke in 1811-1812, when her husband Isidoro Weiss brought an action against her. The birth of Rosario in 1814, bringing Goya new responsibilities as well as happiness, made the situation even more improper. Javier, whose cupidity is well known, his wife and the Goicoecheas could only be shocked and upset to see this young

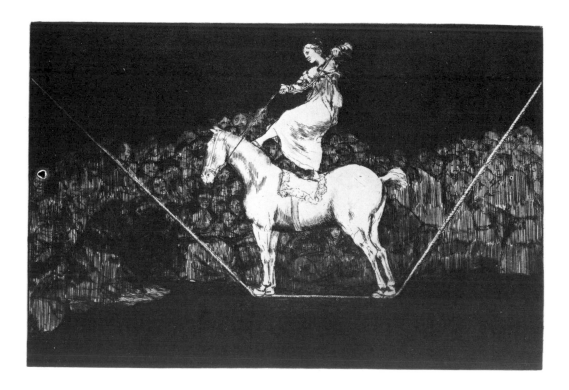

164. *Disparate Puntual (Precise Foolishness).* Around 1815-1824. Etching and aquatint. 24.5 by 35 cm.

This sheet and three others were published in Paris in the magazine *L'Art* in 1877. The Paris copies bear the title *Una reina del circo* (A Circus Queen); Goya's title, however, is much less to the point and like all the others, ambiguous.

252

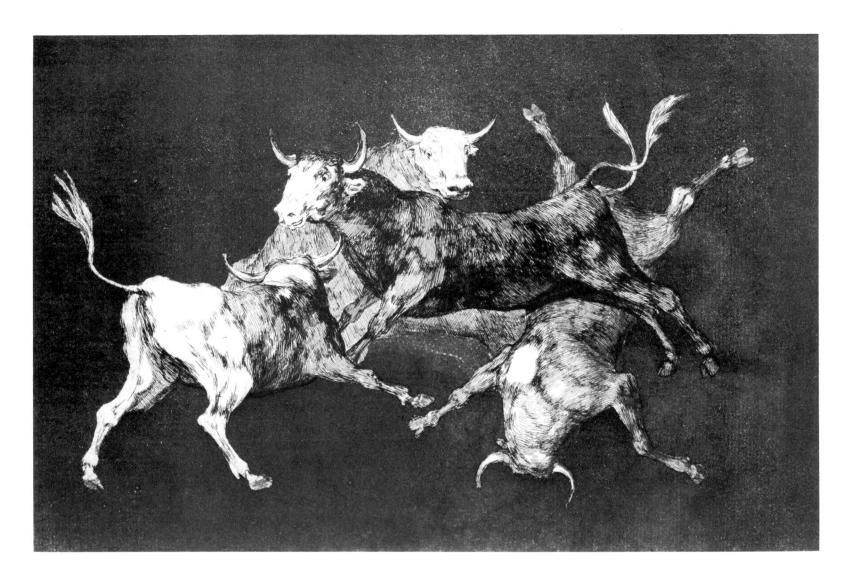

woman — their own relative, moreover — involved in the life of their distinguished kinsman and jeopardizing their chances of inheriting his property. The old man was no doubt under surveillance and the mere suspicion of concubinage, at a time when the Inquisition — which had already taken an interest in him — was in full swing, could involve them in serious trouble. In addition, as events would show, Leocadia was an enthusiastic liberal and well known to the police.

These, it appears, were the reasons for the purchase of the Quinta del Sordo, to which Goya moved when it had been renovated. The exact date is not known, but it was probably not until after his illness, that is, at the beginning of 1820. In the preceding year, he had produced a wide variety of works of a novel kind, which took up all his time. A clumsy lithograph, signed and dated 1819, has survived. A lithographic studio had just opened in Madrid under the direction of José Maria Cardano, who had learned the brand-new engraving technique in Paris and Munich. Goya was immediately attracted by the revolutionary process, just as he had been attracted by the aquatint in 1778 — a proof, if proof be needed, of the insatiable curiosity he would display to the end of his

165. *Disparate de Tontos (Foolishness of the Fools).* Around 1815-1824. Etching and aquatint. 24.5 by 35 cm.
The sheet, published in Paris in 1877, depicts a scene with flying animals so common to Goya. The hand-written title appears somewhat strange as the word *tontos* does not really fit what is shown.

life. Helped and advised by Cardano, he made five or six trial lithographs before his departure for France in 1824. The results were not very encouraging by comparison with what he had achieved in his etchings and aquatints. The fault lay with the transfer system employed, which resulted in poor proofs that had to be touched up in pen or pencil. For the time being, Goya did not carry his experiments with the new technique any further.

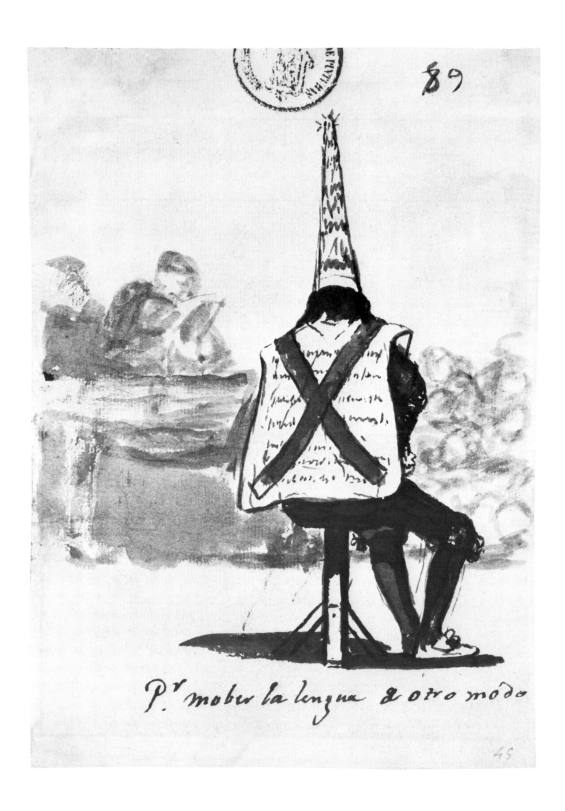

166. *Por mober la lengua de otro modo (Because he spoke differently).* Around 1814-1820. Drawing from Album C (C. 89); sepia, wash. 20.5 by 14.3 cm. Madrid, Museo del Prado.

In the privacy of his studio Goya attacks the despotism of the proceedings of the Inquisition. The hand-written title lists the reason for the conviction that in general was written on the overcoat — the *sanbenito* — the accused had to wear.

On the other hand, he still found copperplate engraving an ideal means of expression. Although it is not possible to establish a precise date, it is generally conceded that the series wrongly designated *Los proverbios* (Proverbs) was started in 1815. From the few trial proofs bearing a handwritten title, it can be seen that he wished to call them *Disparates,* that is, *Follies* or *Extravagances.* Using copperplates from the set he had used for the *Tauromaquia,* he first produced

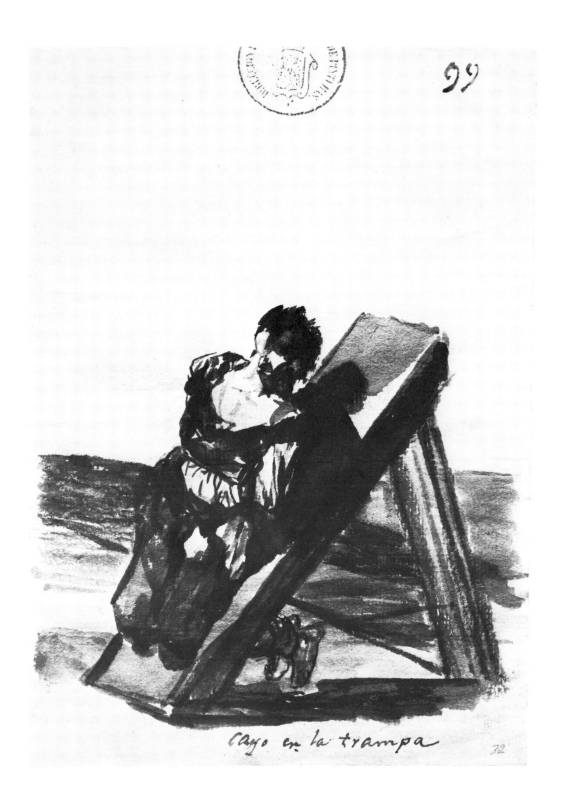

cayo en la trampa

167. *Cayo in la trampa (Trapped).* Around 1814-1820. Drawing from Album C (C. 99); sepia, wash. 20.5 by 14.2 cm. Madrid, Museo del Prado.

Album C, preserved almost in its entirety in the Prado, contains the most dramatic torture and prison scenes in Goya's work. Within the Album they form a closed group, carefully ordered and numbered by Goya.

168. *Quien lo puedo pensar! (Who can believe it!)* Around 1814-1820. Drawing from Album C (C. 105); sepia and Chinese ink, wash. 20.5 by 14.2 cm. Madrid, Museo del Prado.

A maximum of expressiveness is achieved here with the most frugal of means. With its brevity the legend supplements the masterful sheet with regard to content as well as formally.

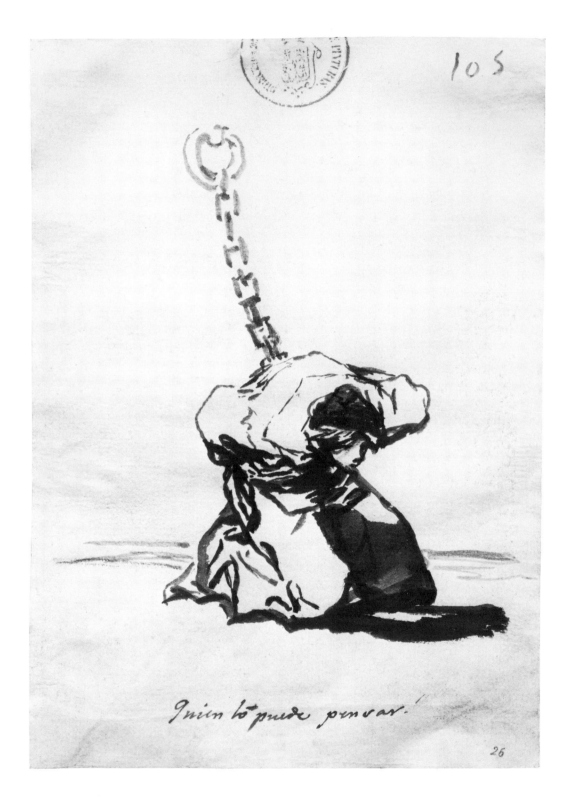

a plate that was added to that series, but whose subject had nothing to do with it: flying men or birdmen operating in a uniformly sombre sky — a timeless dream, harking back to Icarus but reaching forward to our own century.

The rest of the *Disparates,* twenty-two plates in all, must have been executed in no particular hurry since Goya never tried to publish them, but merely

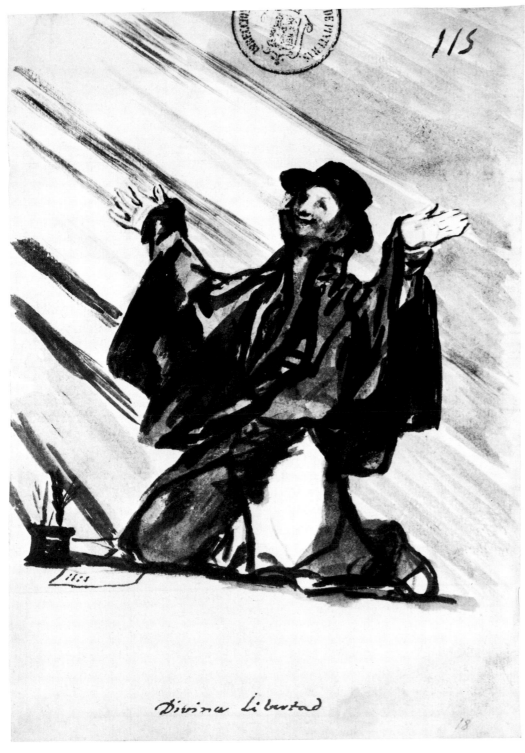

169. *Divina Libertad (Divine Freedom).* 1820-1824. Drawing from Album C (C. 115); 20.5 by 14.4 cm. Madrid, Museo del Prado.

What would the kneeling man, thanking a supernatural light that is inundating him, say without an explanation? *"Divina Libertad"* Goya declares; this cry was emitted by many Spaniards in 1820 when they heard about the revolt of Riego after six years of suppression. The inkwell on the ground makes it even clearer that the freedom of thinking and writing are being addressed here.

contented himself later on when he had to leave Spain with arranging the copperplates in boxes along with those of the *Disasters of War.* In these *Disparates,* as would also be the case later with the *Black Paintings* (Figs. 171-176) of the Quinta del Sordo, Goya's art radically distanced itself from his time. In the *Caprices,* there were many hidden allusions and attacks that it was nevertheless possible

170. Godefroi Engelmann: *El General Riego (General Riego)*. Lithograph. Madrid, Museo Municipal.

The revolt of Riego on January 1, 1820 attracted attention not only in Spain where it initiated the return to liberalism, but also among the Holy Alliance — Russia, Austria, Prussia — that decided to intervene three years later. The constitution of 1812, proclaimed in Cadiz, formed the cornerstone of the Spanish liberalism. The French lithograph translates this conviction into a picture.

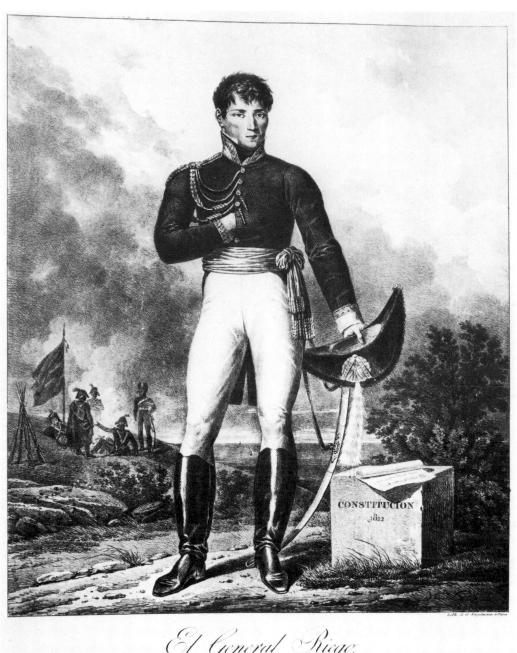

El General Riego.

171. *Atropos (Atropos or Fate)*. 1820-1823. Oil, originally on plastering, transferred to canvas. 123 by 266 cm. Madrid, Museo del Prado.

The painting was located on the long wall, each of them were decorated with two drawings, of the hall on the second floor in the Quinta del Sordo. All catalogues, be they new or old, see an allegory of fate in this painting.

to decipher and relate to contemporary situations, whereas in the works later than 1815 there is a kind of systematic obfuscation that makes them almost impossible to interpret. Times had changed, and the prudence of the *Caprices* was succeeded by a fear that completely obscured the meaning of the *Caprichos enfáticos* and the *Disparates*. He has something to say but his language is so full of circumlocutions and metonymies that we can no longer understand it. There remains only the shock of the imagery, the expressive power of forms bathed in darkness and light whose very impenetrability stupifies us but nevertheless succeeds in conveying its own ambiguous message.

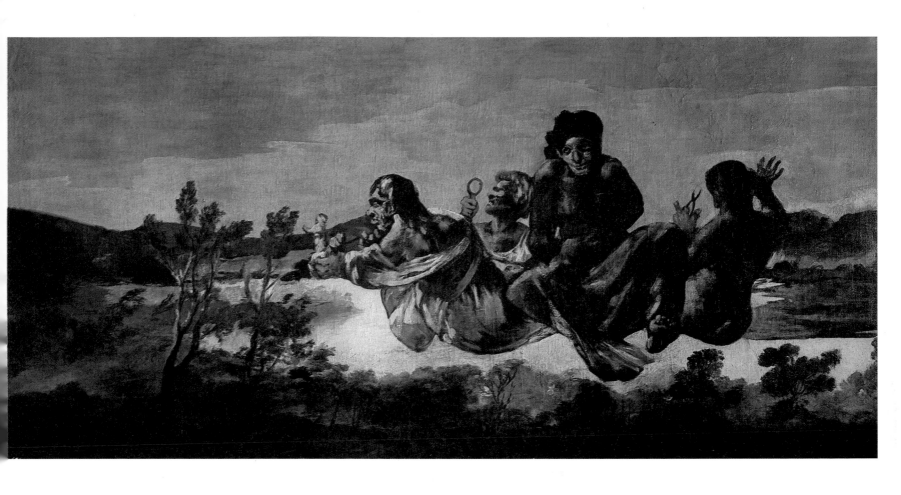

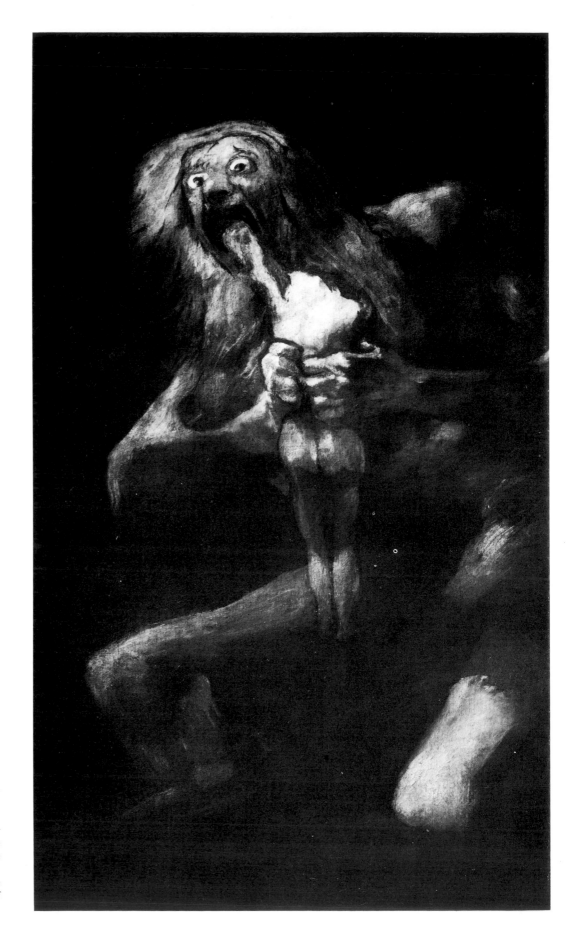

172. *Saturno (Saturn).* 1820-1823. Oil, originally on plastering, transferred to canvas. 146 by 83 cm. Madrid, Museo del Prado.

The painting was located in the hall on the ground floor opposite the entrance to the left of the window on the narrow wall in the Quinta del Sordo. To the right of the window, as a counterpart, was *Judith and Holofernes.* Goya's bloody rendition of the Saturn scene could be the key to the meaning of the *Black Paintings:* pictures of melancholy and of doom.

260

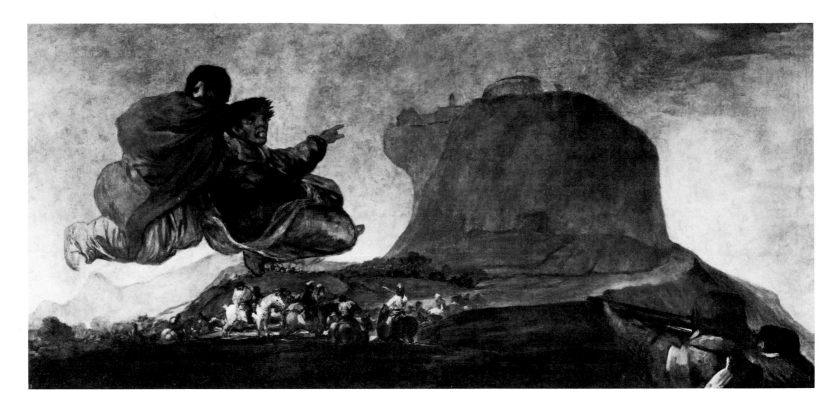

173. *Asmodeo (Asmodeus)*. 1820-1823. Oil, originally on plastering, transferred to canvas. 123 by 265 cm. Madrid, Museo del Prado.

The painting was located on the second floor of the Quinta del Sordo opposite the *Atropos*. The title is based on the inventory of the paintings in the Quinta del Sordo made by Brugada. The relationship between the title and the depiction has thus far not been explained.

On the other hand, the imagery of the albums of drawings from roughly the same period is quite clear. In this sort of private diary kept in the secrecy of his studio, Goya does not mince words, but goes straight to the point, even emphasizing his intentions in the captions that appear on most of the plates. The group of *encorozados* (victims of the Inquisition who wore a *coroza* or pointed cap) and the drawings that follow in Album C (Prado Museum) (GW 1335) are the most striking examples. All these pictures of people absurdly condemned, of prisoners being chained up and subjected to appalling tortures, are reflections of the violence of the period. Goya, as witness, proclaims, protests, expresses indignation: *Quien lo puede pensar?* (Who can believe it?) (Fig. 168); *Que crueldad!* (What cruelty!); *No se puede mirar* (One can't look). At the same time he clearly shows where his sympathies lie: the man kneeling down with his arms raised adoringly to the light pouring over him is a paean to Freedom. *Divina Libertad!* (Fig. 169) says the caption and, to hammer the point home, there is an inkwell on the ground to indicate that here it is the freedom to write, or freedom of expression that is invoked. The monastic orders are not spared by the artist: *Que quiera este fantasmon?* (What does this apparition want?) he asks, as a spectral monk looms out of the shadows. *Que trabajo es ese?* (What kind of work is this?) he fumes, depicting a Capuchin friar deep in prayer. Then he deals with those forced by the secularization laws to cast off their habits. Their sentiments vary considerably: *Lo cuelga ravioso* (He hangs it up in a rage) is his ironic comment on an old monk undressing, whereas a young nun seems happy to be shedding her habit: *Tiene prisa de escapar* (She's in a hurry to escape). However, the fascinating thing about these drawings is not so much what they say as the way they say it. With simply a pen and black or sepia ink, Goya goes straight to

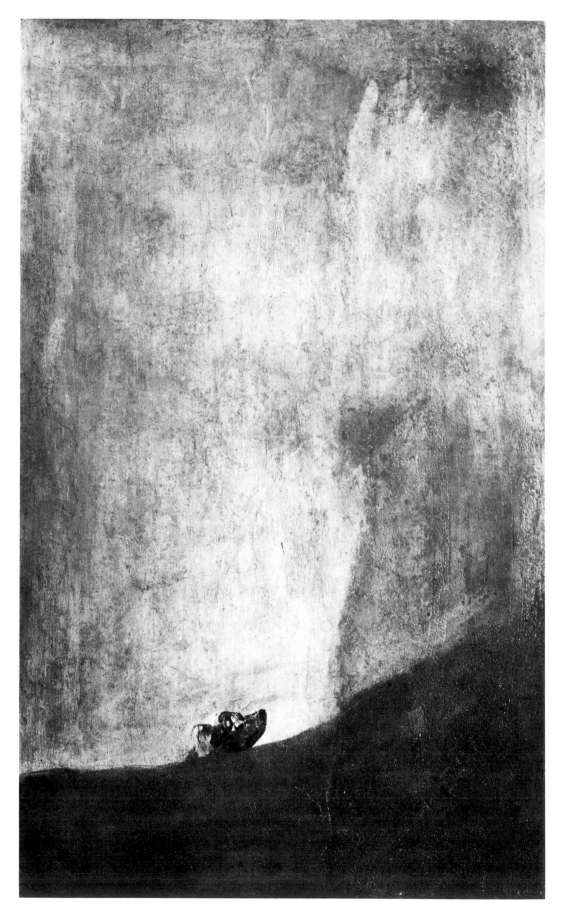

the essential each time; line and wash are employed with economy, everything is reduced to a brief statement, even the title, which is always striking and often eye-catching. These drawings show Goya at his frankest, whereas the engravings of the last period and the *Black Paintings,* works primarily intended for the public or at least visible, are in a different idiom, extremely complex and full of ambiguous symbolism.

In 1819, between his purchase of the Quinta del Sordo and his serious illness at the end of the year, the 73-year-old Goya was extraordinarily active. Not only did he see to the various jobs that had to be done on his new property — enlarging the house, refurbishing outbuildings, laying on water, installing tanks and chain pumps, fencing, and planting vines — but, in the same period, he painted three pictures that show the extent to which contemporary Spain, in its most diverse aspects, was present in his work. First, there was an important commission for the religious community of the Escuelas Pías de San Antón in Madrid. The *escolapios* as they were familiarly called wanted to honor their founder St. Joseph of Calasanz (1556-1648) by dedicating a large altarpiece to him in the church of the College in Calle Hortaleza. On May 9, 1819 Goya was chosen to paint a full-scale scene from the life of the saint. There were several reasons for the choice, notably Goya's fame and the fact that, over the years, he had painted a long succession of important religious works, from the El Pilar frescoes to the recent picture of *Saints Justa and Rufina* for the Cathedral of Seville, among the others being the *Arrest of Christ* in Toledo, the Santa Cueva paintings in Cadiz, and his masterpiece, the frescoes at San Antonio de la Florida in Madrid. Moreover, like Goya, St. Joseph of Calasanz came from Aragon and according to Zapater's nephew Goya had attended the Escuelas Pías in Saragossa as a boy. In fact the painter's great generosity to the *escolapios* of Madrid when the time came to pay for the picture clearly shows that he was anxious to discharge a long-standing debt of gratitude to the *poverello* of education. The agreed price was 16,000 reals. Half of the sum was paid to Goya in July 1819 and when the painting was installed for the saint's feast-day on August 27 the community proffered him the outstanding 8000 reals. He accepted only 1200 and returned the remaining 6800 with this note: "I am remitting this sum to the Treasurer or the Rector since Don Francisco Goya owes it to himself to pay some tribute to his compatriot St. Joseph of Calasanz." The sense of brotherhood among the sons of Aragon alluded to by Goya not only made him consider St. Joseph of Calasanz as his *paisano,* his compatriot, but probably also set him thinking of his childhood at Padre Joaquin's school along with his friend Martin Zapater.

The deep emotion felt by the painter on undertaking this picture imbued it with a quality almost unique in his work. The religious fervor expressed in the *Last Communion of St. Joseph of Calasanz* (Fig. 156) has often been remarked upon. It would perhaps be more correct to speak of the fervor expressed through a religious subject of an old man looking back on his past and reliving it intensely thanks to those who had helped him at the beginning of his life. Goya's heartfelt gratitude to the *escolapios* is also demonstrated in the little *Christ on the Mount*

174. *El perro (The Dog).* 1820-1823. Oil, originally on plastering, transferred to canvas. 134 by 80 cm. Madrid, Museo del Prado.

he painting was located on the second floor of the Quinta del Sordo on the narrow wall to the right of the entrance. The daring of the representation is incomparable. Goya expresses a drama with great intensity through the use of the head of a dog emerging from a dead landscape, a drama that — beyond the fate of an animal — affects the human fate.

of Olives, painted with great dash but nevertheless carefully signed and dated (*Goya fecit ano 1819*), which he sent to the Rector of the College with the following message: "To Pio Peña, Rector of the College of San Antón. I offer you this picture which is intended for the community and which will be the last I shall do in Madrid." From this it had been inferred that as early as 1819 Goya was already contemplating emigration. This seems unlikely since he had just bought the Quinta del Sordo and was only waiting for work on it to be completed before moving in. All he was saying to the Rector was that he was going to leave the actual city of Madrid. At that time, the Manzanares delimited the *Villa y Corte* to the west, so that the Quinta, situated beyond it, lay outside the capital.

The third remarkable work of this last year in Madrid was the portrait of the architect *Juan Antonio Cuervo* (signed and dated 1819), Goya's colleague and friend who had been Director of the San Fernando Academy of Art since 1815. In this admirable and colorful work, the sitter may cut rather a stiff figure, but he is nevertheless intensely alive, with a concentrated gaze that rivets one to the spot. Between the painter and his sitter one again senses that warm fellow-feeling for architects so often expressed by Goya. Many portraits bear witness to it. The earliest one was executed in 1784 at the request of Maria Teresa Vallabriga, and depicts Ventura Rodríguez, architect to the Infante Don Luis de Borbón and designer *inter alia* of El Pilar and the Palaces of Boadilla del Monte and Arenas de San Pedro. This was followed by portraits of Villanueva, architect of the Prado; Isidro González Velázquez, son of the famous painter Antonio González Velázquez; and finally Tiburcio Pérez y Cuervo, nephew of Juan Antonio Cuervo, painted the following year. Through this series of portraits Goya is closely linked to the greatest names among the Spanish architects of the day and thus to some of the most notable architectural achievements in Saragossa and Madrid.

Does the fervor of St. Joseph of Calasanz whose approaching death is foreshadowed on his face as he receives the Communion for the last time reflect a presentiment by Goya of his own death? Before the year was out, he was in fact laid low by a very serious illness from which he almost died. Its nature is not known, but a portrait that is unique in the history of painting has left us a touching testimony of it: *Goya and his Doctor Arietta.* The lengthy caption records the patient's gratitude to the doctor who had saved him: "Goya, as a token of gratitude for the care and attention with which he saved his life on the occasion of the dangerous illness he suffered at the end of 1819, at the age of seventy-three. Painted in 1820." It is impossible to ascertain whether he had already moved to the Quinta del Sordo or not.

Be that as it may, the date of the picture shows that Goya recovered his health just at the moment when hope at last ran high for all liberally-minded Spaniards. On January 1, 1820, Rafael del Riego, a young army captain, led his troops into rebellion at Cabezas de San Juan between Seville and Cadiz. The focus of constitutional resistance to Ferdinand VII, this Spanish region — soon to be followed by others — once more proclaimed the Constitution of 1812 which the King had refused to recognize on his return from exile. The reaction

175. *Duelo a garrotazos (Duel with Clubs).* 1820-1823. Oil, originally on plastering, transferred to canvas. 123 by 266 cm. Madrid, Museo del Prado.

The painting was located on one of the long walls of the hall on the second floor beside the *Atropos* and opposite *El Santo Oficio (The Inquisition).* This wild fight in a nightmarish landscape has been interpreted as a duel between cattle shepherds from Galicia in northern Spain.

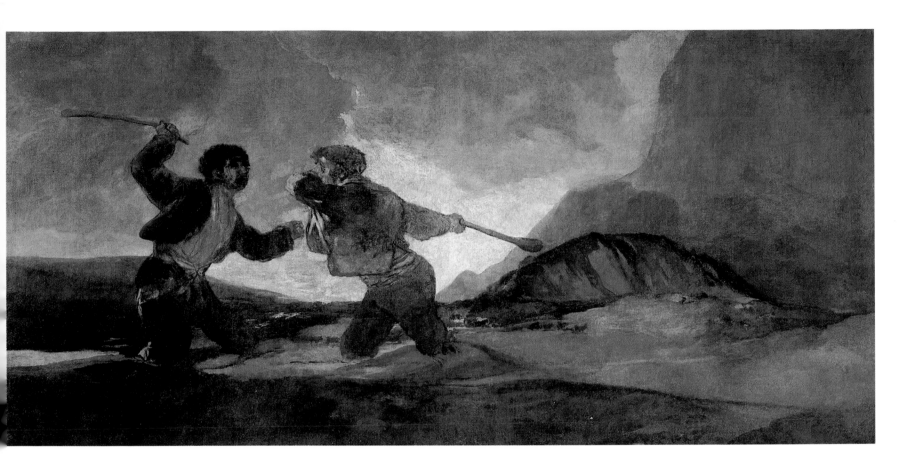

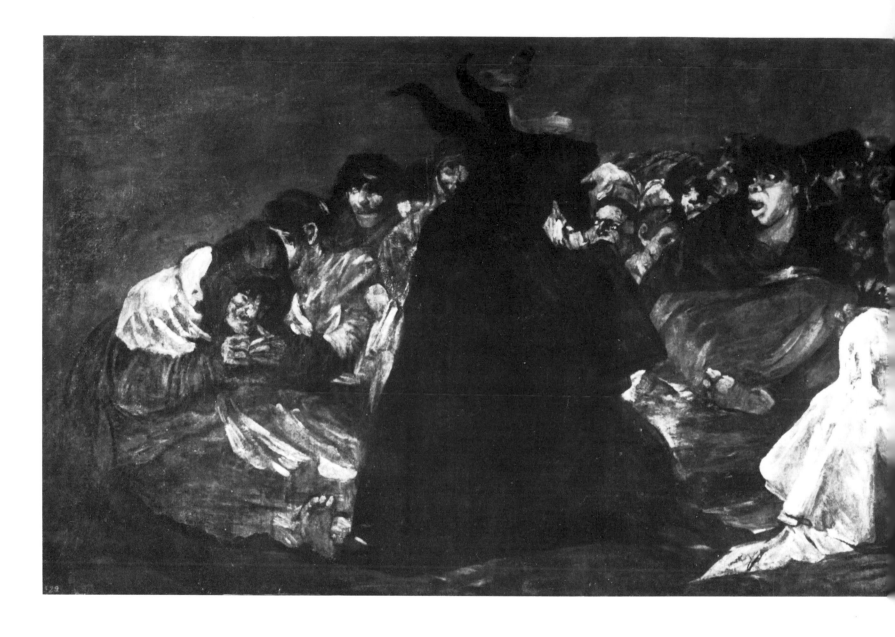

176. *El gran cabron (The Large Ram).* 1820-1823. Oil, originally on plastering, transferred to canvas. 140 by 438 cm. Madrid, Museo del Prado.

The windows in the ground floor of the Quinta del Sordo were arranged differently than on the second floor, so that one continuous painting each could be placed on the long walls: to the left of the entrance *El gran cabron* and opposite *La romeria de San Isidro* (The Pilgrimage to San Isidro). With the dark and threatening silhouette of the ram rearing up in front of the group looking up to it and incapable of any thought, this witch scene is among the most impressive Goya ever painted.

throughout the country was so rapid that, by March 9, Ferdinand VII, despite the profound disgust he had always shown for liberalism, had to swear his agreement to the Constitution and a new constitutional era, lasting only three years, began for Spain.

At the same time, the most muted period of Goya's life began; withdrawing to the Quinta del Sordo, he seemed to vanish into near-oblivion. On April 4, 1820 he attended a meeting of the Academy for the last time. This was probably a meeting he was anxious not to miss since it consisted of a solemn ceremony in which the whole academic body had to swear allegiance to the Constitution. Everything had come to pass that he had prophesied and longed for in the last plate of the *Disasters of War* — *Si resuscitará?* (Fig. 154) (And if she were to rise again?). But now in the Quinta it all seemed no more than a distant echo. He had chosen seclusion and silence, and only his family — the lovely 32-year-old Leocadia and her 6-year-old daughter — shared his retreat. In 1820, Goya

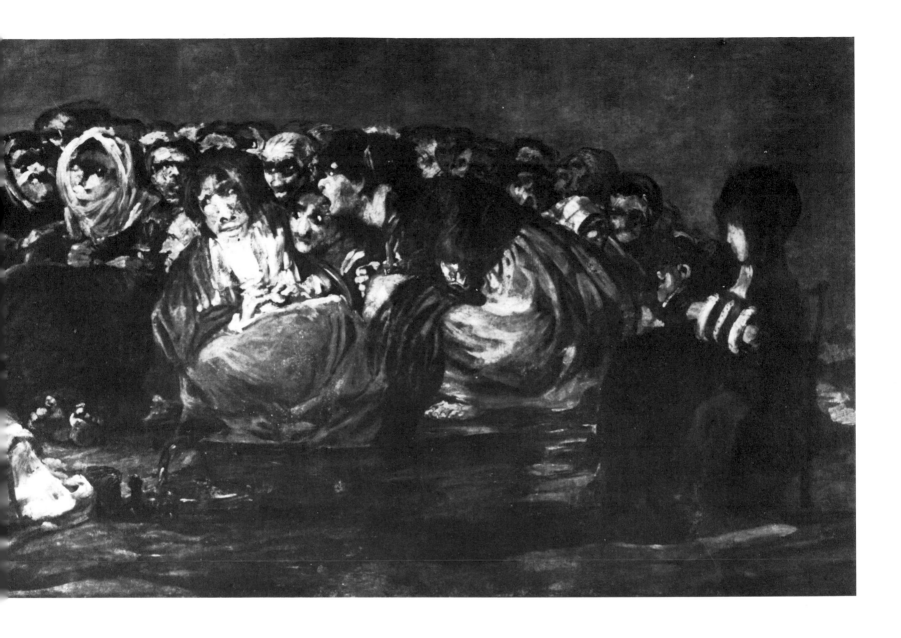

vanished from the life of his time and his biography, from our point of view, became a blank page. Even his work eludes us; apart from the picture with his doctor and the portrait of Tiburcio Pérez y Cuervo, both dated 1820, and the portrait of Ramón Satué, dated 1823, there is no painting that can be dated with certainty. Only the *Black Paintings,* whose presence on the walls of the Quinta is attested, fill in this three-year gap. To these must be added, though this is not absolutely certain, part of the *Disparates* and some unspecified album drawings.

This withdrawal by Goya prior to his departure for France constituted an absolute break with his environment and his time. After being so closely linked with the collective life of Spain, after having lived, though deaf and infirm, in step with the march of History, he seems to have given up and decided to turn his back for good on a world from which he no longer expected anything.

The phrase in his note to the rector of the *escolapios* was in effect a farewell, even before his illness — "this picture...will be the last I shall do in Madrid."

What then of the *Black Paintings* at the Quinta del Sordo? Everything that could be said about them has been said with the legitimate but ultimately vain object of explaining them to the public or of formulating theories that however brilliant are all equally shaky. The first thing to be considered is simply the place and time at which they were painted. First of all, the place — it must be remembered that these large, generally rather gloomy compositions now in the Prado Museum were originally devised to decorate the two main rooms of the Quinta del Sordo. For the first time, Goya produced an important group of paintings for himself alone as a background to his daily life. They thus have nothing in common with the little cabinet pictures painted in 1793 after his first serious illness and presented to the Academy of San Fernando, nor with the scenes of war and violence executed between 1808 and 1814 aside from works intended for the public. Here, on his own walls, the walls of the only country house he ever owned, he created a fantastic monstrous universe of which he would be the sole spectator. Such a work, painted when the artist was between seventy-four and seventy-seven years of age, can only be considered a testament.

This is borne out by the time at which it was conceived. On the one hand, there was the responsibility of a new family, of enjoyable youthful companionship; on the other, there was the shadow of death from which he had just escaped but which would certainly claim him before long. Finally, there was Madrid, which he could see from his windows spread out before him on the other side of the Manzanares like a glowing fresco of his own life from the Florida gardens on the left to the Hermitage of San Isidro quite close at hand, taking in the Royal Palace, the Church of San Francisco el Grande, and the riverbanks of his first cartoons on the way. However close in reality, it all seemed very remote, relegated finally to the past. Too many of his hopes had foundered in that terrible war; the few that remained had been crushed by Ferdinand VII. Spain was plunged into chaos and now he no longer believed in anything. Everything was empty and absurd and all that he could do was to proclaim it on the walls of his home. The *Black Paintings* are the last despairing cry of someone faced with the emptiness of the world and the approach of death. What could be more horrifying than those two peasants brandishing their cudgels in a fight to the death, their feet half sunken in the sand? Has anyone ever painted such an anguished and inexplicable vision as that dog's head emerging from some barren no-man's land? What nightmare spawned those processions of clinging, bleating human larvae, those old men with their Voltairean grins? The world of these paintings is absurd to the point of madness, hovering on the brink of some unimaginable apocalyptic holocaust. Only the *Leocadia,* who presides over the whole gigantic masquerade, leaning on what appears to be a tomb, offers a human face that can be looked at without repulsion. It is veiled and pensive. Is this motionless figure placed there as the ultimate witness? Perhaps Goya really believed that in the *Black Paintings* he was painting his last work. There had been the *Last Communion of St. Joseph of Calasanz* (Fig. 156), then *Christ on*

177. *El entierro de la sardina (The Burial of the Sardine).* Around 1812-1819. Oil on wood. 82.5 by 52 cm. Madrid, Real Academia de San Fernando.

This scene of a carnival is part of the five paintings on wood that Manuel de la Prada bequeathed to the academy. It is one of the first gripping examples of the transformation of a real event into an absurd happening. The probable time of creation of the painting chronologically also places it close to the *Junta of the Philippines,* the *Disparates* and the *Black Paintings.*

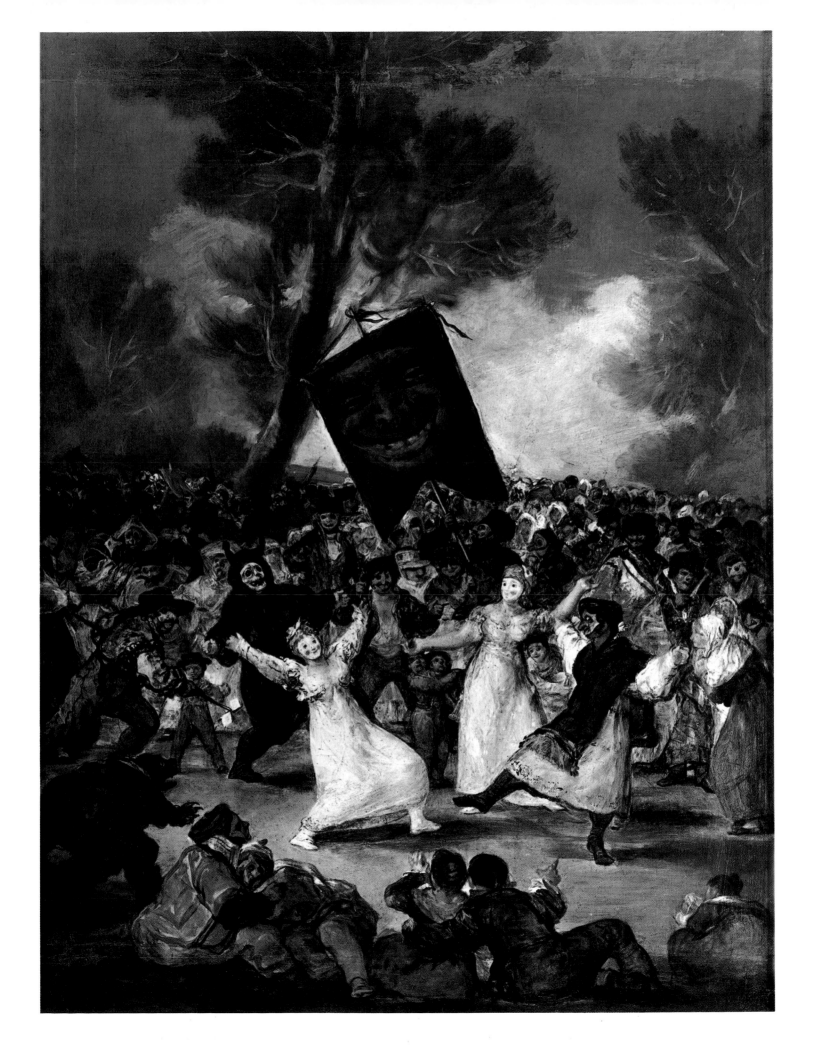

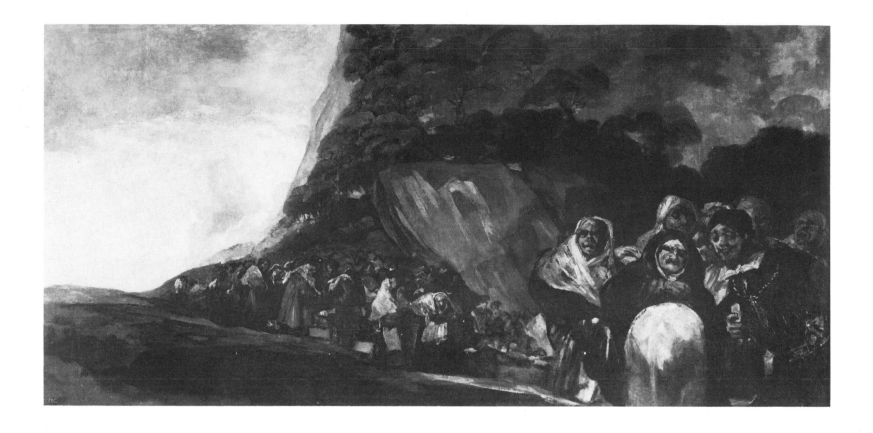

the Mount of Olives (Christ's *last* night), and the *last* moments before death in the arms of Dr. Arietta. All that remained was to set the seal in fourteen large murals on a life already troubled many times by the world of the absurd.

It was Goya's illness in 1793 that threw open the doors of this horrifying world. One of his first glimpses into it is the *Madmen's Yard,* painted during his convalescence. Then came the *Caprices,* and here and there throughout his work terrifying outcrops of the secret universe that from now on he would harbor within him: *The Colossus* (Fig. 122), monstrous and ambiguous; *The Burial of the Sardine* (Fig. 177) an Ash Wednesday masquerade; even the *Royal Company of the Philippines* (Fig. 179), based no doubt on an actual scene but opening on a void in which the apathetic participants are swallowed up. Many other works could be cited, all marked, like fighting bulls, with the brand of the absurd. After occurring only as *moments,* isolated cases in the painter's long life, they suddenly become his basic form of expression in the *Black Paintings.* Thus, starting from the *Caprices,* work firmly anchored in his time, Goya ended up completely alienated from it twenty-five years later. The Quinta del Sordo, with the *Black Paintings* on its walls was the very symbol of his desire to escape from the world in which he had lived since 1775.

The *Black Paintings* were probably finished by 1823. The painter had drawn a line through his life and work and now could die in peace. Unfortunately, peace had no place in Spain. At the Congress of Verona, France was entrusted with intervening in Spain to restore all Ferdinand VII's rights as an absolute monarch and deliver the country from the gangrene of liberalism.

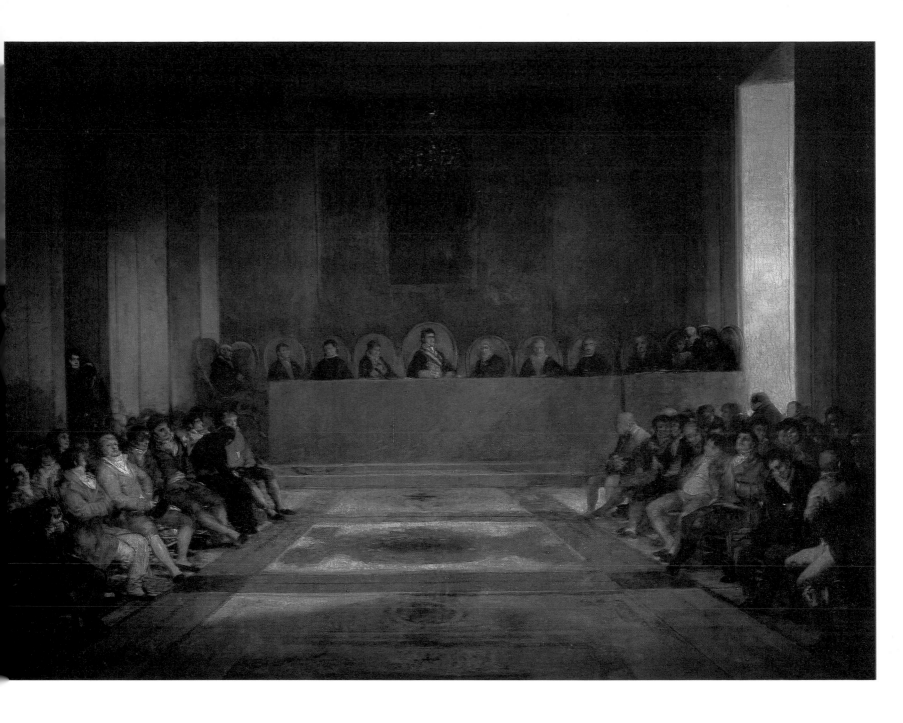

Chateaubriand's proud undertaking ("my Spanish war, the great political event of my life"), the expedition of the Hundred Thousand Sons of St. Louis, began at the crossing of the Bidassoa on April 7, 1823 and ended with the capture of the Trocadero fort near Cadiz on October 31 and that of the seditious city itself on September 30. In a campaign, or rather a stroll through Spain that lasted barely six months the French army led by the Duke of Angoulême once more settled the destiny of a people that had not invited it to intervene. The constitutional period too ended in an absurd masquerade that spelled the return of repression and the horrors of a false peace. Goya, as an old liberal, and even more Leocadia, who had expressed her opinions publicly, were fearful both for themselves and for their children. Between the capture of the Trocadero fort and that of Cadiz, Goya decided to give the Quinta to his seventeen-year-old grandson Mariano. Legally he had no possessions since the various houses he had bought in the course of his life had already been passed on to his son. After saving his property from seizure, he had to save those most dear to him. This was his main preoccupation in the winter of 1823-1824.

For the time being he stayed on at the Quinta seeing if he could arrange his departure for France in such a way as to hold on to his emoluments as First Court Painter. Does the scene depicted in *Asmodea* (Fig. 173) allude to the French soldiers who passed through Madrid in May 1823? If so, it is the only echo of contemporary history in the *Black Paintings*.

Be that as it may it is clear that in giving Mariano the Quinta, which was certainly dear to him on more than one count, Goya was finally severing his links with Madrid and his family. This time he chose exile, showing incredible courage for a man of his age — seventy-seven — in his willingness to give up everything and start a new life abroad. There were certainly strong political reasons for his decision, but he was motivated primarily by his attachment to Leocadia and her little daughter Rosario. The traditional image of Goya in this concluding phase of his life is that of a political exile, a kind of Victor Hugo before the letter. The truth is much less clear cut since from the political standpoint his departure was perhaps not absolutely necessary as will be demonstrated later. On the other hand, it was urgently necessary for Leocadia to leave the country in view of her fervent and much flaunted liberalism. It can thus be seen that Goya went to France to avoid separation from Leocadia who was compelled to go; this man of nearly eighty went into exile not just for political reasons but for sentimental ones.

180. *Maria Martinez de Puga.* 1824. Oil on canvas. 80 by 58.4 cm. Signed and dated. New York, Frick Collection.
This portrait with the incredibly deep black must be dated in the last weeks prior to Goya's departure for France. The person depicted could be related to Dionisio Antonio de Puga, who helped Goya to order his affairs before his departure.

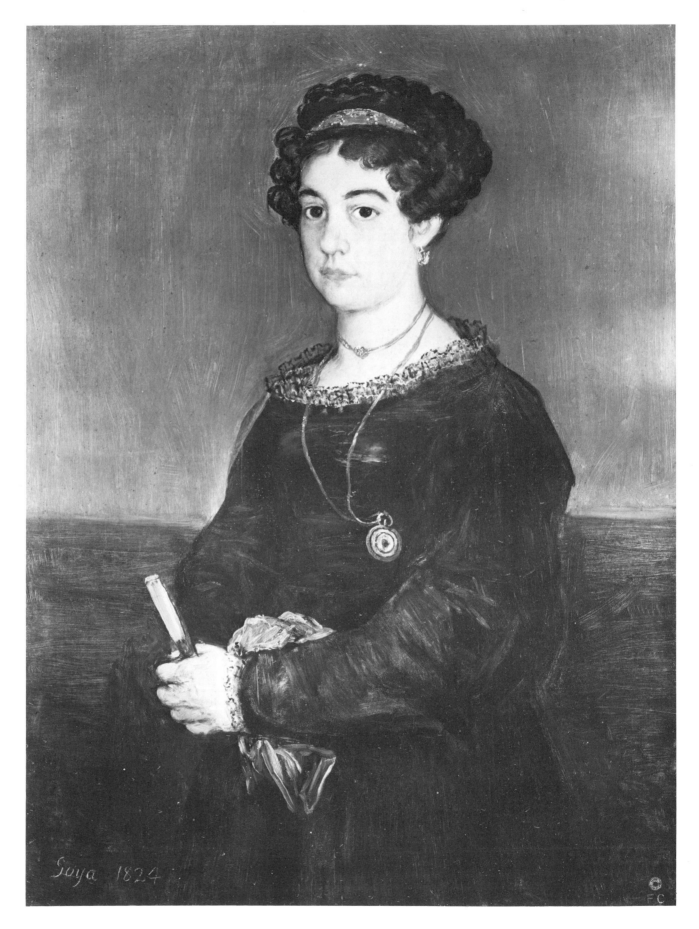

VII

The Time of Exile

VII The Time of Exile

Departure from Madrid — Stay in Paris — The Spanish exiles — The Salon — Life in Bordeaux with Leocadia and her children — Last works: lithographs, miniatures, drawings.

The months preceding Goya's departure for France were among the most dramatic of his seventy-eight years. After choosing to live at the Quinta del Sordo, far from the rumors and upsets of the capital in the hope of passing the rest of his days there in obscurity, he once more found himself carried along willy-nilly on the turbulent flood of history and swept towards one of the hardest fates a man can face: exile. But despite his age, Goya was still unrivalled in his mastery of the difficult art of political compromise. He had already managed, during the French occupation, not to fall completely into the camp of the *afrancesados,* nor into that of the *serviles,* and at the same time to set an example of the staunchest patriotism. After 1814 he had held his own under Ferdinand VII, reserving any display of liberalism for his unpublished engravings such as the *Caprichos enfáticos* and for his many secret album drawings. His sympathies and friendships over more than a quarter of a century had never left any doubt as to his real feelings, but even at the height of the absolutist persecutions, even when faced with the Inquisition, he was respected as Spain's most illustrious painter since the Golden Century. The favors showered upon him by Charles

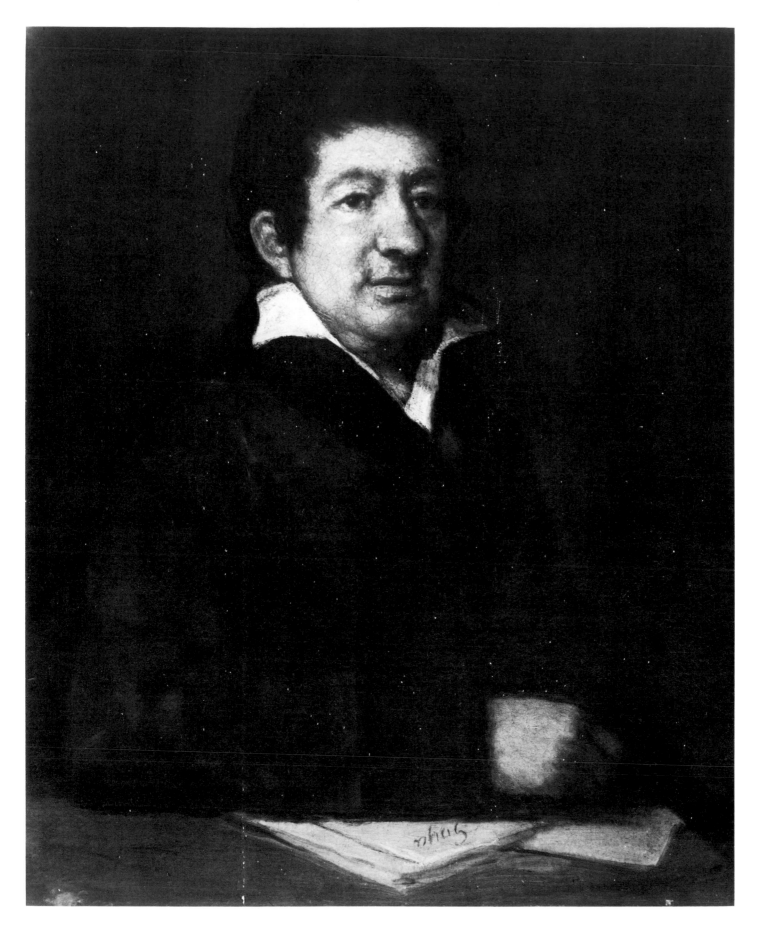

III and Charles IV and his paintings glorifying their reigns had made him an almost sacrosanct figure. He had been so closely identified with Spain and its history for almost fifty years that any attack on his person or his liberty would have seemed to be directed against Spain itself and in particular against the Bourbon monarchy. Nevertheless, quite apart from his personal views, his association with Leocadia Weiss placed him in serious danger; he might be pardoned his own failings but not those of an illicit companion known to the police for her public behavior as a sort of *Pasionaria* before her time.

A document drawn up after the artist's death gives some interesting details on the situation. It is a certificate issued by three high-ranking Spanish officers in support of a request for assistance submitted by Leocadia to the French authorities in 1831. It states that "Madame Leocadia Zorilla de Weiss had been obliged to take refuge in France in 1823 to escape from the persecutions and insults of every kind to which she was subjected because of her political views and the circumstance of her son Guillaume Weiss being an officer in the voluntary militia of Madrid." This information, which was confirmed the following month ("the accuracy of her statement has been recognized"), may partly explain Goya's attitude prior to his departure. Leocadia, who had lived with him, in all probability as *ama de llaves,* for some years had been persecuted and insulted and had to leave Spain in 1823 to escape even greater dangers. But could her son Guillermo, born in 1809, have already been enrolled in the national militia at the age of fourteen? The Cortes had indeed decreed a mass levy to meet anti-constitutional threats; every Spanish male aged eighteen was "forcibly" (*forzoso*) enrolled in the militia and in order to avoid coercion a great many of them joined up as volunteers before they were eighteen. This was the case with Leocadia's son who figures in the document of 1831 as an "officer in the voluntary militia."

On May 24, 1823 the troops of the Duke of Angoulême entered Madrid without firing a shot. King Ferdinand VII had left the capital two months earlier and was in Seville with the Royal Family, the Government, and the members of the Cortes. The French set up a regency in Madrid, and at once the massacre of liberals began. Three years after Riego's revolt, the constitutional period had come to an end with a further foreign invasion and renewed oppression. One need only read the texts of some of the decrees promulgated by the regency to gain an idea of its cruelty: on June 4, all individual liberties were suppressed; on June 23, the property of the militia officers was seized and all militiamen were forbidden to work at any job and had to withdraw to a distance of forty-two leagues from Madrid. Another decree, dated June 21, stipulated that students who had been volunteers in the militia would undergo a sifting process and those authorized to pursue their careers would be subject to close surveillance by their professors and the academic authorities.

These texts alone suggest the state of terror in which Spanish liberals lived once more from June 1823 on; 1820 was being avenged with a violence that was increased tenfold by the certainty of support from Europe. Nevertheless, this spirit of implacable vengeance and intolerance angered the Duke of

181. *Leandro Fernández de Moratín.* 1824. Oil on canvas. 54 by 47 cm. Bilbao, Museo de Bellas Artes.

In Bordeaux, Goya met his old friend Moratín among the Spanish emigrants. He had painted a first portrait of him in 1799. Now the face of the sixty-four year old man has grown so fat that he can hardly be recognized. In a letter to their common friend Juan Antonio Melón, Moratín makes fun of his own looks: "...He wants to paint my portrait which should tell you how beautiful I am..."

182. *Self-Portrait.* 1824. Drawing; pen and sepia. 7 by 8.1 cm. Madrid, Museo del Prado.

Moratín called the seventy-eight year old Goya a "young traveler." According to tradition, Goya executed the portrait in Paris for his friend Ferrer. Twenty-five years after the front cover of the *Caprichos,* Goya's profile is still the same, older and heavier, but still unchangingly self-assured.

Angoulême himself. His message to Ferdinand VII was a brusque recall to moderation and clemency: "Your Majesty's authority was restored fourteen years ago, and it still manifests itself only in arrests and arbitrary edicts. As a result, anxiety, terror, and discontent are beginning to spread everywhere. I asked Your Majesty to proclaim an amnesty and to grant your peoples something reassuring for the future. You have done neither one nor the other."

Once the French troops had left Spain, there was nothing to hold back the tide of hatred, and a new wave of exiles hastened to the Pyrennean frontier. Moratín, who had been living in Bordeaux since 1821, has left an account of what was happening on the other side of the frontier: "We haven't seen the amnesty; in the meantime, emigration continues at all points of the frontier. We are inundated with Spaniards." (Letter to Juan Antonio Melón, December 14, 1823.) But the special thing about the emigrants according to Moratín is that they consisted largely of Spanish noblemen: "As for marquises, I assure you that we are up to our necks in them here; I have only to step into the street and I can't look in any direction without my eye falling on a marquis or a little marquise. They must have started with the expulsion of suspects by eliminating all the marquises, we are so inundated by them here." (Letter to Melón, February 5, 1824.)

An obituary notice on Rosario Weiss states that she was entrusted to the care of the architect Tiburcio Pérez, a friend of Goya's, when the latter had to leave for Bordeaux in 1823. This date is obviously wrong since it is known that the painter did not leave Spain until the King had given his authorization on May 30, 1824. On the other hand this biographical detail suggests that Rosario's mother was no longer with her and that she had stayed on alone with Goya. A letter from the painter to Leocadia in Bordeaux is dated August 13, 1823, which fits in with the indications given to the French authorities in 1831. Thus, although further details are lacking on this period of Goya's life at the Quinta, it seems that Leocadia and her son were directly threatened by the wave of violence unleashed in Madrid in June 1823 and had been obliged to go into hiding. Did they get as far as France at that time, or did they hide somewhere in Spain? The surviving documents do not answer this question. What is important is that Goya himself felt threatened in his turn to the point of taking shelter with an Aragonese friend José de Duaso y Latre. He stayed for three months with this priest, whose duties as editor of the *Gaceta* and press censor placed him above suspicion. These were probably the first three months of 1824, judging from the dedication of the portrait of his host painted by Goya "at seventy-eight years." It is not in fact very clear how Goya lived in the period following the donation of the Quinta del Sordo to his grandson Mariano on September 17, 1823; his departure for France must have been decided on in agreement with Leocadia and the place of exile already chosen: Bordeaux, where exiles from Spain congregated quite naturally.

He still had to resolve one serious problem: how to leave without burning his bridges behind him and above all without running the risk of police action and the seizure of his family's goods as had almost occurred during the French

183. *Scene of a Bullfight*. Around 1824-1825. Oil on canvas. 42.5 by 54 cm. Switzerland, private collection.
As of 1793, Goya depicted the death of the picador — a frequent occurrence in his time — several times, especially on the sheets of the *Tauromaquia*. This painting appeared in a public auction in 1904 together with the *Madmen's Yard* of 1794, now in the Meadows Museum in Dallas. It is shown in the catalogue which states that it is the painting described by Huysmans in 1889. It was then the property of the author Henri Rochefort.

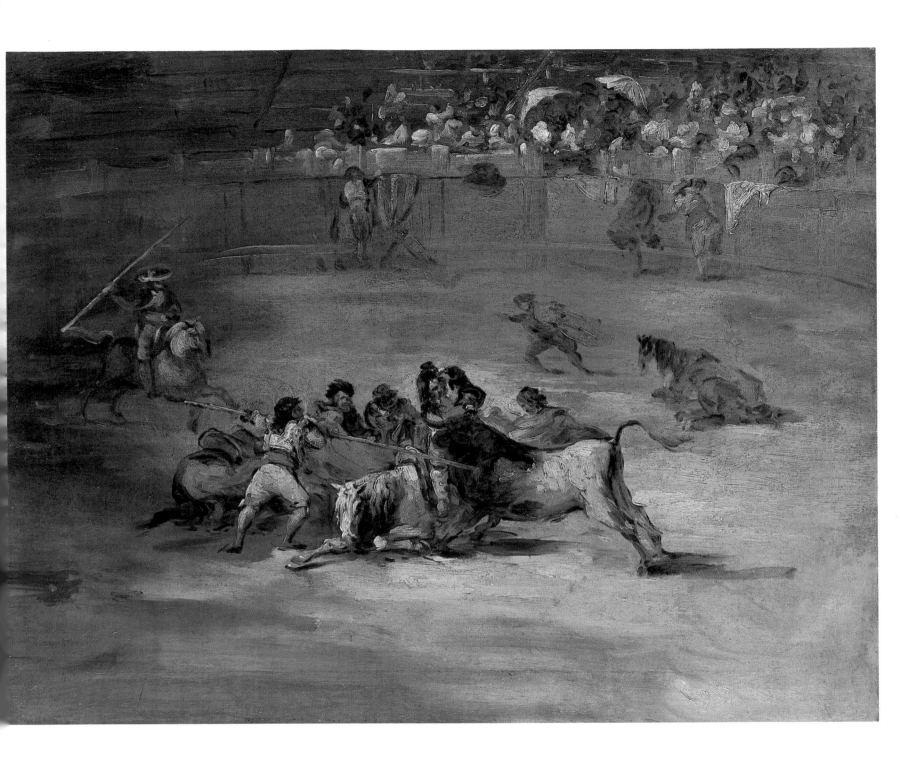

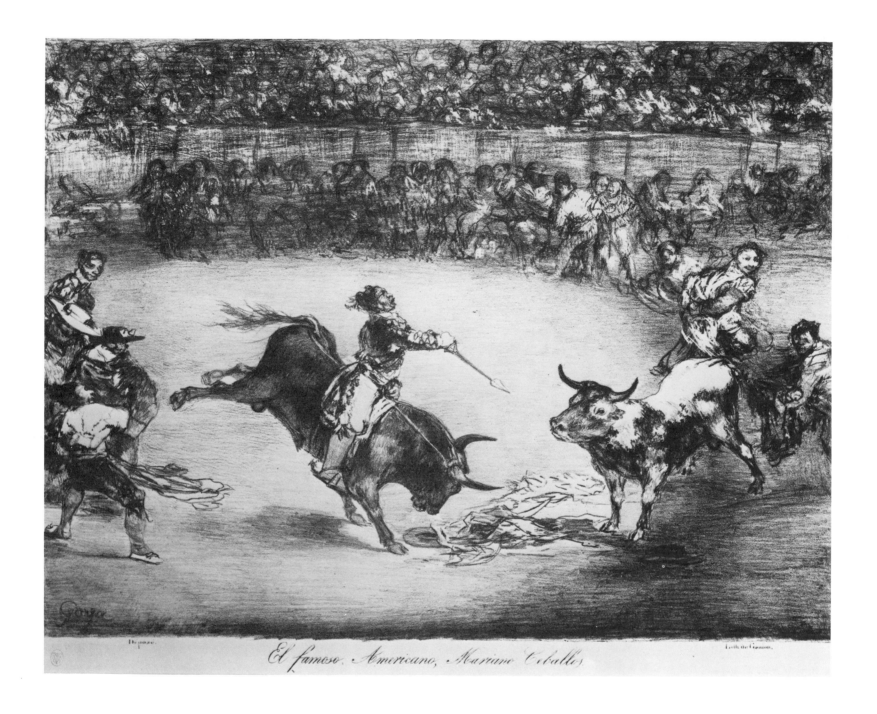

El famoso. Americano, Mariano Ceballos

184. *El famoso Americano, Mariano Ceballos (The famous American, Mariano Ceballos).* 1825. Lithograph. 30.5 by 40 cm.

One of the four lithographs the printer Gaulon in Bordeaux copied in a series of 100 prints. Goya seems to have been fascinated by the deeds of this South American Indian who fought riding on a bull. He also depicted Mariano Ceballos on three sheets of the *Tauromaquia:* sheet 24 shows a similarly daring deed, without the excited masses surrounding the ring, however.

occupation. He had to leave Spain with head held high, as a free man and without losing any of the advantages of his position. To negotiate this in the climate of repression prevailing in Madrid was a very delicate undertaking indeed. It seems certain that Goya was able to achieve his goal only by enlisting the support of some important members of the King's circle, most probably including the Duke of Híjar, Grand Chamberlain to Ferdinand VII. At the behest of the Duke's illustrious family, he had already painted, in 1783, an *Apparition of the Virgin of the Pillar to the Apostle James* for the parish church of Urrea de Gaea (Teruel). Between 1824 and the painter's death, all official documents concerning his first leave and the three successive renewals, as well

as the notice of his final retirement, passed through the hands of the Duke, who gave a favorable opinion each time on the various, often outlandish, requests submitted by Goya to the King. Indeed it seems that the first authorization, by far the most important, was granted in an irregular fashion since the document contained the favorable opinion of the Grand Chamberlain only and had not passed through the office of the Secretary of State. Ferdinand VII expressed his astonishment at this in a marginal note but finally appended his signature. During the two months Goya spent in Paris he met the Duchess of Híjar whose salon was frequented by a number of liberally minded Spaniards. A drawing coming from one of her keepsakes perhaps dates from this visit to the French capital.

On May 2, 1824, perhaps taking advantage of a lull in the repression, Goya presented the King with a request for leave for reasons of health. "Don Francisco Goya, Court Painter to Your Majesty, declares with all due respect that the doctors have advised him to take the mineral waters at Plombières in order to check the ills and infirmities with which his advanced age is burdened; in virtue whereof he begs Your Majesty to be kind enough to grant him the Royal leave with full emoluments for a period of six months." As soon as he was notified of the King's authorization through the intermediary of the Grand Chamberlain, Goya set out for France without further delay.

It has often been wondered why Goya chose Plombières particularly as he never actually went there. Apart from being renowned for the healing virtues of its hot springs as well as being one of the smartest and liveliest spas in France it had the advantage of being far enough from the Spanish frontier to justify an absence of six months.

Goya's movements and the details of his life after his arrival in France are quite well documented in the reports of the French police, who kept a systematic check on the comings and goings of the Spanish exiles, and also in the correspondence of Moratín, who had settled in Bordeaux, and that of Goya himself with his family and friends. The members of his circle were greatly perturbed at the spectacle of this old man of seventy-eight setting out on his travels alone without even a servant to accompany and help him, handicapped as he was by his total deafness and the after-effects of his last illness. He was also a source of worry to the French authorities, who wondered what could be the real motive of the First Court Painter to His Most Catholic Majesty in undertaking this journey.

The first report of his presence on French soil is to be found in a note from the Sub-Prefect of Bayonne to the Minister of the Interior in Paris. "D. Francisco Goya, a Spanish painter whose passport is attached herewith, has received a pass for Paris from the Town Hall of Bayonne. He is going to that city to consult doctors and take the waters prescribed for him." This document is dated June 24, 1824. Thus, for the French authorities, Goya still asserted that he was travelling for his health, but changed his destination to Paris. Three days later Moratín mentioned his passage through Bordeaux in a letter to their mutual friend Juan Antonio Melón in Madrid. "My dear Juan, Goya has actually

185. *Yo lo visto en Paris (I saw this in Paris).* 1824-1828. Drawing from Album G (G. 31); black chalk. 19.4 by 14.8 cm. Switzerland, private collection.

On this sheet Goya mentions Paris for the first and last time in his work. This scene on the street struck him as so strange that he recorded it immediately, or perhaps in Bordeaux drawing on his memory. The legend underlines that he was an eye witness.

yo lo he visto en Paris.

arrived, deaf, old, clumsy and weak and not knowing a word of French. He has come without a servant (though nobody is more in need of one), but is most uncomplaining and eager to see the world. He stayed here three days on two of which he ate with us like a young student. I urged him to return for the month of September and not to get bogged down in Paris and trapped there for the winter which would be the end of him. He is taking a letter requesting Arnao to find him somewhere to stay and to take all the necessary precautions in his regard, of which there are many, the most important to my mind being that he should only go out in a carriage. But I do not know if he will consent to this condition. We shall see if he can survive this journey. I would be very sorry if anything happened to him."

Moratín's account with its affectionate concern for the aged artist gives us very valuable information about his journey to Paris. What is most striking at the outset is the haste of the "young traveller." After the long and fatiguing journey from Madrid to Bordeaux — in 1811 it took Mme Hugo and her two sons more than a month and a half to go from Bayonne to Madrid — Goya spent only three days with his friends Moratín and Silvela before going on to Paris. The reference to his complete ignorance of French is particularly interesting since it would seem to rule out any previous sojourn in France.

186. *Diligencias nuebas o sillas de espaldas. A la comedia No 89 (New carriages or back litters. To the comedy. Number 89).* 1824-1828. Drawing from Album G (G. 24); black chalk. 19.2 by 15.1 cm. Boston, The Museum of Fine Arts (Arthur Tracy Cabot Fund).

Another strange means of transportation recorded in drawings by Goya several times. It could bring a Paris scene to mind, for there Goya lived in the Rue Marivaux across from the Théâtre des Italiens. To the right of the back litter we can see traces of an earlier drawing.

In Paris he was recommended to an old friend of Moratín's, Vicente González Arnao, a well known legal expert who had to go into exile after being Secretary of the Council of State and then Prefect of Madrid during the reign of the usurper. It seems that Goya did not yet know him or had perhaps lost contact with him after his departure from Madrid in 1813. Settling first in Bordeaux with his family, Arnao had performed valuable services for the Prefect of the Gironde, whom he advised on the distribution of relief to the Spanish refugees. At the time of Goya's arrival in Paris he was living in luxury in Rue du Faubourg-Montmartre. He not only acted as legal adviser for Spaniards in Paris, but was also a clever businessman who maintained good relations with a number of embassies and could travel freely between France and Spain. His salon was a meeting place for members of the Spanish colony in Paris regardless of rank. It was frequented not only by *emigrés,* businessmen and soldiers but also by aristocrats with illustrious names such as the Countess of Chinchón, the Duke of San Carlos and the Pontejos — ghosts from an already distant past but forever young and attractive thanks to the magic of Goya's brush. In Paris, in spite of wrinkles and lost illusions, new intrigues of an amorous or political nature had started up with money and gambling playing an increasingly important role.

On June 29 the Minister of the Interior gave the following instructions to the Prefect of Police: "It would be interesting to verify whether, during his stay in Paris, D. Francisco Goya is involved in suspicious relationships that his situation at the Spanish Court would render even more improper. You will keep a close but discreet watch on him to this effect and let me know the results giving me due warning of the date of his departure."

On July 15 the Prefect of Police notified the Minister of the results of his enquiry. "This foreigner arrived in Paris on June 30 and put up at 5 Rue Marivaux. The surveillance he has undergone has failed to show that he has habitual relations with any of his compatriots. He never receives anyone at his lodgings and the difficulty he experiences in speaking and understanding French often keeps him indoors, and he goes out only to visit monuments and walk around in public places. Although he is seventy years old, he appears even older than his age and is in addition extremely deaf." This curious mixture of truth and falsehood makes one somewhat doubt the efficiency of the police of the period. That he was "extremely deaf" and had difficulty in speaking and understanding French is certainly exact; but that he should have looked "older than his age" is hardly surprising since the police report gives his age as seventy whereas he was actually seventy-eight. There was an even more serious error on the part of the police who had kept watch on him: his "habitual relations" were in fact exclusively with Spaniards. First of all there was Arnao, who took care of the painter from the moment of his arrival as Moratín confirms in a letter to Melón dated July 8. "Goya has safely arrived in Paris. Thanks to the letter he brought from me, Arnao has undertaken to look after him and help him as far as possible; he has found him lodgings with a cousin of his daughter-in-law's family. He intends to continue his good offices on behalf of the young

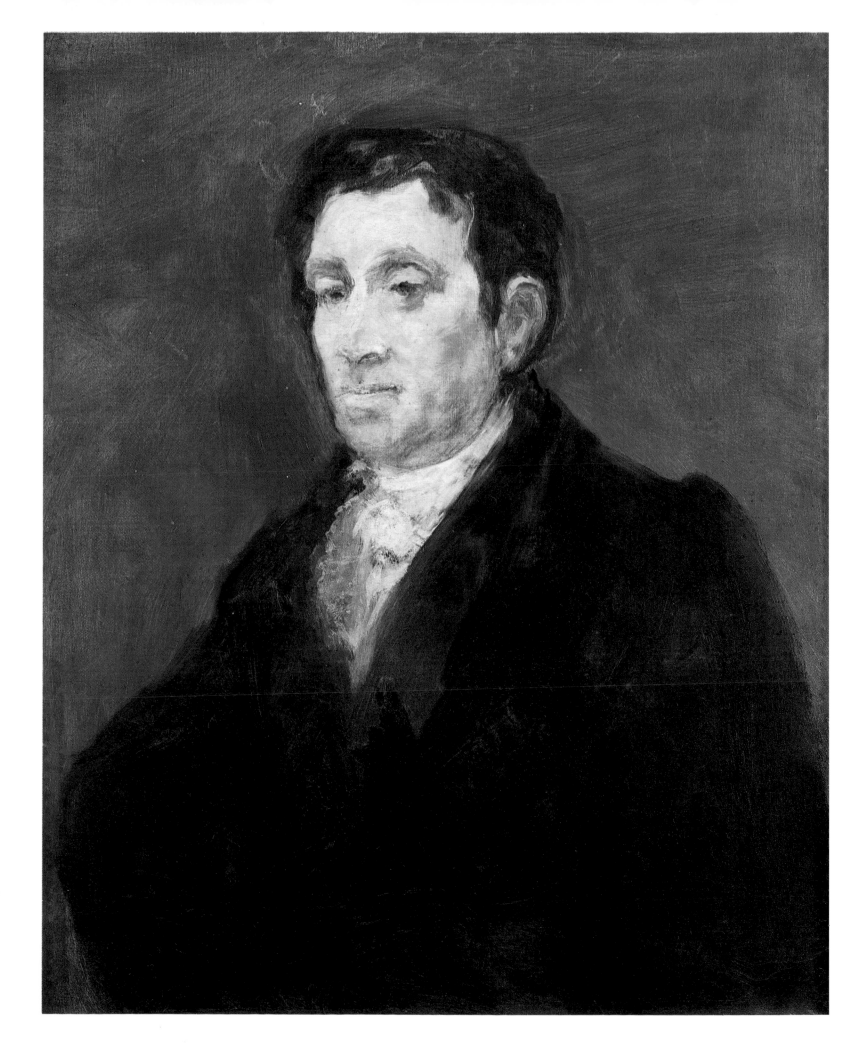

188. *Maja and Matchmaker.* 1824-1825. Miniature on ivory. 5.4 by 5.4 cm. London, Sir Kenneth Clark.

In his correspondence with Ferrer Goya notes about forty miniatures on ivory among the new works he had created in Bordeaux and underlines that "...they are more similar to the brush-stroke of Velázquez than to that of Mengs..." They are executed liberally, in the manner of a watercolor; Goya selects topics he had always been glad to depict in the past, the group of a *maja* with a matchmaker was already included in the *Caprichos*.

189. *Nude Woman Leaning on a Rock.* 1824-1825. Miniature on ivory. 8.8 by 8.6 cm. Boston, The Museum of Fine Arts (Ernest Wadsworth Longfellow Fund).

The female nude, painted for its own sake, without an excuse derived from mythology, appears in Goya's works in 1796-1797 at the time he was living in Sanlucar de Barrameda with the Duchess of Alba; at first it was in his drawings, but then it is the *Naked Maja* for Godoy's secret chamber. This miniature is a last memory of the madness of the past.

190. *Juan Bautista de Muguiro.* 1827. Oil on canvas. 102 by 85 cm. Signed and dated. Madrid, Museo del Prado.

Goya had become friendly with the two Muguiro brothers Juan Bautista and Jose Francisco in France. Jose was married to Manuela Goicoechea, sister-in-law of Javier Goya. During the trip back from Paris to Bordeaux in the last August days of 1824, the painter enjoyed the company of Martin Miguel Goicoechea, the father of Manuela and of the young couple that had just recently returned from England. In the dedication Goya proudly emphasizes his age: eighty-one years old.

traveller and we have agreed that he will see me again here in the month of September."

The relative with whom Goya stayed in Rue Marivaux was indeed a cousin of Gumersinda Goicoechea, the wife of his son Javier. He was the twenty-year-old Jeronimo Goicoechea, the business partner of his uncle Martín Miguel Goicoechea, Gumersinda's father. At the time of Goya's arrival in Paris, Jeronimo was living on his own at the Hotel Favart, Rue Marivaux, and it was there that Goya spent his two months in Paris. The French police considered these Goicoecheas "very estimable people" who "take no part whatsoever in political intrigues and hardly leave their house except to go to the theatre or visit public establishments."

It may be of interest to locate the Hotel Favart where Goya stayed. It exists to this day facing the present Opéra Comique, or Salle Favart, then the Théatre des Italiens. Under the Restoration, this had been the smartest and liveliest part of Paris. The very short Rue Marivaux led into the celebrated Boulevard des Italiens, provisionally renamed Boulevard de Gand in memory of the Hundred Days. This center of fashion was the haunt — after the *Muscadins* and *Merveilleuses* of the Directoire — of the *Gandins* with their English-style moustaches and side-whiskers, sugar-loaf top hats and coats with flared collars. Along the boulevard were the best cafés in Paris — first of all, at the corner of the Rue de Richelieu, the famous Frascati's, whose rooms and gardens were always packed, attracting crowds of gaping sightseers, dancers and dedicated gamblers. Next came the Café Tortoni, famous for its Neapolitan ices, the Café Anglais, and the Maison Dorée, where the capital's most fashionable socialites, financiers and writers were to be found. According to Hugo, it was "the anvil of genius." Since 1778 the roadway had been completely paved, and the tree-lined footpaths made it the favorite walk of the Parisians who would watch the carriages drive past and indulge in daydreams inspired by the profusion of luxury shops on every side. Nearby, on Boulevard Montmartre, was the Passage des Panoramas, where gas-lighting had just made its dazzling appearance. Balzac,

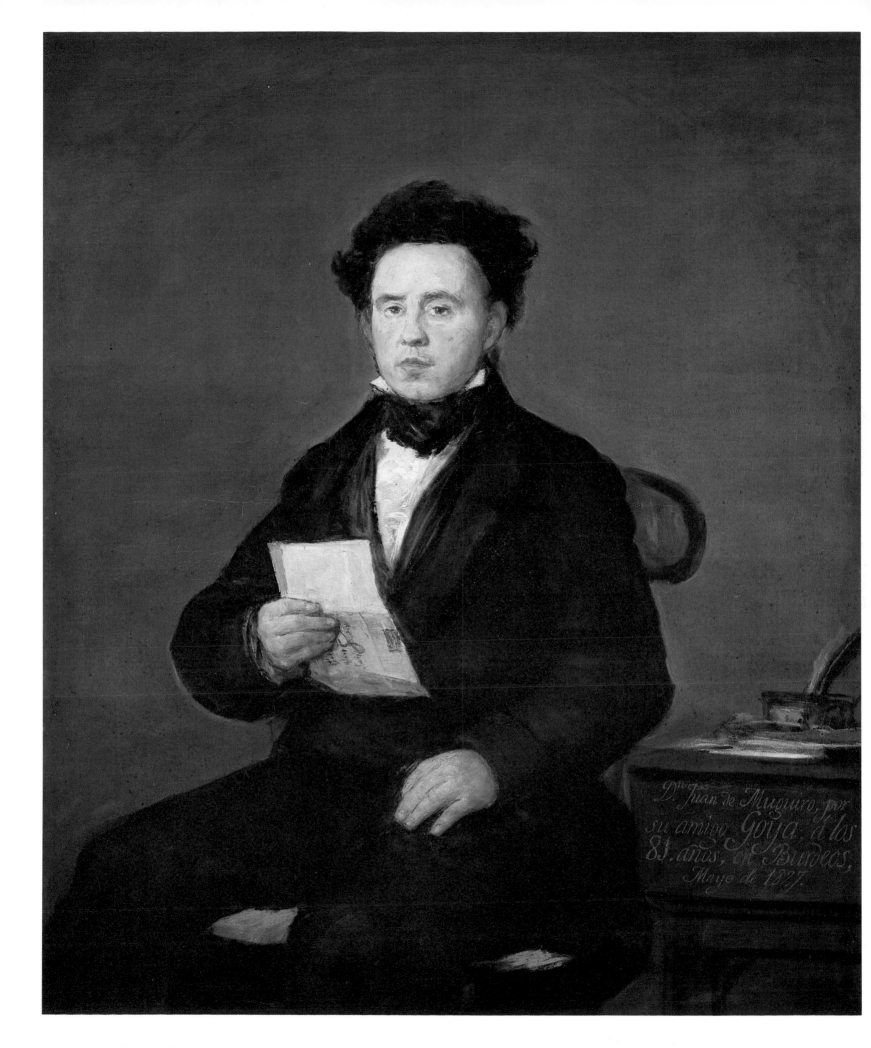

191. *Gran Disparate (Great Foolishness).* 1824-1828. Drawing from Album G (G. 9); black chalk. 19.2 by 15.2 cm. Madrid, Museo del Prado.

Based on its title and its topic the drawing is part of the etchings created in Madrid between 1815 and 1824. "Great Foolishness" Goya says about the man who is being forced to drink while simultaneously stuffing his head that is standing beside him; is he being funny or is this a protest? But against whom and against what?

whose devouring ambition it was to gain access to the brilliant society of the Boulevard, evoked its marvels as follows: "Three thousand shops are scintillating and the great poem of the window displays rings out in stanzas of color."

Some of the more ostentatious members of the Spanish colony had settled in the neighborhood of the boulevards. As we have seen González Arnao was at 25 Rue du Faubourg, while Martín Miguel Goicoechea stayed at the Hotel de Castille, Rue de Richelieu, with his daughter Manuela and his son-in-law José Francisco Muguiro. One of the most important of the exiles, namely

Joaquin Maria Ferrer, lived on a grand scale at 15 Rue Bleue. The possessor of a considerable fortune, this businessman was an associate of the Parisian bankers Delessert, Mallet and Lafitte. The French police considered him the leader of the Spanish republican party and kept him under close surveillance while allowing him to live in Paris with his wife and his brother-in-law. Goya was to become an intimate friend of the family, painting the portraits of both husband and wife — the only ones he seems to have painted in Paris — and also leaving them a bullfighting scene (*Corrida* (Fig. 183), *suerte de vara* GW 1672) and a companion piece representing a *Procession*.

192. *Segura unión natural. Hombre la mitud Muger la otra (Secure natural Union. Half man, half woman).* 1824-1828. Drawing from Album G (G. 15); black chalk. 19.2 by 15 cm. Cambridge, Fitzwilliam Museum.

After having depicted the wicked husband beating his wife in the same Album (G. 13), Goya here invents, slightly maliciously, an ideal system in which both partners are smiling happily. Perhaps this is a witty echo of the family fights that were — if we are to believe Moratín's letters — frequent between Goya and his companion Leocadia.

It has long been known thanks to the research done by Nuñez de Arenas that Goya was welcomed and adulated by the Spaniards in Paris. But this is not quite enough to satisfy our curiosity. What did he do with himself during those two summer months he spent in the French capital? What did he go to see? Above all whom did he meet apart from his compatriots? Did he know any French people? Finally, was it generally known in Paris that the most illustrious painter of the Spanish court was in town? Unfortunately, there is no document that gives any reply to these questions. Any observations on the subject remain hypothetical.

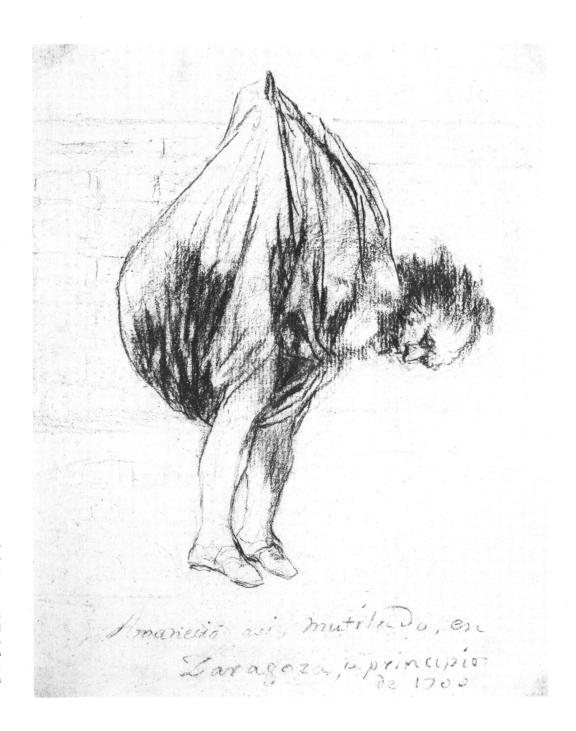

193. *Amaneció así, mutilado, en Zaragoza, a principios de 1700 (This is how he was found, mutilated, in Saragossa at the beginning of 1700).* 1824-1828. Drawing from Album G (G. 16); black chalk. 19.4 by 14.8 cm. Switzerland, private collection.

The title refers to an actual event. In 1700 in Saragossa this horrible human package was found, bleeding and obviously without arms. The drawing proves that Goya did not only follow the events of his own times, but also those of the past to the extent that he found out about them through books or reports that he obtained from his surroundings.

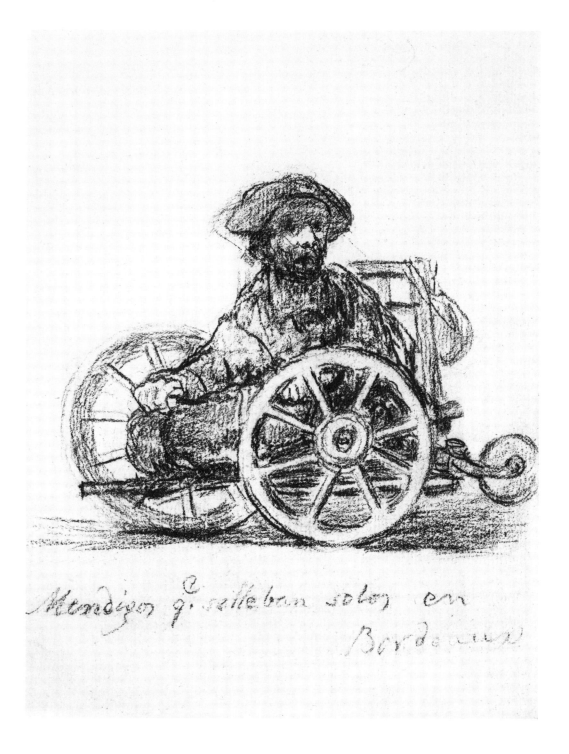

194. *Mendigos que se lleban solos en Bordeaux (Beggars moving about independently in Bordeaux).* 1824-1828. Drawing from Album G (G. 29); black chalk. 18.4 by 14.2 cm. Switzerland, private collection.

While taking walks with the young Brugada, Goya discovered a picturesque and, to him, new world in the streets of Bordeaux. There was no lack of beggars in Spain — the *ilustrados* pointed out how much of a social injustice their presence was often enough — but Goya was highly surprised by the three-wheeled cart of this "modern" beggar.

When the police report tells us that Goya "went out only to visit monuments and walks around public places" it can be assumed that one of the artist's foremost interests would be a visit to the two great Paris art galleries, the Louvre and the Luxembourg Museum. In the latter he would see the works of his contemporaries known only from hearsay in Spain — David, Girodet, Gérard, Gros, Guérin and above all works by the young artists, Delacroix's *Dante and Virgil,* shown at the Salon of 1822, and *Roger Delivering Angélique* by Ingres. What did he think of them? It is not known. Nothing in his correspondence after

his visit to Paris suggests that he had seen these pictures. The same applies to the Salon of 1824 one of the most important Salons of the century awaited impatiently by the whole of Paris Society; contemporary art was expected to be represented in all its brilliance and the prizes, from the simplest medal to official commissions, would distinguish the best artists of the day and hold them up to the admiration of the public. Was Goya, before returning to Bordeaux, among the huge crowds that milled through the rooms of the Louvre on that

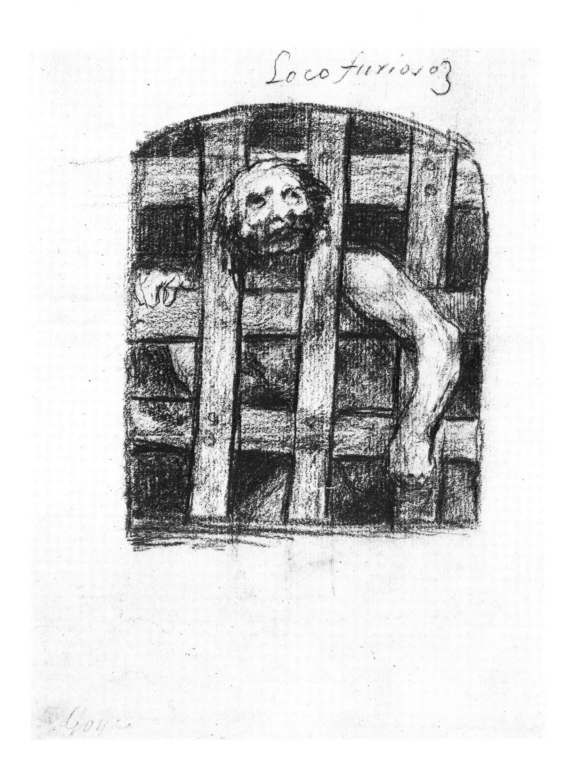

195. *Loco furioso (Enraged Madman)*. 1824-1828. Drawing from Album G (G. 3 (3)); black chalk. 19.3 by 14.5 cm. New York, Ian Woodner collection.

Album G contains a sequence of representations of madmen among which this one here is one of the more tragic figures. The use of the white paper as the wall into which the window with its bars, consisting of thick boards nailed together, has been cut, demonstrates a special daring in the composition. Everything is shapeless, the madman and the cell.

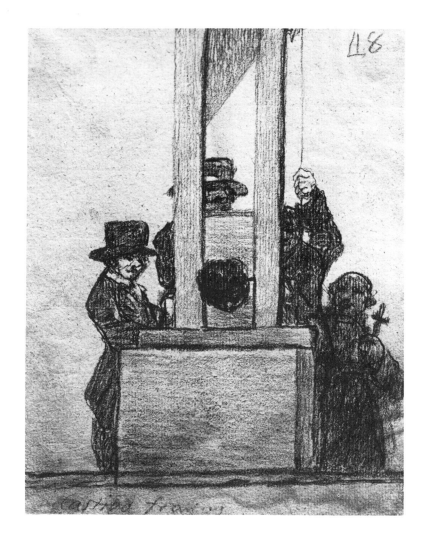

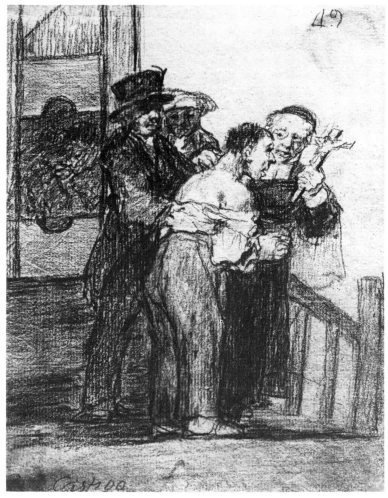

occasion? It would be nice to think so and every biographer of the Spanish master to this day has believed that he must have been there; it is too tempting to visualize the author of the *Second of May* and the *Third of May* standing before the *Massacre of Scios* by Delacroix, the *Vow of Louis XIII* by Ingres, the church interiors by Granet and Leopold Robert's brigands; or sharing with the French public the discovery of Constable's landscapes whose greens so deeply impressed Delacroix. Goya's total silence on the subject of this Salon is a great disappointment. Should it perhaps be concluded that nothing in all those paintings surprised him or even really interested him? This would seem to be the most plausible hypothesis; all he himself had painted and engraved for thirty years had more audacity and was more ahead of its time than even the most revolutionary works at the Salon of 1824. Delacroix had gained some inkling of this in March of that year when he was leafing through a copy of the *Caprices* with his friend Edouard Bertin. He copied most of the plates from it and a few days later wrote in his diary: "...tried lithography. Splendid projects on this subject. Caricatures in the manner of Goya... People of our time; some Michelangelo and some Goya..." Delacroix did not know that the brilliant author

196. *Castigo francés (French Punishment)*. 1824-1828. Drawing from Album G (G. 48); black chalk. Formerly Berlin, Gerstenberg collection; destroyed.

Two drawings that were destroyed at the end of the Second World War depict the guillotine; Goya had observed its use in Bordeaux. Only knowing the Spanish garotte, this was a completely new sight for him. The macabre realism of this execution *à la française* corresponds after almost half a century to that of his first large etching, *El agarrotado* (Strangled with a Garotte).

197. *Castigo (Punishment)*. 1824-1828. Drawing from Album G (G. 49); black chalk. Formerly Berlin, Gerstenberg collection; destroyed.

This drawing takes up the second place in the Album (see illustration 196); chronologically, it should be ahead of the sheet *Castigo francés*: the priest is comforting the condemned prior to the execution.

198. *Semana Santa en tiempo pasado en España (Holy Week in times gone by in Spain).* 1824-1828. Drawing from Album G (G. 57); black chalk. 19.1 by 14.6 cm. Ottawa, National Gallery of Canada.

Goya remembers times gone by and the festivities of Holy Week in Spain, processions, church banners, flagellants, and the sound of the trumpets. Approximately thirty years earlier he had included a similar scene in the Madrid Album (B. 80). At the time he certainly raged against the custom of flagellation; in Bordeaux he remembers it with the mild forgiving of the emigrant.

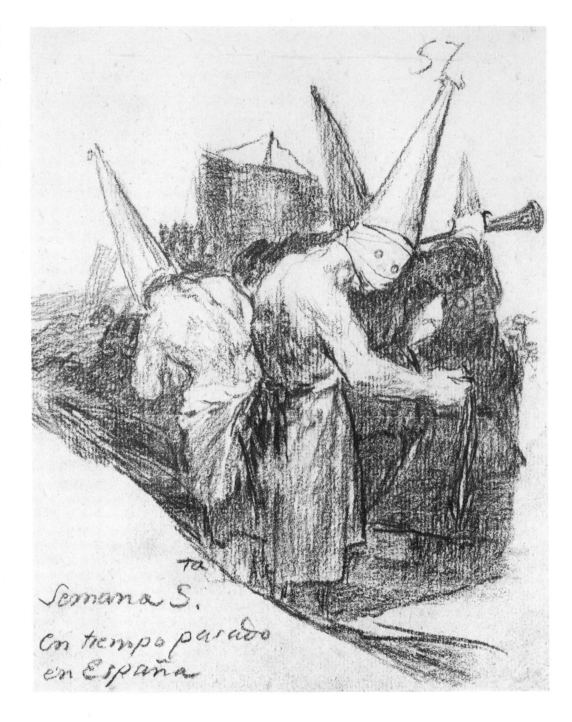

199. *Mariano Goya.* Oil on canvas. 52 by 41.2 cm. Switzerland, private collection.

Goya's very special affection for his grandson is reflected in the three portraits he created of him. This, the last one, was executed during Goya's short stay in Madrid in 1827 one year before his death as stated by a legend located on the back side prior to the restoration. Mariano was twenty-one at the time. A few months later he was called to the death bed of his grandfather and went to Bordeaux with his mother.

of the *Caprices* was in Paris and Goya scarcely thought that a young French painter who would achieve difficult but outstanding fame was already putting him on the same footing as Michelangelo. What would he have said if he had known the whole of his work?

It has also been thought that Goya met the two Vernets in Paris, Carle and his son Horace, undisputed masters of the technique of lithography who were first honored and deservedly so at the Salon of 1824. Here again no proof exists that such a meeting took place. One thing only is certain: between the clumsy lithographic experiments of 1819-1820 and the masterpieces like the *Bulls of*

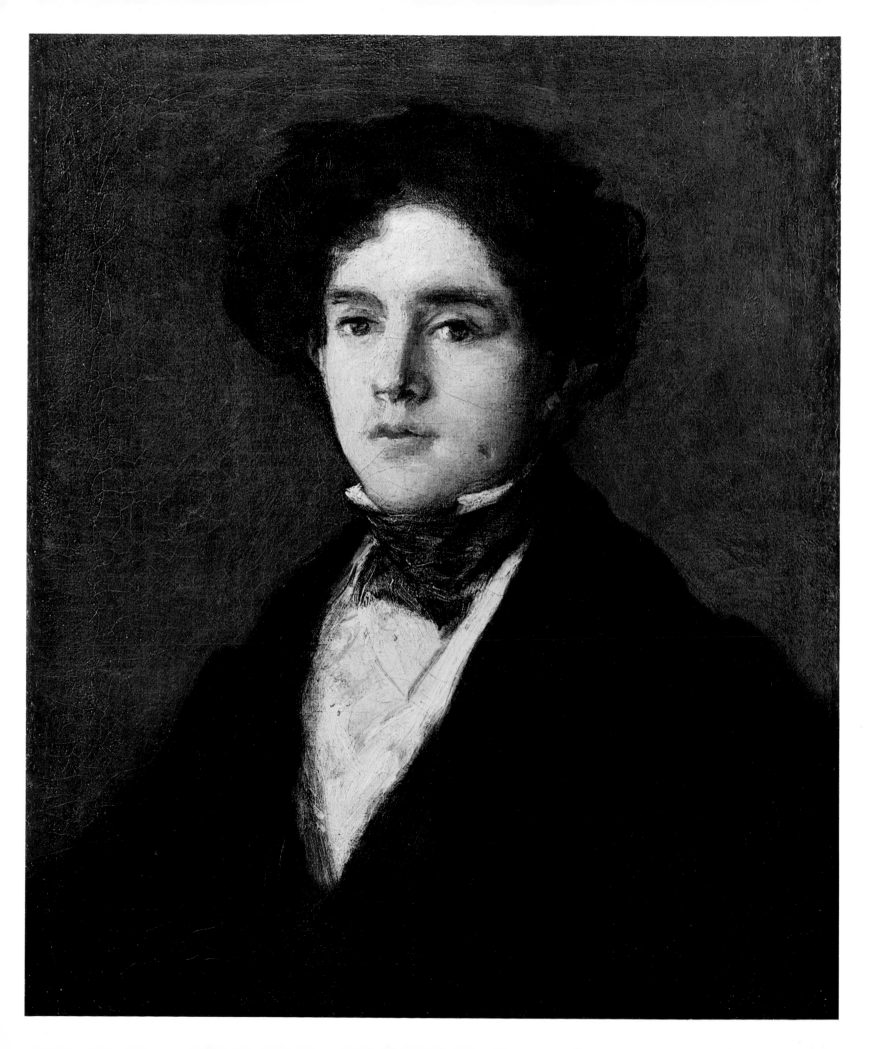

200. *Procession of Monks.* 1824-1828. Drawing from Album H (H. 13); black chalk. 19.1 by 15.4 cm. Madrid, Museo del Prado.

The topic of the procession with its banners offers Goya the opportunity to depict a bunched, slowly moving mass of people. He painted a scene like this for the first time in 1786-1787 for the Alameda de Osuna. During the years of the war he created the more opulent *Procession of Valencia* (Zurich, Buehrle Foundation) followed by the *Procession of Flagellants* for the Academy of San Fernando. On the shown sheet Goya uses the curve from the *Procession of Monks* out of Album F (F. 44) again; he had drawn it prior to his departure from Madrid. This sheet, as well, is a memory of the distant Spain.

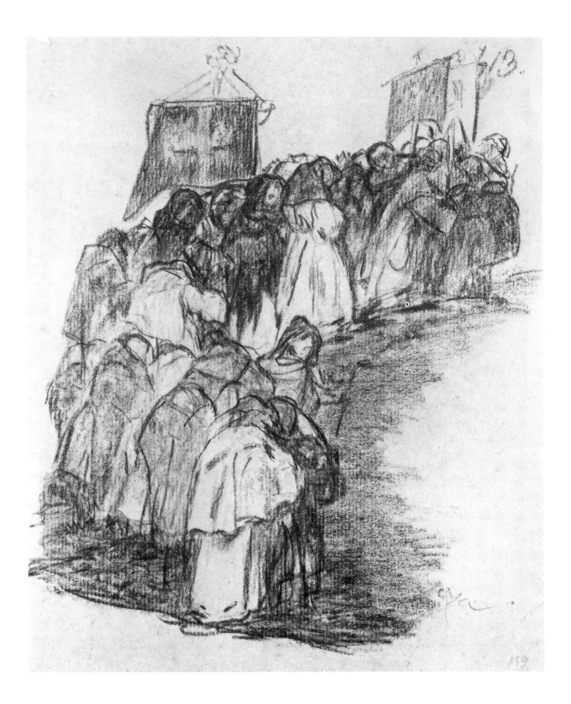

Bordeaux that followed his stay in Paris there is such an enormous change in the use of the stone and in the transition from transfer to direct drawing that the idea of the intervention of an artist who was already versed in the various processes of lithography cannot be rejected. The hypothesis has even been put forward that Goya's purpose in going to Paris was precisely to meet the Vernets on the advice of his friend Jose Maria Cardano, director of the first lithographic establishment in Madrid. This is an ingenious idea but here again the painter's silence on the subject in his correspondence seems baffling. All the more so as in a letter to Ferrer dated December 20, 1825 he happened to speak of his friend the painter, apparently "the incomparable Monsieur Martin" of an earlier

201. *Allegory: War or Evil (?).* 1824-1828. Drawing from Album H (H. 15); black chalk. 19 by 15.5 cm. Madrid, Museo del Prado.

Goya used the form of an allegory frequently, especially at the end of his life: it enabled him to give a basic thought its most pertinent pictorial representation. The meaning is not quite clear here, although the agonizing thoughts of war have been superimposed on everything else since 1808.

letter. Was this Michel Martin Drolling, David's pupil, Prix de Rome 1810, whom Goya called "Monsieur Martin" (Don Martin) in the Spanish fashion? In any case, he is the only famous painter to whom this simple Christian name could refer and also the only one Goya liked to recall after his stay in Paris.

Picturesque traces of his short Paris stay survive in his work, above all a drawing in the first of the so-called Bordeaux albums whose caption could not be more explicit. *Yo lo he visto en Paris* (I saw it in Paris) (Fig. 185, GW 1736); an extravagant yet profoundly human street scene which he transcribed or perhaps did from memory as soon as he was back in Bordeaux. Several drawings in the same album show the sort of sedan chair with a single porter which he

202. *Young Witch (?) flying with a rope.* 1824-1828. Drawing from Album H (H. 19); black chalk. 19.1 by 15.5 cm. Ottawa, National Gallery of Canada.

If we compare this young woman with the witches of the *Caprichos* the break with tradition — it knows no witches flying with a rope — becomes obvious. Although it leaves a somewhat unreal impression, the drawing is closer to scenes at a fair or a circus than it is to a witch scene.

must have seen going past in Rue Marivaux since one of them bears the inscription *A la comedia,* which might be a reference to the Theatre des Italiens or to one of the boulevard theatres. (Fig. 186, GW 1730). Other picturesque sketches of forms of transport are among these drawings in black chalk. They might refer to Paris or to Bordeaux. They bear witness to the tireless curiosity he had throughout his life for any novelty. The sharp eye of the self-portrait of the *Caprices* still scrutinized men and objects with the same avid interest twenty-five years later; the same hand reconstituted without a tremor in a few telling lines a scene he had experienced, underlining it with a *Yo lo vi* or *Yo lo he visto* (Fig. 185) worthy of the best modern documentaries.

In the closing days of August 1824 Martín Miguel Goicoechea with his daughter Manuela and his son-in-law Muguiro arrived in Paris on their return from England. Undoubtedly that was the reason that prompted Goya to return to Bordeaux. He even seems to have left Paris precipitately according to a letter he wrote on November 30 that year to the Duchess de San Fernando, the youngest daughter of the Infante Don Luis de Borbón: "…when I left Paris to come here my departure was very hasty: time was short, I had no money and I accepted the offer of some friends who advanced me my traveling expenses…" As Moratín had recommended he was certainly back in Bordeaux

203. *The Old Woman with a Mirror.* 1824-1828. Drawing from Album H (H.33); black chalk. 19.1 by 14.8 cm. Madrid, Museo del Prado.

Goya goes back to a topic again here that he had already depicted on sheet 55 of the *Caprichos* with the title *Hasta la muerte* (Until Death). The old aristocratic woman in a decaying society has twenty-five years later been replaced by a lonely old woman.

at the beginning of September. At that point his real exile began and, it might be added, his new family life.

As soon as Goya was back in Bordeaux Moratín sent news of him, in a letter dated September 20, to his friends in Madrid, notably his closest friend Juan Antonio Melón. "I have just come from the country where I stayed for two weeks which did me a lot of good. Goya is here with Madame and the children in good furnished lodgings in a pleasant quarter. I think he will be able to spend the winter there very comfortably. He wants to do my portrait which shows you how goodlooking I am since such skillful brushes want to multiply my image..." The presence of Leocadia and her two children in Bordeaux is

204. *Two dancing old Friends.* 1824-1828. Drawing from Album H (H. 35); black chalk. 19 by 14.8 cm. Madrid, Museo del Prado.

It is impossible to be certain whether the faces are real or whether the dancing couple is costumed and masked and, when looking at this scene, we are not quite sure whether we should laugh or cry.

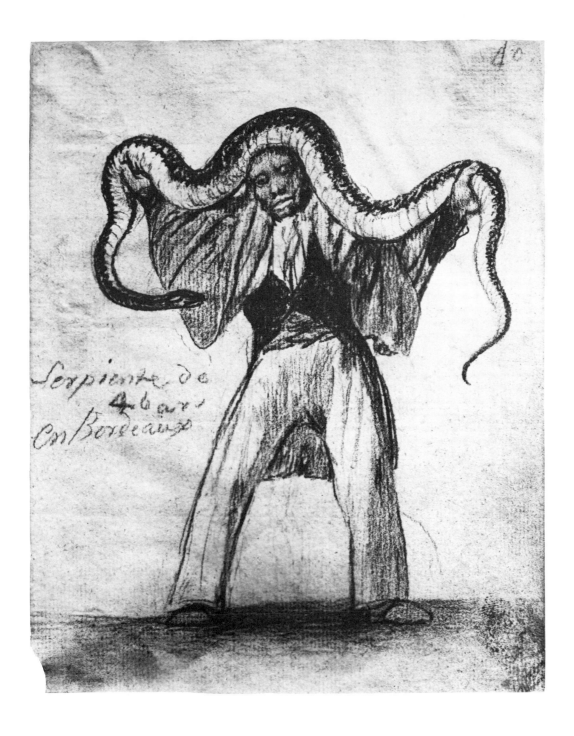

confirmed by a note from the Sub-Prefect of Bayonne to the Minister of the Interior: "I am sending Your Excellency the passport of D. Leocadia Zorrilla accompanied by her two children to whom a provisional permit has been issued for Bordeaux where she is going to join her husband." A note has been added in the margin: "Leocadia Zorrilla, Spanish, thirty-four years old, accompanied by her two children (twelve and nine years)." This in a way is Leocadia's *official* entry into France not under her real name, Leocadia Weiss, but in her maiden name; moreover, she told the French police that she was going to Bordeaux "to join her husband," although Isidoro Weiss had never stayed in France.

205. *Serpiente de 4 bares en Bordeaux (4 Yard long Snake in Bordeaux).* 1824-1828. Drawing from Album H (H. 40); black chalk. Formerly Berlin, Gerstenberg collection; destroyed.

Some of the drawings of Album H bear a special legend. Perhaps these sheets were in Album G originally and were later rearranged by Goya. They included three scenes of a fair in Bordeaux that were unfortunately destroyed at the end of the war along with the collection they were in.

Moratín's letter leaves no doubt about the real purpose of her journey. No sooner had she and the children arrived than they settled in the furnished flat Goya had rented in the Allées de Tourny and there they lived together as best they could until the painter's death in 1828.

For him Bordeaux was a haven of peace, the final phase of a long life whose last twenty years had been shaken tragically by the upheavals in Spanish political life. There he found his friends again, first and foremost Moratín and Silvela who were already old-established exiles and also a lot of acquaintances from the past who had settled in Bordeaux or were passing through on their way to Paris, notably the Marquis de San Adrian whose portrait he had painted in 1804, José de Azanza, former Minister of Foreign Affairs to King Joseph, and Pedro Sainz de Baranda who had played a decisive role in Madrid during the liberal years. But there was also a new circle of friends which had gathered gradually around him and which played an important part in this final period of his life.

First of all there was a young Madrid artist Antonio Brugada trained at the Madrid Academy of Fine Arts between 1818 and 1821, who became a political exile for the same reasons as Leocadia's son and at about the same time, since he had to leave Spain in October 1823 because he had belonged to the militia. At Bordeaux he became the old master's favorite companion and it was on the basis of his recollections that Goya's first biographer Laurent Matheron wrote the chapter on the painter's years in Bordeaux. Thanks to him it is known exactly how his famous friend executed his lithographs and his miniatures in that very original way. He was also a close witness of his everyday life which reveals a man's character as he really is with its changes of mood and its unpredictable fits of temper. By one of those quirks of fate, after Goya's death Brugada married Rafaela Costa, the daughter of a doctor closely connected with Moratín and himself married to Fernanda Bonells whose father was the Duchess of Alba's physician. Around 1813 Goya had painted the portraits of Fernanda Bonells and her youngest son the enchanting Pepito Costa y Bonells in the midst of his toys. Indeed Goya probably knew of Brugada's matrimonial plans — the wedding took place on January 16, 1829 — and this would have increased his affection for his young friend.

Goya's immediate circle included also José Pio de Molina (GW 1666), the first *alcalde* of the constitutional period in Madrid in 1823 and one of the witnesses to the painter's death certificate. Santiago Galos, his business manager who looked after his interests in Bordeaux was of French origin in spite of his name and was a representative of both the business world and the most fervently liberal circles. Juan Bautista Muguiro (Fig. 190), who played a predominant role in Spanish politics after 1833, was a relative by marriage of Martin Miguel de Goicoechea and thus of Goya himself.

Finally, a Bordeaux artist whose name has been closely linked with Goya's engravings, Cyprien Charles Marie Nicolas Gaulon whose lithography studio, opened in 1813, enabled Goya to produce the four famous plates called *Bulls of Bordeaux* (GW 1707). The printer's part may even have gone beyond the usual

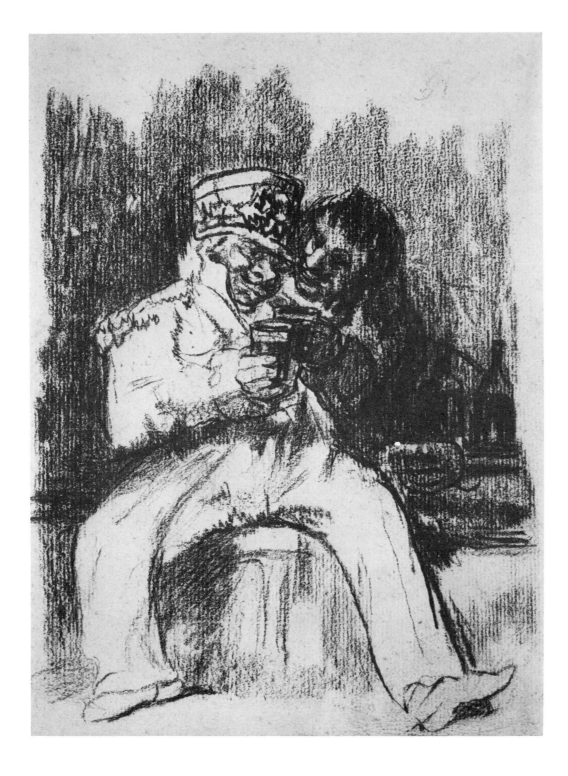

206. *Drinking Soldier with a Citizen.* 1824-1828. Drawing from Album H (H. 51); black chalk. 19.1 by 14.7 cm. Paris, private collection.

The diversity of the topics within one Album is slightly confusing, even if there are occasional groups of drawings. Usually they are things Goya discovered by chance while taking a walk or that he remembers, and not planned sequences to individual topics. This is the case with this soldier, whose light figure contrasts with the dark shape of the innkeeper persuading him to drink.

task of running the prints off. The lithographed portrait of him Goya has left suggests that he was the painter's counsellor and collaborator. In a letter of December 6, 1825 Goya asked his friend Ferrer in Paris to let him know what he and Cardano thought of the print of the first plate and to find out if the connoisseurs in the capital might be interested in his lithographs. Ferrer's reply is not known, but Goya's next letter shows that these new works were not to the taste of those who saw them for the first time. The old man of nearly eighty

was too modern, too bold for his time. But what did people want? They asked him to reprint the *Caprices* which were only just being discovered in Paris. To this strange request to revive a twenty-five-year-old past Goya replied: "What you ask me about the *Caprices* is impossible since the plates were ceded to the king more than twenty years ago as well as the other things I engraved which are now in His Majesty's collection, and on top of that I have been denounced to the Santa [the Inquisition]. But I will not copy them since I now have better works which would sell better. I know that last winter I painted on ivory and I have a collection of some forty experimental items but this is original miniature work such as I have never seen as it has been done with dots and is more like Velázquez' brushwork than like Mengs'…" What a splendidly spontaneous and youthful letter. The old Goya was thinking only of the future, of all the new and original things he was creating, especially these miniatures which were unique in the history of the genre (GW 1676 and 1688, and unpublished). To clarify things to his correspondent he found no better formula than the juxtaposition of Velázquez and Mengs, a real guideline of his art since 1778.

But lithographs and miniatures were parts of his artistic creation that could be sold, that is, what he considered the public section of his work. The main part as in Madrid was still drawing. With a blank piece of paper in front of him he could dream, remember, amuse himself or feel sorry for himself. Two new albums were carefully numbered and classified, one with captions, the other generally without comment. But both have the same format and the same technique of black chalk which he here first used consistently. When he returned to Bordeaux in September 1824 he did not miss the spectacle — novel for him — of the annual fair. A drawing, now unfortunately lost, showed three dwarfs being exhibited at one of the booths. He sent it to the Duchess of San Fernando from whom he had not had time to take leave when he was in Paris. "I take the liberty of sending Your Excellency these three messengers whom I have instructed especially to assure her excellency how grateful I am for her kind remembrance of me and how much I wish to please and serve her. They are three dwarfs shown at the Bordeaux Fair two months ago; I thought it might be interesting to do a sketch of their faces and small figures. The one wearing little trousers is eighteen inches; of the others (who are man and wife) she is twenty-one inches and the husband twenty. I shall be happy if they accomplish their mission, according to the wishes of the invalid who sends them… Bordeaux, November 30, 1824."

The Bordeaux albums contain further evidence of these visits to the fair and of Goya's amused surprise at the performing animals, the exhibitors of snakes and crocodiles, the living skeletons, and the acrobat imitating the telegraph with his legs. He was struck by other unusual scenes which he also transcribed on to paper: the magic boxes in which the bystanders come "to look at what they can't see," according to Goya's caption; the modern means of transport which he saw in France, a mechanical horse, the small three-wheeled cart of the Bordeaux beggar, an old woman drawn by her dog in Paris (GW 1736).

207. *La lechera de Burdeos (The Milkmaid of Bordeaux).* 1825-1827. Oil on canvas. 74 by 68 cm. Madrid, Museo del Prado.

Along with his last portraits, Goya created this mysterious and enchanting painting of the milkmaid of Bordeaux. The painting was in the possession of Leocadia Weiss who sold it to Juan Bautista Muguiro for an ounce of gold. As the picture already had its present title at the time, we can assume that it really does depict one of the pretty girls who transported milk from the country to the city riding on a donkey as described by Moratín in one of his letters. It is the last work by Goya and it is filled with light and beauty.

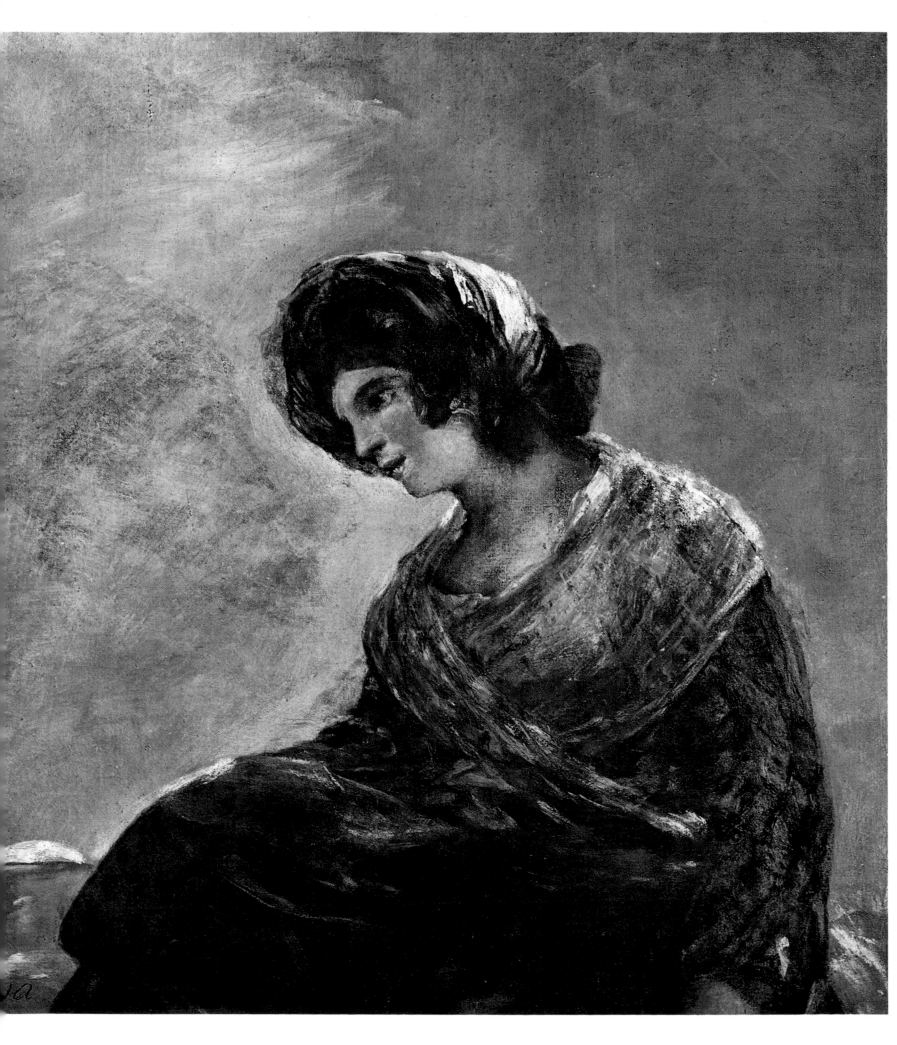

But there are also the nightmare visions which had not left him since 1793: the *Gran disparate* of the man who has to feed his head which is lying beside him (GW 1718); the huge flying dog swooping down on a village; the man who is unable to undo the lock barring a desirable young woman; another fleeing from fire that is already enveloping him. There are also many tragic and horrible scenes, such as the mutilated jumble of human beings hanging from a nail (GW 1724), the long series of madmen (Fig. 193) the most touching of which are behind enormous bars clumsily put together (GW 1738), and finally an unusual thing for Goya, the guillotine which he shows twice with the simple caption, *Castigo francés* (French chastisement, Figs. 196, 197).

The variety of drawings in these two Bordeaux albums constitutes a sort of grand final fresco where all the images that had obsessed him since the time of the *Caprices* appear higgledy-piggledy. The last masterpiece, the last look at life in its immutable beauty and horror. Many of these drawings are signed which is very rare for Goya. Did he want to assert himself more forcefully through that or did he intend to engrave a final series before his death? The black-chalk technique suggests lithography: there is the same velvety quality of black and white, the same thick yet incisive line that fashions the shapes without overloading them.

It is surprising that during the painter's last years in Bordeaux when his life was so full of domestic upheavals and physical suffering he made two journeys to Madrid at the age of eighty: in 1826 to request his definitive retirement without loss of salary, and finally in 1827 apparently simply on a whim. Until the very

end he drew, engraved and painted. The *Portrait of my dear Mariano* (GW 1664) and the tender *Bordeaux Milkmaid* (Fig. 207, GW 1667) show him imperturbably youthful and master of his palette. In one of his last letters to his son Javier he was worrying about his future at the thought that he might live to ninety-nine like Titian. Although he had already done so much for his son and grandson he wondered how he could do more, how he could leave them a respectable heritage through wise investments. Did he have any idea that his name and his work would soon constitute the most fantastic capital a father could bequeath to his family? And that the annual income of twelve thousand reals he was hoping to achieve at last would be a drop in the ocean compared with the pictures he left to Javier and the hundreds of copperplates, engravings and drawings still lying in crates at the Quinta del Sordo?

Only Leocadia would go out of his life empty handed, dependent wholly on public charity. As for Rosarito, despite her father's patient drawing lessons she was never more than a mediocre artist, too inclined to copy without scruple.

Buried in Bordeaux in the same vault as Martin Miguel Goicoechea, Goya remained interred in France until 1901. Administrative difficulties, the indifference of the authorities and to some extent being forgotten combined to delay the apotheosis of the Spanish master. Chance decreed that it should wait for the twentieth century; this was the sign that the modern quality of his spirit had at last gained recognition. But Spain, in laying his mortal remains to rest in the church of San Antonio de la Florida, made a gesture to be expected from the homeland of Velázquez: it restored Goya to his angels and his demons in that Sistine Chapel of modern art.

Appendix

Illustrations

Selected Bibliography

Exhibition Catalogues

1900 Obras de Goya, Ministerio de Instrución Pública y Bellas Artes, Madrid

1922 Exposición de Dibujos 1750-1860, Sociedad Española de Amigos del Arte, Madrid

1928 Catálogo ilustrado de la Exposición de Pinturas de Goya, Museo del Prado, Madrid

1928 Exposición de Obras de Goya, Zaragoza

1932 Antecedentes, Coincidencias e Influencias del Arte de Goya, Sociedad Española de Amigos del Arte, Madrid

1935 Exposition de l'Oeuvre gravé, de Peintures, de Tapisseries et de Cent dix Dessins du Musée du Prado, Bibliothèque nationale, Paris

1937 Exhibition of Paintings, Drawings and Prints by Francisco Goya, California Palace of the Legion of Honour, San Francisco

1938 Peintures de Goya des Collections de France, L'Orangerie du Musée du Louvre, Paris

1938 From Greco to Goya, The Spanish Art Gallery, London

1941 The Art of Goya. Paintings, Drawings and Prints, Art Institute, Chicago

1951 Goya, Bordeaux

1953 Goya—Gemälde, Zeichnungen, Graphik, Tapisserien, Kunsthalle, Basel

1954 Goya—Drawings, Etchings and Lithographs, The Arts Council, London

1955 Goya. Drawings and Prints from the Museo del Prado and Museo Lázaro Galdiano, Madrid, and the Rosenwald Collection, National Gallery of Art, Washington, D.C. (circulated by the Smithsonian Institution)
Supplementary volume: Paintings, Drawings and Prints ... at The Metropolitan Museum of Art, New York

1955 Goya, Palacio de Carlos V, Granada

1956 De Tiepolo à Goya, Bordeaux

1959-1960 Stora Spanska Mästare, Nationalmuseum, Stockholm

1961 Goya (IV Centenario de la Capitalidad), El Casón, Madrid

1961-1962 Goya, Musée Jacquemart-André, Paris

1963 Trésors de la peinture espagnole—Eglises et Musées de France, Musée des Arts décoratifs, Paris

1963 El Greco to Goya, John Herron Museum of Art, Indianapolis, Ind.; Rhode Island School of Design, Providence, R.I.

1963-1964 Goya and his Times, Royal Academy of Arts, London

1966 Goya—Zeichnungen, Radierungen, Lithographien, Ingelheim on the Rhien

1966 Spanische Zeichnungen von El Greco bis Goya, Kunsthalle, Hamburg

1970 Goya, Mauritshuis, Den Haag; Orangerie du Musée du Louvre, Paris

1974 The Changing Image: Prints by Francisco Goya, Museum of Fine Arts, Boston

1978 Goya en la Biblioteca Nacional, Madrid

1979 Goya, 1746-1828, Peintures—Dessins—Gravures, Centre Culturel du Marais, Paris

1979-1980 L'art européen à la Cour d'Espagne au XVIIIᵉ siècle, Galerie des Beaux-Arts, Bordeaux; Grand-Palais, Paris; Museo del Prado, Madrid

1980-1981 Goya. Das Zeitalter der Revolutionen, 1789-1830, Kunsthalle, Hamburg

1981 El Greco to Goya, The Taste for Spanish Paintings in Britain and Ireland, The National Gallery, London

1981 Goya's Prints, The Tomás Harris Collection in the British Museum, London

1982 Goya dans les collections suisses, Martigny

1982-1983 Goya and the Arts of his Time, Meadows Museum, Dallas

1983 Goya en las colecciones madrileñas, Museo del Prado, Madrid

General Books

Angelis, Rita de, und Paul Guinard, Tout l'oeuvre peint de Goya, Paris 1976

Araujo Sanchez, Zeferino, Goya, Madrid 1895

Arnaiz, José Manuel, Eugenio Lucas, su vida y su obra, Madrid 1981

Azcárate, Pablo de, Wellington y España, Madrid 1960

Baticle, Jeannine, und Cristina Marinas, La Galerie Espagnole de Louis-Philippe au Louvre, 1838-1848, Paris 1981

Bedat, C., L'Académie des Beaux-Arts de Madrid, 1744-1808, Toulouse 1974

Beroqui, Pedro, Una biografia de Goya escrita pur su hijo, in: Archivo Español de Arte III, 1927

Beruete y Moret, Aureliano de, Goya pintor de retratos, Madrid 1916

—Goya, composiciones y figuras, Madrid 1917

—Goya grabador, Madrid 1918

Boix, Félix, La Litografía y sus origenes en España (Arte Español VII)

Bouvy, Eugène, L'Imprimeur Gaulon et les origines de la lithographie à Bordeaux, Bordeaux 1918

Calvert, Albert F., Goya, London 1908

Camón Aznar, José, »Los Disparates« de Goya y sus dibujos preparatorios, Barcelona 1951

—Goya, Saragossa, 1980-1981

Carderera, Valentin, Biografia de D. Francisco Goya, pintor, in: El Artista II, 1835

—Goya, Seminario Pintoresco, 1838

—François Goya—Sa vie, ses dessins et ses eaux-fortes, in: Gazette des Beaux-Arts VI, 1860

Céan Bermúdez, Juan Agustín, Diccionario Histórico de los mas ilustres Profesores de las Bellas Artes en España, Madrid 1800

Crispolti, Enrico, Disegni inediti de Goya, in: Commentari IX, 1958

—Otto nuove pagine del taccuino »di Madrid« di Goya et alcuni problemi ad esso relativi, in: Commentari IX, 1958

Cruzada Villaamil, Gregorio, Los tapices de Goya, Madrid 1870

Delteil, Loys, Le Peintre graveur illustré XIV, XV, Paris 1922

Demerson, Georges, Goya en 1808, no vivia en la Puerta del Sol, in: Archivo Español de Arte XXX, 1957

—Don Juan Antonio Meléndez Valdés et son temps, Paris 1962

Desparmet Fitz-Gerald, X., L'Oeuvre peint de Goya, Paris 1928-1950, 2 volumes of text, 2 volumes of tables

Ezquerra del Bayo, Joaquin, La Duquesa de Alba y Goya, Madrid 1928

—Las Pinturas de Goya en el Oratorio de la Santa Cueva, de Cádiz, in: Arte Español IX, 1928

Florisoone, Michel, Comment Delacroix a-t-il connu les »Caprices« de Goya? in: Bulletin de la Société de l'Histoire de l'Art Français, 1957, 1958

—La raison du voyage de Goya à Paris, in: Gazette des Beaux-Arts LXVIII, 1966

Font, Eleanor Sherman, Goya's source for the Maragato series, in: Gazette des Beaux-Arts LII, 1958

Gassier, Pierre, De Goya-Tekeningen in the Museum Boymans, in: Bulletin Museum Boymans Rotterdam IV, 1, 1953

—Les dessins de Goya au Musée du Louvre, in: La Revue des Arts I, 1954

—Goya, Genf 1955

—Francisco Goya, Die Skizzenbücher, Fribourg 1973

—Francisco Goya, Die Zeichnungen, Fribourg 1975

—Les portraits peints par Goya pour l'infant Don Luis de Borbón à Arenas de San Pedro, in: Revue de l'Art Nr. 43, 1979

—Goya. Tutti i dipinti, Mailand 1981

—und Juliet Wilson, Francisco Goya, Leben und Werk, Fribourg 1970

Gaya Nuno, Juan Antonio, La Pintura Española fuera de España, Madrid 1928

Glendinning, Nigel, A new view of Goya's Tauromaquia, in: Journal of the Warburg and Courtauld Institutes XXIV, 1961
—Goya and England in the Nineteenth Century, in: Burlington Magazine CVI, 1964
—Goya and his critics, London 1977
Gómez–Moreno, María Elena, Un cuaderno de dibujos inéditos de Goya, in: Archivo Español de Arte XIV, 1941
González Martı, Manuel, Goya y Valencia, in: Museum III, 1913
González Palencia, Angel, El estudio crítico mas antiguo sobre Goya, in: Boletín de la Real Academia de la Historia, 1946
[Goya], Colección de cuatrocientos cuarenta y nueve reproducciones de Cuadros, Dibujos y Aguafuertes de Don Francisco de Goya. Precedidos de un Epistolario del gran Pintor y de las Noticias Biográficas publicadas por Don Francisco Zapater y Gómez en 1860, hg. von Saturnino Calleja, Madrid 1924
[Goya], Goya and the Spanish Tradition, in: Apollo, London, Oktober 1981
[Goya], Número extraordinario, Goya 100, Madrid 1971
[Goya], Número extraordinario, Goya 148-150, Madrid 1979
Goya, Francisco de, Les Caprices, Facsimile edition, edited and translated into French by Pierre Gassier, Grenoble 1979
Goya, Francisco de, Diplomatario, edited by Angel Canellas Lopez, Saragossa 1981
Goya, Francisco de Cartas a Martín Zapater, edited by Mercedes Agueda and Xavier de Salas, Madrid 1982
Goya, Francisco de, La Tauromachie, Facsimile edition, edited and translated into French by Pierre Gassier, Grenoble 1982
Gudiol Ricart, José, Goya and Ventura Rodríguez, in: Spanska Mästare, Stockholm 1960
—Les peintures de Goya dans la Chartreuse de l'Aula Dei à Saragosse, in: Gazette des Beaux-Arts LVII, 1961
—Paintings by Goya in the Buenos Aires Museum, in: Burlington Magazine CVII, 1965
—Goya [Biographie und kritischer Werkkatalog], 4 Bde., Barcelona 1970

Harris, Enriqueta, Goya, London-New York 1969; Cologne, 1969
Harris, Tomás, Goya, Engravings and Lithographs, Oxford 1964

Held, Jutta, Farbe und Licht in Goyas Malerei, Berlin 1964
—Goyas Akademiekritik, in: Münchner Jahrbuch der Bildenden Kunst N.F. XVII, 1966
Helman, Edith F., The Elder Moratín and Goya, in: Hispanic Review XXIII, 1955
—The Younger Moratín and Goya: on »Duendes« and »Brujas«, in: Hispanic Review XXVII, 1959
—Trasmundo de Goya, Madrid 1963
—Identity and Style in Goya, in: Burlington Magazine CVI, 1964
—Fray Juan Fernández de Roxas y Goya, in: Homenaje a Rodríguez-Moñino, Madrid 1966
—Jovellanos y Goya, Madrid 1970
Hempel-Lipschutz, Ilse, Spanish Painting and the French Romantics, Cambridge 1972
Herr, Richard, The Eighteenth-Century Revolution in Spain, New Jersey 1958

Klingender, F.D., Goya in the democratic tradition, London 1948; 2 Aufl. 1968
—Goya und die demokratische Tradition Spaniens, Berlin 1954

Lafond, Paul, Goya, Paris 1902
—Nouveaux Caprices de Goya, Suite de trentehuit dessins inédits, Paris 1907
—Les dernières années de Goya en France, in: Gazette des Beaux-Arts XXXVII, 1907
Lafuente Ferrari, Enrique, Goya: El Dos de Mayo y los Fusilamientos, Barcelona 1946
—Ilustración y elaboracíon en la »Tauromaquia« de Goya, in: Archivo Español de Arte LXXV, 1946
—Antecedentes, coincidencias e influencias del arte de Goya, Madrid 1947
—Miscelánea sobre grabados de Goya, in: Archivo Español de Arte XXIV, 1951.
—Los Desastres de la Guerra de Goya y sus dibujos preparatorios, Barcelona 1952
—Die Fresken von Goya, Genf 1955
—Goya, Sämtliche Radierungen und Lithographien, Vienna—Munich, 1961
Levitine, George, Some Emblematic Sources of Goya, in: Journal of the Warburg and Courtauld Institutes XXII, 1959
Loga, Valerian von, Francisco de Goya, Berlin 1903
Longhi, Roberto, Il Goya romano e la cultura di Via Condotti, in: Paragone V, 1954
Lopez-Rey, José, A Contribution to the Study of Goya's Art, The San Antonio de la Florida Frescoes, in: Gazette des Beaux-Arts XXV, 1944
—Goya and the World around him, in: Gazette des Beaux-Arts XXVIII, 1945
—Goya y el mundo a su alrededor, Buenos Aires, 1947
—Goya's Caprichos, Beauty, Reason and Caricature, Princeton 1953
—A Cycle of Goya's Drawings, London 1956
—Goya and his Pupil María dél Rosario Weiss, in: Gazette des Beaux-Arts XLVII, 1956
—Goya at the London Royal Academy, in: Gazette des Beaux-Arts LXIII, 1964
Lozoya, Marqués de, Goya y Jovellanos, in: Boletín de la Real Academia de la Historia, 1946
—Algo mas sobre Goya en Italia, in: Archivo Español de Arte XXIX, 1956

Madrazo, Pedro de, Viaje Artístico, Barcelona 1884
Malraux, André, and Pierre Gassier, Dessins de Goya au Musée du Prado, Genf 1947; Goya Drawings from the Prado, London 1947
Mariani, Valerio, Primo Centenario dalla Morte di Francesco Goya—Disegni inediti, in: L'Arte XXXI, 3, 1928
Matheron, Laurent, Goya, Paris 1858
Maule, Nicolás de la Cruz y Bahamonde, Conde de, Viaje de España, Francia e Italia, Cádiz 1813
Mayer, August L., Dibujos desconocidos de Goya, in: Revista Española de Arte XI, 1932
—Francisco de Goya, Munich, 1923
—Echte und falsche Goya-Zeichnungen, in: Belvedere, 1930
—Some Unknown Drawings by Francisco Goya, in: Old Master Drawings IX, 1934-1935
—Les tableaux de Goya au Musée d'Agen, in: Gazette des Beaux-Arts LVII, 1935
Millicua, José, Anotaciones al Goya joven, in: Paragone V, 1954
Moratín, Leandro Fernández de, Obras Postumas III, Madrid 1868
—Diario (Mayo 1780-Marzo 1808), hg. von René und Mireille Andioc, Madrid 1967
—Epistolario, hg. von René Andioc, Madrid 1973

Morales y Marín, J.-L., Los Bayeu, Saragossa 1979

Museo del Prado, Catalogo de las pinturas, Madrid 1972

Nordström, Folke, Goya, Saturn and Melancholy, Stockholm 1962

Núñez de Arenas, M., Manojo de noticias—La suerte de Goya en Francia, in: Bulletin Hispanique 3, Bordeaux 1950

Ortega y Gasset, José, Papeles sobre Velázquez y Goya, Madrid 1950; Velázquez und Goya, Stuttgart 1955

Pérez de Guzman, Juan, Las colecciones de cuadros del Príncipe de la Paz, in: La España Moderna 140, 1900

Pérez Sánchez, Alfonso E., Catálogo de la Colección de Dibujos del Instituto Jovellanos de Gijón, Madrid 1969
—Entorno a Corrado Giaquinto, in: Archivo Español de Arte XLIV, 1971

Pintos Vieites, María del Carmen, La politica de Fer- nando VII entre 1814 y 1820, Pamplona 1958

Ponz, Antonio, Viaje de España, 18 volumes Madrid 1772-1794

Salas, Xavier de, Goya: La Familia de Carlos IV, Barcelona 1944
—El segundo texto de Matheron, in: Archivo Español de Arte XXXVI, 1963
—Sobre un autorretrato de Goya y dos cartas inéditas sobre el pintor, in: Archivo Español de Arte XXXVII, 1964
—Sur les tableaux de Goya qui appartinrent à son fils, in: Gazette des Beaux-Arts LXIII, 1964
—Inventario de las pinturas de la colección de Don Valentin Carderera, in: Archivo Español de Arte XXXVIII, 1965
—Precisiones sobre pinturas de Goya: »El Entierro de la Sardina«, la serie de obras de gabinete de 1793-1794 y otras notas, in: Archivo Español de Arte XLI, 1968
—Una carta de Goya y varios comentarios a la misma, in: Arte Español XXVI, I Fasc., 1968-1969
—Inventario, Pinturas elegidas para el Principe de la Paz, entre las dejadas por la viuda Chopinot, in: Arte Español XXVI, I Fasc., 1968-1969
—Sobre un retrato ecuestre de Godoy, in: Archivo Español de Arte XLII, 1969
—Sur cinq dessins de Goya au Musée du Prado, in: Gazette des Beaux-Arts LXXV, 1970
—Dos notas a dos pinturas de Goya de tema religioso, in: Archivo Español de Arte XLVII, 1974

—Aportaciones a la Genealogía de Don Francisco de Goya, in: Boletín de la Real Academia de Historia CLXXIV, 1977
—Une miniature et deux dessins inédits de Goya, in: Gazette des Beaux-Arts LXXXIV, 1979
—Goya, Milan 1978

Saltillo, Marqués del, Goya en Madrid: su familia y allegados (1746-1856), Madrid 1952

Sambricio, Valentin de, Tapices de Goya, Madrid 1946
—Francisco Bayeu, Madrid 1955
—Los retratos de Carlos IV y María Luisa, por Goya, in: Archivo Español de Arte XXX, 1957

Sánchez Cantón, F.J., Goya en la Academia, in: Real Academia de Bellas Artes de San Fernando, Primer Centenario de Goya. Discursos…, Madrid 1928
—Los dibujos del viaje a Sanlúcar, Madrid 1928
—Goya, Paris 1930
—La estancia de Goya en Italia, in: Archivo Español de Arte VII, 1931
—Como vivía Goya, in: Archivo Español de Arte XIX, 1946
—Los cuadros de Goya en la Real Academia de la Historia, in: Boletín de la Real Academia de la Historia, 1946
—Goya, Pintor religioso, in: Revista de Ideas Estéticas IV, 1946
—De la estancia bordelesa de Goya, in: Archivo Español de Arte XX, 1947
—Los Caprichos de Goya y sus dibujos preparatorios Barcelona 1949
—Vida y obras de Goya, Madrid 1951; The Life and Works of Goya, Madrid 1964
—Goya, refugiado, in: Goya 3, 1954
—Museo del Prado: Los dibujos de Goya, Madrid 1954
—Le Pitture Nere di Goya alla Quinta del Sordo, Milan, 1963
—Goya y sus pinturas negras de la »Quinta del Sordo«, Barcelona 1963

Sarrailh, Jean, L'Espagne éclairée de la seconde moitié du XVIIIᵉ siècle, Paris 1954

Sayre, Eleanor A., An Old Man Writing—A Study of Goya's Albums, in: Boston Museum Bulletin LVI, 1958
—Eight Books of Drawings by Goya—I, in: Burlington Magazine CVI, 1964
—Goya's Bordeaux Miniatures, in: Boston Museum Bulletin LXIV, 1966

Seco Serrano, Carlos, Godoy, el hombre y el político, Madrid 1978

Soria, Martin S., Agustín Esteve and Goya, in: Art Bulletin XXV, 1943
—Las miniaturas y retratos-miniaturas de Goya, in: Cobalto, Fasc. 2, 1949
—Agustín Esteve y Goya, Valencia 1957

Starkweather, William E.B., Paintings and Drawings by Francisco Goya in the Collection of the Hispanic Society of America, New York 1916

Symmons, S., Goya, London 1977

Tormo, Elias, Las Pinturas de Goya y su clasificación cronológica, in: Varios Estudios de Arte y Letras I, Nrn. 1-2, 1902
—Los Goyas del Museo de Agen, in: Boletín de la Sociedad Española de Excursiones XXXVI, 1928

Torra, Eduardo, Federico Torralba u.a., Regina Martyrum, Goya, Saragossa 1982

Torralba Soriano, Federico, Goya, Economistas y Banquerons, Saragossa 1980

Trapier, Elizabeth du Gué, Goya, A Study of his Portraits 1797-1799, New York 1955
—Unpublished Drawings by Goya in the Hispanic Society of America, in: Master Drawings, I, 1963
—Goya and his Sitters, New York 1964

Urrea, Fernández, J., La pintura italiana del siglo XVIII en España, Valladolid 1977

Viñaza, C. Muñoz y Manzano, Conde de la, Goya: su tiempo, su vida, sus obras, Madrid 1887

Weissberger, Herbert, Goya and his Handwriting, in: Gazette des Beaux-Arts XXVIII, 1945

Wehle, Harry B., Fifty Drawings by Francisco Goya, in: The Metropolitan Museum of Art Papers, Nr. 7, New York 1938

Williams, Gwyn A., Goya and the Impossible Revolution, London 1976

Yebes, Condesa de, La Condesa Duquesa de Benavente, Una vida en unas cartas, Madrid 1955

Yriarte, Charles, Goya, sa biographie, les fresques, les toiles, les tapisseries, les eaux-fortes et le catalogue de l'oeuvre, Paris 1867

Zapater y Gómez, Francisco, Goya, noticias biográficas, Saragossa 1868

Index of Illustrations

Goya's Works

Index of Names

This index consists only of the names of people.

Photographic Credits